ADVANCE PRAISE FOR

REEL DIVERSITY

"*Reel Diversity: A Teacher's Sourcebook* is truly one of the most innovative texts for teaching about diversity and social justice to come along in many years. Using analysis and discussion of clips from popular films coupled with cleverly designed activities and exercises, *Reel Diversity* will soon become a mainstay of courses and workshops on multicultural education, human relations, and workplace diversity. From *Legally Blonde* to *The Lion King* the authors have fashioned a major learning tool that will be sure to draw even the most reticent student into thought-provoking debate."

William A. Howe, Consultant for Multicultural Education at the Connecticut State Department of Education and former President of the National Association for Multicultural Education (NAME)

"Never has going to the movies been such a powerful medium for infusing social justice and concepts of power/privilege into the classroom. Finally! A tool for teaching that goes beyond 'celebrating diversity' and moves toward creating equity and community. Johnson and Blanchard are to be lauded for their development of this volume to critically engage students in discourse on difference."

Sue Rankin, Associate Professor of Education Policy Studies, College Student Affairs Research Associate, Center for the Study of Higher Education, The Pennsylvania State University

"Finally, a resource that provides tangible tools for utilizing the powerful medium of film and other media to empower individuals to be active change agents in our world. *Reel Diversity* is a welcome addition to the literature that will assist teachers and facilitators in developing engaging experiences for students."

Vernon A. Wall, Director of Educational Programs & Publications,
ACPA—College Student Educators International & Founding Faculty,
Social Justice Training Institute

"The power of film helps us all see ourselves in a new light while encouraging us to collectively explore issues of fairness and social justice on a new level. The practical guidance *Reel Diversity* offers provides a roadmap to diversity educators, student affairs professionals, faculty across disciplines, and student leaders on how to effectively use the concept of 'difference' as a starting place for true growth as it offers a comprehensive solution for initiating serious conversations about diversity at all levels of education around a media students enjoy."

Jennifer DeCoste, Associate Vice President for Institutional Diversity Initiatives,
Clarkson University

REEL DIVERSITY

Studies in the
Postmodern Theory of Education

Joe L. Kincheloe and Shirley R. Steinberg
General Editors

Vol. 348

PETER LANG
New York • Washington, D.C./Baltimore • Bern
Frankfurt am Main • Berlin • Brussels • Vienna • Oxford

Brian C. Johnson &
Skyra C. Blanchard

REEL DIVERSITY

A Teacher's Sourcebook

PETER LANG
New York • Washington, D.C./Baltimore • Bern
Frankfurt am Main • Berlin • Brussels • Vienna • Oxford

Library of Congress Cataloging-in-Publication Data

Johnson, Brian C.
Reel diversity: a teacher's sourcebook / Brian C. Johnson, Skyra C. Blanchard.
p. cm. — (Counterpoints: studies in the postmodern theory
of education; vol. 348)
Includes bibliographical references.
1. Multicultural education—United States.
2. Cultural pluralism—Study and teaching—United States.
3. Motion pictures in education—United States.
4. Film excerpts—United States. I. Blanchard, Skyra C. II. Title.
LC1099.3.J635 370.1170973—dc22 2008030876
ISBN 978-1-4331-0403-9
ISSN 1058-1634

Bibliographic information published by **Die Deutsche Bibliothek**.
Die Deutsche Bibliothek lists this publication in the "Deutsche
Nationalbibliografie"; detailed bibliographic data is available
on the Internet at http://dnb.ddb.de/.

Grateful acknowledgment is hereby made to copyright holders for
permission to use the following copyrighted material:
Janet Lockhart & Susan Shaw, *Writing for Change: Raising Awareness of Difference, Power,
and Discrimination.* Reprinted by permission of the publisher, Tolerance.org of the
Southern Poverty Law Center. www.tolerance.org.

Danielle Walker and Thomas Walker, *Doing Business Internationally, 2nd edition,* © 2003.
Reprinted by permission of the publisher, The McGraw-Hill Companies.

Kimmel & Ferber, *Privilege; A Reader,* © 2003. Reprinted by permission of the publisher,
Westview Press, a member of Perseus Books Group.

Cover design by Sophie Boorsch Appel

The paper in this book meets the guidelines for permanence and durability
of the Committee on Production Guidelines for Book Longevity
of the Council of Library Resources.

Contents

Acknowledgments

The authors owe a great deal of gratitude to the many people who have supported this project. We are indebted to the many folks who allowed us access to their personal movie libraries. Special thanks to the staff s of the numerous video rental stores, but most especially to the management and staff members of Movie Gallery in Watsontown, PA (Laura, Beca, Trish, and Brian—you guys are awesome! Thank you for your help, suggestions, and kindness in support of our little "school project"). A special nod of thanks goes to Jeff Martin for his tireless efforts. We also honor the work of Shirley Steinberg, first as a scholar and mentor, but also for being the champion of this project to bring it to fruition

From Brian: To my wonderful wife and biggest fan, Darlene—thanks for always being in my corner, no matter how insane my ideas. To my kids, Aubyn and Analisa—thanks for all the times you did research for me; you are my greatest accomplishments. Boe—your encouragement was tangible—God bless you. Pastors James and Jilline Bond, thank you for helping me understand my "assignment" and pushing me forward. Finally, I must acknowledge the untiring support of Danielle Scott of Gaspipe Theatre Company (Lewisburg,

PA). Thank you for your selfless support of this project. Danielle—honestly, this project would never have been done without you. Thanks for speaking into my life the possibility that I could indeed write a book. Thanks to you and Derek for your artistic gifts, and for the hundreds of movies you let me borrow throughout this process!

From Skyra: I would like to first thank Brian Johnson for giving me the opportunity to be a small part of this project. Thank you for always believing in my abilities even when I did not believe in them. Next I would like to thank my family for always supporting me and loving me more than life. Lastly, I'd like to thank my friends and those who continually help me to learn and grow.

Preface

This book will serve as a resource manual for teachers who want to introduce and infuse the concepts of diversity and social justice into their courses. It provides easily accessible lessons for use in secondary, undergraduate, and graduate classroom instruction. The strength of the volume lies in its suitability for courses and workshop presentations.

The manuscript includes a discussion on the power of the film medium for teaching today's students, that is couched in the language of media literacy so that students understand the value of movies as harbingers of cultural expectations, mores, and beliefs, and not just as a source of entertainment. We present proven guidelines for teaching diversity using a framework that deconstructs national opinion and culture from both majority and minority perspectives. Critical to diversity education is the development of a shared language among teachers and learners; this text provides a list of important definitions about difference and power dynamics. The manual closes with a discussion on the role of the teacher as a crucial factor in minimizing cultural dominance, prejudice, and discrimination in our society that favors majority groups and demonizes minorities.

Another feature of *Reel Diversity* is an extensive section on designing a diversity education course using mainstream Hollywood film as the vehicle. Teachers will benefit from the classroom teaching ideas including suggested instructional activities, recommended readings, possible assignments, and advice on creating a classroom atmosphere for tough, sometimes politically and emotionally charged, topics.

Rather than just being another book on film literacy, theory, and criticism, this resource manual stands out from its competitors for its practical, user-friendly mini-lessons using film clips from mainstream Hollywood feature films from a variety of genres. The lessons in this book are designed to supplement instruction on diversity issues. For each term in the list of definitions, we have provided a movie clip that illustrates the concept being taught. Most clips last no longer than 10 min. in length. We have also developed a list of questions following each clip that can be used to encourage cross-cultural dialogue. With over 150 clips and nearly 500 discussion questions, both novice and experienced educators will find visual illustrations to support their instruction.

This volume is written by teachers for teachers who desire to expand concepts of diversity beyond simple celebration, acceptance, or tolerance—the buzzwords of diversity—to an increasingly more significant understanding of and critical engagement with the issues of difference. No other book offers this type of practical, teacher/student-friendly material that is usable in a variety of classroom, workshop, and seminar formats.

The first section, "Introduction: Teaching Diversity Lessons Through Film," covers the reasons why film is a good medium for teaching today's students as well as dealing with the issue of media literacy.

Chapter 1, "Guidelines for Teaching Diversity," discusses how to expand our concepts of diversity to allow for increased critical engagement by students and teachers.

Chapter 2, "Creating a Common Lexicon," emphasizes how critical the development of a shared language is to diversity education. It also provides a list of important definitions about difference and power dynamics.

To effectively understand the role that diversity plays in society, we must explore and deconstruct how American culture functions. Chapter 3, "Developing a Course on American Diversity (with an Emphasis on Film)," focuses on understanding culture, race, gender, and sexual orientation through the medium of American cinema.

Designed to complement instruction on issues of difference, Chapter 4, "Film Clips and Questions for Discussion," outlines visual examples of the diversity definitions. Each clip has a description of the entire film, a detailed

commentary of the scene, questions designed to spur conversation, and the film citations.

The conclusion, "The Prevailing (Hidden) Discourses," concludes the resource manual with a discussion of the ways in which power, oppression, prejudice, dominance, and ethnocentrism survive in American culture.

The featured films are grouped by topical definition in the appendix.

Introduction:
Teaching Diversity
Lessons through Film

In other words, films appeared to be vehicles of amusement, a highly regarded and sought after source of fun and joy. . . . However, within a very short period of time, it became clear to me that the relevance of such films exceeded the boundaries of entertainment.

Henry Giroux, 1997

Each person's individual identity is shaped by a number of different forces, including, but not limited to, parents and other family members, peer groups, social and religious organizations/leaders, educational providers and institutions, communities, and media messages. These forces, in many ways, dictate particular meanings and interpretations of the world around us. In your life, what have these forces taught you about who you are, and what have they said about people who are not like you?

Many times, these messages are not communicated verbally; they are often embedded in traditions, behaviors, activities, and the like. Of the above list of cultural shapers, few send more powerful messages (subtle and overt) than the *Hollywood machine*. The movie industry spends billions of dollars to produce films for all ages and reaps billions in return through a public that is thirsty for

the next big hit. Our national economy, in many ways, is supported by this industry, and in like manner, our cultural identities are influenced by Hollywood images.

Because of our relatively easy access to movies, this medium has become the visual aesthetic that students continue to admire today. Students watch movies on VHS (though this medium is quickly dying), DVD, the Internet, and via the newer craze, the video iPod™. This medium satisfies the students' increasing needs for visual stimuli and can be used as a productive and efficient tool for teaching despite the common misconception that students want to watch movies because they do not want to read. Most people do not think about how movies shape our beliefs and worldview. Specifically, our individual cultural identities are continually shaped, changed, and sometimes distorted by what we see in movies. Giroux adds, "Films appear to inspire at least as much cultural authority and legitimacy for teaching specific roles, values, and ideals as do the more traditional sites of learning such as the public schools, religious institutions, and the family" (Giroux, 1997, p. 53).

Generally speaking, movies have a knack for creating, maintaining, and inverting social issues in America, and the consequences are often played out in the classroom. The line between entertainment and educational message is often blurred, and students use the "knowledge" gained from movies as fact, thus creating difficulties and controversies. Students often take at face value those films that are "based on a true story" without critically evaluating the liberties that studios take with stories for a dramatic effect. This book looks at how movies can be used both in discussing and in questioning diversity issues in the classroom in a productive and educated way.

We, as educators, understand that teachers often feel ill equipped to teach diversity issues because they are uncomfortable, because of the fear of being offensive or stereotypical, or because they just lack the knowledge to do so. Moreover, teacher education programs rarely prepare students to actually teach and explore diversity issues. This lack of knowledge is not aided with the use of popular textbooks either. Although many newer textbooks have sections that provide students with diversity connections, they are most often couched in the language of dealing with the diverse as *at risk*. The section on diversity is almost certainly not the focus of the curriculum, and thus it is more often skipped than utilized. If the goal of education is to produce citizens who are global thinkers, how much longer can eliminating this element from the curriculum be acceptable?

Limitations for Teaching with Film

Although we suggest that movies are a great place to start a diversity dialogue, they have their limitations. First, students are often not equipped to view movies critically as this medium is usually a vehicle of entertainment, not education. Before educators can begin teaching students through the use of film, they must introduce students to the concept of critically analyzing film to get the most from the experience—to become media-savvy and literate. Thus, this means that teachers themselves need to learn first how to view movies critically. Second, teachers often do not have time to show complete films, so it is up to them to find the best parts of movies to maximize both their time and their objectives for their lessons. Furthermore, teachers must believe in the legitimacy of film as a cultural educational medium; in addition, they should understand how the film medium appeals to students. Through this book, we have attempted to minimize the guesswork for teachers. Multiple aspects of the lesson as it relates to a specific diversity issue are laid out.

As we examine these cinematic influences, we operate from the following two foundations: (a) each film is political in that it has a message and (b) there are no *mistakes* in films. The editorial process is such that multiple people must approve the film's content before it is released to the general public—this includes those *ad-libbed* moments.

Jowett and Linton (1980) argue that movies create a type of "visual public consensus" (p. 75) that has the power to bypass traditional methods of teaching (family, church, school) and establish immediate relational contact with the watcher. In what ways do the studios, directors, actors, and the action of the films determine and reflect our national opinion, our personal values, and how do they enforce cultural ideals? Media literacy explores the ways in which our individual and societal psyches are impacted by cinematic expression. What determinations can we make about race, ethnicity, gender, and sexual orientation as they are defined by Hollywood standards? These questions and others form the central focus of this resource manual.

Mainstream films, then, can be seen as a "reflector" of our national opinion; because we live in a culture of instant gratification, film producers must offer easily reproducible, formulaic content. The studios are often at the mercy of the public that is satisfied with familiar themes, clearly identifiable characters, and expected conclusions. Film audiences seem to prefer what is repackaged, old, familiar, and comfortable. If the film strays too far from convention, the audiences generally boycott and don't show up to see the film (we must remember, after all, that movies are made to make money). For an example of the formu-

laic conventions, take films such as *Dangerous Minds*, *Freedom Writers*, and *The Blackboard Jungle*.

Here's the equation: Take one urban high school, add a bunch of rowdy, undisciplined, poor, drug-dealing, violent, functionally illiterate Black and Latino students, then add an unqualified, first-time White teacher who is from a privileged background, and voila! An instant box office smash! Yes, there are films like *Stand and Deliver* and *Lean on Me* that feature Black and Latino school leaders, but the usual discourse is still there. What meaning, then, does the noncritical viewer take from the multiplicity of films like this, most of which are based on true stories? The formula remains: Black and Latino kids are deviance-prone animals in need of a savior (who is usually White).

This impoverished and violent racial phenomenon played out in school-centered films related to Blacks and Latinos is juxtaposed against films focused on the White experience in schools where the overwhelming pattern is affluence, private education centered on learning the classics, preparation for college admissions, marriage, careers in government and industry, and a legacy of power passed from generation to generation. Films such as the *Dead Poets' Society*, *The Emperor's Club*, *The Skulls*, *Mona Lisa Smile*, *School Ties*, *The Great White Hope*, *Finding Forrester*, *O*, and even trivial comedies such as *Van Wilder*, *Road Trip*, *Animal House*, and so many others show Hollywood's belief in the academic excellence and socioeconomic prowess of Whites.

Interestingly enough, there is a scene in *Dangerous Minds* where the filmmakers revealed the racialized formula. Ms. Johnson (played by Michelle Pfeiffer) is talking to the tough student leader, Emilio (Wade Dominguez), after she "saved" him from being arrested. She seeks to understand Emilio's experience—why he is the way he is—and asks about his family background and history of violence. Emilio retorts, "So, now you're gonna try and psychologize me. You're gonna try to figure me out. Let me help you—I come from a broken home and we're poor, alright . . . I've seen the same movies you did."

One thing is true about this movie: the writers, directors, and producers—the minds behind this movie—are *dangerous*.

References

Giroux, H. (1997). Are Disney movies good for your kids? In S. Steinberg & J. Kincheloe (Eds.), *Kinderculture: The corporate construction of childhood* (pp. 53–68). Boulder, CO: Westview.

Jowett, G., & Linton, J. (1980). *Movies as mass Communication*. Newbury Park: Sage.

ONE

Guidelines for Teaching Diversity

Ortiz and Rhoads (2000) created a multicultural education framework that insists that those "learning" diversity become astute in understanding culture (self and others), deconstructing White culture, and developing a multicultural outlook that leads to an action orientation. Becoming a critical "reader" of movie texts is an important task in both understanding American culture and being able to educate students about diversity concepts.

"Diversity" has for a very long time been focused on the subject of race. Ask an educator what the percentage of diversity is in their class or school and most of them will begin counting "the pepper in the salt" or the number of black and brown faces that they have seen. Majorities are thus left out of the conversation and are free to withdraw or point the finger at others. Diversity has been posited as an "us versus them" phenomenon, and engaging with racial diversity then becomes a "minority" issue. (The same thing happens along other dimensions as well—men rarely think of gender, heterosexuals do not realize that they have a sexual orientation, etc.)

Diversity at its core focuses on difference, but what we don't discuss often enough is what those differences are. In addition to the laundry list of identity

dimensions—age, race, religion, sexual orientation, socioeconomic class, ability, and the like—we should be willing to critically examine values, mores, traditions, interpretations, techniques, symbols, and ideologies (and the intersections of identity dimensions). You've probably heard of the cultural iceberg:

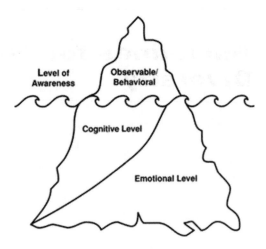

Source: Brace, T. (1995, p. 40)

We are accustomed to talking about what is above the surface, what is easily observable and measurable. That is where "typical" diversity lives. A person talks about belonging to a particular cultural group or identity but is rarely able to discuss what it means to belong to that culture. The focus is primarily on clothing, food, and music styles, but what gets forgotten or minimized are the beliefs, values, and assumptions of a culture that motivates the manifested behavior above the surface. A beneath-the-surface cultural exploration will include an explanation of the reasons why and how a particular culture eats a particular food or dresses in a particular style. It includes the epistemology or the philosophy by which a person or group determines worldview and culture.

Additionally, our traditional diversity discourse does not include the systemic nature of oppression or the inherent power dynamics that prevail. Today's student will look at our textbook images of enslaved people in chains and groups behind the fences of internment camps and the archival images from the 1950s and 1960s and suggest that "we've come so far" and "things aren't as bad as they used to be." They will argue that racism is a thing of the past because they do not see lynchings on a regular basis or because Eminem is on the rap charts and Usher is singing on the pop charts, thereby ignoring the systemic and systematized ways that minority groups are often ignored, exploited, and oppressed on a daily basis.

Without critical examination, the ills of society become the "fault" of the victim. Let's use a film example: in most movies that focus on the issue of rape, the alleged perpetrator inevitably suggests that the victim was "dressed like she wanted it," or she was "out late at night" in a particular location, or that she was acting seductively, or that she "led me on." What is ignored is how the notion of male dominance has created a sexist system whereby women are objectified by their sexuality and commoditized for male use and abuse. It is this same belief in male dominance that inhibits male victims of rape from coming forward.

Part of the challenge of being a diversity educator is to create a classroom atmosphere where the cultural identities of the students are affirmed and supported. This is seconded by attempts to liberate each community member to be a whole person, where each learner has the freedom to critically explore and examine his or her own and others' opinions, beliefs, attitudes, and identities in a supportive environment. To do these, you as the teacher must uphold a firm commitment to diversity and recognize that there are multiple dimensions of diversity including, but not limited to, culture, race, ethnicity, nationality, geographical locations, age, sexuality and sexual orientation, ability, socioeconomic status, gender, class, linguistics, and religion. You must be equally committed to the values of social justice and creating equity and access for underrepresented and marginalized groups.

Critical engagement with diversity and multiculturalism then becomes an opportunity for teachers and learners to challenge ethnocentric assumptions and the manners in which we have been shaped by educational institutions, religious traditions, community leaders, family systems, and the mass media. We ardently support the notion that creating a multicultural outlook is an important component of "getting a good education" as it helps to build critical thinking and decision-making skills and also provides opportunities for intercultural and cross-cultural interactions and relationship building. Critical multiculturalism is not about being "politically correct" nor about labeling all persons who identify as majorities as enemies or bad people. In fact, we believe that critical multiculturalism must welcome the vantage points of all members of the classroom community, at the same time continuing to seek to ensure that minority groups have the equitable opportunity to be full-fledged members of the learning community. This type of education encourages teachers and learners to move beyond a mere "celebration of diversity" toward a better understanding of difference, particularly those differences that work to reproduce inequalities in the United States and their local communities and school settings. As most of us have had our lives shaped by/among homogenous groups, we have consequently grown up with biases that we have never

learned to question. This book is about learning to question our cultural shaping by examining contemporary mainstream films.

In our technologically advanced society, dialogue between individuals and groups has been reduced to quick blurbs on AOL Instant Messenger (AIM) and pokes on Facebook or MySpace; rarely do we sit down and face each other to openly discuss important topics. Furthermore, our politically correct (i.e., conflict avoidant and passive aggressive) culture has created a world where, all too often, unspoken misconceptions and biases about color, culture, and creed become stumbling blocks to understanding and respect. Worse, these barriers can breed intolerance and hate. To help break down those barriers, students and teachers must openly and candidly discuss the taboo subjects, discussions that often only happen behind closed doors or in secret cliques.

For this to happen, teachers must create a safe and trusting environment that supports and promotes the discussion of issues regarding diversity and multiculturalism. Through honest, facilitated dialogue we can explore issues that are prevalent in society and that influence our everyday lives. Having these real conversations will provide an experience that is impactful and can serve to challenge and potentially enhance our educational experiences. Teaching about diversity through the film medium allows us greater opportunity

- to engage in honest dialogue about issues that affect society
- to gain a new perspective on various cultures and
- to have meaningful discussions in peer groups.

Film literacy and multicultural literacy then become opportunities for students to engage in important cultural subjects. Exploring these cultural ideals frees educators and students to ask questions about how films are created, their representations, their makers, and how we make meaning individually and as a collective audience. Both literacies require examination of the credentials and biases of the directors, writers, and actors, the verisimilitude of the voices and action, and the apparent assumptions that are being made by the creators *about* the audiences as movie watching is an interactive and circular exchange between the studios and the audience.

Addressing the Tensions of Diversity

Conflicts and clashes about diversity can arise in the classroom daily. Try to imagine this real-life classroom situation that happened recently to one of the authors of this text:

During a game of *Catch Phrase*™ with a group of senior English students,

a female White student was responsible for describing the word *Africa*. The buzzer beat faster and faster, indicating the time for obtaining a team point was almost at an end. In order to try to win the point for her team, the clue she chose was to point at the two Black people in the class (one of which was the teacher). There was no dialogue accompanying this gesture, just her fingers pointing to the Black people in the room.

Later on, the student had a second chance to describe a word; she pointed to the Black teacher and said "*She* doesn't do this!" Her word was *suntan*.

How Would You Address This "Teachable Moment"?

When hot moments and conflicts inevitably arise, teachers should directly confront the issue or offensive remark. They must think rationally, remain neutral, and find teaching opportunities in these occurrences. If a teacher cannot find a workable position in the conflict, he or she must recognize it and put it aside for later processing. The deferment allows both the facilitator and the participants to calm down and plan strategies to effectively confront the topic. Before the end of the session, the group should return to the moment and deal with it, exploring the differing viewpoints surrounding it. No hot moment is ignored or left undiscussed.

Developing Trust

It is important very early in a diversity course to develop an atmosphere of trust and sensitivity, not the faux sensitivity of political correctness, but the ability to speak freely among colleagues (this freedom does come with responsibilities). These types of courses can be highly emotional, can produce anxiety and fear, and can be frustrating for learner and teacher. Setting the tone for amicable dispute and discussion is important. Students need to be invited to be able to ask critical and challenging questions of one another. This cannot happen in a classroom of strangers.

Considerable effort must be taken in the first several classes to lessen the strangeness between the individuals in the class. The more you break down the barriers and fears of multicultural engagement, the greater your ability to get into the nitty-gritty of the material. The following activity has proven effective as a classroom icebreaker and should be done within the first couple of class meetings.

Hello, My Social Identities Are . . .

In new situations, we are accustomed to introducing ourselves to new people by saying our name, or wearing a nametag that reads, "Hello, My Name is. . . ." What would happen if we introduced ourselves in the fullness of our identities? Understanding yourself and how your values and worldview interact with others is an important factor in developing community.

Each participant will be given a sheet of nametags that have the following 10 social identities listed (name, race, gender, religion, sexual orientation, home state or country, family income, major or favorite subject, first/native language, and pet peeve) and will be asked to self-identify their cultural identities by wearing the nametags (these can be customized for the issues that you will be addressing in the class).

Invite students to identify as they see fit—as creatively as they desire. Giving them license to self-identify accomplishes two goals: students have the opportunity to name themselves rather than feel required to use proscribed monikers, and we are controlling for safety and minimizing associated risks, inasmuch as students can choose to limit how much personal information they share at a first meeting.

Students will then meet and mingle with other participants and will be encouraged to question each other about what is written on the nametags. Next, students will be asked to identify which of their social identities is most salient to them and to place that name tag in the middle of their forehead (to signify that this identity is something they think about frequently), and then given the same charge to mix and mingle. Finally, students will then separate into "like kind thinkers" (with those with similar salient identities), and groups will discuss what it means to be in a social group with others. In the debriefing, the facilitator will also notice how the groups often fall out (typically, the concept that makes one "different" is what is most salient, e.g., racial minorities think about race; women about gender; lesbian, gay, bisexual, transgender/transsexual (LGBTs) about sexual orientation, etc.).

Sharing their own personal stories and histories can go a long way in helping students understand cultural heritage. Lead them in discussions of how they experience campus and school cultures. How would they describe the school's values and beliefs, norms, symbols, and language? Entertain their thoughts on how they perceive campus life for persons from minority groups.

It is also important to point out that deep discussions around diversity issues are best dealt with when students have relationships with one another. This is an important ingredient that allows for foibles and mistakes without major explosions. There are several assumptions that must be made if you are going to deal with these issues in your classroom:

1. Many people internalize anger, fear, contempt, and guilt about both their ignorance of certain terminologies and how they express them in unhealthy and unproductive ways in school and in the workplace.
2. Blatant and subtle forms of racism, sexism, and other "-isms" exist in daily interactions, media portrayals, and cultural institutions.
3. Diversity engagement addresses these emotions and behaviors by providing a place for them to be expressed, confronted, corrected, if necessary, and overcome.

Teachers must be aware that we must engage dialogue with the understanding that the process of dialogue itself can reproduce inequality unless participants recognize that we come to the table with unequal relations of power and privilege. Creating opportunities to discuss these assumptions requires teachers and students to learn how to honestly communicate with each other.

References

Brace, T. (1995). *Doing Business Internationally: The Guide to Cross-Cultural Success*. Willowbrook, IL: Irwin Professional Publishers.

Ortiz, A., & Rhoads, R. (2000). Deconstructing whiteness as part of a multicultural educational framework: From theory to practice. *Journal of College Student Development, 41*(1), 81–93.

 TWO

Creating a Common Lexicon

One of the most important steps to take in diversity education is to ensure that all participants in the dialogue share a common vocabulary or language about diversity. Teachers who wish to explore deeper levels of diversity dialogue have a responsibility for increasing access to that dialogue. Many times students do not have the vocabulary to participate freely; the fear of "saying the wrong thing" is often very significant (especially for majority students). This reticence is a major deterrent to speaking about difference. In his book, *Frames of Mind*, Howard Gardner suggests that those with a keen understanding of their strengths and needs are in much better position than those with limited or faulty self-knowledge (1983).

Diversity educators often talk about the necessity and importance of cross-cultural competencies. This includes having the cultural awareness of both self and others, possessing factual knowledge about the cultural traditions and mores of others, and attaining the behavioral skills necessary to navigate cross-cultural situations. In their book *Multicultural Competence in Student Affairs*, Pope, Reynolds, and Mueller (2004) have identified the ability to communicate across lines of difference as paramount to achieving competence. What

traditional foci on differences have created are chasms that are difficult to cross. Students need to be able to have significant conversations about relationships, ethnicity, activism, and outlooks on life.

Students fail to move into deeper engagement with the issues mainly because of a lack of preparedness for such conversations. Majority students, in particular, have difficulty approaching the topics because they have been left out of the dialogue for so long. Diversity has been a predominantly minority-based discourse, and majorities feel like they are encroaching on a territory that is not their own. What we have then is an opportunity to demonstrate that to have a minority means to have a majority—opening the access to a dominance discourse that is so necessary in truly engaging the issues of difference.

Most institutions state that engaging with diversity is everyone's responsibility, which sounds good, but is everyone prepared for the challenges that such work brings? Engaging with diversity and inclusion often means focusing on the minority, with little to no attention paid to the predominant group and the opportunities they have to create change. Individual majority persons (heterosexuals, Christians, Americans, males, Whites, etc.) are typically marked as enemies and bad people (often unwarranted) and are rarely invited to the multicultural table. Most students (majority and minority) do not possess the vocabulary to contribute to the discussion in meaningful ways, and many retreat altogether citing "I'm tired of all this diversity stuff."

In some ways, majorities must be invited to move beyond surface sensitivity to building authentic relationships and critical engagement with diversity issues. We must begin by asking two questions: What does a majority need to understand about minority groups and how can majorities get the information they need? These questions must be coupled with a review of power dynamics, with the goal of moving from surface sensitivity to a deeper level of empathy and an orientation toward action on diversity issues. To understand the majority side of difference, we have to be willing to engage the minority experience. We must help students become cognizant and competent in understanding the facts of underrepresentation, the power of social contexts, and the systemic nature of oppression (the real enemy).

This text provides educators with a list of definitions that raise awareness of differences, power, and discrimination (seminal topics when dealing with these issues). It is necessary that all students and educators "speak the same language" and all work from a common lexicon. Rev. Mark Radecke, a Lutheran pastor, once stated that "It should not be a surprise that there is diversity of opinions about diversity." A statement like this underscores the rationale to have common definitions that set the stage for your instruction.

In this resource manual, we utilize the following definitions that appear in

Writing for Change: Raising Awareness of Difference, Power, and Discrimination, a teaching kit from Teaching Tolerance, a project of the Southern Poverty Law Center (used with permission). For more information on Teaching Tolerance and its free resources for teachers and community leaders, see www.teaching-tolerance.org.

It is important to note that the definitions below reference the systemic nature of the dynamics of difference. Teachers must assist students with establishing systemic understanding in order for them to "resist, transform, and appropriate mediated understandings, instead of passively absorbing images of who they should be and how they should act within social categorization (race, gender, class, sexual orientation, etc.)" (Jacobs, 2005, p. 7).

Anti-Semitism	Systematic discrimination against, disparagement of, or oppression of, Jews, Judaism, and the cultural, intellectual, and religious heritage of Jewish people.
Classism	A system of power and privilege based on the accumulation of economic wealth and social status. Classism is the mechanism by which certain groups of people, considered as a unit according to their economic, occupational, or social status, benefit at the expense of other groups.
Compulsory heterosexuality	The assumption that women are "naturally" or innately drawn sexually and emotionally toward men, and men toward women; the view that heterosexuality is the "norm" for all sexual relationships. The institutionalization of heterosexuality in all aspects of society includes the idealization of heterosexual orientation, romance, and marriage. It creates institutionalized inequality of power, and legal and social discrimination against homosexuals, and the invisibility or intolerance of lesbian and gay experience.
Co-optation	Various processes by which members of dominant cultures or groups assimilate members of target groups, reward them, and hold them up as models for other members of the target groups. *Tokenism* is a form of co-optation.
Difference	A characteristic that distinguishes one person from another or from an assumed "norm," or the state of being distinguished by such characteristics.
Discrimination	Unequal treatment of people based on their membership in a group.
Dominance	The systematic attitudes and actions of prejudice, superiority, and self-righteousness of one group (a nontarget group) in

relation to another (a target group). *Internalized dominance* includes the inability of a group or individual to see privilege as a member of the nontarget group.

Ethnocentrism The emotional attitude that one's own ethnic group, nation, or culture is superior to all others or is the norm by which others are measured.

Gender A cultural notion of what it is to be a woman or a man; a construct based on the social shaping of femininity and masculinity. It usually includes identification with males as a class or with females as a class. Gender includes subjective concepts about character traits and expected behaviors that vary from place to place and person to person.

Heterosexism A system of beliefs, actions, advantages, and assumptions in the superiority of heterosexuals and heterosexuality. It includes unrecognized privileges of heterosexual people and the exclusion of nonheterosexual people from policies, procedures, events, and decisions about what is important.

Homophobia Thoughts, feelings, or actions based on fear, dislike, judgment, or hatred of gay men and lesbians or those who love and sexually desire those of the same sex. Homophobia has roots in sexism and can include prejudice, discrimination, harassment, and acts of violence.

In-group (non-target group) The people in each system or relation of oppression who are in power in that oppression. Members of nontarget groups are socialized into the role of being oppressive, becoming perpetrators or perpetuators of the cycle of oppression, either actively or indirectly. A nontarget group may retain its power through force, the threat of force, and/or misinformation about the target group. Members of nontarget groups also have a history of resistance that is usually not recognized.

Invisibility The absence of target groups from the media, policies, procedures, legislation, social activities, and other milieus, which reinforces the notion, conscious or unconscious, that nontarget groups are the norm. Invisibility contributes to the disempowerment of target groups and the perpetuation of the cycle of oppression.

Oppression The systematic, institutionalized mistreatment of one group of people by another for any reason. Oppression is based on a complicated and changing network of unequal power relations.

Out-group (target group)	The people in each system or relation of oppression who are without power in that oppression. Members of target groups are socialized into the role of being oppressed, internalizing the mistreatment and misinformation about the group(s) to which they belong. Each target group usually also has a history of resistance, which may not be recognized by people outside the target group.
Power	Generally, the accumulation of money, goods, authority, sway, or influence. Specifically the differential ability based on unequal distribution of wealth, influence, or physical force to control the economic, political, sexual, educational, and other important decisions of others.
Prejudice	An opinion, prejudgment, or attitude formed without sufficient knowledge about a group or its members.
Privilege	An invisible set of unearned rights, benefits, or assets that belongs to certain individuals simply by virtue of their membership in a particular nontarget group. Privilege is a dynamic system of overlapping benefits that may act to any particular individual's benefit in one set of circumstances and to that person's detriment in another.
Racism	The systematic mistreatment of people of color based on the belief in the inherent superiority of one race and thereby the right to dominance. Racism is one manifestation of institutionalized differences in economic, social, and political power in which members of some ethnic and cultural groups benefit at the expense of others.
Sexism	The systematic economic, sexual, educational, physical, and other oppression of women as a group; the exploitation and social dominance of members of one sex by another.
Social justice	A combination of laws, behaviors, and attitudes promoting equal rights and fair treatment of all members of society. The practice of social justice includes resistance to racism, sexism, classism, and other forms of oppression.
Stereotype	An exaggerated belief, image, or distorted truth about a person or group—a generalization that allows for little or no individual differences or social variation.

The above definitions often refer to the -isms as systemic and institutional. This is an important part of the education of difference. Bigotry and bias are indeed personal and individual, but their greatest impact is at the societal level.

Encourage your students to learn these definitions as part of the central curriculum. The film clips used later in this resource manual will be based upon these definitions. The next section focuses on the design of a diversity education course that is also reflective of these definitions.

References

Developing Definitions. Retrieved June 21, 2008 from http://www.tolerance.org/teach/web/wfc/pdf/section_1/1_14_developing_definitions.pdf

Gardner, H. (1983). *Frames of mind: The theory of multiple intelligences.* New York: Basic Books.

Jacobs, W. (2005). *Speaking the lower frequencies: Students and media literacy.* New York: SUNY Press.

Pope, R., Reynolds, A., & Mueller, J. (2004). *Multicultural competence in student affairs.* San Francisco: Wiley.

Developing a Course on American Diversity (with an Emphasis on Film)

For the instructor interested in designing a film course that focuses on the issues of difference in American culture and society, this chapter provides an outline and discussion of such a course. We provide a series of recommended films and learning outcomes to serve as a guide for the potential instructor. Where appropriate, we provide opportunities to utilize the clips featured in this resource manual.

Film courses are wide ranging in their pursuits and objectives; it is important to note that the course we are recommending is a study of the film medium as a cultural phenomenon rather than the aesthetics of film production. What we offer is not movie-making techniques (though literacy in certain terms is recommended), but an understanding of the social implications of film. We focus on mainstream film and its influence on our common understanding of culture, race, religion, sexual orientation, and gender and the extent to which these are truthfully represented or oversimplified. We argue that to understand film is to comprehend cultural art and artifacts. Your students, then, need not be film studies majors to participate fully in this recommended course.

We analyze contemporary American film with particular attention to story lines and plot, genre conventions, thematic meaning and interpretation, and

characterization. We emphasize that students become critical, visually literate "readers" of movie texts and that they learn to exercise critical thinking and analysis skills to move beyond the entertainment value of film to its moral and educational utility, particularly the ideological points of view embedded in cinema. The larger goal of this course is to teach students how to critically analyze and evaluate films as cultural texts.

We take seriously the idea that popular film can be a vehicle for social commentary, analysis, and criticism. We examine both how a film works as a cultural medium and how and why it affects the viewer the way it does. We learn how to use popular American films to understand competing perspectives on American history, culture, and society.

We must acknowledge, then, that the shaping of worldviews and attitudes about difference is determined by the constraints of one's cultural orientation and societal ideologies. In our experience of teaching diversity concepts, we find that most students have had their lives shaped by/among homogenous groups. As a consequence, they have grown up with biases that they have never learned to question. As such, we must endeavor also in this "course" to offer ways that the student can understand and challenge his or her own sense of self and worldview by expanding students' informational bases, uncovering truths, and dispelling misconceptions in media portrayals.

Ours is a study of the problems and issues raised by the historical depiction of minorities, gender, sexualities, and class in American film. Individual sections of the course analyze the depiction of African Americans, Native Americans, Asian Americans, Latino Americans, women and femininity, men and masculinity, sexuality, and class struggle and class difference. Emphasis is on how these categories have been "coded" in Hollywood mainstream film to perpetuate stereotypes and to maintain White patriarchal power. We also examine how the "majority" is constructed in Hollywood film—a factor often unchallenged in contemporary discussions about diversity. To truly understand the experiences and perspective of the minority, we must be willing to comprehend the perspective of the majority groups and their systemic influence on the actions, interactions, and outlook of minority groups.

Learning Objectives

By the end of this course, students will have an understanding of

1. the impact and influence of historical, political, and cultural milieus on the proliferation of archetypes of particular groups;

2. the process of examining and understanding one's own identity along the lines of race, ethnicity, sexual orientation, and gender;

3. the role of education, the media, and other influences on individual identity development and social understanding; and

4. the process of deconstructing cultural norms and attitudes.

Notes for students

When reading/watching these texts, try to put yourself in the place or shoes of the characters. This understanding of perspective will aid your ability to read between the lines. As you read, write plenty of notes. Question the text's imagery and symbolism. Look for hidden meanings. Sometimes a short phrase will give incredible insight into the work.

Special note

Sensitive subjects will be a regular topic of conversation. The issues of race and sexual orientation are often difficult to address in educational arenas, as it is sometimes uncomfortable for some people. In order for our class to function, we must stress that all opinions are welcome, but should be tempered in such a way as to limit potential difficulties. (Be prepared; some of the works we read/view include racial epithets and negative depictions of minorities. We also show films that feature violence as well as men and women in sexual situations and nudity.) We do not censor films (although the instructor has the right to determine what is appropriate for the class).

Notes for instructors

Prior to screening any particular film in class, we recommend requiring some type of prescreening exercise to familiarize students with the film. Students coming in "cold" are often ill prepared for critical evaluation and resort to watching a film for entertainment and plot only. One method we have found useful is requiring a standard assignment due at the beginning of the screening period. In this assignment, students are expected to locate and read three critical reviews for each film due on the date we watch a particular film. Two of the reviews must be from a published source that has an editorial review process, such as the *New York Times* or *Entertainment Weekly*. In other words, reviews should not be some random person's blathering on a web site (although web-based reviews from authoritative film critics, such as Ebert & Roeper or Leonard Maltin, would be acceptable). Students must submit a one-page summary of the reviews at the beginning of the class period.

Unit 1: Exploring, Deconstructing, and Understanding Culture

The design for this course was significantly influenced by the Ortiz and Rhoads (2000) multicultural education framework. According to their study, developing an action orientation toward critical multiculturalism begins with the ability to understand culture. In this unit, we present the components of culture, describe the requirements of cultural attachment, and discuss how possessing or belonging to a culture impacts a person's or group's worldview. We review three films that have proven to be excellent resources for understanding issues of culture: *Krippendorf's Tribe* (1998), *Pleasantville* (1998), and *The Breakfast Club* (1985).

What Is Culture?

Cultures are maps of meaning through which the world is made intelligible. It can also (very simplistically) be defined as a group's "total way of life." Sociologists and anthropologists agree that culture is made up of four components: symbols, language, norms, and values and beliefs.

Symbols

Anything that carries a particular meaning can be described as a symbol. Most often, we see symbols as something that we wear or something that is easily distinguishable. A cross is a symbol that carries a particular meaning, especially for Christians who would identify the cross as a sacred element. This symbol adorns the steeples of churches and the necks of many believers of the Christian faith. The same can be said of the Star of David for the Jewish people.

One of the most recognizable symbols in world culture is the big "golden arches" of the McDonald's brand name. You could be driving down a highway or a stretch of road in Appalachia or walking down the crowded streets of Beijing or wandering through the courtyards of Yaroslavl, Russia, and see a giant yellow "M." It would not matter whether you spoke the language of the particular area, but the chances are you could get your hunger needs satisfied at that location. Even if the menu were to be written in Greek, it is more than likely that you would be able to order a Big Mac™ without much difficulty. This is the power of the symbol created by a fast food culture.

Although symbols do not often change in their meaning, the value of that

symbol can change. A person's religious affiliation or belief system may change, but the cross will still carry its original meaning. A person's interpretation of the symbol may be relative; our monetary symbols are a good example. In the 1950s, a gallon of gas was mere pennies; anyone who has gone to the pump recently has felt the sting of a difference in the value of a dollar. As young children, many of us used to dance a jig when we received a shiny new quarter. Years ago, there was such a thing as a "penny candy" store. A child with a quarter was rich and could purchase a wealth of candy treasures. Imagine giving that same quarter to a 30-something adult who is married, with a mortgage, carrying two car notes, and is paying student loans. How do you think that person would respond to your offer to assist them with paying those bills by giving them a shiny new quarter? What's different? The monetary value of this particular symbol has not changed: it is still one quarter of a dollar, a 25-cent piece. However, your outlook on what you would be able to do with the money has changed.

Language

It can be said that we only know the world through our language—a system of symbols that allow communication with others. Our children are taught the ABCs as building blocks toward a more complex system of communicating verbally and in print. Understanding any particular language is akin to deciphering a code; only the initiated are able to participate fully. Language is at once a unifier for groups of people and at the same time a sectarian phenomenon.

Just ask a person who has traveled in a foreign land who was unable to speak the native tongue—they will reveal feelings of frustration and fear. Ask the parent who struggles to understand the slang of the teenager who is becoming a stranger in their own home—an alien who seems to be speaking a completely different language. Communication, then, is revealed as the means to which *we* become *us*.

A more recent phenomenon in current culture is the linguistic challenge of understanding electronic text messaging. There are over 80 million people sending electronic messages across the globe daily, whether through e-mail, cellular phones, or through downloadable instant messaging platforms such as AIM and Yahoo! Texters have their own lexicon—there are thousands of shorthand cues that facilitate conversations. Web site translators have been developed to demystify this language. This language has become an art form of sorts; emoticons (symbols used to express emotion) also abound in this electronic language. Here are a few examples:

- @)-;- A flower
- :-X A big wet kiss!
- >:-@! Angry and swearing
- << . . . >> A hug (replace . . . with name).

For most, these are just random, possibly misplaced keystrokes. But to the avid text writer, they are markers of the *lingua franca*.

One need not understand every individual symbol to be fluent in a particular style of communication; one needs only a few clues. Read the following statement aloud:

> I am a kxy pxrson in this dxpartmxnt and I am nxxdxd vxry much.

Chances are you have never seen this series of words in the English language, but you probably had little trouble capturing the meaning of the words. That is because you understand the coded system—*The Matrix*, as it were (this is a discussion of film after all)—and your mind translated these strange symbols into a useful and familiar pattern.

Norms

All societies are based upon some form of guiding principles and expectations of behavior. The norms are those rules that guide behavior. It is these rules that guide the socialization processes from parents, from the pulpits and rostrums of churches, mosques, and synagogues, from chalkboards and podiums, to the children and students and parishioners of all types. These cultural dynamics set the manners in which we live and interact daily with those who are like us and those who are different. Anthropologist Marvin Harris once wrote, "Humans cannot eat, breathe, defecate, mate, reproduce, sit, move about, sleep or lie down without following or expressing some aspect of their society's culture. Our cultures grow, expand, evolve. It's their nature" (1999, p. 16). One of the most prominent ways of "norming" (making normal) is through the gender roles socialization processes. From birth, American children are trained to obey the norms of masculinity and femininity—girls wear pink, boys blue. Girls are emotional, but *Boys Don't Cry*. Girls play with dolls while boys play with action figures. Girls are "sugar and spice and everything nice," but boys are made of "snakes and snails and puppy dog tails." Years ago, and sadly in some circles today, boys are taught to pursue careers in science, business, and government, while women are taught to be in their "place" as wife and mother, and occasion-

ally a career woman. Although times have changed a bit, we see this paradigm still alive in the fact that women earn significantly less than men for similar work.

Norms can be written or unwritten and vary in intensity. Norms govern time and orientation toward time. For instance, punctuality is an expectation for an applicant being interviewed for a position. If the interview is slated to begin at 9:00 A.M., the applicant is *supposed* to show up at least 15 min. early. Norms make us dress a certain way—what would happen if the applicant showed up for the interview dressed in a red bathing suit rather than a three-piece suit and tie? No matter the educational and professional credentials of the candidate, it is highly likely that person would be blackballed for inappropriate dress. The hiring manager probably did not tell the candidate *not* to show up in a bikini, but the candidate is expected to already know the appropriate attire.

It is important to recognize that norms can vary across cultures. Understanding this factor is crucial to comprehending the ways in which people interpret their experiences. This is revelatory in discussing film because depending upon one's life experiences and worldviews, reactions to certain elements or themes in films can differ. Have you ever watched a movie where everyone around you was laughing, but you just didn't get it (or vice versa)?

Most of our systems of belief are accepted upon the basis of what we would call *truth*. What we must understand is that there are multiple truths, and our norms are based upon culturally variant truths. Here's one truth that bears repeating: "everything you're sure is right can be wrong in another place."

Values and Beliefs

Values are standards of desirability, goodness, and beauty that provide guidelines for living, and like our norms, they can vary across time, race, ethnicity, nationality, language, gender, and down the list of cultural groupings. Our values are both personal and societal (they may differ or match). Our values are born out of our socialization processes, often implanted before we make official decisions about our value systems ("I was born an Episcopalian, I will die Episcopalian"). Our values range across groups, both in presence and in intensity. Our values determine our ethics and morality, ideology and doctrine, political orientations, and social activities. They also govern the ways in which we interact with others—deciding who is *us* and who are *they*.

Our values are embedded in cultural traditions and mores; most of our values have been imprinted upon us through cultural forces like our parents. Think for a moment about the process of making vinyl record albums. Some-

how, a simple plastic disc when placed on a turntable with a metal needle produces melodies of all sorts. The music was somehow encoded in a system of circular grooves; our values socialization is a similar process. We are each grooved by some process; the problem is most of us do not recognize when our record is playing or what song is sung at any given time.

Beliefs are statements that are held to be true. Although our values are relative and possibly changing over time, our beliefs tend to be cemented. Greek thinkers equated beliefs with knowledge—a person's epistemology—the stance a person takes as gospel truth, despite "proof" of an alternative viewpoint. Creation versus evolution is one such debate.

In many ways, having a culture means acting out the demands of that culture.

Recommended activity:	**Cultural proverbs and adages**

The following activity is designed to examine the values and requirements of American culture through common proverbs and adages.

Step One: In groups of 3–4, generate a list of American cultural proverbs and identify the value being taught.

> 1. *Examples:*
> - The early bird catches the worm. (*punctuality*)
> - Don't count your chickens before they hatch. (*caution*)

Step Two: Have groups report back to the larger group the proverb and its related value.

Step Three: Let's look again at our list of American proverbs. But this time, identify the *action* that is required.

> 2. *Examples:*
> - The early bird catches the worm. (*punctuality*) (wake up early)
> - Don't count your chickens before they hatch. (*caution*) (spend wisely)

Step Four: Groups can report the proverb, value, and culturally required action:

Proverb	Related value	Action required
1		
2		
3		
4		
5		
6		
7		

Culture can be defined on two levels: the personal and the societal.

1. *Personal* Culture or worldview is defined as the manner in which a person perceives his or her relationship to nature, institutions, other people, and things.
2. *Societal/institutional* At this level, culture is best defined as "a pattern of basic assumptions—invented, discovered, or developed by a given group as it learns to cope with its problems of external adaptation and internal integration—that has worked well enough to be considered valid, and therefore, to be taught to new members as the correct way to perceive, think, and feel in relation to those problems" (Schein, 2004, p.17)

One way to think of societal culture is to imagine the American way of life since the terrible attacks of September 11, 2001. Prior to that day, few Americans thought about issues of national security, terrorism, or securing our borders (well, except our Southern borders). Think about life now. In the months following those incidents, national patriotism was at an all-time high, we have a Department of Homeland Security, we are at war in two different countries, and are fighting "a global war on terrorism." It is doubtful that American life will go back to the former obliviousness.

Our cultural identities can dictate how we are oriented to the natural and metaphysical world around us. These dimensions of culture help us to understand our orientations toward time, activities, human relationships, and toward the environment. These orientations teach us, on both the personal and the institutional levels, to perceive

1. what behaviors are rewarded and in what way;
2. who "fits" in the organization, social, or peer group;
3. how "members" are expected to interact;
4. the pace of the day, project, etc.;
5. relationship to history, present reality, and future goals;
6. relationship to the influences and constraints of the environment; and
7. degree of appreciation for differing worldviews, cooperation, and collaboration.

Often, our socialization and acculturation processes are mostly unnoticed and as such, unchallenged. Most students are unaware of the reasons why they believe or act a certain way. If asked to identify what their culture(s) mean to their sense of self, few would be able to answer intelligibly. What they may be able to tell you, though, are stories about their upbringing and the messages they received from their elders. This is a great place for an assignment to invite students to explore their cultural upbringing.

Recommended activity:	Defining your culture

Who am I? How did I get that way?

This assignment is designed to help you explore your own identity development in relation to your cultural shaping.

What messages did you receive from teachers, parents, coaches, clergy, the media, or others? How did this affect your image of yourself and your own sense of identity?

In a 5–7-page paper, share the messages that you have received about what is "normal" in terms of race, gender roles, socialization, and sexual orientation? What specifically did you hear about the "other" (or, the not-so-normal)? Be prepared to give an oral presentation on your cultural background.

You should expect to hear how students were raised with the ideals of equality and respect for all. How their parents loved everybody and how they do not see differences between peoples. You *will* hear these sentiments repeatedly. Occasionally you may have a brave student who will share a different truth, but, by and large, there will be a whole lot of love in the room. (That's okay; we'll challenge these notions later in the course.)

There can be quite a fear about "outing" your family's values and beliefs systems. Most diversity conversations are wrought with anxiety because peo-

ple are fearful of saying the wrong thing and being labeled as bigots. As the teacher, you must be able to design an atmosphere where cross-cultural communication can occur. As teachers who are trying to encourage this type of dialogue, we must be aware of strategies to minimize unnecessary labeling. In our classes, when students speak from their true selves (even if the comment is potentially hot-button), we are reluctant to call a student's comments bigoted or racist. To remove the harm from fiery darts being hurled at a person who makes an inappropriate comment, we argue that the comment is reflective of participation in a racist, sexist, heterosexist, or bigoted society. This is important, particularly for teachers who work with students who are inexperienced in multicultural environments or regions. For instance, in our region in central Pennsylvania, many citizens use the antiquated term "colored" when referring to racial minorities. Those astute in cultural politics understand the damage caused by this term and how some could be angered by its use, but this is the language of the region, and the student should be give some latitude (and re-education on proper terminology) rather than backlash

To help break down these barriers, we must invite students to have open conversations about relationships, ethnicity, activism, and life where they can candidly discuss the taboo subjects that often only happen behind closed doors on campus. They need a model to show how to disagree and still build a community! Developing cross-cultural communication skills is paramount in the design of a diversity and multiculturalism course. Through honest dialogue and valuable "hands-on" activities in this sample course, we explore issues that are prevalent in society and that influence our everyday lives. Having these real conversations provides students with an experience that is impacting, life changing, and personally challenging. Through intentional dialogue about issues that affect society, students can gain a new perspective on life in other cultures.

How Cultures Are Created

As a means of exemplifying how cultures are created and function, we recommend that the class view the film *Krippendorf's Tribe*.

Krippendorf's Tribe (Touchstone Pictures, 1998), written by Charlie Peters, directed by Todd Holland
Starring: Richard Dreyfuss, Jenna Elfman, Natasha Lyonne, Lily Tomlin
Genre: Comedy/Family

Runtime: 94 min
Rating: PG-13 for sexual humor
Tagline: The last undiscovered tribe is about to expose themselves

James Krippendorf and his wife are celebrated anthropologists on the teaching faculty at a prestigious college; their research has taken them and their children to varied countries around the world to study and learn from indigenous peoples. Sadly, Jennifer Krippendorf dies while searching for a new, lost tribe in New Guinea. After her death, James is devastated and withdraws from his life at the university. He spends most of the university's grant funds on personal expenditures, trips, and luxury items for his children and does not complete the research. When the university administration demands that he give a lecture about his research findings, Krippendorf scrambles to create the lost tribe. He and his children invent the Shelmikedmu tribe (the name Shelmikedmu is a contrivance of the Krippendorf children's names—Shelley, Mickey, and Edmund). Their "discovery" becomes a matter of national attention, and Krippendorf becomes a celebrity. But how will all of this media attention affect his family and his future? (This is a simple comedy; no Oscar-worthy performances here; no depth of character, a major slap in the face to anthropological and sociological science, but still a worthy film to talk about culture.)

The Krippendorfs build a culture from scratch; actually, they take elements of several different cultures that they have studied over the years. Ask your students to take notes of the cultural elements and practices of the Shelmikedmu.

Earlier in this text we referred to the cultural iceberg. Most of your students will be accustomed to talking about elements of surface culture—foods, music, style of dress, and the like. Few, however, will be able to tell you "why" certain cultures do particular things. The elements of deep culture are primarily out of an individual's awareness. If designed with words, the cultural iceberg would look a bit like this:

Art · Music
Literature · Drama
Dance · Games · Cooking
Dress
(Surface) ★★★★★★★★★★★★★★★★★★★★★★★
Modesty · Beauty · Childrearing · Inheritance
Cosmology · Authority · Courtship · Sin · Justice
Work · Leadership · Decision making · Disease · Cleanliness

Deportment · Problem solving · Nonverbal Communication ·
Relationship to Nature · Time · Language · Social interaction · Emotion
Roles related to age, sex, class, occupation · Kinship · Friendship
·Individualism/collectivism

Source: Adapted from Weaver (1986).

Fortunately for your students, the Krippendorfs often discuss the rationale behind the Shelmikedmu traditions (even though they are fictitious). For example, Mickey and Edmund, Dr. Krippendorf's sons, are in the process of *becoming* Shelmikedmu, and Krippendorf enters the room with a movie camera filming:

> **Mickey**: Hey! The Shelmikedmu do not allow their pictures taken without the ritual body paint.
> **James:** Nicely put . . .
> **Mickey:** It is our way.
> **James**: Yo!

Locating and discussing the Shelmikedmu way of life should be a relatively innocuous task. You could then ask students to begin thinking about their own cultural cosmologies. A possible assignment is for students to design their own genograms. A genogram is a "family map" of a family's relationship system.

Recommended activity:	**Cultural genogram, paper, presentation, and show and tell**

The Genogram

This assignment will help students to explore their own personal intersections of race, class, gender, sexuality, ethnic, and cultural roots. You should be able to see your family history and everything important about your family by looking at the genogram. The genogram should reflect your family's cultural context as well as names and dates. It should present at least four generations, including your own, starting with your great grandparents (and their siblings). I encourage you to go back further in your family history if you are able. Interviewing family members is essential for this task!

See the following page for an example of a genogram.

Write a 5–7-page paper about *your* family. Following are some questions to consider in this paper and in your genogram:

1. Whom does your family consist of? Include first and last names, birth, death, and wedding dates.
2. What are their sociodemographic characteristics (race, ethnicity, socioeconomic status, religion, place of birth, occupation, physical or mental abilities, sexual orientation, marriage history, etc.)?
3. How did your great grandparents and grandparents and parents, siblings, extended family, and others influence who you are today? What values, morals, beliefs, and characteristics have been passed down *transgenerationally*? What were the dominant intersections of identity for them and for you today?

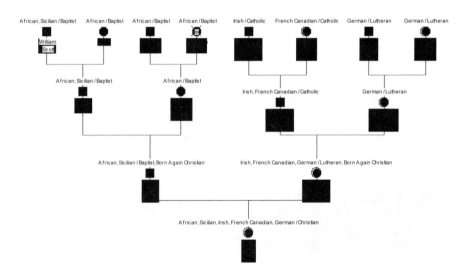

Numerous genealogical software programs can be purchased to assist students with this project. Some programs can be downloaded for free or for a trial membership. One such is Smart Draw, available at http://www.smartdraw.com/specials/genogram.htm?id=106685&gclid=CLnI7q6k2ZQCFQObFQodzE99jw (last accessed July 24, 2008). The purpose of this activity is to convey a picture of the important aspects of your family that have influenced who you are and how you view the world. How a person defines himself or herself and is defined by a society depends upon how that person comes to understand that society. Have your students entertain a discussion on how they define American culture after viewing *Krippendorf's Tribe*.

Postscreening discussion: *What is American culture?*

1. What is an American?
2. Where does an American come from?
3. What does an American want?
4. How are Americans the same?
5. How are Americans different?
6. What is the meaning of the term "Native American"?
7. How would you describe American culture using the four components of culture?

In order to become cultural "anthropologists," your students should possess a strong awareness of their own cultures. Although it is necessary for anthropologists to be as unbiased as possible, it is also necessary for them to be aware of their cultural tendencies in order to comprehend another's culture. Therefore, absolute objectivity, which would require that the anthropologist have no biases, and as a result no culture at all, should be given up in favor of a relative objectivity based on the characteristics of one's own culture. The anthropologist is forced to include himself and his own way of life in his subject matter. In order to study others, and to study culture in general, the anthropologist uses his own culture.

"Living" Culture

Once students understand cultural concepts, we must turn their attention to what it means to live culture *culturally*. Our cultural orientations toward time, activity, human relationships, and our environment dictate the guiding rules and norms that we must follow—particularly the rules that dictate what group we belong to and identify with, and those with whom we do not identify. Finding film exemplars for this concept is rather facile; one only need look at films related to high school interactions. The genre of teen comedy is full of examples, but we highly recommend John Hughes's 1985 classic, *The Breakfast Club*. We prefer this film because it gives us the ability to view culture in a fishbowl environment—all of the action happens in one day, mostly in one room (a school library), only five characters (with two additional periphery characters). We get to see living culture under a microscope.

The Breakfast Club

The Breakfast Club (A&M Films, 1985), written and directed by John Hughes
Starring: Molly Ringwald, Emilio Estevez, Judd Nelson, Anthony Michael Hall, Ally Sheedy
Genre: Comedy/Drama
Runtime: 97 min
Rating: R for language and drug references and usage
Tagline: Five strangers with nothing in common, except each other

Five high school students from different social strata meet each other and suffer through all-day Saturday detention. Brian "The Brain" Johnson (Anthony Michael Hall), Claire "The Princess" Standish (Molly Ringwald), John "The Criminal" Bender (Judd Nelson), Andrew "the Athlete" Clark (Emilio Estevez), and Allison "The Basketcase" Reynolds (Ally Sheedy), are veritable strangers but bitter enemies, but through the day they learn that they have a lot in common.

The Breakfast Club is a useful movie for introducing the topics of stereotyping. It is incumbent upon us to recognize that stereotyping exists everywhere in all types of communities; left unchallenged, stereotypes grow into prejudice and discriminatory behavior toward people of differing backgrounds. This film is not only a case study of sorts in intergroup relations—the conflicts are inherent as are the struggles for power and the ways in which target groups are co-opted—but the film also provides the manner in which groups who are different find commonality. Joseph Ofori-Dankwa, professor of business at Saginaw Valley State University, coined the term "diversimilarity" to describe the ability to see similarities across and despite cultural differences.

This is an important concept for novice students of diversity issues. Diversity has become a burden in education circles, especially to the ones who "are" the diversity on the campus. Racial and religious minorities and LGBTs are often expected to carry the extra burden of being cultural representatives who must educate the campus on their difference, while trying to do the work of being a student or fulfilling professional expectations. Meanwhile, majority persons have been allowed to see diversity as someone else's problem or issue; after all, the minorities are the diverse ones (at least, that's the way we typically operate). Majority persons tire of the issue, withdraw for fear of saying the wrong thing, and the minorities are forced to fill the void in the conversation.

Aren't we all diverse? Each of our institutions is 100 percent diverse. Di-

versity simply means difference—differences in gender, sexual orientation, race, ethnicity, social class, marital and parental status, ability, age, religion, geography, national origin, values, languages, and other methods of expression, identities, and more. This 100 percent diversity does not mean that 100 percent of all members of the institution feel as though they are part of the community. I acknowledge that there are many at our schools who feel that their identities are at odds with the majorities, many even feeling the need to hide particular parts of their own identities.

We talk quite a bit about schools as communities. Diversity by itself does not build community—division and diversity come from the same root word. For many, to talk about diversity is to be speaking about "someone other than me." This is particularly true for those who can identify as a majority person (typically Whites, males, heterosexuals, Christians, Americans). These groups tend to see themselves as "normal" whereas those whose identities do not match are labeled "different."

Acknowledging diversimilarity (Ofori-Dankwa & Lane, 2000) provides a number of opportunities to decrease the tensions that having a diverse campus can bring, because it lends more readily to moving toward full inclusion. We are not advocating for ignoring differences—these cultural differences are necessary in academic communities as we search for multiple truths, but, regrettably, we have allowed our differences to create impassable chasms between us. Diversimilarity creates bridges across the divides, increases opportunities for creative thinking and problem solving, fosters greater compatibility in workgroups, eases tensions in the student experience, and gives majorities multiple entry points into the multicultural community. These are the true benefits of having a diverse and inclusive campus.

As students screen *The Breakfast Club*, they will want to be on the lookout for the ways in which these students solve their problems, the ways in which power and leadership are exchanged, and the markers of cultural identity.

This film is a staple in television syndication, so there is a chance that many of your students have seen it already. (The TV version has been sanitized a bit, so we highly recommend the original version.) Those who have seen the film understand that each character is a representative of some commonly stereotyped group in American high schools: nerds, jocks, snobby rich kids, punks, and the willfully strange. Because of its high visibility, students may approach this film with a "been there, done that" attitude, and it may be more difficult for them to read the film differently. Giving them a unique assignment may help.

Recommended activity: Welcome to *The Breakfast Club*!

There are five distinct characters in the film *The Breakfast Club*, each representing a different group, clique, or stereotype. Your task for this assignment is to create a sixth character to insert into the action; the new character must be a racial or sexual minority. In addition to describing the racial or sexual identity of the new student, your essay should clearly define which "group" the new student would represent, describe the style of clothing and speech, what that student had for lunch during detention, the reason why the student is in detention, at least two conflicts that the person would have during the day (with whom and why), and the person(s) with whom the character would be most closely associated with by the end of the film. What real-life actor would portray this person?

To assist students with the development of their new characters, distribute the following list of questions that will help guide their reading of the film:

1. Which characters were you able to relate to best and why?
2. Which of these groups exist here at our school? What other groups exist that were not depicted in the movie?
3. What were some of the things that united the group and brought them closer?
4. Can you recall times in the movie when one character stuck up for another (defended them)? What was your reaction to this? Would this happen in real life? Should this happen in real life? Have you ever stepped in and defended someone who was getting picked on? Why or why not?
5. Do you feel there are places/activities in this school where everyone can feel like they belong? Why or why not?
6. Explain who is battling for leadership and how that battle is finally resolved.
7. List three stereotypes highlighted in the movie and how the group got past them.
8. How do the students grow or change throughout their day together?
9. Explain three different conflicts among characters and how they were resolved.
10. Write four of the unwritten group rules established throughout their day.

You may want to have students share their assignments with the entire class.

This would allow you, as the teacher, to analyze the depth and breadth of their language around stereotypes and difference. You can assess how comfortable they are talking about these issues, especially if there are students in the class whose identity is perceived to match the descriptions of the new characters.

Cultural Norms Produce Oppression

The Breakfast Club as a diversity discussion is beneficial in that it is a good way to explore the individualistic side of understanding culture—how "I" interact with the world around me. The world, nation, society, or community we operate within also has culture and produces culture. *Pleasantville* (1998) is a fine example of how culture happens and how personal and societal cultures interact. The film also introduces the systemic and institutional nature of oppression.

In this story, two youths from the present day are sucked into a 1950s-era television show where they become the main characters, Bud and Mary Sue. Pleasantville is a quaint little town of perfection, where the basketball team never misses a shot, teens in love were only "going steady," and girls were wearing the varsity letter jacket of their beaus—Lovers' Lane was merely for holding hands and stargazing. No one had ever left Pleasantville, as the roads did not go anywhere. Married couples slept in separate beds; Dad was the breadwinner and Mom took care of the care and nurture of the children, and she made sure to have a home-cooked meal on the table when Father came home. Our protagonists, whose present-day names were David (Tobey Maguire) and Jennifer (Reese Witherspoon) Parker, introduce the late twentieth-century values into this pristine way of life to very "colorful" results. You see, *Pleasantville* the TV show is in black-and-white and as the new Bud and Mary Sue, David and Jennifer influence teen sexuality and values, the idyllic nature of this "backward" town begins to change. The more David and Jennifer assimilate and interact with the teens of Pleasantville, characters and personalities begin to change to vivid Technicolor. With each kiss or sexual awakening, the Pleasantville way of life fades away.

Pleasantville (New Line Cinemas, 1998), written and directed by Gary Ross
Starring: Tobey Maguire, Reese Witherspoon, Don Knotts, William H. Macy, Jeff Daniels, J. T. Walsh
Genre: Fantasy/Comedy/Drama
Runtime: 124 min
Rating: PG-13 for some thematic elements emphasizing sexuality and for language
Tagline: Nothing is as simple as black and white

This film provides an excellent foray into discussions on stereotyping, racism, prejudice, discrimination, and oppression. Prior to screening this film, review cultural orientations and ask students to define the above terms (as defined in Chapter 2). Students will probably need assistance in understanding the systemic nature of oppression and racism. Today's students often struggle with locating oppressive behaviors in a systemic context because they view it as a few "bad" people or isolated instances. They fail to see the legal and societal sanctions and enforcements, systems of reward and punishment, and the collective collusion of the ordinary citizenry. *Pleasantville* offers plenty of opportunities to see these in action, particularly the scene highlighted in the clips section of this text. (We also recommend the featured clip on the film *The Incredibles* also included in this manual.)

To understand better the notion of power and how it works in an oppressive system, students need to understand the following definitions: dominance, in-group (nontarget), out-group. It may be helpful for students to identify the diversity concept, the group that is in power (normal), the group(s) that is(are) disempowered (diverse/abnormal), and the name of the particular oppression. Opposite is a chart designed to understand this power dynamic:

It is important to note several items on this chart:

1. Gender is a social construct that focuses on conformity to rules about masculinity and femininity. Men who are effeminate have less power than masculine men.
2. There is argument over the age range of the power group. This range of 35–65 years of age is related to the greater likelihood that a person in this age range is more established in their career (economic viability).
3. Body size is likely to not be talked about in most discussions of diversity, but the influence of body size in our society should not be ignored. Open any beauty magazine and you can see the normativity of being thin.
4. The nontarget group for ability is marked as "temporary." This is in reference to the chance of ability changing because of accident or injury.

Studying *Pleasantville* is a great opportunity to introduce important lessons from American history. The striking color changes and related symbolism are reminiscent of the racial dynamics of the 1950s–1960s (or the 1650–1660s and each decade since). The systemic realities of racial oppression may be lost on some of your students, inasmuch as teaching on the Civil Rights Movement has lost some of its appeal and *movement*. Most students are convinced that the movement has ended—things are so much better—so they will need

your leadership to understand some of the profound imagery in the movie. Yes, they will probably get the references to "no coloreds allowed," but they will no doubt need your help to understand the McCarthyesque trials that questioned the borders of orthodoxy and creativity (but here is an opportunity to connect the Patriot Act to historical references). The courtroom trial toward the end of the film is reminiscent of the scene in *To Kill a Mockingbird* where the court is divided by race—coloreds in the balcony and Whites on the floor.

Dimension of diversity	Nontarget group	Target group(s)	Oppression
Race	Whites	Blacks, Native Americans, Asians, Latinos, biracials	Racism
Gender	Gender-conforming males	Nonconforming men, women, transgender	Sexism, transgenderism
Age	35–65	Children, elderly	Ageism
Sexual orientation	Heterosexuals	Lesbian, gay, bisexual	Heterosexism
Socioeconomic class	Wealthy	Poor, working class	Classism
Religion	Christian	Hindu, Muslim, Jewish, atheist, agnostic, Wiccan, pagan	Anti-Semitism, Islamophobia
Body size	Skinny/athletic	Obese	Size oppression
Ability	Temporarily able-bodied	Disabled, mentally handicapped	Ableism

As mentioned above, *Pleasantville* gives an example of how oppression begins, takes shape, and becomes systemically powerful. Director Gary Ross has been quoted as saying, "This movie is about the fact that personal repression gives rise to larger political oppression; that when we're afraid of certain things in ourselves or we're afraid of change, we project those fears on to other things and a lot of very ugly social situations can develop."

As the citizens of Pleasantville experience the dissonance of new cultural

phenomena, their black-and-white shading becomes multicolored. The elders (White males) who possess the power of patriarchy sense that something is afoot and decide that the changes that are taking place are dangerous. Big Bob, the town mayor (played by J.T. Walsh), decides that he and his fellow men must face the colored element head on:

> **Bob:** People, people . . . I think we all know what's going on here. Up until now everything around here has been, well, pleasant. Recently certain things have become unpleasant. It seems to me that the first thing we have to do is to separate out the things that are pleasant from the things that are unpleasant. George, why don't you and Burt take the lead on this. Why don't you put together a kind of an "Un-Pleasant Activities Committee"?

Later, the men are out at the local bowling alley when George (William H. Macy) enters; he is very disheveled. He tells the men how he returned home from work (as usual) and expected his wife to have dinner on the table. He learns that his wife has turned colored and has left him for another man. As he is telling his story, Burt removes his jacket to reveal an iron-shaped scorch mark on his shirt. Bob responds:

> My friends, this isn't about George's dinner or Burt's shirt. It's a question of values. It's a question of whether we're gonna hold onto the values that have made this place great. So the time has come to make a decision. Are we in this alone, or are we in it together?

The men gather chanting "Together! Together! Together!"

In a later scene, the Un-Pleasant Activities Committee has drafted a set of rules that will deter any further change among the Pleasantville teens and women. The goal is to stamp out the culturally different practices (and to retain the black-and-white way of life). Many of the embittered noncolored citizens have staged a book burning (prior to David's and Jennifer's arrival, the books all contained blank pages, but now the stories are filling in by themselves). They also vandalized the local malt shop because the owner had been painting nude pictures on the window (of his new love, George's wife). At a town meeting, Bob announces the code of conduct to settle the town's anxiety:

> No matter how upset we may get, or how frustrated we may be, we're not gonna solve our problems out in the street. It's just the wrong way to do it. We have to have a "Code of Conduct" we can all agree to live by. Now, I asked George and Burt here to sketch out some ideas—and I think they've done a terrific job. If we all agree on these then we can take a vote and I think we'll start to move in the right direction.

[He begins to read the code.] ONE: All public disruption and acts of vandalism are to cease immediately. TWO: All citizens of Pleasantville are to treat one another in a courteous and "pleasant" manner . . .

[The kids are hiding in the ruined malt shop.]

Lisa Anne: Courteous and pleasant manner. That doesn't sound too bad.
David/Bud: THREE: The area commonly known as Lover's Lane as well as the Pleasantville Public Library shall be closed until further notice. FOUR: The only permissible recorded music shall be the following: Pat Boone, Johnny Mathis, Perry Como, Jack Jones, the marches of John Phillips Souza or the Star Spangled Banner. In no event shall any music be tolerated that is not of a temperate or "pleasant" nature.
Kids: Oh my gosh . . . No . . .
David/Bud: FIVE: There shall be no public sale of umbrellas or preparation for inclement weather of any kind. SIX: No bedframe or mattress may be sold measuring more than 38 inches wide. SEVEN: The only permissible paint colors shall be BLACK, WHITE, or GRAY, despite the recent availability of certain alternatives. EIGHT: All elementary and high school curriculums shall teach the non-changist view of history—emphasizing continuity over alteration.

This process of societal and cultural change to preserve a predominant identity's way of life is also very revelatory of the ways that minority groups experience life in a society that they see is not their own. In mostly subtle (some covert) ways, minority students perceive hostility and aggression, a sense of being out of place, and pressure to assimilate. This film provides an excellent introduction to the discussion of oppression as a systemic force.

Important terms to define are: subculture, counterculture, cultural relativism, assimilation, tolerance, acculturation, ethnicity.

This would be a good place to return students to their discussion of their own socialization processes. The following exercise will help students explore the messages that they received about groups of people (stereotypes).

Note: In this next exercise, encourage students to avoid self-censorship—no one will be looking at their papers. You will probably note the quiet snickers and nervous looks over shoulders.

Recommended activity: What have you heard?

There are three parts to this personal awareness exercise.

Part One: There are 14 boxes below that have titles of groups of people. On the

lines below the title, write down two things that you have *heard* about these people.

Part Two: Read through your statements and check the square on the left of the items you believe to be true about those groups of people. (Again, no censoring.)

White men	Black men
☐ ___bad dancers___ O ☐ ___good providers___ O	☐ _They're all drug dealers_ O ☐ _____ O
Jews	**Gay men**
☐ _____ O ☐ _____ O	☐ _sexually promiscuous_ O ☐ _wanna be women_____ O
Black women	**Latino men**
☐ _____ O ☐ _____ O	☐ _____O ☐ ___good providers___ O
White women	**Latino women**
☐ _____ O ☐ _____ O	☐ _____O ☐ _____O
Muslims	**Asian men**
☐ _____ O ☐ _____ O	☐ _____O ☐ _____O
Asian women	**Native American men**
☐ _____ O ☐ _____ O	☐ _____O ☐ _____O
Native American women	**Lesbians**
☐ _____ O ☐ _____ O	☐ _____O ☐ _____O

Part Three: Look at the statements that you wrote down about the group or groups to which you personally identify and fill in the circle to the right of the statements that are true about you.

Debriefing: Most of what your students will have written down will be negative—ask them why. Discuss the possible sources of these statements. What does this exercise suggest to us about how we view people in groups? What group(s) did you find it difficult to write about? Why? (Most students will probably have the least amount of information about Native Americans—entertain thoughts on why that is. This would also be a good opportunity to discuss the concept of invisibility.) What is it like to live up to (or shy away from) these expectations about "your people"?

It is important to carefully distinguish the differences between culture and race. In our diversity conversations, we often talk about Black culture or Latino culture—most often we are referring to the limited surface components of music, foods, clothing, and speech styles. In the next section, we explore the American concept of race and racial identity, the ways in which race is lived in society, and the racial line of oppression that is woven into the fabric of American society.

Unit 2: Teaching Race, Racial Identity, and Racism

One could easily argue that the American system is one built upon the construct of racial superiority of Whites—a belief system carried from Europe but perfected in the New World. It is also no secret that race is an uncomfortable topic for most people. To acknowledge America's racial heritage is to also acknowledge the lasting legacy of racism and racial oppression that is still in operation today. It is interesting that race is such a taboo topic, especially given that our conversations about the topic are so simplistic. For the uninitiated, race is simply about skin color. Teachers, however, will need to explore the possibilities of raising students' awareness of the complexity of racial dynamics.

Race, admittedly, is a wide open subject and has challenges for paring to digestible sections. We highly recommend starting with the notion that race is a social construct, rather than a matter of biological or genetic differentiation. The video documentary series, *Race: The Power of an Illusion* (California Newsreel, 2003) is an excellent resource for exploring the scientific, histori-

cal, and social uses and misuses of American race issues. The videos have accompanying teaching resource kits using both print and online methodologies; these resources are available at http://www.pbs.org/race. One activity called the "Sorting Activity" invites learners to correctly label the race of 20 persons simply by looking at a picture.

We recommend beginning with a discussion on the definitions of racial categories used by the U.S. government and census. Race is a fairly recent historical phenomenon, and some may argue that it is a purely Western concept. Social status in ancient times was more commonly predicated on issues of nationality, religion, and class rather than physiognomy. It was well into the eighteenth century when a person's physical appearance became cause for social deprivation or exploitation. This oppression by race became more readily useful for legal and capitalistic gain, but to establish the legal (and moral) standing, a racial hierarchy was created to identify who was superior and who was inferior. That being said, we invite students to understand racial categorization from the governmental vantage point.

For the most part, census standards identified four racial categories: American Indian or Alaskan Native, Asian or Pacific Islander, Black, and White. Additionally, Hispanic and not of Hispanic origin were added as ethnic categories rather than racial (as Hispanics can be of any race); the category "some other race" was a sort of catch-all for those who might identify as multiracial. Let's take a look at the racial classifications used by the federal government according to the *Revisions to the Standards for the Classification of Federal Data on Race and Ethnicity* (1997)

American Indian or Alaskan Native

A person having origins in any of the original peoples of North and South America (including Central America) and who maintains tribal affiliation or community recognition

Asian

A person having origins in any of the original peoples of the Far East, Southeast Asia, the Indian subcontinent including, for example, Cambodia, China, India, Japan, Korea, Malaysia, Pakistan, the Philippine Islands, Thailand, and Vietnam

(Continued on following page.)

Black or African American

A person having origins in any of the Black racial groups of Africa. Terms such as "Haitian" or "Negro" can be used in addition to Black or African American

Hispanic or Latino

A person of Cuban, Mexican, Puerto Rican, South or Central American, or other Spanish culture of origin, regardless of race. The term "Spanish origin" can be used in addition to Hispanic or Latino

Native Hawaiian or Other Pacific Islander

A person having origins in any of the original peoples of Hawaii, Guam, Samoa, or other Pacific Islands

White

A person having origins in any of the original peoples of Europe, the Middle East, or North Africa

For your students, you will want to explore several particular points from the following chart:

1. Native Americans are the only group that must "prove" their racial identity and be certified by the federal government.
2. African American is the only category to mention skin color.
3. Middle Easterners and North Africans are described as White.

You may also want to lead a discussion on the purposes and continued classification by race in terms of education and social stratification. Undoubtedly there will be students who argue that we should "just get rid of" racial categories as they have generally been more divisive than helpful; furthermore, since the "problems" of race are a thing of the past, then we can just transcend race and stop talking about it. We submit that in order to do so, we must finally address the subject and actively and openly discuss race.

The Ortiz and Rhoads (2000) multicultural education framework suggests that beginning with an explication of White race and culture is an important

first step in student learning. How do students make sense of Whiteness, particularly if they are White? The normative nature of Whiteness often leaves Whiteness unexamined and unnamed. Most often, only those who are non-White racial minorities are named. To be White is to be *average* (as in the "average American") and to be the assumed norm. In most news stories, you know a person is White *if* their racial identity is left unsaid; stories concerning a racial minority specify the race. The automatic assumption of minority criminality can be associated with this practice of the obviousness of Whiteness.

In a racially hierarchical system, as we have in the United States, White is the color of the marketplace—the center of economics and commerce, education, law and government, and religion. Historically, skin color determined access to the marketplace. One must not negate the economic, social, and political power exerted from the central position of the marketplace. From within, Whiteness has become moral, right, and beautiful—the concept by which non-Whites are judged and granted or denied access to the marketplace. Those racial minorities (which initially included the Irish, Jewish, Italian, and Scottish peoples) were excluded and only granted access by skin color similarity and by assimilation to the mainstream.

In the "What We Believe" section of his online journal *Race Traitor: Journal of the New Abolitionism*, Harvard professor Noel Ignatiev argued that the only way to change the marketplace is to "abolish the White race" (http://www.racetraitor.org; para. 4; last accessed on July 24, 2008). His work suggests removing Whiteness from the central core and foci to allow all persons the same access and equity to resources, education, and economics—in a way, applying the same scrutiny to whiteness as has been given to the actions and attributes of minority groups for centuries. Ask racial minorities who attend predominantly White schools what it feels like to be "diverse." What many may tell you is that it is like living under a microscope or spotlight—always having to be mindful of actions as not to disparage "their people." To shine a light on Whiteness is to bring to light the advantages of predominance. It also helps students understand how puritanical Whiteness has been elevated in our society, mainly through the notions of ethnocentrism, the belief in the superiority of Whites, and in the argument of having "earned our way" through meritocracy.

A film that highlights the supremacy of Whiteness is Joel Schumacher's 1993 film, *Falling Down*.

A divorced engineer for the defense industry gets stuck in L.A. traffic and finally snaps. He gets out of his car and begins a walk through central L.A., where he encounters various levels of harassment, which he learns to deal with

by acquiring weapons along the way. His actions attract the attention of a retiring cop, and he gets involved with the case, following the engineer's path toward Venice, where his daughter is having a birthday party.

Falling Down (Alcor Films, 1993), written by Ebbe Roe Smith, directed by Joel Schumacher

Starring: Michael Douglas, Robert Duvall, Barbara Hershey

Genre: Drama

Runtime: 113 min

Rating: R for violence and strong language

Tagline: The adventures of an ordinary man at war with the everyday world

This critically acclaimed film is a great example of how unconscious most White persons are of their racial dominance. At the opening of the film, William Foster (Michael Douglas) is sitting in deadlocked traffic. The heat is sweltering, his air conditioning is not working, and the handle just broke from his window. He appears to be trapped. Around him are the multicultural faces of the people of Los Angeles. Bill looks like he is ready to snap. All of a sudden, Bill jumps out of his car and begins to walk away, leaving his car in the middle of the highway. A driver behind him questions where he is going and Bill declares, "Home," and walks away.

The remainder of the film is an experiment in blind White privilege and the unconscious ways that White people, especially "the angry White male," exercise White dominance and superiority. The table below describes Bill's (known throughout the film as D-Fens because of his vanity license plate) interactions with various persons or groups. As the film is screened, you may want to help highlight the systemic and structural mechanisms through which Bill conducts himself. He does not see himself as a perpetrator of oppressive behavior, but as a victim of societal demographic changes. So blind is Bill that despite the significant destruction he has caused throughout his afternoon journey, he questions Detective Prendergast's assumption of his guilt: "What? I'm the bad guy?" Interestingly, this is a similar question that Douglas asks in a different film. In the 1994 film *Disclosure*, Tom Sanders (Douglas) asks. "When did I have the power?" This is in relation to the question of male dominance in the corporate world.

Discuss the meaning of Bill's interaction with the young African American boy who teaches Bill how to use a bazooka.

Mr. Lee, Korean grocer	Bill is dissatisfied with the price of a can of soda and decides to "roll back prices to the 1950s." He vandalizes the store and assaults the owner. *Listen for the language of nationalism.* Steals a bat from the owner
Latino gang members	Meets two youths sitting on a rock in what Bill calls "gangland." The youth try to steal Bill's briefcase, but Bill beats them away with the stolen bat. Bill takes a knife from them, throws the bat away, and keeps his briefcase. A short time later, the gang members unsuccessfully attempt a drive by shooting on Bill who takes a duffle bag full of guns from them and shoots one of the boys before walking away. *Take note of who gets shot and who does not.*
Homeless man	A homeless man asks Bill for spare change, but Bill refuses. He tells the man to get a job, but the unnamed man makes excuses. Bill surrenders his briefcase (containing only Bill's lunch) and walks away. *Listen to Bill's language about employment*
Whammy Burger employees and customers	Bill enters a fast food restaurant and demands breakfast, although the restaurant has stopped serving breakfast. He threatens the employees and guests with a gun, which accidentally misfires. Bill demands that the manager serve him and harps on the quality of the food he receives
Black customer at the bank	A Black gentleman is picketing a local bank for refusing him a loan. The unnamed man is dressed similarly to D-Fens and he announces that the bank denied him because they deemed him "not economically viable." The man is arrested, but before the police car drives away, the man says to Bill, "Don't forget me," and Bill nods his head. *What are the similarities and connections between Bill and the unnamed Black man?*

(Continued on following page.)

Survival store owner	Bill needs to change his clothes and enters a survival store. Nick, the owner, recognizes him as a fugitive from the law and hides him from the police investigator. Nick insults two gay customers and a female police officer. Nick assumes that Bill shares his political values and shows Bill his collection of Nazi paraphernalia, but Bill is repulsed by the assumption. Nick tries to assault him, and Bill stabs him with the stolen knife from earlier, and then shoots him to death. *Why is Bill so incensed by Nick's assumption?*
Older men at golf course	Bill interrupts a golf game between two older gentlemen by walking onto the golf course. One of the men tries to hit Bill with a golf ball, and Bill draws a gun and threatens him. The man has a heart attack and Bill watches as he suffers. *Listen for cues on Bill's feelings toward the rich who take advantage of the working class*
His ex-wife	Bill finally reaches "home" where the viewer learns that he is barred by a restraining order. He kidnaps his ex-wife and daughter and takes them to the pier where he intends to kill them (and possibly himself)
Detective Prendergast	Retiring police officer Detective Prendergast is on his last day on the job before moving to Lake Havesu with his wife. Prendergast has been tracking D-Fens all day and finds him on the pier. Prendergast shoots Bill, but before he dies Bill asks, "I'm the bad guy?"

It is important to note that White supremacy is often only recognized as the overt actions of groups such as the neo-Nazis, Ku Klux Klan, and the Skinheads. Their violence against racial, sexual, and religious minorities has long been noted. Films that effectively explore these groups are *American History X* (1998), *Higher Learning* (1995), and *Apt Pupil* (1998). (Note that these movies often carry an "R" rating and may not be suitable for younger audiences

because of thematic elements of violence and sexuality.) Teaching these films is important; however, we prefer films that examine the systemic and more subtle impacts of difference. Filmic examples such as these help to reinforce the notion that racism, therefore, is only perpetrated by a few twisted individuals.

White superiority has other faces, one of which is a paternalistic attitude toward minorities that suggests that minorities are "better" because of the influence of Whites. Historically, English missionary activity into the *dark continent* of Africa, and, in part, the African slave trade, was said to evangelize and enlighten the savage beasts. The "savior complex" is deeply rooted in the psyche of the American majority (Titone, 2000), and a variety of films bear this out (*To Kill a Mockingbird, A Time to Kill, Glory, Rising Sun, Freedom Writers,* and many more); one such film is *Dangerous Minds*.

Dangerous Minds (Simpson & Bruckheimer Films, 1995), screenplay by Ronald Bass, directed by John N. Smith
Starring: Michelle Pfeiffer, Courtney B. Vance
Genre: Drama
Runtime: 99 min
Rating: R for language
Tagline: She broke the rules . . . and changed their lives

Based upon the true story chronicled in the book, *My Posse Don't Do Homework,* by the protagonist of the film, Louann Johnson, *Dangerous Minds* follows the first teaching experience of Ms. Johnson. A former marine finds herself searching for work and is recommended for a teaching position by her friend, Hal. Johnson is hired immediately to teach the "Academy students," a bunch of unruly miscreants. She has no formal training or experience as a teacher but is charged with what could be described as the most challenging students.

This could be an interesting moment for teachers to discuss American public education and the intersections of race, class, and academic success. There is room for discussions on the impact and ramifications of legislation like the No Child Left Behind Act. Additional topics for review could be the overrepresentation of racial minorities in special education programs, teacher expectations and guidance and impact on college and career decisions, and stereotype threat (self-fulfilling prophecy where some minorities fail to achieve because of internalized stereotypes).

As mentioned earlier, *Dangerous Minds* is a useful tool in helping students understand formulaic conventions. Try this exercise: after watching an hour of

the film, stop the movie. Ask students who have never seen the film to describe how it ends. Undoubtedly, they will be able to tell you. Why? Because they have "scene" it before!

Students should begin exploring the constructs and processes of White racial identity development. This is an important factor; as mentioned earlier, Whiteness tends to be seen as a blank slate. Students of color are often required to serve as experts on racial matters in academic and social arenas. This phenomenon has much to do with White students' general lack of understanding of their own racial identity. Because of their majority status, White students rarely see themselves as possessing a race, much less understand how Whiteness operates in society. Without identifying as raced, White students may have neither the tools nor the lexicon to participate in academic dialogues about sensitive issues such as race, thereby minimizing their ability to see, understand, or empathize with the struggles, concerns, or perceptions voiced by persons of color. Although Whiteness has recently come to the fore in academic study, there are few mechanisms in place on college campuses or high schools to engage White students in the processing of their own racial identities.

The White race has been defined as "those Americans who self identify or are commonly identified as belonging exclusively to the White racial group regardless of the continental source of that racial ancestry" (Helms & Piper, 1994, p. 126). Studies on racial identity development for White persons are a relatively new phenomenon in the past two decades. Whiteness as an area of academic study has taken on greater prominence in the latter part of the last decade as evidenced in the work of Feagin (2000), Goodman (2001), Hobgood (2000), McIntosh (1998), and Wellman (1993).

The nature of social dominance allows White persons to be socialized (normed) to believe that they are not raced (Helms, 1992; McIntosh, 1998), and to be the reference point for all ethnic groups. African, Latino, Asian, Native American (ALANA) persons are diverse. Most White racial identity theories are based on how Whites perceive or interact with other racial or ethnic groups and therefore do not acknowledge Whiteness as a racial marker or heritage (Hardiman, 2001; Helms & Cook, 1999; Ortiz & Rhoads, 2000). These models operate from a standpoint of White dominance, conscious or unconscious attitudes that focus on racial superiority, prejudice, discrimination, or racism, whereas most models for ALANA populations are shaped by cultural differences (Hardiman, 2001). Hardiman contends that White racial identity models for the twenty-first century should include a focus that is "directed at White identification with White culture" (2001, p. 111) because of the "scant attention to the way Whites identify in a cultural sense with their race" (p. 124).

In the film *Dangerous Minds*, Ms. Johnson stands on the soapbox of "choice." She argues that the students have the power to overcome their negative circumstances by simply *choosing* to do something different. The students who choose to attend school, who choose to stay off drugs, who choose to "get on that bus" are guaranteed (by Johnson, at least) to have a better life. This is a good time for students to explore the subject of privilege, as Ms. Johnson seems to believe in the "pull yourself up by your bootstraps" theory. The seminal work of Peggy McIntosh ("White Privilege: Unpacking the Invisible Knapsack," 1988) has led to a proliferation of "privilege walk" exercises. The premise is that students line up as if having a foot race, and the teacher-facilitator reads a series of statements related to the students' identities. If the student identifies with a read statement, the student follows the instructions given to step forward or backward. Inevitably, people of color find themselves at the rear of the formation, whereas Whites tend to be leading the pack. There are a variety of these exercises available that focus on race, gender, sexual orientation, and more. We recommend a multi-identity approach that is weighted heavily with race statements but allows for more variant identity dimensions. This exercise, coupled with a discussion on defining the American dream, can significantly help students to understand the insidious nature of privilege and how we are each impacted.

Another method of discussing White racial identity among White youth is to explore the intersections of Whites and hip-hop music. Much of the talk related to the film *Dangerous Minds* is in understanding the powerful soundtrack. Have students listen to, read, and discuss the lyrics to the movie's theme song, "Gangster Paradise," by rapper Coolio. Bakari Kitwana's book, *Why White Kids Love Hip Hop: Wangstas, Wiggers, Wannabes, and the New Reality of Race in America* (2005) provides a profound review of the intersections between race and this musical culture.

Teachers should also be prepared to discuss racial identity models for minorities as well. It would be time consuming to discuss each particular racial identity model for each group, but a generalized model can be developed from the multiple models. One resource that is rather exhaustive on racial identity is *Identity Development of Diverse Populations: Implications for Teaching and Administration in Higher Education* (Torres, Howard-Hamilton, & Cooper, 2003).

Films that center on racial identity are plenteous, but we highly recommend *Malibu's Most Wanted* (2003) and *Good Fences* (2003). Both of these films center on how race is both personal and societal. In *Malibu's Most Wanted*, a

wealthy White teen imagines himself as Black, and in *Good Fences*, the Spaders, an African American family, moves into an all-White neighborhood, and four Spaders (Tom, Mabel, Stormy, and Tommy II) each desperately tries to come to terms with a new racial self. In both films, each of these characters wrestles with the thought that race is "a mask that grins and lies."

We also recommend viewing films that are more authentic representations of minority characters and cultures. These are more difficult to find, but every once in a while, one comes along that breaks the conventional misrepresentations. *Real Women Have Curves* (2002), *Smoke Signals* (1998), and Disney's *Brother Bear* (2003) offer better readings.

Speaking of authenticity, the following in-class exercise has proven an interesting discussion starter. On the blackboard, draw the following chart. Have students come to the board and write titles of films that fit each category:

White	Black	Native American	Latino	Asian	Gay	"Chick Flicks"	"Guy" Movies

Ask students to examine the reasons why a particular film may (or may not) fit into a particular category. How does the race of the lead actor play into the decision? What about the director or writer? How does setting, plot, or action play into the decision? Explore those categories that do not receive much attention—why don't students know titles of Native American films, for instance?

No discussion of race in the movies is complete without an exploration of the archetypes that have appeared historically in drama, literature, and film. Screening portions of Griffith's classic *The Birth of a Nation* may be a way to start this discussion. How do these stock character types persist in today's society and films?

> Stereotypes of African Americans, Latinos, Asians, and Native Americans as savage, stupid, docile, and nomadic helped justify policies of exploitation, extermination, and enslavement by the white population and institutions they established (Shah, 2003, p. 6).

The most persistent archetypes are in representations of Blacks, Latinos, and Asians. Native Americans are virtually left out of current dialogue and representation (unless they are White-identified).

Blacks	Bucks, Mammies, Coons/Pickaninnies, Toms, and Mulattoes Resource: Bogle (2001)
Latinos	Greasers, Madonnas, Spitfires, Bandidos, Latin Lovers Resource: De Los Santos (2002)
Asians	Yellow Peril, Dragon Lady, Lotus Blossom, Charlie Chan Resource: Shah (2003)

Each of these archetypes is representative of how these minority groups have been viewed, and in most cases, demonized for White supremacist purposes. Each racial group has a violent criminal who is out for blood and sexual conquest of White women; a docile, nonthreatening older figure who is happy with the status quo of social repression; one that desires to be seen as White (by birth or choice); one that is supersexualized; one for comic relief; and one that is sarcastic and sassy—dangerous because of a conniving intelligence.

Dealing with race, racism, and racial identity as structural concepts of experiencing American culture is important to students learning systemic oppression. How one lives in community with others is largely dependent upon how they view themselves and how they interpret how others view them. It is similar when exploring issues of sexual orientation, sexual identity, and heterosexism.

Unit 3: Teaching Sexual Orientation

For heterosexuality to achieve the status of the "compulsory," it must present itself as a practice governed by some internal necessity. The language and law that regulates the establishment of heterosexuality as both an identity and an institution, both a practice and a system, is the language and law of defence and protection: heterosexuality secures its self-identity and shores up its ontological boundaries by protecting itself from what it sees as the continual predatory encroachments of its contaminated other, homosexuality. (Fuss, 1991, p. 2)

Heterosexuality, like Whiteness, is a given, is powerful, dominant, assumed, and *normal*.

As Fuss mentions above, heterosexuality is a protected institution. It carries the blessings of the church, governmental and legal bodies, and the average citizen. It is unquestioned as right and pure and sacred. Heterosexuals receive

economic benefits (tax breaks for married couples), legal protections (social security, freedom from bias, and spousal rights), and are socially accepted. Oppression against homosexuals, called heterosexism, works in favor of heterosexuality. People in same-sex relationships cannot claim each other on their taxes, have no ability to claim each other on their insurances, and have no rights to their partner's medical decisions or death benefits. Stereotypes abound for lesbian, gay, and bisexual persons; what are the heterosexual stereotypes? Its colloquial equivalent—straight—is explanatory of its place in our society.

Like Whiteness, heterosexuality goes unchallenged as a social construct. In conversations about sexual orientation, the topic of heterosexuality often goes undiscussed. Heterosexuals often must be told that they have a sexual orientation. Doing this invites them to think about how heterosexuality operates in our society. In this section, we examine sexual orientation as an identity construct, the developmental processes for those who do not identify as heterosexual, and the types of privileges afforded to heterosexuality, and the personal and societal oppression for those who do identify "normally." We highlight four films: *But I'm a Cheerleader* (1999), *Brokeback Mountain* (2005), *Saved!* (2004), and *Latter Days* (2003).

Sexual orientation is one of the most controversial topics in popular and educational arenas. It elicits anger, discomfort, queasiness (for some), and a wide range of other emotions and feelings. This is the one topic that definitely causes a stir in the classroom, both from student participants and possibly from administrators and parents.

Much of the controversy stems from a question of sexual orientation being so much more than sexual behavior. In their pamphlet *Sexual Orientation and Youth* (2008), the American Psychological Association defines sexual orientation as "an enduring emotional, romantic, sexual, or affectional attraction that a person feels toward another person." Notice the layered definition: sexual orientation is more than just sex. This is why most heterosexuals find it difficult to define their own sexual orientation in terms that are nonsexual. We often hear about "keeping it in the bedroom" when referring to gay and lesbian peoples who "come out of the closet," because for heterosexuals, sexual orientation is the act of sex and not a way of life.

Ask your students this question: *If a person has same-sex sex, can that person consider himself or herself as "straight" or heterosexual?* Get ready for some interesting conversation. Help them consider the possibilities that sexual behavior may not be definitive. Consider the following examples:

1. Incarcerated men often have sex with other men out of convenience/ necessity. The same is true of women in prisons or boarding schools

where there are relatively no men.

2. On reality television shows and series such as *Girls Gone Wild*, heterosexual women kiss and fondle one another (to the delight of heterosexual men—most of whom would argue that homosexuality is wrong, evil, and disgusting—hmmm!).

3. Psychologists suggest that rape and molestation are acts of power and not sex; most child molesters and rapists of same-sex acts are heterosexual.

To assist in exploring heterosexual orientation, Worthington, Savoy, Dillon, and Vernaglia (2002) suggest examining the differences between sexual orientation (predisposition or attraction), sexual identity (self as a sexual being), and sexual orientation identity (conscious acceptance of sexual orientation). Like racial identity processes, they also argue acknowledgment of heterosexuality as a social identity that includes a sense of sexual ethnicity (belonging to the heterosexual group) and the attitudes toward sexual minorities.

There is also a bit of confusion as to the differences and intersections of sexual orientation and gender. Most Americans operate under a binary system: men like and want to have sex with women; women like and want to have sex with men—no ifs, ands, or buts. In the same manner, men act like men and women should act like women (read the underlying thought—gay men want to be women; lesbians want to be men). There is a correlation, as Bieschke (2002) notes, "one must understand oneself as a man or a woman before one can understand one's heterosexuality" (p. 577). The film *Kinsey* (2004) explores the groundbreaking work of real-life Dr. Alfred Kinsey, whose studies examined sexual orientation as a continuum between exclusively heterosexual and exclusively homosexual. Gender roles socialization dictates a limited view of the intersections of gender and sexual orientation. To more fully understand the popular view of compulsory heterosexuality with its links to gender constructions, we recommend screening the film *But I'm a Cheerleader* (1999).

But I'm a Cheerleader (Cheerleader LLC, 1999), written by Brian Wayne Peterson, directed by Jamie Babbit

Starring: Natasha Lyonne, Michelle Williams, RuPaul, Cathy Moriarty

Genre: Comedy/Romance

Runtime: 85 min

Rating: R for strong language and sexual content involving teens

Tagline: A comedy of sexual disorientation

Warning! This film is unabashedly campy!

Megan Bloomfield (Natasha Lyonne) is leading the dream life in high school—popular cheerleader with a hot boyfriend (whom she happens to hate kissing). Sure, she only has pictures of scantily clad women in her locker, and sure she is a bit touchy-feely with her female friends, but that doesn't make her gay (or, does it?). Suspected of being a lesbian by her parents and friends, Megan is sent to True Directions, a gay rehabilitation center, to be "redirected" towards heterosexuality.

There are two central thoughts in this film: (a) homosexuals can be "cured" and (b) heterosexuality is the performance of gender roles. Once Megan gets to True Directions, she and the other clients must prove their heterosexuality through simulated heterosexual sex acts and rituals of motherhood and fatherhood, and "proper" gendered work and activities. After viewing *But I'm a Cheerleader*, entertain a discussion on what it means to be heterosexual based upon the tests the teenagers must endure. You may wish to entertain a few of these questions from the Heterosexual Questionnaire (Rochlin, 2003):

Purpose: The purpose of this exercise is to examine the manner in which the use of heterosexual norms may bias the study of gay men's and lesbians' lives.

Instructions: Heterosexism is a form of bias in which heterosexual norms are used in studies of homosexual relationships. Gay men and lesbians are seen as deviating from a heterosexual norm, and this often leads to marginalization and pathologizing of their behavior,

Read the questionnaire below with this definition in mind. Then respond to the questions:

1. What do you think caused your heterosexuality?
2. When and how did you first decide you were a heterosexual?
3. Is it possible that your heterosexuality is just a phase you may grow out of?
4. Is it possible that your heterosexuality stems from a neurotic fear of others of the same sex?
5. If you have never slept with a person of the same sex, is it possible that all you need is a good gay lover?
6. Do your parents know that you are straight? Do your friends and/or roommate(s) know? How did they react?
7. Why do you insist on flaunting your heterosexuality? Can't you just

be who you are and keep it quiet?

8. Why do heterosexuals place so much emphasis on sex?

9. Why do heterosexuals feel compelled to seduce others into their lifestyle?

10. A disproportionate majority of child molesters are heterosexual. Do you consider it safe to expose children to heterosexual teachers?

11. Just what do men and women do in bed together? How can they truly know how to please each other, being so anatomically different?

12. With all the societal support marriage receives, the divorce rate is spiraling. Why are there so few stable relationships among heterosexuals?

13. Statistics show that lesbians have the lowest incidence of sexually transmitted diseases. Is it really safe for a woman to maintain a heterosexual lifestyle and run the risk of disease and pregnancy?

14. How can you become a whole person if you limit yourself to compulsive, exclusive heterosexuality?

15. Considering the menace of overpopulation, how could the human race survive if everyone were heterosexual?

16. Could you trust a heterosexual therapist to be objective? Don't you feel s/he might be inclined to influence you in the direction of her/his leanings?

17. There seem to be very few happy heterosexuals. Techniques have been developed that might enable you to change if you really want to. Have you considered trying aversion therapy?

18. Would you want your child to be heterosexual, knowing the problems that s/he would face?

19. What were your first reactions upon reading this questionnaire?

Source: Rochlin, M. (2003). The heterosexual questionnaire. In M. Kimmell & A. Ferber (eds.), Privilege: A reader (pp. 75–76). New York: Perseus Books.

Homosexual Orientation

If heterosexuality is to be "straight" and normal, homosexuality is therefore "crooked" and abnormal. Let's face it—in American society, individuals are considered heterosexual "until proven guilty." A normative heterosexuality is constantly operating in our society, and for the average American. Think about

simple introductions for a moment. Most of us, when we meet someone for the first time, we question whether or not that person has a spouse or a boyfriend (if a girl) or a girlfriend (if talking to a boy). Asking this simple, *innocent* question assumes a heterosexual construct. What if the person identifies as gay or lesbian? This question requires the person to decide whether to self-identify and possibly risk injury or harassment. (The Gay, Lesbian, and Straight Education Network [GLSEN] National School Climate Survey found that four out of five LGBT students report verbal, sexual, or physical harassment at school and more than 30% report missing at least a day of school each past month out of fear for their personal safety.)

The American Psychological Association indicates that gay, lesbian, and bisexual adolescents follow a developmental path that is both similar to and quite different from that followed by heterosexual adolescents. All teens face the challenges of body changes, peer groups, fitting in, and developing values systems. Gay, lesbian, and bisexual youth must also cope with prejudiced, discriminatory, and violent behavior and messages in their families, schools, and communities. Such behavior and messages negatively affect the health, mental health, and education of lesbian, gay, and bisexual young people.

LGBT teens often face isolation and stigmatization and face being ostracized by family and friends. Support systems are rare, and students often plummet into depression and suicidal ideation. Gay teens without support systems are at risk of substance abuse and risky sexual behavior; the fear of retaliation by family and friends render students unwilling or unable to ask for help.

Unlike heterosexual youth and adults, LGBT people must decide when it is safe to "come out" (admitting one's homosexual attractions to self and others). The process of deciding to out oneself is highly subjective but generally begins in an intimate circle and expands—the parents are usually the last to find out.

It is important to acknowledge the reasons why LGBT peoples must come out—to disclose this "private" information. There are two reasons: the power of assumed heterosexuality necessitates acknowledging the difference, and sharing personal information (particularly about love and relationships) is a healthy, normal activity. This process, however, is often quite difficult for the gay, lesbian, or bisexual adolescent because there is a strong (and well-founded) fear of being rejected by others.

Exercise: What do you know about the gay lifestyle?

Your students will have a variety of opinions and beliefs about homosexuality; you will need to give them room to discuss these feelings and values in a safe

and supportive environment. They may need coaching about proper terminology; remind them about ground rules developed during the first days of class.

These varied thoughts will largely be stereotypical, much having been influenced by national opinion about the issues. Take them head on. You can anticipate the following belief systems (most of which are untrue) in play:

1. Gay people can ordinarily be identified by certain mannerisms or physical characteristics
2. In a gay relationship one partner usually plays the "husband"/ "butch" role and the other plays "wife"/ "femme" role.
3. We do not know what causes homosexuality.
4. Most gay people could be cured by having really good sex with a member of the opposite sex.
5. The majority of child molesters are gay.
6. Most gay people regard themselves as members of the opposite sex.
7. Homosexuality is not "natural"—that is, it does not exist in nature and therefore proves that it is dysfunctional.
8. Gay people should not be teachers because they will try to convert their students to the gay lifestyle.
9. Gay people have made a conscious decision to be gay.
10. There are very few "bisexuals"; most people are either completely homosexually or heterosexually oriented.
11. There are some significant differences between the lifestyles of gay men and lesbians.
12. Homosexuality is a type of mental illness and can be cured by appropriate psychotherapy.
13. One homosexual experience as an adolescent will play a large part in determining whether a person will be homosexually oriented as an adult.

Source: Adapted from Obear, K. (1989, March). Opening doors to understanding and acceptance: Facilitating workshops on lesbian, gay and bisexual issues. Materials presented at the American College Personnel Association meeting in Washington, DC.

Heterosexuals enjoy the benefit of being born heterosexual. Little to no research has been conducted to prove the "causes" of heterosexuality, but this

is not so with homosexuality. Scientists, researchers, and the general public have pronounced numerous reasons why people are gay, including the following (some of these are addressed in the therapy sessions in *But I'm a Cheerleader*—have students give suggestions according to the cultural messages in our society).

Following is a list of some of the suggested *causes* of homosexuality. None of them is right or wrong—research finds evidence for and against each of them (Blumenfeld & Raymond, 1993):

1. *Seduction* Children and teenagers are exposed to older seducers who influence them to be gay.
2. *Bad example* Children grew up with too much "gayness" around them.
3. *Unattractiveness* People are unattractive to the opposite sex and, therefore, become gay.
4. *Sex segregation* People live in close contact with mostly the same sex throughout their lives and learn to prefer them.
5. *Heredity* Gays are "born that way." It's genetic.
6. *Congenital defect* Something went wrong with the nervous system while they were in the womb.
7. *Hormone imbalance* Disorder of the endocrine glands and therefore do not have enough male or female hormones.
8. *Wrong upbringing* Boys are raised as sissies, girls are raised as tomboys. People are raised to think and act like the opposite sex and are therefore attracted to the same sex.
9. *Running away from it all* People are afraid or ashamed of their own male–female roles and therefore become homosexual.
10. *Emotional sickness* Caused by problems with parents while growing up (possibly to "get back" at parents; rebellious).
11. *Natural impulse* Homosexuality is as natural as heterosexuality. If our society approved it, we would do it.
12. *Taste* Matter of preference or choice.

Coming to terms with homosexual orientation identity is a subjective process that happens at varying stages in people's lives. A film that examines coming out as a developmental process is the 2005 Academy Award–winning film, *Brokeback Mountain*.

Brokeback Mountain (Focus Features and River Road Entertainment, 2005), written by Larry McMurtry and Diana Ossana, directed by Ang Lee

Starring: Jake Gyllenhaal, Heath Ledger, Randy Quaid, Anne Hathaway, Michelle Williams
Genre: Drama/Romance
Runtime: 134 min
Rating: R for sexuality, nudity, language, and some violence
Tagline: Love is a force of nature

Brokeback Mountain is the story of two ranch hands, Ennis Del Mar and Jack Twist, who meet for the first time when they are hired to herd sheep into the mountains. They work as a team but live separately—one sleeps with the sheep and one stays at base camp and prepares meals. They only come together for meals and to exchange supplies, but one particularly cold evening, the two sleep in the same tent. The two have sexual intercourse that night although neither identifies as gay. Their relationship blossoms and through intermittent rendezvous, they remain an item for nearly 20 years. Both men live heterosexual lives; each has a wife, but Ennis is unable to completely separate from his wife and children. Jack, on the other hand, desires to have an open relationship with Ennis. Ultimately Jack is murdered (presumably a hate crime), and Ennis must face the facts of his undying love.

This film provides a great opportunity to discuss sexual identity and acceptance of self as a homosexual as well as the realities of normative heterosexuality. The two main characters at varying times wrestle with their sexual orientations and gender roles. Emphasizing his confusion, Ennis blames Jack for "making me the way I am. I'm nothing . . . and nowhere." After their first night of lovemaking, the two men declare their heterosexuality:

Ennis Del Mar: You know I ain't queer.
Jack Twist: Me neither.

One way of asking students to read this film is to have them search for clues and cues of the homosexual identity development model, the seminal work of Vivian Cass (1979). This six-stage model acknowledges a fluid process whereby an individual comes to terms with his or her sexual orientation identity:

1. *Identity confusion* Having an understanding that there is something different about you. Feeling a disconnect between what you feel and experience and normative cues. Recognition of a difference.
2. *Identity comparison* Gaining an understanding that sexual orientation is what the difference is about, coming into intellectual understanding of the difference between your experience and others. More able to

accept that you don't fit into the cultural norm (largely an internal process). May work toward having a "happy straight life" despite not quite being in the norm. Sometimes very negative toward LGBT people and stereotypes. Experimenting with intimate encounters, sometimes clandestine.

3. *Identity tolerance* Seeking out LGBT environmental cues. Meeting other LGBT people. Experimenting with relationships, sex, and dating. Moving more consciously into the proximity of an LGBT culture. Observing other LGBT people, evaluating behaviors and ideas, and internalizing those that seem congruent with developing a sense of LGBT identity.

4. *Identity acceptance* Questions of "Who am I" and "Where do I belong" have been largely answered. You might experience significant tension between "passing [for heterosexual]" and "coming out." Coming out to those you care about is important because you want to be honest with them. LGBT identity is now a central part of self.

5. *Identity pride* This is the "activist stage." You have become comfortable in your identity and understand that it's not you that has the problem but normative culture. May rally against "straight culture." You may be very angry and militant.

6. *Identity synthesis* Sexual orientation continues to be an important part of self-identity but is less of a defining factor in your sense of self. Make the choice to live an honest life—not hiding sexual orientation.

Recommended activity: Acceptable male homosexuality in the movies

It goes without saying that American society does not look favorably on homosexuality; yet, we have seen a proliferation of gay male characters or themes in recent Hollywood blockbusters. Discuss 3–5 ways by which Hollywood presents "acceptable" male homosexuality in current films? (3–5 pages)

Brokeback Mountain has been hailed as a "gay cowboy movie" that broke barriers for gay actors and promoted acceptance of gays in American culture. It can be argued that this film was in no way a "gay movie." This was a heterosexuals' movie, made by heterosexuals for heterosexuals, and starring heterosexuals. What are the delineations between heterosexual movies featuring gay characters and movies made by gays for gays? Refer to the students' responses from the earlier assignment about acceptable male homosexuality in films for cues.

For example, in heterosexual movies with gay references, the gay characters are often subsidiary eunuchs with no romantic partners, straight actors playing gay, flamboyant sissies, best friends to straight women, or dying of some incurable disease or are killed.

Interestingly enough, gay in American culture is also coded as White. Gay popular culture (media, literature, art, and film) is decidedly represented by White heroes and heroines. The invisibility of people of color also deserves attention; to be gay and "of color" compounds minority statuses and makes the coming out process all the more difficult. Reynolds and Pope (1991) and McCarn and Fassinger (1996) discuss the complexity of multiple oppressions, which includes a developmental process of passive acceptance of normative expectations, acceptance of one minority aspect of self, compartmentalization of minority identities, through a more fully developed and integrated sense of self.

The minority emphasis models focus on the dual development of both ethnic and sexual identities and the integration of the two. This is often especially difficult because the minority person may find himself or herself marginalized on all fronts. For example, a gay Black man may find himself not accepted by Whites because he is Black, not accepted by Blacks because he is gay, and not accepted by gays because he is Black. If the marginalized person happens to be a woman, she may find herself in a triple-bind, being discriminated against because of her gender, race, and sexual orientation.

Homosexuality and Christianity

Few intersections of identity dimensions, however, are more controversial than the issues of sexual orientation (particularly homosexuality) and religion (particularly Christianity). During the course of the last decade, as civil rights for LGBT citizens (often stigmatized as "the homosexual agenda") has come to the political and social fore, hatred and bias toward gay people has taken on new heights. Heterosexuality's normativity and acceptance are often touted as "God's plan," and letters-to-the-editor in newspapers across America often contain contentious and vitriolic sentiments that "gays will be punished by God," or the 1980s belief that AIDS was "God's curse on gays."

Two films that address the intersections of religion and homosexuality are *Saved!* (2004) and *Latter Days* (2003). The two are markedly different—*Saved!*, like *Brokeback Mountain*, is made for a heterosexual palate, whereas *Latter Days* is made for gay audiences. As students screen *Saved!* and *Latter Days*, they will undoubtedly be able to pick up on the differences between hetero-gay movies

and gay-gay movies. The most obvious will be overt sexuality and behavior in gay-gay movies. Discuss what the other differences might be.

Saved! (United Artists, 2004), written and directed by Brian Dannelly
Starring: Mandy Moore, Macaulay Culkin, Mary Louise Parker
Genre: Comedy/Drama
Runtime: 92 min
Rating: PG-13 for strong thematic issues involving teens—sexual content, pregnancy, smoking, and language
Tagline: Lead us not into temptation

This film is centered around the American Eagle High School, an evangelical Christian school that is not shy about teaching religious dogma. Popularity is based upon depth of commitment to conversion of lost souls and the appearance of righteousness and holiness. No one knows this more than Hilary Faye (Mandy Moore); she wields her devotion like a sledgehammer; she is determined to convert any ne'er-do-wells "as an example of God's will triumphing over a savage, Godless nation." Hilary Faye has four pet projects in her proselytizing quest: her wheelchair-bound brother, Roland; his rebellious Jewish girlfriend, Cassandra; Mary, Hilary's friend who had sex with her boyfriend Dean because "Jesus said it was OK"; and Mary's boyfriend, Dean, who confesses to being gay (hence Mary's mission from God) and is sent to a reparative therapy clinic. Hilary Faye will go to great lengths to show her devotion to God and she preaches to everyone she meets. In the following exchange, Hilary Faye sets the tone for the entire movie: [to Mary regarding Dean] "Come on, you're not born a gay, you're born again."

Latter Days (Funny Boy Films, 2004), written and directed by C. Jay Cox
Starring: Steve Sandvos, Wes Ramsey, Joseph Gordon-Levitt, Jacqueline Bisset
Genre: Drama
Runtime: 92 min
Rating: R for strong sexual content and language
Tagline: Aaron prays. Christian plays . . . opposites attract

In this semiautobiographical film, writer/director C. Jay Cox tells the story of Aaron, a young Mormon minister on missionary assignment in Los Angeles, who with his team of elders is to spend a year teaching others about their faith.

They meet a gay playboy, Christian, who lives in the same apartment complex as the young ministers. Christian has little difficulty in meeting and seducing men (heterosexual and gay), and his friends bet him that he would not be able to "convert" Aaron. Eventually, Aaron reveals that he has been questioning his sexuality, and he and Christian fall in love. When the other elders find the two embracing lovers, Aaron is sent back to Utah where he is promptly excommunicated by a religious tribunal led by his own father. Aaron attempts suicide and is sent to a psychiatric treatment center, more for conversion shock therapy than mental health. Ultimately, Christian and Aaron find one another in a triumph of love.

The film has very strong anti-Christian sentiment. Explore the reasons why a film by/for gay audiences may be interested in this type of content. There are numerous dialogue exchanges that exemplify heterosexism and bigotry against gays. The following discussion between Aaron and his father at the excommunication hearing says much about the theme of this film:

> **Elder Farron Davis**: As president of the Pocatello stake it is my unhappy duty and obligation to convene this church court on behalf of the Elder Aaron Davis for the grave and grievous sin of homosexuality. In the light of your abnormal and abominable state and your refusal to see you have been duped into a hogwash alternative lifestyle . . . I wish my shame was enough for both of us. Not to mention the shame you brought to this church . . . our family . . . our ancestors . . .
>
> **Aaron**: Wait a minute, our ancestors? Dad, your grandfather had half a dozen wives, and the same goes for every single person in this room. I'd say we were the original definition of "alternative lifestyle."
>
> **Elder Farron Davis**: Are you calling us hypocrites?
>
> **Aaron**: No, we've gone way beyond hypocrisy, Dad, now we're just being mean.

In its attempts to decry Christian bias against gays, *Latter Days* can be condemned for the same misbehavior. These two exchanges reveal an anti-Christian bias that is suggestive of a parochial, limited viewpoint of "all" Christians. The first discussion is between Christian, Aaron, and Ryder (Gordon-Levitt) when Aaron and Ryder visit Christian to save him; the second is on a basketball court where Julie and Christian are playing Ryder and another elder:

> **Ryder**: Yeah, God hates homos.
>
> **Christian**: You're gonna come into my house and tell me God hates homosexuals?
>
> **Aaron**: And the French.
>
> **Ryder**: [*puzzled*] God hates the French?
>
> **Aaron**: Everyone hates the French.

Julie: Why don't we play two-on-two?

Ryder: But you're . . .

Julie: A girl? So I can't play. But then again, I am black, so maybe I can. Your problem's gonna be deciding which one of your narrow-minded stereotypes is gonna kick your lily-white ass.

Ryder: Yeah, right.

Julie: Afraid you'll get beat?

Christian: By a girl, and a fag?

Ryder: We'll mop you like a dirty floor.

All too often, religious doctrine and beliefs go unchallenged for most people. The following assignment provides students the opportunity to interview a spiritual leader about his or her teachings about sexual orientation.

Recommended activity:	The interview

Interview a religious leader of your particular faith tradition on his or her teachings and doctrine related to sexual orientation (heterosexuality and homosexuality). How does this teaching coincide with your current belief/value system? (Include the name and contact information for the interviewee and a list of the questions that you ask.) You should summarize the findings of the interview; it should not be in a Q&A format.

Identify the name, title/position, and religious affiliation of the person you interviewed. Describe your relationship with this person including the length of time you have known the interviewee. What was the initial reaction of the person when you described the purpose of the assignment?

1. *National organization* Describe that person's understanding of the national body's teachings or policies related to homosexuality. Are there applicable scriptural/textual sources the national organization refers to in its teachings? In what ways does the interviewee agree/disagree with the policies of the national organization?

2. *Church involvement* Are homosexual couples welcome in the local assembly? Can they be involved in activities, committees, church leadership? What about ordination? Are there official statements of welcome or disapproval?

3. *Surprises learned?* What did you find most interesting or surprising during your interview?

4. *Personal impact* How does this person's teaching coincide with your current belief/value system?

Visit www.ecwr.org/movie.htm and view the short 5-min. video about one organization that offers reconciliation services for Christians who identify as LGBT. Discuss your reactions and thoughts in light of this assignment (it is all right to respectfully disagree too).

This unit on the treatment of sexual orientation in American society is likely to be controversial, political, and emotional for some. Homosexuality, especially, brings up a variety of responses, some visceral. We contend, nevertheless, that it is a worthwhile learning experience for students. Additionally, dealing with sexual orientation provides an opportunity to introduce the topic of gender constructions, gender identity, and sexism and transgenderism.

Unit 4: Gender in American Culture

What are little boys made of?
"Snakes and snails and puppy dogs tails
that's what little boys are made of!"
What are little girls made of?
"Sugar and spice and all things nice
that's what little girls are made of!"

For decades, preschool and elementary-aged children have been singing and quoting this little ditty, thereby galvanizing the idea that women are the "fairer sex" and "boys will be boys." Gender roles socialization often begins before birth. With the advances in technology that have allowed for prebirth determination of the baby's sex, parents begin to shop for the appropriate pinks and dolls for girls and blues and sports equipment for boys. By the time kids enter the school system, the message of the differences between girls and boys has been repeatedly drilled into them.

Similarly, gender socialization has been about "place": fitting a predetermined mold of characteristics and attributes—the 1950s image of the dutiful wife who cooks and cleans and whose sole *raison d'etre* was to be the social, emotional, and sexual support for her husband. Popular culture magazines such as *Good Housekeeping* and the *Ladies' Home Journal* became organs for the cultural education of women to understand their place. With articles focusing on the how-tos of being a "good wife," women were urged to lives of domesticity, docility, and subservience to men. Men, on the other hand, were rarely given advice on being good husbands, at least not to the same extent as women. The man's job was simple: be the family's financier.

The quest for equal rights for women has focused attention on the economic, educational, and political empowerment of women—bringing them from places of invisibility and the shadow of patriarchy. Women's studies programs proliferated at colleges and universities, feminism became a household word, and magazines such as *Ms.* transformed the ways that women viewed themselves. Unfortunately, so much attention on uplifting women has diminished the ways we deconstruct the meanings of maleness and male dominance and privilege. In popular constructions, women are the subject of gender studies and conversations, whereas men are left out of the spotlight.

Once again, the idea of a cultural dichotomy plays out in gender constructions: women and men, boys and girls. Culturally deconstructed, the binary system has historically played out like this: a woman can be a whore or be pure; men are strong; women are weak; masculinity is desired; femininity is not. An interesting twist, however, is the way femininity is linked with race/class. Nineteenth-century middle- and upper-class women were told it was "women's nature" to be frail while slave women worked alongside men. Gender, then, becomes a natural place of crossroads for the cultural intersections of identity.

Films addressing traditional gender roles are abundant, but few drive the point more than children's animated films. Research has shown that our most significant learning takes place from infancy to 5 years of age; children's brains are like sponges. Our children trust, without much explanation, any information coming from parents, caregivers, teachers, and other sources such as television and movies. Animated films become excellent sources of cultural teaching and learning; few grow up without being impacted by this cultural force. Many of these films have catchy songs and soundtracks that further ingrain the message (music's impact on learning is oft cited). (Refer to the description of Disney's *Pocahontas* in the clips section for an example.)

Gender roles in feature-length animated films for children have not changed much since their advent in the 1950s. Adult women are characterized as ugly witches and evil stepmothers (if present at all). Teenaged girls are blonde and blue-eyed princesses—ladies waiting to be rescued by a handsome prince who would come to whisk them off to an enchanted land where they "all lived happily ever after." Women stayed at home talking to mirrors; men went to work. Time after time, despite changing landscapes, storylines, and graphic technologies, this was the predictable formula that countless children have grown accustomed to viewing. Roles for women in animated films began to change slightly in the twenty-first century. One film that was meant to introduce a new type of female character—the superhero—was the instant classic, *The Incredibles* (Walt Disney Pictures, 2004).

The Incredibles (Walt Disney Pictures, 2004), written and directed by Brad Bird
Starring: (Voices of) Craig T. Nelson, Holly Hunter, Samuel L. Jackson, Jason
Lee
Genre: Animated/Family
Runtime: 115 min
Rating: PG for action violence
Tagline: Expect the incredible

Recent legislation has forced all superheroes to hang up their capes and to not use their superhero powers and to assimilate into the general population. One superhero, Mr. Incredible, has problems giving up his old life of solving crimes and saving people. He and his wife, Elastigirl, have been living ordinary lives as Robert and Helen Parr; they live in the suburbs with their three children, Dash, Violet, and Jack Jack. When an evil mastermind develops a weapon to destroy the city, the family must work together to vanquish the foe and, once again, save the day.

The superhero image is relatively new for animated films. An argument can be made though that each of the characters reified the traditional roles for gender. After screening this film, explore the gender roles played by the Parr family, paying particular attention to the symbolism of their respective superpowers:

1. Robert/Mr. Incredible (super strength)
2. Helen/Elastigirl (rubberized skin and elasticity)
3. Violet (invisibility and force fields)
4. Dash (super speed)
5. Jack Jack (shape shifter)

In a telling description of the gender roles and expectations, Edna E'Mode, who designes new costumes for the Incredibles, discusses the new design with Helen:

> **Edna:** Your boy's suit I designed to withstand enormous friction without heating up or wearing out, a useful feature. Your daughter's suit was tricky, but I finally created a sturdy material that can disappear completely as she does. Your suit can stretch as far as you can without injuring yourself, and still retain its shape. Virtually indestructible, yet it breathes like Egyptian cotton.

Help your students understand their own gender role socialization with the following activities.

Recommended activity: Gender differences

Are there different expectations for boys and girls/men and women?

For the next series of activities, break into groups of males and females (to be inclusive of transgender students); allow students to self-identify for break-out groups.
Answer the following statements:

1. Girls and women may be expected to . . .
2. Boys and men may be expected to . . .

Differences between sex and gender:

1. Women give birth to babies; men do not (sex)
2. Little girls are gentle, boys are not (gender)
3. Men's voices break at puberty. Women's do not. (sex)
4. Women can breastfeed babies; men cannot (sex)
5. Most construction workers are men (gender)
6. In ancient Egypt, men stayed at home and did weaving while the women handled family business and inherited property (gender)

Being a girl, being a boy:
In like kind groups, complete the following sentences:

1. (Girls) I'm happy that I'm a girl because . . . / I wish I was a boy so that I could . . .
2. (Boys) I'm happy that I'm a boy because . . . / I wish I was a girl so that I could . . .

Gender roles

In like kind groups, complete the following statements:

1. The best thing about being a man is . . .
2. A man would never let a woman see . . .
3. A boy would be praised by his parents if . . .
4. A girl would be praised by her friends if . . .
5. Men get embarrassed when . . .

6. Women really want to . . .
7. A girl would get teased if she . . .

Gender assumptions—Tracy

Tracy is 10 years old. He lives with his mom and dad. He likes playing sports and listening to music. His best friend lives next door.

1. Which sports do you think Tracy likes playing?
2. Who do you think is his favorite band?
3. What is his best friend's name?
4. What do you think he does when he comes home from school?
5. What do you think his favorite color is?
6. What do you think his favorite food is?
7. What job do you think he wants to do when he grows up?

Tracy is 10 years old. She lives with her mom and dad. She likes playing sports and listening to music. Her best friend lives next door.

1. Which sports do you think Tracy likes playing?
2. Who do you think is her favorite band?
3. What is her best friend's name?
4. What do you think she does when she comes home from school?
5. What do you think her favorite color is?
6. What do you think her favorite food is?
7. What job do you think she wants to do when she grows up?

Group Exercise

Gender Assumptions (Agree/Disagree)

The professor will read out some statements regarding the advantages and disadvantages of being a man or a woman. If you agree, move to one end of the room. If you disagree, move to the other end of the room. When participants have moved to the chosen place in the room, one person from each end of the room will volunteer his or her reasons for their choice. The group can change their mind and move after hearing other people's reasons.

Participants divide into four smaller groups:

1. List the advantages to being a woman in our society.
2. List the advantages to being a man in our society.
3. List the disadvantages to being a man in our society.
4. List the disadvantages to being a woman in our society.

Discuss the similarities and differences between the lists. Ask whether men and women are limited by these roles and how? Are any of the roles interchangeable?

Like the subject of race, gender is about performance and conformity to societal strictures, rather than the commonly held belief that sex organs determine gender. Expand students' gender lexicons by explaining the following terms from Martin (2005):

1. *Gender* A socially constructed system of classification that ascribes qualities of masculinity and femininity to people. A sense of self as masculine or feminine regardless of external genitalia.
2. *Gender conformity* When a person's gender identity and sex "match" (i.e., fit social norms). For example, a male who is masculine and identifies as a man.
3. *Gender expression* An expression of one's own gender identity. This can include, but is not limited to, personality traits, behaviors, appearance, mannerisms, interests, hobbies, and values.
4. *Gender identity* The gender a person sees themselves as being. This can include refusing to label oneself with a gender. Gender identity is also often conflated with sexual orientation, but this is inaccurate. Gender identity does not cause sexual orientation—a masculine woman is not necessarily a lesbian.
5. *Gender role* How "masculine" or "feminine" an individual acts. Societies commonly have norms regarding how males and females should behave, expecting people to have personality characteristics and/or act a certain way based upon their biological sex.
6. *Gender-variant/gender nonconforming* Displaying gender traits that are not normatively associated with their biological sex. "Feminine" behavior or appearance in a male is gender-variant as is "masculine" behavior or appearance for a female. Gender-variant behavior is culturally specific.
7. *Intersex* Intersexuality is a set of medical conditions that feature congenital anomaly of the reproductive and sexual systems. That is, intersex people are born with sex chromosomes, external genitalia,

or internal reproductive systems that are not considered *standard* for either male or female.

8. *Sex* Refers to a person based on their anatomy (genitalia, chromosomes, internal reproductive organs).

9. *Transgender* Transgender people are those whose psychological self (gender identity) differs from the social expectations for the physical sex they were born with. Transgender is not a sexual orientation; transgender people may have any sexual orientation. Some transgender people live in a gender role different than their associated biological sex.

10. *Transsexual*[1] Refers to a person who experiences a mismatch of the sex they were born and the sex with which they identify. May desire to change anatomy (sexual reassignment surgery).

11. *Transvestite*[2] Individuals who regularly or occasionally wear the clothing socially assigned to a gender not their own but are usually comfortable with their anatomy and do not wish to change.

Manhood and Masculinity

Some might argue that we have been studying the world through a male lens since antiquity, and they would be correct. "Man" has been universally accepted as the generic norm for all; the study of women as *different* from men is still a relatively new concept. Manhood as a complex social structure has been understudied. We need to continue to reexamine the generalizations of men and masculinity to understand the systems of oppression that validate male dominance (typically characterized as violence, aggression, lack of emotionality, competitiveness, and status).

It is important to note that the pressures to conform to masculine roles are significant on the average male psyche. It has been said that the greatest insult to a man is to refer to him as effeminate in some way. This pressure, in some ways, has a causal link to the aggressive behaviors described above. To acknowledge one's "feminine side" is tantamount to social suicide, and it leaves men open to ridicule and harassment (Kimmel & Aronson, 2004).

One film that effectively handles the notions of male masculinity and femininity is *Fight Club* (1999).

Fight Club (Art Linson Productions, 1999), written by Jim Uhls, directed by David Fincher

Starring: Brad Pitt, Edward Norton, Meat Loaf, Helena Bonham Carter
Genre: Action/Drama
Runtime: 139 min
Rating: R for disturbing and graphic depiction of violent antisocial behavior, sexual content, and language
Tagline: How much can you know about yourself if you've never been in a fight?

One could call *Fight Club* male bonding on steroids. Take a nameless 30-something weak-willed insomniac and couple him with a brash, take-no-prisoners traveling soap salesman who has a penchant for sex, booze, and violence. The two become fast friends after the narrator (Norton) loses his apartment in an explosion, which we later learn Tyler (Pitt) had set. After a few drinks the two challenge each other to a playful fist fight in the parking lot of a bar. Soon, they are starting underground "fight clubs" nationwide where men pummel each other in a sign of camaraderie.

Soon the fight clubs become a front for Tyler's Project Mayhem, an underground sect that has plans to crush the nation's financial centers in protest of rampant capitalism. When the narrator learns of the plot, he tries to subvert the plan but is blocked. We learn that the narrator and Tyler are the same person (two sides of the same coin), and the narrator finds a way to "murder" Tyler, but not before Project Mayhem's biggest target explodes.

At first glance, *Fight Club* is just another action movie about violence and bloodshed. It is easily dismissed if the reader misses the metaphoric and symbolic meanings. The narrator's crisis of masculinity causes his insomnia. The narrator could be described as the effeminate side of the duo. The opening moments of the film are very telling.

The scene begins with Jack sitting on the toilet; he is holding a magazine and is peering at the centerfold. One could assume that Jack is reading a pornographic magazine, but it is actually a furniture catalog. The narrator is discussing becoming a slave to the "IKEA nesting instinct"; he describes how his furniture defines him. Jack suffers from insomnia, and his doctor encourages him to visit a testicular cancer support group to really understand pain and suffering. He does, and while there he meets and partners with a large man, Bob (played by rocker Meat Loaf), who shares his story of steroid abuse and its negative results on him emotionally and physically (Bob now has very large breasts, similar to a woman's). Bob encourages Jack to "let go and cry" and pulls Jack into his bosom. Jack begins to weep and at the end of the scene we see him fast asleep in his bed.

Just think about this imagery for a moment. The narrator is an "everyman" character who breaks all the "male" traditions as he sits ogling at a furniture

catalog instead of naked women. His doctor sends him to a testicular cancer support group to cure his insomnia. To the ordinary man, the testes are the most *sensitive* area on the body and the center of manhood in a way, and our narrator is sent to a place where sensitive conversations are the order of the day. He finds solace in the arms of a man with breasts who because of steroid abuse has lost his own manliness. In Big Bob's arms he is able to release his stress through crying and is able to break his insomnia. *What does this say about gender constructions for the narrator?*

Tyler Durden, on the other hand, is uber-masculine, hypersexual, and dangerous. He takes pleasure in being punched in the face; he enjoys the taste of his own blood. He is politically aware and plots to destroy consumerism in our culture. He verbally insults the narrator's lack of masculinity (the narrator lets us know that he feels alive when fighting with Tyler and the others). Tyler explains the crisis of masculinity and the need for fighting:

> Man, I see in Fight Club the strongest and smartest men who've ever lived. I see all this potential, and I see it squandered. God damn it, an entire generation pumping gas, waiting tables; slaves with white collars. Advertising has us chasing cars and clothes, working jobs we hate so we can buy shit we don't need. We're the middle children of history, man. No purpose or place. We have no Great War. No Great Depression. Our Great War's a spiritual war . . . our Great Depression is our lives. We've all been raised on television to believe that one day we'd all be millionaires, and movie gods, and rock stars. But we won't. And we're slowly learning that fact. And we're very, very pissed off.

Tyler is at once a rule maker and a rule breaker. He will not be told what to do and is a nonconformist, although one could argue that he has been totally programmed by gender role socialization. In the end, the narrator feels he must destroy this dark side of himself. *Entertain students' opinions on the demise of Tyler Durden, and their prognostications of the narrator's future—how will this knowledge of himself impact his own gender identity?* (The 1999 film *American Beauty* has a similar treatment of the issue of masculine gender conformity.)

Recommended activity: Masculinity in American culture

Understanding masculinity in American society

On the board, write the following (have students complete the statements):

1. "Real men . . ."
2. What actors are "real men"?
3. List words that describe typical characteristics of
 - Men
 - Women

List and discuss pejorative (disrespectful or insulting) words or phrases that apply to men. Discuss the meanings of these phrases and their uses in our society.

We know that there is gender discrimination and sexism against women. In what ways may men be discriminated against?

Femininity

The proscriptions of femininity in American cinema are plentiful. Women are expected to be dainty and lady-like, while seeking their own Prince Charming. Recent films such as *She's the Man* (2006), *What Women Want* (2000), and Disney's *Beauty and the Beast* (1991) support this age-old archetype; it is, after all, "a tale as old as time" (sung by Mrs. Potts [Angela Lansbury] in *Beauty and the Beast*). There is a newer image that is quickly becoming a cultural force and that is the skinny, half-naked, booty-shaking, alcoholic party girl who is willing to degrade herself sexually to get the pretty boy, the most-popular-boy-in-the-school who will only use her and throw her away. She is the one who will show her breasts for some silly trinket or T-shirt. This phenomenon is on display in virtually every teen comedy of the past 10 years—the *American Pie* series (1999, 2001, 2003), *Varsity Blues* (1999), the *Scary Movie* series (2000, 2003, 2006), and a host of others (and let's not forget the reality TV shows that are everywhere. What kind of prize is Flavor Flav that scores of young women would degrade themselves for him on VH-1's *Flavor of Love*?). A young woman featured in the documentary film *What a Girl Wants* (2001, Media Education Foundation) was quoted as saying, "teenagers used to go to the movies to see adults have sex, but now adults go to the movies to see teenagers having sex." This reveals a very telling element of both images of femininity in American culture—both are designed to fulfill the desires of men and masculinity.

Diverging from these images of femininity and womanhood in American movies, two films have challenged the traditional notion of what being a woman is all about. Hilary Swank won an Academy Award in *Million Dollar Baby* for her portrayal of Maggie Fitzgerald, a young woman who climbs the rankings to become a championship boxer. But Maggie is critically injured

in the ring and is paralyzed (and dies in a mercy killing by her manager). *Did she die for breaking the rules of femininity?* Another film that shows female masculinity and power is *Disclosure* (1994), starring Demi Moore as a sexually aggressive corporate powerhouse named Meredith Johnson. Her sexuality is seen as a threat (to men and masculinity) and as unnatural and something to be feared. Michael Douglas plays Tom Sanders who is the "victim" of Meredith's sexual power, and she is ultimately fired. Tom is later uplifted by three female "caregivers" (his lawyer, his wife, and an executive at the technology firm where he works). *Was Meredith sacrificed on the horns of the masculinity altar?*

Films like these suggest that women who step outside of the boundaries of feminine gender roles will be punished. One film series, though, defies conventions to show women in powerful masculinized roles with the female character emerging at the end—Quentin Tarantino's *Kill Bill* (vol. 1, 2003; vol. 2, 2004). The films were designed to be shown as companions of the same tale rather than the second film (vol. 2) being seen as a sequel. To show them as one film, however, would require a 4-hr time slot. We recommend, then, using vol. 1.

Kill Bill, vol. 1 (Miramax Films, 2003), written and directed by Quentin Tarantino

Starring: Uma Thurman, Lucy Liu, David Carradine, Vivica A. Fox, Daryl Hannah

Genre: Action/Thriller

Runtime: 111 min

Rating: R for strong, bloody violence, language, and some sexual content

Tagline: Here comes the bride

Uma Thurman narrates and stars as the Bride, an unnamed female assassin who was betrayed by her former boyfriend, Bill (Carradine). On her wedding day, a very pregnant Bride was brutally attacked by Bill and some of his female henchmen. Bill shoots the Bride in the head and leaves her for dead. She awakens from a coma 4 years later to learn that her baby has been stolen and an orderly has been selling access to her comatose body for sexual favors. After killing the orderly and stealing his truck (which he calls "The Pussy Wagon"), the Bride vows vengeance on Bill and his former associates. One by one, the Bride slaughters her enemies, a gang of female assassins (all having nicknames of poisonous snakes). (In light of the discussion of gender roles and feminine masculinity, discuss the symbolism of the Bride stealing the truck and the naming of the female assassins.)

Traditional femininity has been coded as docile, weak, and irrational. In this twist on female masculinity, the Bride coolly dispatches her enemies as if she were following a checklist. She indicates in one conversation, "It's mercy, compassion, and forgiveness I lack. Not rationality." Her weapon of choice is a custom-designed Hattori Hanzo sword, which was fashioned purposely for her killing mission. In his message to her, Hanzo describes a traditionally masculine reason for combat—one that is readily adopted by our heroine:

> For those regarded as warriors, when engaged in combat, the vanquishing of thine enemy can be the warrior's only concern. Suppress all human emotion and compassion. Kill whoever stands in thy way, even if that be Lord God, or Buddha himself. This truth lies at the heart of the art of combat.

This line is reminiscent of the instructions given by the Cobra Kai sensei, John Creese, in *The Karate Kid* (1984): "We do not train to be merciful here. Mercy is for the weak. Here, in the streets, in competition. A man confronts you, he is the enemy. An enemy deserves no mercy."

By the end of vol. 1, the Bride has killed many of her enemies, but Bill has managed to elude her grasp. She does not complete her mission until the end of vol. 2. It is important to note however that this saga ends by replacing traditional female gender roles at the "right" position and place. The Bride learns that her child, a daughter named B.B., is alive and in Bill's custody. In their final battle, Bill manages to give the Bride a dose of truth serum and she tells him that when she learned of her pregnancy, her maternal instincts led her to choose the child above a future with Bill. After killing Bill, B.B. and the Bride are in a hotel room. The screen fades to black and this quote appears, "The lioness has rejoined her cub. All is right in the jungle."

Recommended activity: Coming attractions

Become a movie critic You will partner with a classmate and together you will visit http://www.apple.com/trailers/ and view the movie trailers of at least three new theatrical releases (in theaters or upcoming at the time of the assignment) and discuss the target audience of the films through the lens of gender and gender roles. You will present your findings in the Ebert and Roeper format in class. Have fun with this assignment—BE CREATIVE!

The purposes of this assignment:

- To explore how the media reinforces gender roles and stereotypes.
- To explore female and male images and gender stereotypes.
- To think about sources of information and attitudes about gender.

Things to do to prepare for this assignment:

1. Skim through a wide variety of magazines and examine the way women are portrayed and the ways men are portrayed. Discuss the images and how these images maintain roles and stereotypes. Are these images accurate? How do young men and young women feel about being portrayed in this way?
2. Instead of magazines, look at the portrayals in television advertisements.
3. Brainstorm about the ways that women and men are depicted in films, TV dramas, songs and music videos, proverbs and religious epics. *What are the men and women doing? What characteristics do they show?*
4. Discuss the roles that society expects men and women to play. What are the common stereotypes of males and females—how are these stereotypes supported or broken in ads and in the film trailers you explore?

Things to think about:

1. What are the images of male characteristics? Of females?
2. Which of these characteristics do you think are realistic or not realistic?
3. What do these images suggest that girls and boys/men and women can do?
4. How are you similar to the images? How are you different?
5. How do you feel about the stereotypes that are common in society?

Here's a question If the goal of movie trailers is to attract as many people as possible to the theaters, then in what ways do the trailers appeal to all viewers? What techniques are used? What strategies? Are there hidden messages beneath the surface? (For example, a "chick flick" stereotypically has women as the target audience, but in what ways does the trailer appeal to a masculine or male audience?)

Transgender Identity

The binary male/female gender construct is in some ways limited and limiting. The gender definitions above acknowledge the presence of transgender people—*trans* simply mean "cross," so by this term we are addressing those whose identities cross genders. This definition includes those who psychologically do not feel comfortable in their own bodies or whose physiognomy crosses genders. This topic is confusing for most Americans as we have been programmed to function in this binary structure. In most minds, a man is born a boy and a girl grows into a woman—case closed; these are, of course, based upon genitalia.

The experiences of those who experience gender from outside or between the binary are relatively negative, from both social and legal perspectives. In some ways, this difficulty is related to the presumption of the homosexuality of transgender people (transgender is not a sexual orientation despite its inclusion in the LGBT acronym), who then become subject to the vilification, bias, harassment, and violence inflicted upon gay people. (Gagne, Tewksbury, & McGaughey, 1997). Homophobia does, then, uphold traditional gender roles (Blumenfeld, 1992). Similarly, transgendered students face invisibility, ostracism, isolation, and self-concealment as part of their everyday experience (Rankin, 2005). This invisibility of transgender people is common, and as you can imagine, Hollywood has followed suit either with a lack of portrayals of transgender people or by keeping them the subject of pity or ridicule.

Two representative films are *Boys Don't Cry* (1999) and *The Crying Game* (1992). Hilary Swank's portrayal of (real-life) Teena Brandon, a biological female living as a boy named Brandon Teena, earned her an Oscar. Once Teena's secret was found, she was brutally raped; while making her report to the police, she identified as having a "gender identity disorder," which only reaffirms the thought that anyone outside the binary construction is psychologically troubled. Teena is ultimately murdered. The British import, *The Crying Game*, garnered critical acclaim, especially with its surprise twist—the main character, Fergus (Stephen Rea), a member of the Irish Republic Army, has an exotic new girlfriend named Dil, whom he learns later is actually a male transsexual. After a few moments of revulsion and days of avoidance, Fergus finally comes back to Dil. Although worthy of consideration as an artistic film, Dil's transsexuality is not given much consideration or discussion. We recommend, then, the critically acclaimed film *Transamerica*, a film that was dedicated entirely to the subject.

Transamerica (Belladonna Productions, 2005), written and directed by Duncan
Tucker
Starring: Felicity Huffman, Kevin Zegers
Genre: Drama/Adventure
Runtime: 103 min
Rating: R for sexual content, nudity, language, and drug use
Tagline: Life is more than the sum of its parts

Stanley Osbourne, a preoperative transsexual, has been living as a woman,
named Bree, for quite some time, as required by the doctors in preparation for
his sexual reassignment surgery. A week before surgery, she (*ze*—an inclusive
pronoun for transsexuals) learns that she (as Stanley) had fathered a son years
ago. Toby calls from a New York prison, and Bree's doctor requires her (*zer*) to
travel to meet him in order to effectively close the door on his male past. At
their first meeting, Bree does not tell Toby that she is his father, but lets him
think that she is a Christian missionary who has come to lead his lost soul to
salvation.

Toby has a drug problem and has been selling himself as a prostitute, and
he is not interested in being saved. He would like to get to Los Angeles to
begin a career in gay pornographic films. Their journey is wrought with chal-
lenges, especially when Bree decides to take Toby to her parents' home—the
parents who refused to accept Stanley as Bree. This visit to the Osbourne fam-
ily home creates numerous opportunities for discussion with students. The fol-
lowing exchange between Bree and her mother is an example:

> **Elizabeth Osbourne:** Look at your life. You've never been able to stick to a decision.
> I mean 10 years of college and not a single degree. How do you know you
> won't change your mind about this, too?
>
> **Bree:** Because I know.
>
> **Elizabeth:** Don't do this awful thing to yourself, please. I miss my son.
>
> **Bree:** Mom, you never had a son.
>
> **Elizabeth:** How can you say such a thing?
>
> **Bree:** Now you know how I felt when you hired those private detectives.
>
> **Elizabeth:** We only tried to do the best for you.
>
> **Bree:** Is that why you tried to have me committed?
>
> **Elizabeth:** You tried to kill yourself!
>
> **Bree:** Because you tried to have me committed!
>
> **Elizabeth:** I don't know why you have to be so emotional.
>
> **Bree:** I am not emotional! God, my cycle's all out of whack.
>
> **Elizabeth:** You don't have cycles!

Bree: Hormones are hormones. Yours and mine just happen to come in purple little pills.

There are several scenes like this where we see the realities of transgender living for both the individual person and their friends and families. There may be confusion on both sides, questions, assumptions, fears, and anger. Below are several examples:

Bree: Jesus made me this way so I could suffer and be reborn the way he wanted me!

Toby: You're gonna cut your dick off for Jesus?

Bree: They don't "cut it off!" It just becomes an innie instead of an outtie.

Bree: My body may be a work-in-progress, but there is nothing wrong with my soul.

Murray: Your mother and I both love you.

Elizabeth: But we don't respect you!

Dr. Spikowsky: How do you feel about your penis?

Bree: It disgusts me. I don't even like looking at it.

Dr. Spikowsky: What about friends?

Bree: They don't like it either.

Dr. Spikowsky: No, I mean do you have the support of friends?

Bree: I'm very close to my therapist.

Dr. Spikowsky: What about your family?

Bree: My family is dead.

Recommended assignment: Transsexual acceptance and climate

After screening *Transamerica*, invite your students to conduct a campus/school climate study for transsexual students. How would Bree experience life at your school? Interview a member of the senior administration, two teachers or faculty members, five students (not friends). If you have residence halls or dormitories, inquire about housing spaces, restroom use from your residence hall professional staff. How would admissions officers represent how transfriendly your campus is (or isn't)? Students will share findings via oral presentation and written narrative.

Notes about this assignment Undoubtedly, there will be some discomfiting types of comments made by xenophobic students, particularly as students begin talking about living quarters. Many people are "equal opportunity" minded as long as the contentious difference is elsewhere, but when it becomes personal, that is a different story altogether. This type of conversation may require some students to examine their own upbringing in regard to fairness, equality, and tolerance. Encourage students to not shy away from this conversation. This appeal to higher principles is a great skill to help students when they ask, "What can I do?" in response to societal failings.

Additionally, there may be questions about dating and sex issues for transsexuals, particularly related to nomenclature. For instance, "If a woman was born a man and is now dating a woman, is she a lesbian?" Questions like these are attempts to categorize and decipher how a person fits into the binary system. This is again evidence of the intersections of gender and sexual orientation.

One film that challenges these intersections of gender and sexual orientation (as well as race and religion) is Robert Townsend's *Holiday Heart* (2000). Holiday is a gay man who, by day, is a church choir director and, by night, a popular drag queen at a local night spot. This movie was chosen, in part, because of the actor who plays Holiday. Ving Rhames is a heterosexual actor known for his muscles and masculinity in such films as the *Mission Impossible* series (1996, 2000, 2006), *Body Count* (1998), *Con Air* (1997), and *Rosewood* (1997). Rhames is generally called upon to perform roles where brawn is necessary; he plays bouncers, fighters, bodyguards—real "tough guy" roles. He breaks convention in his role as Holiday.

Holiday Heart (MGM, 2000), written by Cheryl West, directed by Robert Townsend

Starring: Ving Rhames, Alfre Woodard, Mykelti Williamson

Genre: Drama

Runtime: 100 min

Rating: R for language and drug content

Tagline: A drag queen faces his toughest act ever. Fatherhood

Following the death of his life partner, Fisher, an in-the-closet police officer, Holiday decides that he is going to emigrate to Paris, France. As he is

making final preparations, he comes to the aid of a young girl, Nikki, whose mother is being beaten up by a drug dealer. The girl's mother, Wanda (Woo-dard), is a drug addict who wants to be a good mother but is struggling with her addiction. She and Nikki are "warrior women" who write poetry and stories as a means of creative control of their lives. Big-hearted Holiday cancels his trip to care for Nikki and Wanda, and all seems to be going well. Wanda has remained clean and sober, but when she falls in love with Silas (Williamson), a drug dealer, Wanda is in danger of falling off the wagon. Despite his best efforts, Wanda cannot kick the habit and abandons Nikki and Holiday. Nikki and Holiday are a dynamic duo; he raises her with old-fashioned values laced with advice about overcoming obstacles. Wanda is murdered by a dealer to whom she owes money (sadly, she also tries to prostitute Nikki to him), and Holiday and Silas agree to raise her together.

Students familiar with the corpus of Rhames's work will be shell-shocked to see him in this type of role. Though Holiday has effeminate mannerisms he is no stranger to a fist fight. Most of his opponents underestimate his strength and fighting skill, for they make assumptions that because he is gay, he is there-fore weak (a common stereotype). He is a professional drag queen (only dresses as a woman for employment). He is not a transsexual. He lives his life as a man (although he does wear women's clothing to Fisher's funeral). In his interac-tions with Fisher, however, Holiday does play a more femme role. In the open-ing scene, for instance, Fisher buys Holiday a new home, and Holiday insists that Fisher carry him over the threshold. He is a nurturing father to Nikki and a caregiver to Wanda. At the same time, Holiday has masculine tendencies. In one exchange, Nikki asks Holiday whether he enjoys sleeping with men; Holi-day affirms. The discussion continues:

Nikki: So, are you and me gonna march in the gay parade?
Holiday: Oh no baby. I'm from the old school. I marched with King [Martin Luther]—I ain't about to start marching with the queens.

Holiday Heart, while leaning a bit toward the melodramatic, is worthy of consideration in this course because it addresses issues in the common mind-set. In a scene with Wanda, for example, Holiday tries to explain the cause of his homosexuality. As a teenager, Holiday was placed in a reform school with much older boys who raped him repeatedly. He admits, however, that he is happy that God made him the way he is. Another reason we recommend this film is because of the dearth of gay movies or characters featuring Afri-can Americans or other racial minorities. The film also hints at the matter of homosexuality within the Black church. We do acknowledge that some of the

Cultural dimension	Titles of films
Socioeconomic class	*Working Girl* (1988) *The Outsiders* (1983) *Erin Brockovich* (2000) *Class Action* (1991) *Higher Learning* (1995) *The Pursuit of Happyness* (2006) *Harry Potter and the Chamber of Secrets* (2002) *Titanic* (1997)
Religion and spirituality	*Dead Man Walking* (1995) *The Namesake* (2007) *Facing the Giants* (2006) *Gone Baby Gone* (2007) *Schindler's List* (1993) *Dogma* (1994) *The Passion of the Christ* (2004)
Nationality and language	*American Me* (1992) *Mi Familia* (1995) *Rendition* (2007) *Spanglish* (2004) *The Siege* (1998) *Not Without My Daughter* (1991) *Born in East L.A.* (1987)
Ability	*The Other Sister* (1999) *What's Eating Gilbert Grape?* (1993) *Radio* (2003) *Rain Man* (1988) *Forrest Gump* (1994) *Sling Blade* (1996) *I am Sam* (2001) *A Beautiful Mind* (2001) *Lorenzo's Oil* (1992)
Age	*Cocoon* (1985) *Driving Miss Daisy* (1989) *The Notebook* (2004) *Waking Ned Devine* (1998) *On Golden Pond* (1981) *American Beauty* (1999)

film's strengths are also some of its weaknesses—another straight actor, stereo-
typical "gay" mannerisms, homosexuality "caused" by molestation, and the like.
The highlight is Ving Rhames in this role. (He returns to a Holiday-esque role
as Duncan, an in-the-closet police officer who decides to out himself to the
force, in 2007's *I Now Pronounce You Chuck and Larry*, starring Adam Sandler
and Kevin James.

Conclusion

We have outlined a possible course on understanding American culture and
diversity. The goal again was to create opportunities for students to challenge
their own socialization while coming to terms with emergent or changing be-
lief systems and to critically decipher national and community cultural stan-
dards. We examined the issues of culture, race, gender, and sexual orientation
both as separate dimensions and as interlocking phenomena. As instructors
we continue to encourage you to examine the diverse and the mainstream,
the individual perspective and the societal/institutional systems at play, and
understand that dominance and oppression are powerful forces and have great
impact upon our personal worldviews.

Still other areas for consideration are socioeconomic class and status, a
more in-depth look at religion and spirituality, ability, nationality, language,
and so much more. If interested, the films on the opposite page can add to your
discussions of these dimensions.

This course would be served well in a 3–4-hr. per class session format,
which provides time to watch movies in their entirety as well as opportunities
for full lectures and classroom discussion and other activities. Most teachers,
however, do not have the luxury of such a long time frame as this, so we offer
the film clips in the coming pages that allow use of mainstream movies as a
companion to your instruction.

Notes

1. See clip from the film *To Wong Foo, Thanks for Everything, Julie Newmar* in this volume for
 a visual example of the differentiation of gender definitions for transsexual, transvestite, and
 drag queen.
2. See note 1.

References

Bieschke, K. (2002).Charting the waters. *The Counseling Psychologist, 30*, 575–581.

Blumenfeld, W. J. (1992). "How homophobia hurts everyone." In M. Adams, W. J. Blumenfeld, R. Castaneda, H. W. Hackman, M. L. Peters, & X. Zuniga (eds), *Readings for diversity and social justice: An anthology on racism, antisemitism, sexism, heterosexism, ableism and classism* (pp. 267–275). New York: Routledge.

Blumenfeld, W. & Raymond, D. . (1993). *Looking at gay and lesbian life.* Boston: Beacon.

Bogle, D. (2001). *Toms, coons, mulattoes, mammies and bucks: An interpretive history of blacks in American films.* New York: Continuum.

Cass, V. (1979). Homosexual identity formation: A theoretical model. *Journal of Homosexuality, 4*(3), 219–235.

De Los Santos, N. (2002). *The bronze screen: 100 years of the Latino image in Hollywood* (http://www.bronzescreen.net/index.html) Last accessed on June 22, 2008.

Feagin, J. (2000). *Racist america: roots, current realities, and future reparations.* New York: Routledge.

Fuss, D. (1991). *Inside/out: Lesbian theories/gay theories.* New York: Routledge.

Gagne, P., Tewksbury, R., & McGaughey, D. (1997). Coming out and crossing over: Identity formation and proclamation in a transgender community. *Gender & Society, 11*(4), 478–504.

Goodman A. (2001). Six wrongs of racial science. In *Race in 21st century America*, C. Stokes, T. Melendez and G. Rhodes-Reed (eds.), pp. 25–47. Lansing: Michigan State University Press.

Hardiman, R. (2001). Reflections on white identity development theory. In C. Wijeyesinghe & B. Jackson (eds.) *New perspectives on racial identity development: A theoretical and practical anthology*, pp. 108–128. New York: NYU Press.

Harris, M. (1999). *Theories of culture in post-modern times.* Walnut Creek, CA: AltaMira Press.

Helms, J.E. (1992). *A race is a nice thing to have: a guide to being a white person or understanding the white persons in your life.* Topeka, KS: Content Communications.

Helms, J.E., & Cook, D.A. (1999). *Using race in counseling and psychotherapy: theory and process.* Needham, MA: Allyn & Bacon.

Helms, J. & Piper, R. (1994). Implications of racial identity theory for vocational psychology. *Journal of Vocational Behavior, 44*(2), 124–38.

Hobgood, M. (2000). *Dismantling privilege: An ethics of accountability.* Ohio: Pilgrim Press.

Kimmel, M. (2004). "Masculinity as homophobia: Fear, shame, and silence in the construction of gender identity." In P. F. Murphy (ed.) *Feminism and masculinities* (pp. 182–199). London: Oxford University Press.

Kitwana, B. (2005). *Why white kids love hip hop: Wangstas, wiggers, wannabes, and the new reality of race in America.* New York: Basic Civitas Books.

Martin, L. (2005). *Translating identities.* Portland: University of Oregon Press.

McIntosh, P. (1988). White privilege: Unpacking the invisible knapsack. In M. Andersen & P. Collins (eds.) *Race, class, and gender: An anthology* (2003), pp. 103–107. New York: Thompson.

McCarn, S. & Fassinger, R. (1996). Revisioning sexual minority identity formation: A new model of lesbian identity and its implications for counseling and research. *The Counseling Psychologist, 24*, 508–534.

Ofori-Dankwa, J., & Lane, R. (2000). Four approaches to cultural diversity: Implications for teaching at institutions of higher education. *Teaching in Higher Education, 4*(1), 493–499.

OMB Notice *Revisions to the Standards for the Classification of Federal Data on Race and Ethnicity* published 10/30/97. Retrieved from http://www.census.gov/population/www/socdemo/race/Directive_15.html on June 19, 2008.

Ortiz, A., & Rhoads, R. (2000). Deconstructing whiteness as part of a multicultural educational framework: From theory to practice. *Journal of College Student Development, 41*(1), 81–93.

Rankin, S. (2005). Climate for LGBT College Youth. In J. Sears (Ed.), *Encyclopedia of sexualities, youth & education,* pp. 737–740. Westport, CT: Greenwood.

Reynolds, A. & Pope, R. (1991). The complexities of diversity: Exploring multiple oppressions. *Journal of Counseling and Development, 70*(1), 174–180.

Schein, E. (2004). *Organizational culture and leadership.* San Francisco, CA: Jossey Bass.

Shah, H. (2003). "Asian culture" and Asian American identities in the television and film industries of the United States. *Simile, 3*(3), 1–10.

Titone, C. (2000). Educating the white teacher as ally. In Joe Kincheloe (ed.), *White reign: Deploying whiteness in America* (pp. 159–175). New York: St. Martin's Press.

Torres, V., Howard-Hamilton, M., & Cooper, D. (2003). *Identity development of diverse populations: Implications for teaching and administration in higher education.* California: Jossey-Bass.

Weaver, G. (1986). Understanding and coping with cross cultural adjustment stress. In R.M. Paige (ed.), *Cross-cultural orientation: New conceptualizations and applications* (pp. 137-167). Lanham, MD: Rowman & Littlefield.

Wellman, D. (1993). *Portraits of White racism.* Cambridge: Cambridge University Press.

Worthington, R., Savoy, H., Dillon, F., & Vernaglia, E. (2002). Heterosexual identity development: A multidimensional model of individual and social identity. *Counseling Psychologist, 30*(4), 496–531.

 FOUR

Film Clips
and Questions
for Discussion

How can a family of cartoon superheroes, a set of talking alien robots who can transform into cars, or a sewer-dwelling rat and his shell-shocked turtle "sons" help teach important lessons about diversity? The lessons in this book are designed to supplement your instruction on diversity issues. For each term listed in Chapter Two above, you will find a movie clip that illustrates the concept you are teaching. Most clips last no longer than 10 min. in length. We have also developed a list of questions that you could use to get conversations rolling. In this chapter, we utilize mainly contemporary films released between 1990 and 2007 to allow for greater probability of availability at the local video store or school library.

Perhaps the greatest single obstacle confronting teachers who want to use film during instruction is the schedule. Most teachers have less than an hour of classroom time (40–50 min. on average), which does not give them enough time to adequately review even a short film and have a critical discussion. To use feature films, teachers must divide the film into three or four class periods. Understanding this challenge, we have taken the liberty to find meaningful clips to watch that get at the heart of the issues of difference.

Each illustration gives a brief statement on the content and rating of the movie. Most of the lessons are written in a way that assumes that the movie clip will not be shown—providing necessary plot summary and describing the crucial scene concretely—but does include elapsed times so the instructor can locate the scene easily if the film is actually used. (*Highly recommended*) (Questions that are specific to the clip shown are denoted by the symbol 🐾)

We must stress again that these clips are designed to complement your instruction about the issues of difference. Teaching diversity concepts is often controversial and, as stated earlier, students do not often possess the cross-cultural awareness, knowledge, and skills to be successful in these types of discussions. To effectively harness the power of these visual images, the teacher must prepare the students for what they might see and what they should be on the lookout for. This preparation should include providing information that is necessary for comprehension, including ensuring that students understand key terminology. Providing students with an overall context of the film is important, as well as helping them to understand how a particular clip fits into the film's action and storyline.

To ensure that the lessons are useful and useable for a variety of age groups from high school through adult learners, we have taken on the additional challenge of trying not to use scenes that contain objectionable elements (although it is difficult to find something that is not objectionable to anyone). In other words, we illustrate from PG-13 and R-rated movies, but do not necessarily use PG-13 or R-rated scenes. Thus, many of the illustrations we have chosen will not contain profanity or nudity because we want all learners, no matter the age, to be able to watch the clips. If some objectionable element in the movie appears within, immediately precedes, or follows a selected clip, we do include a warning. (*Such clips are denoted by the symbol* 🔲.)

Note: As the instructor, however, you must decide which clips are most suitable for your audience. You are responsible for ensuring that the content is developmentally and age-appropriate for your students and that you have appropriate permissions to use film in your classroom.

Here's a sample of the lessons you will find in this book.

Sample Lesson

Anchorman: The Legend of Ron Burgundy

Definition(s): Sexism

Plot summary: It is the 1970s as San Diego anchorman Ron Burgundy is the top dog in network TV, which gives way to his freewheeling sexism with his network cronies, but all that's about to change when ambitious reporter Veronica Corningstone—a woman—has just arrived as a new coanchor at his TV station.

In this scene: Ron is running late to do his broadcast of the evening news. Unsure of what to do, the studio is persuaded to allow Veronica Corningstone to fill in for Ron. As Veronica begins her newscast, the male anchors are trying to distract her so that she will make a mistake and embarrass herself. To their dissatisfaction, she completes the broadcast without incident and receives praise from the producer. Ron finally arrives and reassures everyone that they could now do the news as normal. Ron is incredulous when he learns that a *woman* has read his news. The next day Veronica is promoted to coanchor of the Channel Four news team. The scene ends after the announcement of Veronica's appointment and Ron exclaims "What is this—amateur hour?" [OBJ]

Discussion questions:

- This film is set in the 1970s when women's roles in the business world were limited. What gender-specific roles for women are still enforced today?
- In today's society, women still earn significantly less money for doing the same work as men. How might we change this phenomenon?
- ☛In this scene, as Veronica prepares to deliver the news for the first time, she begins to chant "power . . . power . . . power." Why? What does this say about women who want to get ahead?

Anchorman: The Legend of Ron Burgundy (DreamWorks, 2004), written by Will Ferrell and Adam McKay, directed by Adam McKay
Elapsed time: This scene begins at 00:52:14 and ends at 00:56:13 (DVD Scene 14)
Rating: PG-13 for sexual humor, language, and comic violence

Note that the running times are approximated and may vary depending upon the format of the DVD or VHS tape. We have provided enough detail in the

scene descriptions that will help you locate the scene on a DVD or tape of any format. This method will help you find the scene quickly, even if you are unfamiliar with the film. (We utilized Microsoft Media Player™ for timing the clips.)

A Note about Using Copyrighted Materials

The Copyright Act allows for showing copyrighted film scenes during the course of regular classroom instruction. A teacher may not charge a fee for viewing the scenes, and only students in the course are permitted to view (no public viewing). You must use a legal copy of the film that has either been rented or purchased. This instructional use provision within the copyright code does cover using "home use" (the FBI warning at the beginning of the video) rented videos in the classroom.

Ace Ventura: When Nature Calls

Co-optation/prejudice

> After spending time searching for spiritual enlightenment, Ace is hired to locate and rescue a sacred bat that has been stolen from an African village. If he fails, intertribal warfare will ensue. Ace is an animal conservationist, so this request should not be a challenge, but bats are the one animal that Ace loathes. How will he overcome his fear and assuage the intertribal conflict?

Ace Ventura (Jim Carrey) must infiltrate the Wachootoo village to search for clues to the missing bat, but how can this White man blend into a Black African village? Of course he is immediately found and the tribal chief refers to Ace as *Equinsu ocha* (translated "White Devil"). The villagers, described as "savages," surround Ace with spears (Ouda, his translator, regularly misinterprets Ace's words into threats). The chief declares that Ace must pass all Wachootoo tests of manhood or else he will be killed. The tests include walking over hot coals, performing surgery with bare hands, and a fight against the village's toughest fighter in the Circle of Death. Ace is easily beaten, but because he makes the chief laugh (the chief calls him "a sissy girl"), he is spared death. The scene ends as Ace and Ouda flee the Wachootoo village.

- How would you describe the process by which you introduce someone new to your group of friends? Is there any "test" that is required for acceptance?
- What does it feel like to try to become accepted by another person or group?
- ❦ Ace is referred to as *Equinsu ocha*, or "White Devil"; the villagers are described as "savages"; the chief calls Ace "a sissy girl." Why do people resort to name-calling?
- Describe the following terms: culture shock, acculturation, biculturation.

Ace Ventura: When Nature Calls (Morgan Creek Productions, 1995), written and directed by Steve Oedekerk
Elapsed time: This scene begins at 00:51:48 and ends at 01:04:00 (DVD Scene 21)
Rating: PG-13 for crude language

Addams' Family Values

Discrimination/dominance

Those creepy, kooky, mysterious, and spooky Addamses are back—Gomez, Morticia, Wednesday, Pugsley, Lurch, and Thing. They are trying to save Uncle Fester from certain death from his gold-digging, murderous wife. This family's love is proof that "blood is thicker than water."

Wednesday and Pugsley are away at summer camp, where the camp directors are announcing the end-of-summer dramatic production of the Pilgrims arriving in the New World. They are announcing the cast: the most popular camper, Amanda Buckman, will play the lead, and her supporting cast are her group of friends (all of whom are White, blond, and blue-eyed). One of the staff members suggests that "everyone cannot be stars" and announces the list of people who will play the Indians—all of whom are religious, racial, or social minorities. In announcing the person who will play Pocahontas, the camp director announces that Wednesday, "our own little brunette outcast," will assume the role.

- Identify strategies and measures to prevent and report incidents of sexual and racial discrimination.
- How has the recent anti-immigration legislation increased discrimination in our society?
- What contributions to American culture have been made by immigrants from different parts of the world?

Addams' Family Values (Orion Pictures, 1993), written by Paul Rudnick, directed by Barry Sonnenfeld
Elapsed time: This scene begins at 00:52:26 and ends at 00:54:03 (DVD Scene 9)
Rating: PG for some language

Akeelah and the Bee

Dominance/prejudice

Eleven-year-old Akeelah Anderson's life is not easy: her father is dead, her mom ignores her, and her brother runs with local gangbangers. She's smart, but her environment threatens to strangle her aspirations. Responding to a threat by her school's principal, Akeelah participates in a spelling bee to avoid detention for her many absences. Much to her surprise and embarrassment, she wins. Her principal asks her to seek coaching from an English professor named Dr. Larabee who takes her all the way to the National Scripps Spelling Bee.

Akeelah's friend, Javier, invites her to his home for his birthday party. Dylan, a rival speller, challenges several others to a Scrabble™ marathon. He destroys most players, except Akeelah, who almost trumped him. Dylan's father, who is also his spelling coach, chastises Dylan for a poor showing. He drags him to an indoor location and derides him by saying, "If you can barely beat a little Black girl at a silly board game, how do you expect to win the National Bee?" The scene ends when Dylan and his father leave the party.

- What is at the heart of all types of prejudice?
- Which forms of prejudice are most socially acceptable and which are least acceptable? Why are some forms more acceptable than others?
- How would you respond to a close friend or family member who made

some type of prejudiced comment? Would your reaction be different if it were a stranger or acquaintance?

Akeelah and the Bee (Spelling Bee Productions, 2006), written and directed by Doug Atchison

Elapsed time: This scene begins at 00:43:50 and ends at 00:47:06 (DVD Scene 10)

Rating: PG for some language

Aladdin

Classism

You'll be transported to a faraway land where fantasy and reality collide. Aladdin, a streetwise orphan on a mission to prove his worth, meets Jasmine, the girl of his dreams. There's a problem—Jasmine is a princess and is forbidden to marry someone who is not of royal heritage. All seems lost until Aladdin obtains the services of a genie who grants Aladdin's wish to become a prince.

Aladdin is on the run from the police after he steals a loaf of bread from a local merchant. He gets away, and he and his pet monkey, Abu, settle in for a nice dinner. Just then, Aladdin notices two young orphans who are looking for a meal; he and Abu share their bread with them. Soon after, a well-dressed man on a royal steed nearly runs down the children, referring to them as "filthy brats" and lifting his whip to beat them. Aladdin rescues the children and says to the prince, "If I were as rich as you, I could afford some manners." The prince refers to Aladdin as a "worthless street rat." He adds, "You were born a street rat. You will die a street rat and only your fleas will mourn you," before entering the palace gates. Aladdin states, "I am not worthless." The scene ends with Aladdin looking over the palace and dreaming about living like the rich who "never have any problems at all."

- In many movies, rich people are portrayed as mean and unscrupulous. Why do you suppose this is?
- What are the mechanisms for people to change socioeconomic classes?

- Historically, in England, social class was based largely on birth and the nobility of lineage rather than available cash, whereas, in America, nobility was swapped for land and property ownership and business ownership and wealth. Discuss.

Aladdin (Walt Disney Pictures, 1992), written by Ron Clements, John Musker, Ted Elliot, and Terry Rossio, directed by Ron Clements and John Musker
Elapsed time: This scene begins at 00:09:25 and ends at 00:12:10 (DVD Scene 3)
Rating: G for all audiences

Amazing Grace

Social justice

Based on the true events of William Wilberforce's decade-long quest to have slavery abolished in the British states and colonies. William at first struggled with the manner in which to fight for his abolitionary calling, whether it should be through political or religious means; he managed to do both. His mentor, John Newton (Albert Finney), was a former slave ship captain who was haunted by his memories of the atrocities of human bondage; Newton is the author of the well-loved hymn "Amazing Grace".

Utilizing a fellow Parliamentarian, Wilberforce (Ioan Gruffudd) has gathered several heads of state and their families aboard a small sailing vessel under the pretense of a "thank you for your support" reception. The guests are enjoying the revelry of food and drink until Wilberforce shows them the slave ship *Madagascar* that has just docked after dropping off its human cargo to Jamaica "where it delivered 200 men, women, and children. . . . When it left Africa, there were 600 on board. The rest died of disease or despair." The guests are clearly unnerved by the strange smell in the air; Wilberforce describes it as "the smell of death. Slow, painful death." He asks them to remove their handkerchiefs from their noses and take deep breaths of the smell. The scene ends as William states, "Remember that smell. Remember the *Madagascar*. Remember that God made men equal."

- 🎬 In this particular scene, in what ways was having the guests smell

the stench an effective and/or ineffective technique for the abolitionist movement? What techniques might you use if you were Wilberforce?

- Assistance programs, such as *Feed the Children,* often use images of real people in dire circumstances. Why does it often take such graphic pictures in order to make an impact?
- Evaluate this statement: No one is born prejudiced.

Amazing Grace (Bristol Bay Productions, 2006), written by Steven Knight, directed by Michael Apted

Elapsed time: This scene begins at 00:54:13 and ends at 00:56:51 (DVD Scene 12)

Rating: PG for thematic material involving slavery and some mild language

American Gangster

Power/oppression

Based upon the true story of Frank Lucas (Denzel Washington), a no-nonsense drug lord who ruled the streets of Harlem during the 1970s. Frank lived by a code of honor, high expectations of his employees, and offering a high-quality, low-cost product. Frank meets his match when Detective Richie Roberts (Russell Crowe) gets the case.

Frank has been invited to the palatial home of Dominic Cattano (Armand Assante), one of the major underground crime bosses of the day. After skeet shooting and breakfast with the wives, Frank and Dominic settle down to talk business. Dominic is concerned that Frank is gaining too much of the drug traffic and is bordering on monopoly. Using dairy farmers as a metaphor, Dominic explains how monopolies were made illegal because "nobody wants to compete with a monopoly" because it would put many of them out of business. Frank argues that he is "just trying to make a living"; Dominic agrees that making a living is the right of an American businessman, but not "at the unreasonable expense of others—cause that's when it becomes un-American." He continues to lecture Frank on setting a controlled, fair market price for his product; Frank replies, "I set a price that I think is fair." Dominic wonders whether Frank is concerned about "the fellow dairy farmers," and Frank responds, "I'm thinking of them, Dominic, about as much as they've ever thought about me." Dominic proposes a business deal with Frank that would ensure

Frank's protection, "peace of mind," and increased national distribution. He admonishes Frank that Dominic's friends are not as peaceable as he is—"you talk to them about Civil Rights, they don't know, you know. They're not open to change. Not from the way things are done and who's doing it. I talk to them, and there are no misunderstandings; and that's what I mean by your peace of mind." Frank apparently strikes a deal with Dominic; as they are leaving, Mrs. Lucas questions why Frank is willing to trust him, when they "look at us like we're the help." Frank argues, "They work for me now" as he enters his car and the scene ends. [OBJ]

- Why is it important for majorities to join forces with minorities to fight oppression?
- Can you think of other instances in the history of this country where it took someone of one ethnic background to speak on behalf of a different ethnic circle? Name them.
- Evaluate the pros and cons of a monopoly on society.
- A high-profile African American athlete once stated, "I'm not black anymore; I'm rich." How do you feel about this statement? What might he have meant?

American Gangster (Universal Pictures and Imagine Entertainment, 2007), written by Steven Zaillian, directed by Ridley Scott
Elapsed time: This scene begins at 01:13:50 and ends at 01:17:30 (DVD Scene 11)
Rating: R for violence, pervasive drug content and language, nudity, and sexuality

Anchorman: The Legend of Ron Burgundy

Sexism

It's the 1970s as San Diego anchorman Ron Burgundy is the top dog in network TV, which gives way to his freewheeling sexism with his fraternal crew. But all that's about to change (or be jeopardized) as ambitious reporter Veronica Corningstone has just arrived as a new employee at his TV station.

In this scene, Ron is running late to do his broadcast of the evening news. Unsure of what to do, the studio is persuaded to allow Veronica Corningstone to

fill in for Ron. As Veronica begins her newscast, the male anchors are trying to distract her so that she will make a mistake and embarrass herself. To their dissatisfaction, she completes the broadcast without incident and receives praise from the producer. Ron finally arrives and reassures everyone that they could now do the news as normal. Ron is incredulous when he learns that a *woman* has read his news. The next day Veronica is promoted to coanchor of the Channel Four news team. The scene ends after the announcement of Veronica's appointment and Ron exclaims, "What is this—amateur hour?" [OBJ]

- This film is set in the 1970s when women's roles in the business world were limited. What gender-specific roles for women are still enforced today?
- In today's society, women still earn significantly less money for doing the same work as men. How might we change this phenomenon?
- 🎥In this scene, as Veronica prepares to deliver the news for the first time, she begins to chant "power . . . power . . . power." Why? What does this say about women who want to get ahead?

Anchorman: the Legend of Ron Burgundy (DreamWorks, 2004), written by Will Ferrell and Adam McKay, directed by Adam McKay

Elapsed time: This scene begins at 00:52:14 and ends at 00:56:13 (DVD Scene 14)

Rating: PG-13 for sexual humor, language, and comic violence

Annapolis

Discrimination/power

Jake Huard (James Franco), a tough streetwise kid, has long had a dream of being accepted into the officers' training program at the U.S. Naval Academy. He gets his wish, but acceptance is only the first hurdle; he must make it through a rigorous training program and the hard-nosed Midshipman Lieutenant Cole (played by Tyrese Gibson).

In his first days as a new recruit at the academy, Huard and his fellow "plebes" are in the throes of physical training. In typical military fashion, the recruits are being yelled at in multiple directions by their superiors. One of the recruits, a Latino man named Estrada, is being grilled by one of the officers, who states

"What is that smell? Is that you, Estrada? You been taking Puerto Rican show-ers instead of real ones?" He continues to question (insult) Estrada about his hygiene. He demands, "I want you to shower and shave every three hours after lights out. And no more cologne." The scene ends when the officer declares "At ease" and the soldiers stop exercising.

- 🎥 The original meaning of the term "plebe" is "common people." What is the significance of the new recruits being called plebes? What message(s) might the officers be trying to suggest about the soldiers' relationships to each other and to their superiors?
- 🎥 What is meant by the term "Puerto Rican shower"? Why?
- The term Latino is often used as a blanket term for multiple ethnicities and nationalities among people of Hispanic descent. Why is it impor-tant to know the differences between the various Latino cultures?

Annapolis (Touchstone Pictures, 2006), written by Dave Collard, directed by Jus-tin Lin

Elapsed time: This scene begins at 00:13:31 and ends at 00:15:08 (DVD Scene 4)

Rating: PG-13 for some violence, sexual content, and language

Antwone Fisher

Dominance

Antwone is a bit of a hothead. His career in the U.S. Navy is on the line if he does not manage to get his anger under control. He is man-dated to go to counseling, and he reluctantly submits. His counselor, Dr. Jerome Davenport (Denzel Washington, who also directs), helps him to understand and heal from his abusive past and to connect with a family he has never known.

Antwone has finally decided to open up to Dr. Davenport after several weeks of sitting in silence. He begins the counseling session describing his being born in prison and his father's murder. He never really knew his parents; his mother abandoned him at an orphanage. At a subsequent meeting, Antwone describes his placement in a foster home with a family named Tate. He introduces his

foster brothers, Keith and Dwight, Rev. and Mrs. Tate, and Cousin Nadine. Mrs. Tate is a domineering authoritarian who uses violence and intimidation in her child-rearing. Antwone describes a church service where Mrs. Tate requires the boys to "catch the Holy Ghost" to receive cookies after church. The boys are later tied to a pole and are beaten for "putting their dirty hands on the walls." She regularly reminds the boys of their pasts—"I took you in when your no-account mammies threw you away and this is the thanks I get." Later, Mrs. Tate stops beating Antwone, but starts to use fire to intimidate him. Antwone says, "I tried everything I could to get her to like me, and nothing ever worked." Mrs. Tate often refers to the boys as "niggers," so much that Antwone cannot remember his own name. Dr. Davenport asks Antwone whether Mrs. Tate was ever nice to him, and he describes how he knew what type of mood she was in by the smells in the air when he woke up. If Mrs. Tate was in a good mood, she made pancakes. Later, Antwone explains how Mrs. Tate kicked him out of the house for being sassy to her and refusing to allow her to beat him anymore—"Retarded nigger, don't nobody want you," she says, "even your damn mammy didn't want you." At the close of their session, Dr. Davenport gives Antwone a book to help him "understand the mentality of people like the Tates." The book is titled *The Slave Community*, and Davenport explains to Antwone the generational curse of a slave mentality that was adopted by many Black Americans who descended from slaves. Dr. Davenport tells Antwone that he must learn to channel his anger in more positive directions.

- 🐾 Describe a time when you felt like Antwone: "I tried everything I could to get her to like me, and nothing ever worked."
- How would you describe the lasting legacy of slavery in the United States?
- What is "stereotype threat"?

Antwone Fisher (Fox Searchlight Pictures, 2002), written by Antwone Fisher, directed by Denzel Washington

Elapsed time: This scene begins at 00:13:00 and ends at 00:29:22 (DVD Scene 6)

Rating: PG-13 for violence, language, and mature thematic material involving child abuse

Antz

Out-group/difference

A young worker ant named Z is dissatisfied with his life of conformity within the ant colony; he wants to be a free thinker and wants to see life outside of his prescribed role as a worker. Princess Bala, heiress to the throne, feels the same way—trapped in a role that she does not want. After a chance meeting, Bala and Z fall in love and seek to break down the barriers between royalty and worker, while protecting the colony from predators.

Princess Bala and her maidservants have escaped from the palace and are looking to have a little fun. She has removed her crown and will attempt to blend in at the local nightclub. Z is at the bar and is complaining about how all of the workers conform to their proscribed roles and functions. All of the ants are directed by an announcer to begin dancing; they all dance in the same pattern in lockstep time. Bala asks Z to dance and they move into formation; however, Z breaks form and begins to freestyle and Bala follows suit. Their out-of-time dancing is a distraction to the other ants, and one of the soldier ants calls him a "lazy worker" and a "troublemaker" and physically threatens Z because he refuses to "get back in place." The scene ends after Princess Bala kisses Z and runs away.

- How would you describe the pressures to conform in your own life?
- Why do you think those who go against the norm are frowned upon or thought of as "weird"?
- How are we more accepting of celebrities' foibles than those we know intimately?
- Is there a time when being a non-conformist is wrong and can have negative results for the masses or individuals?

Antz (DreamWorks Pictures, 1998), written by Chris Weitz, Paul Weitz, and Todd Alcott, directed by Eric Darnell and Tim Johnson

Elapsed time: This scene begins at 00:13:52 and ends at 00:17:17 (DVD Scene 5)

Rating: PG for mild language and menacing action

Any Given Sunday

Invisibility

Third-string quarterback Willie (Jamie Foxx) is being interviewed by a TV journalist who asks Willie about the treatment of African Americans in the world of professional football. Willie's star begins to rise while both the veteran quarterback and famous coach are being viewed as relics. A classic match-up of good versus evil, young versus old, selfishness or loyalty—all played out on the football field.

Willie is being interviewed by a TV journalist who asks Willie about the treatment of African Americans in the world of professional football. Willie argues that the predominance of Black athletes and the dearth of Black coaches and owners are very telling statistics. Toward the end of the scene, the reporter speaks to Willie using slang terms, mimicking what some believe is Black speech code. [OBJ]

- What dimensions of a person's identity can be invisible to society but nonetheless, important to the individual?
- In this clip, Willie suggests that racism may be the cause of the lack of minority owners and coaches in the professional football league. What are your thoughts on this issue?
- Evaluate this statement: It is impossible for someone socialized in U.S. society to not be influenced by racism.

Any Given Sunday (Warner Brothers, 1999), written by Daniel Pyne and John Logan, directed by Oliver Stone

Elapsed time: This scene begins at 01:12:44 and ends at 01:13:19 (DVD Scene 23)

Rating: R for strong language and some nudity/sexuality

Babe: Pig in the City

Discrimination

In this sequel about a talking pig who has gained fame as a sheep dog, Babe and Mrs. Hoggett are trying to capitalize on Babe's fame to

raise money to save the Hoggetts's farm that has fallen on hard times. Their journey takes them on a wild run full of talking animals and unfriendly humans.

Babe is overlooking the city skyline and wondering why he was brought from the farm where he had a good life as a sheep dog. While he is not paying attention, a monkey enters the room and steals his owner's suitcase. Babe follows the monkey to a room downstairs where a group of chimpanzees treat him unkindly, asking him to prove that the suitcase belonged to him. The shadowy figure of an orangutan appears behind a curtain and the orangutan questions what is going on. One of the chimps calls Babe a "naked pink individual," and the other says he "is of a foreign extraction; possibly even an alien." The orangutan, showing his intellectual prowess, calls the chimps "drooling imbeciles" and begins citing the scientific name for pigs. He describes Babe as "an inconsequential species with no other purpose than to be eaten by humans." He continues, "[t]his lowly, handless, deeply unattractive mud-lover is a pig." The scene ends as Babe mentions his lack of comfort with the conversation.

- 🎥 Explain the parallels between the animals in this scene and stereotyped groups. Who, or what groups, might each of the animals represent?
- Darwinism defines "survival of the fittest" in the animal kingdom. How might this be characterized in human communities?
- How does the "model minority myth" reinforce systems of power?
- Evaluate why looks are so important in value judgments, particularly when differences are observed.

Babe: Pig in the City (Universal Pictures, 1998), written by Judy Morris and Mark Lamprell, directed by George Miller
Elapsed time: This scene begins at 00:20:20 and ends at 00:24:11 (DVD Scene 8)
Rating: G for all audiences

Barbershop

Out-group/ethnocentrism

Calvin Palmer (played by rapper-actor Ice Cube) has inherited his father's barbershop and is struggling to keep it afloat and accomplish his

dream of being a recording industry producer. Truthfully, he has no desire to run the community barber business and unfortunately sells it to a local loan shark who plans to turn it into a gentlemen's club. When Calvin realizes the treasure he has let slip through his fingers, he will go to any lengths to get it back.

Jimmy (Sean Patrick Thomas) is one of the barbers in the shop, but he thinks he is better than everyone else because he has a college education. He is letting people know that he has plans to "better" himself; he is not going to be a barber forever. His words grate on most of the people in the shop, especially another barber, Ricky, who has a criminal history. Jimmy often tries to outsmart his peers with his book smarts; he states that "having an education guarantees I won't spend the rest of my life behind bars. I'm just saying, being educated means you have opportunities." Ricky interrupts, "And the rest of us are doing what? Biding our time?" When Isaac, a White barber, chimes in about the role of a barber being a "respectable position," and his dreams of owning his own barbershop, the conversations becomes racialized. Jimmy responds, "Let me tell you something. You will never own a black barbershop." The group discusses whether Tony Roma's restaurant makes BBQ ribs better than Black people (as proof that Whites can or cannot have a Black barbershop). The scene ends after Lamar, a customer in Calvin's chair skips out on paying for his haircut, and Calvin exclaims, "That's why we can't have a Black business in the ghetto."

- 🐾 What does Calvin mean by his statement, "That's why we can't have a Black business in the ghetto"? How should we view his comments?
- 🐾 Jimmy believes that his education makes him superior. How would you describe the correlation between education and worth? Self-worth?
- How would you describe your level of comfort in interracial situations? How might your feelings be different if you are in the majority group? In the minority group?

Barbershop (Metro Goldwyn Mayer Pictures, 2002), written by Mark Brown, Don Scott, and Marshall Todd, directed by Tim Story

Elapsed time: This scene begins at 00:41:20 and ends at 00:44:51 (DVD Scene 15)

Rating: PG-13 for language, sexual content, and brief drug references

Beauty and the Beast

Gender

A lonely beast lives behind closed gates outside the village—his only companions are his talking candlesticks and furniture. Only the love of a beautiful woman could break the spell. Belle is able to see the beast's heart beyond his gruff exterior.

Gaston is God's gift to womankind—at least that's what he thinks about himself. He is the guy that every other guy wants to be and every girl wants to be with, except free-thinking Belle. She is unimpressed with his bravado and, in fact, is repulsed by him. Ultimately she rejects his offer to become Mrs. Gaston. Gaston is sulking in the local pub; he is amazed at Belle's rejection of his advances—he is, after all, Gaston, and "No one says no to Gaston." The men at the pub each sing in praise of his intimidating masculinity, his superior physique, and his physical prowess.

- How would you describe "a real man"? What is a "real woman"?
- A commercial slogan in the 1980s was "Don't hate me because I'm beautiful." In what ways do a person's looks impact his or her success or failure in American culture?
- Why is being a "mama's boy" a negative, but being a "daddy's girl" a badge of honor?

Beauty and the Beast (Walt Disney Pictures, 1991), written by Linda Woolverton, directed by Kirk Wise and Gary Trousdale

Elapsed time: This scene begins at 00:26:31and ends at 00:31:12 (DVD Scene 8)

Rating: R for language

Becoming Jane

Compulsory heterosexuality/gender

The youth and coming-of-age of famed writer Jane Austen (author of *Sense and Sensibility*) is explored in this romantic drama. Austen is weary of living the proscribed life of women and is determined to succeed as a professional author, despite her mother's pressure to marry

the next eligible bachelor; that is, until she falls in love with Tom Lefroy, a poor, lawyer-to-be. How can she balance her professional aspirations with her heart palpitations?

It is very early on a Sunday morning and Jane (Anne Hathaway) has just had a breakthrough in her writing. She celebrates by banging out a tune on the piano, which awakens the entire house. Later, Reverend Austen, Jane's father, is preaching a sermon on the roles of women. He states, "The utmost of a woman's character is expressed in the duties of daughter, sister, and, eventually, wife and mother. It is secured by soft attraction, virtuous love, and quiet in the early morning [a comment made toward Jane]." He continues by talking about women's work—"If a woman happens to have a particular superiority, for example, a profound mind, it is best kept a profound secret. Humor is liked more, but wit? No. It is the most treacherous talent of them all."

- What are the stereotypical roles of men and women?
- Where did these definitions of "manhood" and "womanhood" originate?
- Author Virginia Woolf once argued that all a woman needs to be successful is to "have a room of one's own" to be creative and free. What might she have meant, and how true is this statement?
- Are there consequences for breaking gender roles? Generate a list for both men and women and compare their severity.

Becoming Jane (Miramax Films, 2007), written by Sarah Williams and Kevin Hood, directed by Julian Jerrold

Elapsed time: This scene begins at 00:00:51 and ends at 00:04:53 (DVD Scene 1)

Rating: PG for brief nudity and mild language

Bedazzled

Stereotype/homophobia

Move over *Devil and Daniel Webster*, there's a new Lucifer in town, and she is smokin' hot! Elizabeth Hurley stars as the devil who tricks love-starved Elliot Richards into selling his soul for three wishes (and three attempts at love). Elliot believes that his secret crush, Allison, would

fall madly in love with him if he were cool, rich, and famous. Elliot must learn the hard way—mess with the devil and you get burned!

Complaining that the devil tricked him with his previous wish, Elliot uses his next wish to become "smart, articulate, witty and sophisticated, charming," to be knowledgeable, popular, and good looking. The devil grants his wish and he becomes a successful and worldly, Pulitzer prize–winning author. While at a posh soiree, Elliot amazes Allison with his knowledge and way with words. She is wooed by his charm and agrees to go back to Elliot's home for a night of love-making. To both their surprise, Elliot's bed is already occupied—by his gay lover. Elliot was not aware that the devil made him a gay, successful writer. Elliot attempts to prove his heterosexuality by asking Allison to kiss him; she agrees and he sadly admits that he is gay. The scene ends as Elliot sits down on the bed as his lover tells the story of Elliot wearing a speedo on Fire Island.

- Hollywood dramatic films featuring gay characters or story lines (such as *Brokeback Mountain* and *Philadelphia*) have been critically acclaimed with some receiving Academy Awards. Given the antihomosexual sentiment in the United States, how would you make sense of this?
- Elliot's lover mentions Fire Island; where is this place and what makes it a popular tourist destination for gays and lesbians?
- Make the argument that although discrimination against racial minorities is frowned upon, bias against gay persons seems to be all right.
- Name five gay or lesbian actors in Hollywood. What types of roles have they played? How are gay actors treated in the film industry?

Bedazzled (20th Century Fox, 2000), written by Harold Ramis, Larry Gelbart, and Peter Tolan, directed by Harold Ramis
Elapsed time: This scene begins at 00:55:53 and ends at 01:04:09 (DVD Scene 13)
Rating: PG-13 for sex-related humor, language, and drug references

Bend It Like Beckham

Prejudice

Jess Bhamra is an East Indian teenager living in London with her sister Pinky and her parents. Jess loves soccer and idolizes profes-

sional soccer player David Beckham. Her parents, however, want Jess to follow cultural traditions and focus on finding a suitable husband. Instead, Jess begins playing for an all-girls British team, despite her parents' disapproval. She befriends a teammate, and both girls battle unsupportive parents and share a mutual crush on their coach.

Jess is playing in a championship game and has just scored a goal to move her team in the lead. A rival player pushes Jen and verbally assaults her; Jess retaliates physically and is thrown out of the game. Afterwards Joe, the coach, disciplines Jess for behaving badly, as it may have cost them the championship. Jess explains that the other player used a pejorative term for Indians, and Joe comforts her by stating that he had similar experiences as an Irishman living in England.

- 🎬 What does the coach mean when he says to Jess, "I understand, I'm Irish"?
- 🎬 What should Jess have done when she was called the bad name?
- List and define the pejoratives that you have heard about minority groups. How often do you hear them spoken?
- Evaluate this statement by French philosopher, Voltaire: "Prejudices are what fools use for reason."

Bend It Like Beckham (Kintop Pictures, 2002), written and directed by Gurinder Chadha
Elapsed time: This scene begins at 01:04:33 and ends at 01:07:58 (DVD Scene 21)
Rating: PG-13 for language and sexual rating

The Birdcage

Compulsory heterosexuality/heterosexism/out-group

In an adaptation of *La Cage Aux Folles*, a gay cabaret owner and his drag queen companion agree to put up a false straight front so that their son can introduce them to his fiancée's right-wing moralistic parents.

This scene begins when Armand and Val enter the room. Val is explaining who

his fiancée's parents are (her father is a conservative senator and founder of the Coalition of Moral Order). Recognizing that he has gay parents and this may be problematic for his prospective in-laws, especially Senator Keely who is up for reelection, Val asks Armand to "be a little less obvious" and to "change his mannerisms" as well as redecorate his home to remove any semblance of gay art or culture. Furthermore, Val asks his father to send Albert (Armand's life partner who is a drag queen) away while the Keelys are in town. He asks them to "tone it down a little and make it [the home] a little more like other people's homes." [OBJ]

- What are your thoughts on the benefits and disadvantages of gay adoption?
- What is something you've learned by watching your parents' example?
- What is your opinion about political conservatives' focus on a return to healthy, happy marriages as opposed to gay marriages? How necessary is an amendment to the U.S. Constitution to "protect marriage"?
- How do you think homosexuality is affecting family values in America?

The Birdcage (United Artists, 1999), screenplay written by Elaine May, directed by Mike Nichols

Elapsed time: This scene begins at 00:34:02 and ends at 00:37:29 (DVD Scene 9)

Rating: R for language

Black Hawk Down

Oppression/ethnocentrism

In this gritty, true-to-life story, a team of Special Forces of the U.S. Army is sent to Somalia on an assignment to capture an insurgent leader who has refused food to thousands of Somali people. The Somali militia, however, has quickly outnumbered the small band of soldiers and they are fighting for their lives.

Michael Durant, a pilot for the Special Forces unit, has been captured and taken hostage by the militia. He is hurt very badly (and has possibly been

tortured). The Somali leader is speaking with Durant and asks Michael, "You are the ranger who kills my people?" Durant denies this allegation. The leader offers him a cigarette, but Durant refuses. "That's right. None of you Americans smoke anymore. You all live long, dull, uninteresting lives." Durant mentions that he does not have the power to negotiate with them, to which the leader responds, "Course not. You have the power to kill, but not to negotiate. In Somalia, killing is negotiation." He continues to question—"Do you really think we will put down our weapons and adopt American democracy? That the killing will stop? We know this: without victory, there can be no peace. There will always be killing, you see? This is how things are in our world." The scene ends as the leader walks out of the room and a helicopter flies overhead and someone is repeating "Mike Durant, we will not leave you behind."

- Why were many Americans surprised by the terrorist attacks on September 11, 2001? What do comments like "Why do *they* hate us"? reveal about American dominance and privilege?
- 🎥 Suppose in a foreign country there were a cultural requirement that if a person offers you a cigarette, you must smoke it. What would you do? How does one discover the cultural norms of a particular place? Should tourists and other visitors be held accountable for cultural mistakes?
- Evaluate the comments of actor and human rights activist Harry Belafonte, who once argued "Our foreign policy has made a wreck of this planet. I'm always in Africa, and when I go to these places I see American policy written on the walls of oppression everywhere."

Black Hawk Down (Revolution Studios, 2001), screenplay written by Ken Nolan, directed by Ridley Scott

Elapsed time: This scene begins at 01:43:57 and ends at 01:45:58 (DVD Scene 19)

Rating: R for intense, realistic, graphic war language

Boat Trip

Heterosexism/stereotypes

Nick and Jerry, two heterosexual best friends, decide to take a vacation together, but their travel agent books them on a gay cruise line. The

two have at least 4 days before they reach a land destination. Add the arrival of 12 female members of the Swedish tanning team and a hot female dance instructor, and Jerry and Nick have their work cut out for them.

Nick (Horatio Sanz) and Jerry (Cuba Gooding, Jr.) are getting "dirty dancing" lessons from Gabrielle (Rosalyn Sanchez). Jerry is very attracted to her, but she thinks he is gay. The two are dancing very seductively and Gabrielle suggests that Jerry looks at her and touches her like a straight man would. Jerry argues that no one could teach him how to be gay—the film cuts to Jerry getting instructions on how to be gay from one of the passengers, including learning the words to "I Will Survive," the supposed gay theme song. Jerry warns Gabrielle that he could "turn into a raging heterosexual."

- You find out that the leader of your church or synagogue is gay. How would you respond?
- What would you do if someone of the same sex flirted and made a pass at you?
- How would you react if you were to learn that your mate or spouse had had a lover of the same sex before you knew each other?

Boat Trip (Apollo Media, 2002), written by Mort Nathan and William Bigelow, directed by Mort Nathan

Elapsed time: This scene begins at 00:47:15 and ends at 00:49:59 (DVD Scene 12)

Rating: R for strong sexual rating, language, and some drug material

Borat: Cultural Learnings of America for Make Benefit Glorious Nation of Kazakhstan

Anti-Semitism

A fictional documentary following the exploits of Borat (Sacha Baron Cohen) as he travels from his homeland in Kazakhstan to America. He falls in love with superstar Pamela Anderson and travels the country to find her—breaking all American cultural rules as he travels.

Borat is in his home country attending an event that is similar to the running of the bulls in Spain; here it is the "running of the Jews." The people of the

town chase a puppet head with a huge nose and curls of hair on the sides of its face. The townspeople run and hide in fear as the head comes down the street. The person inside the head then stops in the middle of the street to lay a giant egg, after which the children are ordered to "smash the Jew egg."

- What are some additional ways that we hear and see anti-Jewish sentiment in our society today?
- Have you ever heard the phrase "Jew 'em down"? In what context is it used and why?
- Besides Jewish people what other religious groups face regular discrimination in our country? What things are said about or done to them?
- Have you ever talked about your religious beliefs with someone of a different faith tradition? What was that like?

Borat (Dune Entertainment, 2006), written by Sacha Baron Cohen and Anthony Hines, directed by Larry Charles

Elapsed time: This scene begins at 00:04:00 and ends at 00:05:15 (DVD Scene 2)

Rating: R for pervasive, strong, crude, sexual content including graphic nudity and language

Bridge to Terabithia

Dominance/power/out-group

The classic children's story by Katherine Paterson comes to life in this literary adaptation. Jess has been training all year long to be the fastest boy in the fifth-grade relay races. He manages to beat everyone except Leslie, a new girl, who blows past him. The two forge an unlikely friendship and together rule an imaginary world of their creation.

May Belle is excited that her dad packed Twinkies in her lunch and she is announcing this to her friends on the school playground. Looking over his shoulder, her older brother, Jess, warns her to stop bragging about the dessert. She argues back, "You're just mad because I got some and you didn't." Jess states that he just doesn't want her to lose the cakes. Soon, May Belle comes running to tell Jess that the school bully, Janice, has stolen her Twinkies. Sev-

eral other young students are complaining that Janice also makes them pay $1 to use the bathroom. In the background, Janice is blocking the bathroom door. Jess's friend Leslie leads a protest march toward the bathroom while chanting "Free to pee" because "That's not fair. Peeing's definitely supposed to be free." May Belle confronts Janice about the stolen cakes and demands that she return them. When Janice refuses, May Belle tells Jess "You're supposed to beat her up. You're my brother." Fearful, Jess tells May Belle "Do you know what would happen if I were to pick a fight with her?" to which May Belle answers, "You'll get your butt kicked." May Belle walks away crying. Leslie tells her, "We'll get her back, won't we Jess?"

- Name instances in your life when fear prevented you from standing up against an oppressive force.
- What is nonviolent social change? How is this nonviolent approach an effective form of social protest?
- What are some mechanisms or vehicles for groups to establish dominance or power over others? What are the effects upon both groups?

Bridge to Terabithia (Walt Disney Pictures and Walden Media, 2007), written by Jeff Stockwell and David Patterson, directed by Gabor Csupo

Elapsed time: This scene begins at 00:41:12 and ends at 00:42:50 (DVD Scene 7)

Rating: PG for thematic elements including bullying, some peril, and mild language

Brokeback Mountain

Compulsory heterosexuality

Two ranch hands meet for the first time and spend a summer herding sheep on the back side of Brokeback Mountain. Neither of them expected to fall for the other; this story follows Ennis (Heath Ledger) and Jack (Jake Gyllenhaal) as they try to keep their relationship secret and lead the ordinary life of family men.

As the scene opens, Jack and Ennis are in a motel room sharing what's been happening in their lives since they last saw one another 4 years ago. Jack tells how he met his wife, Lureen, and how her father hates him. Jack asks, "What are we gonna do now?" Ennis is unsure, but says, "I doubt there's nothing we

can do. So now I'm stuck with what I got here." Later, Ennis is at home and is packing for his "fishing trip" back to Brokeback with Jack (who is waiting outside). Alma, Ennis's wife, is uncomfortable about Ennis leaving for the weekend; she cries as Ennis departs. Up on Brokeback, the boys spend time fishing and swimming and sitting by the campfire talking. Jack suggests that he and Ennis could have a life together and proposes that they set up house and begin a cattle business together. Ennis responds, "I already told you; it ain't going to be that way. You got your wife and baby in Texas; I got my life in Riverton." He continues, "The bottom line is, we're around each other and this thing grabs hold of us again in the wrong place at the wrong time, and we're dead." Ennis tells Jack a story about two men who lived together and the horrible death that one of the men suffered. He shares how his father took him to see the body of the dead man when he was just 9 years old. Ennis questions whether his father actually committed the murder. "Two guys living together," Ennis says, "No way." He adds, "We can get together once in a while way the hell out in the middle of nowhere, but, once in a while." He tells an infuriated Jack, "If you can't fix it, you gotta stand it . . . There ain't no reins on this one." [OBJ]

- Have you ever felt forced to act or be a certain way because of someone else's expectations? Describe how that feels.
- Describe a time when you felt you had to hide a friendship or other relationship from your parents or friends. What were the reasons why you felt the need to hide?
- Explore how Jack and Ennis's feelings toward being "out" differ.
- 🎥 What do you suppose is the significance of Ennis's father taking him to see the dead body at such a young age?

Brokeback Mountain (Focus Features and River Road Entertainment, 2005), written by Larry McMurtry and Diana Ossana, directed by Ang Lee
Elapsed time: This scene begins at 01:05:13 and ends at 01:13:05 (DVD Scene 12)
Rating: R for sexuality, nudity, language, and some violence

A Bronx Tale

Ethnocentrism/racism

In Robert De Niro's directorial debut, the streets of the Bronx force

young men to grow up fast. On these mean streets, you either fight or roll with a crew who can. De Niro stars as Lorenzo Anello, a hard-working bus driver who is fighting to protect his son, Calogero, from falling into a life of organized crime.

Calogero is smitten with Jane, a new student at his school, but she is off-limits because she is "a colored girl." In his neighborhood, Italian is the preferred ethnicity. After making secret plans to go out with Jane, Calogero (or, "C" as he prefers to be called), is hanging out with his *amici* (friends) in front of their favorite hotspot. Soon, several Black youths ride their bikes down the street, which bothers several of C's friends, who begin to physically assault the Black youths. Aldo punches one of the riders and says to him, "This is our neighbor-hood, you Black bastard!" C is torn by his allegiance to his Italian heritage and friends and by his newfound interest in Jane. In a conversation with his men-tor, Sonny (Chazz Palminteri), C questions the right thing to do; Sonny tells him to follow his heart. "I'm trying," C says, "but we hate these people. I don't hate them, but you know. I like her and everything, but she ain't White." Later in a conversation with his dad, C questions the propriety of interracial dating. Lorenzo states (while arguing that he is not prejudiced), "when it comes to marriage, we should marry within our own." When C goes to pick up Jane for their date, she informs him that her brother was one of the boys that he and his friends had attacked. The scene ends when C calls Jane's brother a "nigger" and they get back in the car. 🎬

- Why do you think some groups feel that it is important to "marry within our own"?
- 🎬 Why does C resort to calling Jane's brother a "nigger"? Does he mean it? Explain.
- Does your hometown have "territories"? If so, how did these territories come about and how are they enforced today?
- In what ways do your beliefs and values differ from your parents? Have you ever hated someone because you thought it was expected of you to do so, be it through your parents' beliefs or some other influence? How might you change this?

A Bronx Tale (B.T. Films, 1993), written by Chazz Palminteri, directed by Robert De Niro

Elapsed time: This scene begins at 01:17:17 and ends at 01:27:00 (DVD Scene 16)

Rating: R for language, violence, and sexuality

Brother Bear

Social justice

> Brotherhood takes on a new meaning as a young hunter named Kenai
> seeks vengeance against a bear that killed his older brother, only to be
> magically changed into a bear himself. His only chance to change back
> is to take care of a young bear cub whose mother he killed.

After a bear takes the life of his oldest brother, Sitka, the impulsive youngest
brother Kenai vows to kill the bear. His middle brother, Denahi, tells Kenai
that killing the bear is wrong and will not reverse Sitka's death. Kenai ignores
him and tracks the bear to a remote site and ultimately kills the bear. Suddenly,
the mountain site is flooded with a heavenly light, and Sitka (in the form of
an eagle spirit) lifts Kenai and the bear into the air and transforms Kenai into
a bear. The scene ends when Kenai, the bear, falls into the river and Denahi
retrieves Kenai's totem necklace and spear.

- 🎬 What point(s) might Sitka be making by turning his younger
 brother into a bear?
- How might an "eye for an eye" philosophy help/hinder social justice
 in our society?
- Evaluate the role spirituality/religion plays in maintaining social jus-
 tice (positively or negatively).

Brother Bear (Walt Disney Pictures, 2003), written by Tab Murphy and Lorne
 Cameron, directed by Aaron Blaise and Robert Walker
Elapsed time: This scene begins at 00:14:35 and ends at 00:24:28 (DVD Scene
 5)
Rating: G for all audiences

Can't Hardly Wait

Stereotypes/co-optation

> Huntingdon Hills High School has just graduated its senior class and

the movie's action is set at an all-night graduation party. The story follows Preston, a social outcast, who is vying for the attention of the popular girl, Amanda.

In this scene we are introduced to Kenny (Seth Green), a young White suburbanite who has adopted a pseudo-Black persona. He and his friends are in a convenience store making plans for sexual conquest at the party of the night; Kenny has even packed a special backpack full of erotic paraphernalia. They each use street slang words and phrases like "peep this, yo" and "roll up on that shortie" (slang for woman) and wear urban style clothing. ⌈OBJ⌉

- 🐭 What is the significance of Kenny's adoption of a "Black" style and character?
- Define "wigger" and "wanksta."
- It has been said that White youth are "cultureless." How would you describe "White culture"?
- Evaluate this statement made by Harvard professor, Noel Ignatiev: "The country needs some *reverse oreos:* a whole bunch of folks who look white on the outside but don't act white. So many, in fact, that it will be impossible for those in power in this country to really be sure who's white merely by looking. When that happens, the value of the white skin will diminish." (Ignatiev, N. "The Point Is Not to Interpret Whiteness but to Abolish It." *Race Traitor: Journal of the New Abolition.* Retrieved June 21, 2008 from http://www.racetraitor.org/abolishthepoint.pdf).

Can't Hardly Wait (Columbia Pictures, 1998), written and directed by Harry Elfont and Deborah Kaplan

Elapsed time: This scene begins at 00:09:45 and ends at 00:11:05 (DVD Scene 5)

Rating: PG-13 for teen drinking and sexuality and for language

Catwoman

Gender

Patience Phillips (Academy Award–winning actress Halle Berry) is a wallflower working at an advertising agency. She stumbles upon a

secret that the company she represents has created a disfiguring beauty and skin treatment. She is murdered, but is reborn with amazing cat-like abilities and reflexes, but with little memory. Her mission is to hunt down her killers and make them pay.

Patience has been having trouble getting used to her new skills; she has never experienced life in this way. She has a newfound interest in feline activities and as the scene opens, she is doing research on the Internet about the cat in antiquity. She visits an ostracized professor named Ophelia (who has been denied tenure after 20 years—"male academia" she says) who informs her of her special identity as a "catwoman" and shows her how she fits into the lineage of human felines. Professor Ophelia teaches Patience about the Egyptian goddess Bast—"a rarity—a goddess of the moon, and of the sun." She explains that Bast represents "the duality in all women. Docile, yet aggressive. Nurturing, yet ferocious." Ophelia tells Patience the process and purpose of her rebirth; "Catwomen are not contained by the rules of society. You follow your own desires." She contends, "This is both a blessing and a curse. You will often be alone and misunderstood. But you will experience a freedom other women will never know." In addition to having heightened senses, Patience as a catwoman will have "fierce independence, total confidence, and inhuman reflexes," which concerns Patience enough to ask, "So I am not Patience anymore?" Ophelia responds, "You are Patience and you are Catwoman. Accept it, child. You've spent a lifetime caged. By accepting who you are, all of who you are, you can be free; and freedom is power." The scene ends with Patience and Midnight the cat sitting atop a building and Patience declaring that she must find out who killed her.

- 🐾 How much does the description of Bast apply to the characteristics of women? What are the dualistic comparisons for men?
- Confidently independent women are often seen as threatening. Why? To whom or what are they threatening? What pejoratives are used to describe these types of women?
- 🐾 Patience must become Catwoman to experience "true freedom." How would you encourage her to become "free" without the use of superpowers?
- 🐾 Ophelia believes her denial of tenure was related to sexism in the academy. What other scenarios are there where women are denied something because of their gender?

Catwoman (Warner Bros. Pictures, 2004), written by John Brancato, Michael Fer-

ris, and John Rogers, directed by Pitof
Elapsed time: This scene begins at 00:46:33 and ends at 00:51:26 (DVD Scene 14)
Rating: PG-13 for action violence and some sensuality

Charlie and the Chocolate Factory

Oppression

> *Charlie and the Chocolate Factory* is a contemporary adaptation of Roald Dahl's classic literary tale about the inner workings of Willie Wonka's factory. In a quest to find someone to take over his life's work, Wonka has a contest that yields five children the opportunity to have unbridled access to the exclusive factory.

Mr. Wonka's guests meet the Oompa Loompas, the diminutive people who staff the factory. The clip begins as Augustus Gloop is ravaging the edible forest. One of the children notices the Oompa Loompas who are hard at work in the background. Mr. Wonka explains how he found Loompa Land and convinced the Oompa Loompa chief to move his people to the factory; he offered to pay them in cocoa beans (a prized delicacy to the Oompa Loompas). Wonka and the chief are shaking hands as the scene ends.

- Define the following terms: exploitation, marginalization, powerlessness, violence, and cultural imperialism. How are these concepts shown here?
- 🎞 In this clip, all of the Oompa Loompas are played by the same man. In what ways does this reflect how agent groups may view the perspectives of target groups?
- 🎞 In what ways might Mr. Wonka's trip to Loompa Land be symbolic of American infiltration into other countries? How does one country impose its beliefs on another?

Charlie and the Chocolate Factory (Warner Bros., 2005), screenplay written by John August, directed by Tim Burton
Elapsed time: This scene begins at 00:44:15 and ends at 00:48:06 (DVD Scene 15)
Rating: PG for quirky situations, action, and mild language

Chicken Run

Dominance

Facing certain death at the chicken farm where they are held, Rocky the rooster (Mel Gibson) and Ginger the chicken (Julia Sawalha) decide to rebel against the evil Mr. and Mrs. Tweedy, the farm owners. Rocky and Ginger lead their fellow chickens in a great escape from the murderous farmers and their farm of doom.

The Tweedys call for the daily roll call of the hens so that they can count the number of eggs laid. When it is found that #282 (Edwina) has not produced any eggs all week, she is immediately carried off to a shed where she is killed. The scene ends when Ginger says "We've got to get out of here."

- Evaluate this statement: If certain groups stayed in their place, we would have fewer problems. Who benefits from thinking like this?
- Exploitation can be defined as one group benefiting from the labor of others. What examples of exploitation do you see in American society?
- 🐾 In this clip, Edwina is unable to produce eggs; we might call her barren. How does our society view women who cannot have children? How do we treat older women in our society?

Chicken Run (Aardman Studios, 2000), written and directed by Peter Lord and Nick Park

Elapsed time: This scene begins at 00:07:14 and ends at 00:10:43 (DVD Scene 3)

Rating: G for all audiences

The Chosen

Anti-Semitism

Set in the 1940s and based on the best-selling novel by Chaim Potok, *The Chosen* follows two Jewish friends, one a son of an ultra-orthodox rabbi, the other a son of a more secular father. Danny, a member of

the orthodox Hasidim, must decide whether allegiance to his father's way of life is most important or whether his friendship with Reuven is paramount.

Reuven is in a coffee shop with his friends and they are teasing him about getting good grades with the help of his Hasidic friend, Danny. When Danny shows up, Reuven runs outside to meet him while the teasing intensifies and the friends make faces behind the store window. One of Reuven's friends makes fun of the word *Hasidim* and states "Hasidim!—I seed 'im too, but I don't believe him." (He uses a stereotypical "ethnic" [Black vernacular?] voice to say this line.)

- Explain denominationalism. How is it possible for two people of the same religious background to approach their lives and beliefs in different ways? Should everyone who practices a particular faith agree about everything?
- What did former presidential candidate Pat Buchanan mean when he once stated that "Anti-Catholicism is the anti-Semitism of the intellectual."
- It is rare to see a person of color who fights against anti-Semitism. What might be the reason(s)?

The Chosen (20th Century Fox, 1981), screenplay written by Edwin Gordon, directed by Jeremy Kagan
Elapsed time: This scene begins at 00:23:12 and ends at 00:24:29 (DVD Scene 6)
Rating: PG

The Chronicles of Narnia: The Lion, the Witch, and the Wardrobe

Co-optation

During World War II, four siblings (Lucy, Susan, Edmond, and Peter) are forced to flee their home in London and move in with an eccentric professor. While playing hide-and-seek, the children enter a wardrobe that is an entrance to the fantasy world of Narnia. There they learn about a prophecy that states that four children will lead a revolution against the evil White Witch. They accomplish their mission with the

help of a talking lion named Aslan. This film is a literary adaptation of the classic by C. S. Lewis.

Edmund is wandering about the new world, when suddenly a huge sleigh passes by him and a troll-like creature lunges after him and pins him down and holds a knife to his neck. The troll is stopped by the White Witch who performs magic tricks to gain Edmond's trust. Upon learning about his siblings, the witch tells Edmund how she would like to meet the rest of his family, but he dismisses the idea by telling her that they are "nothing special." She admits that they might not be as "delightful" as Edmund but proffers the possibility that he may become a prince or king of Narnia and that his siblings could be his slaves. The scene ends when Peter pushes Edmund down on the bed for making Lucy cry.

- Define assimilation. In what ways are minorities who assimilate rewarded?
- Famed feminist thinker Gloria Steinem once questioned minority groups' "familiar temptation to falsify a condition of one's birth or identity and pretend to be part of a more favored group." In what ways do racial minorities, women, sexual minorities, and religious minorities feel pressure to "pass" for being in a majority?
- Define tokenism. What might it feel like to be tokenized?

The Chronicles of Narnia: The Lion, the Witch, and the Wardrobe (Walt Disney Pictures, 2005), screenplay written and directed by Andrew Adamson
Elapsed time: This scene begins at 00:29:42 and ends at 00:36:00 (DVD Scene 6)
Rating: PG for battle sequences and frightening moments

Clueless

Dominance/in-group

Follow the exploits of Cher, a popular teenager in an upper-class high school, as she attempts to shed her "shopping and boys" image to a more socially conscious one.

Cher (Alicia Silverstone) is getting dressed to take her driver's license test. She is tearing through her closet looking for "responsible-looking" clothes and can't find a particular blouse. While she asks her Latina housekeeper for assistance, she also asks why the housekeeper has not given instructions to the gardener because Cher doesn't "speak Mexican." The housekeeper storms off offended stating "I not a Mexican." Josh chides Cher stating that Lucy, the housekeeper, is from El Salvador. Cher is "clueless" and wonders why this matters.

- What does a majority need to understand about minority groups and how can majorities get the information they need?
- What makes it difficult to have meaningful relationships across the racial divide?
- Evaluate this statement: "The color of one's eyes or skin is irrelevant to me. I treat everyone the same." Do you think that all people want to be treated the same? Do you want to be treated like everyone else? What happens to people with unique needs in a system that treats everyone the same?

Clueless (Paramount, 1995), written and directed by Amy Heckerling
Elapsed time: This scene begins at 01:11:04 and ends at 01:11:58 (DVD Scene 12)
Rating: PG-13 for sex-related dialogue and some teen use of alcohol and drugs

Coyote Ugly

Sexism

Violet Sanford (Piper Perabo) has made her way to New York City with plans to make it in the music business. To make ends meet, she begins working at the Coyote Ugly bar where the female baristas serve up sexy attitude with every drink!

In this local bar, the women are in control. They make the rules. Lil, the owner of the club, is chastising Jersey for getting her fined for squirting water on the fire marshal. Jersey will be fired if she does not come up with $250 before the end of her shift. Jersey holds an auction for a young male who has come to the bar to visit her. (He had originally offered her $9 to help her reach her goal, but

she didn't want his money.) Soon, women are pawing at him, and the price for a night out with him is rising.

- 🎬 This scene seems lighthearted and cute, but what if the person being auctioned off were a woman? How would this change the scene? Would a bar like this be as successful if it were run by men? Why or why not? How would the scene change if the auctioned man were Black?
- Folklore suggests that the term "coyote ugly" is a direct reference to how trappers noticed that coyotes chewed off their feet in order to escape traps. Given the general plot of this film, what might the title reflect?
- 🎬 Why does Jersey seem to get so much satisfaction out of objectifying this man? What satisfaction might the man have been getting? Was he at fault for participating?

Coyote Ugly (Touchstone Pictures, 2000), written by Gina Wendkos, directed by David McNally

Elapsed time: This scene begins at 00:35:00 and ends at 00:40:00 (DVD Scene 11)

Rating: PG-13 for sensuality

Crash

Stereotype/discrimination

Class, race, and other demographics collide and intersect on the streets and suburbs of Los Angeles in this gritty drama. The action reveals how connected and interconnected lives can be and how one person's actions can cause a chain reaction. The film took home three Oscars, including Best Picture.

Two Arab Americans are trying to purchase a gun at a local store. The two are speaking in a foreign language, and the store clerk says, "Yo, Osama! Plan a jihad on your own time," which angers the two customers. The clerk continues by insulting the man's use of the English language. When the man protests stating he has the right to buy a gun because of his American citizenship, the clerk refuses to sell him a gun. The man calls the clerk "ignorant." The clerk shouts

back, "Yeah, I'm ignorant. You're liberating my country, and I'm flying 747s into your mud huts and incinerating your friends" and throws the man out of the store. Later, Anthony (Chris "Ludacris" Bridges) and Peter (Larenz Tate) are complaining about the horrible service they received while in a restaurant. Anthony believes his racial identity is the cause of the maltreatment and discusses how even other Blacks believe the stereotypes about Black people. He notices a White couple (Sandra Bullock and Brendan Fraser) walking down the street, and how the woman becomes "cold" when she sees the two Black males. He challenges the notion that she should be scared of them: "Man look around you," he says to Peter, "You couldn't find a whiter, safer, or better lit part of this city right now, but yet this White woman sees two Black guys who look like UCLA students strolling down the sidewalk, and her reaction is blind fear." He continues, "If anybody should be scared around here, it's us. We're the only two Black faces surrounded by a sea of over-caffeinated White people, patrolled by the trigger-happy LAPD. So you tell me, why aren't we scared?" Just then, the two brandish weapons and steal the car of the White couple. OBJ

- 🎬 Describe each of the stereotypes and assumptions depicted in this scene. Where do these sentiments come from?
- 🎬 Explain the irony at the end of the scene. Is this meant to be funny? Is this meant to cause anger? What is the prevailing message?
- How do history and historical occurrences shape the way people interact and view other people of different cultures, races, ethnicities, and the like?
- 🎬 What did Peter mean by "If anybody should be scared around here, it's us"?

Crash (Lionsgate Films, 2005), written by Paul Haggis, Robert Moresco, directed by Paul Haggis
Elapsed time: This scene begins at 00:05:55 and ends at 00:10:00 (DVD Scene 2)
Rating: R for language, sexual content, and some violence

Cursed

Homophobia/difference

Horror master Wes Craven satisfies the bloodlust in all of us as Ellie

(Christina Ricci) and her brother, Jimmy, learn that they have been infected and are changing into werewolves. The Los Angeles night life just got a little more interesting!

Jimmy is in his kitchen preparing to cook himself a meal when there is a knock on the door from his school rival, Bo, who has a history of calling Jimmy "fag" and "fairy" and making other inappropriate comments related to his perceived sexual orientation. When Jimmy questions why Bo is at his house, Bo wonders how Jimmy "knew" (that Bo himself is gay) and attempts to kiss Jimmy. Since Bo presumes that Jimmy is also gay, he mentions "Why wouldn't you know? It takes one to know one, right? Of course *you* would know." Jimmy rebuffs him and states that he is not gay—"Not that there's anything wrong with it." When Jimmy repeats that he is not gay, but "cursed," Bo responds, "I know. It sure feels like that, doesn't it? Not being able to tell anyone." The scene ends as Jimmy goes back inside the house and leaves Bo on the porch. [OBJ]

- What is "gaydar"? Is it possible to tell whether someone is gay?
- 🎬 Jimmy refuses Bo's advances by saying "not that there's anything wrong with that" (a phrase made popular on an episode of *Seinfeld*). Why do you think he felt he had to say that?
- Think broadly about why it is so difficult for people with a nonheterosexual orientation to "be themselves," particularly in public. Create a list of these reasons, comparing emerging themes, and so on.
- In his book, *The Celluloid Closet*, Vito Russo discusses the trend for homosexuals to be depicted as serial killers. What is the societal benefit for this trend?

Cursed (Dimension Films, 2005), written by Kevin Williamson, directed by Wes Craven

Elapsed time: This scene begins at 00:53:27 and ends at 00:55:55 (DVD Scene 9)

Rating: R for language

D3: The Mighty Ducks

Oppression/privilege

Emilio Estevez is back in this third installment of the little hockey

team that defies the odds. This time the team has won scholarships to the prestigious Eden Hall Academy, but Coach Bombay (Estevez) has left them for another team. The new captain has not quite cut the mustard and the students' scholarships are on the line if they lose the big game.

The Ducks are getting on their tour bus when the dean of the school enters the bus to tell them that the board will be revoking all of their scholarships. He says that the team is underperforming and he is "under pressure" to get rid of the players. The dean claims that the coach would be better off if the other students were gone; the coach could choose his own team. The coach prefers to stay with the Ducks. When he threatens to leave if the students were dismissed, the dean states, "We'll miss you" and walks away. At the board meeting, none of the board members speaks up against the revocation of the scholarships, until the team's lawyer, Coach Bombay (who is an alumnus of Eden Hall), informs the board of his intent to sue the school for breach of contract. After the meeting, some of the elitist students share their disdain for the Ducks. One student says, "Congratulations on destroying our school." Charlie (Joshua Jackson) responds, "Hey, look, it's our school too. It's everyone's school, you stupid jock." The jock argues back, "No, it will never be your school. You are our own little affirmative action, brought in for color to entertain us. But you couldn't even do that. You'll never belong; you'll never be more than a bunch of rejects on a free ride." Russ (Kenan Thompson) suggests that it is the rich kids who are on the free ride—"Mummy and Daddy gave you everything, huh?" He promises to "show the whole school what a joke you are" before leaving the school. The scene ends after the groups go their separate ways.

- 🎬 What assumptions are being made by both groups regarding "the haves" and "the have-nots"?
- 🎬 Why do none of the board members speak up against the revocation of the scholarships?
- Is affirmative action a form of privilege? What is the purpose of affirmative action? What are the benefits and disadvantages? Who benefits? In what ways has affirmative action been racialized?

D3: The Mighty Ducks (Walt Disney Pictures, 1996), written by Steven Brill and Jim Burnstein, directed by Robert Lieberman
Elapsed time: This scene begins at 01:12:12 and ends at 01:19:49 (DVD Scene 8)

Rating: PG for some hockey roughhousing and mild language

Dangerous Minds

Dominance/privilege

An ex-marine teacher struggles to connect with her students in an inner city school. Based on the true story *My Posse Don't Do Homework* by Louann Johnson.

In an effort to get students to read poetry, Ms. Johnson offers a prize for the group of students who are able to find the meaning of a poem by Dylan Thomas. The winners are to be taken to a fancy French restaurant called The Flowering Peach. On the night of the prized dinner, only one student, Raoul, shows up. This clip begins when Ms. Johnson and Raoul enter the restaurant. Raoul is clearly out of his element here, and this is evidenced by his confusion in reading the menu, his misunderstanding the waiter's comments, and his anxiety. He does not seem to understand fine dining etiquette, and Ms. Johnson coaches him on how to act and speak. The scene ends as Raoul runs down the alley.

- 🌀 Why was Raoul so anxious and uncomfortable? How would you feel if you were in his shoes?
- 🌀 When Raoul explains how he bought the jacket, Ms. Johnson questions, "Why didn't you buy it in the store?" What does this question say about Ms. Johnson?
- If White people accepted that they have internalized some feelings of superiority, how would that change the way that racism is discussed?
- How can one be a good person and still perpetuate racism? How can active antiracism help White people as well as people of color?

Dangerous Minds (Simpson & Bruckheimer Films, 1995), screenplay written by Ronald Bass, directed by John N. Smith

Elapsed time: This scene begins at 00:59:30 and ends at 01:05:19 (DVD Scene 10)

Rating: R for language

The Devil Wears Prada

Co-optation

In this retelling of the "small town girl makes it big in the city" story, Andy (played by Anne Hathaway) joins the staff of swank fashion magazine, *The Runway*, which is led by the boss from hell, Miranda Priestly (Oscar winner Meryl Streep). Miranda is insufferable and young Andy, who has little to no fashion sense, must bear the scorn of her coworkers as she blossoms into a close protégé of the boss.

Andy is out to dinner with her father and she is trying to explain why she has chosen to serve in a secretarial position with Miranda Priestly; she gets a phone call from her boss to arrange travel for Miranda despite the fact that there is a hurricane prohibiting air travel. The next day, Miranda berates Andy and explains the reason why she chose Andy to be her assistant. Miranda hired the "smart, fat girl" with the "impressive resume" because she thought she would be "different" than her past assistants. Andy cries to Nigel (Stanley Tucci) who agrees to help her by dressing her in the finest designer clothing but not without scolding Andy for her pretentious, yet whiny, behavior.

- 🐭 What did Miranda mean when she said she hired the "smart, fat girl" because she thought she would be "different" than the rest? What does this tell us about the previous assistants? What does this reveal about Miranda's thoughts toward the obese (although Andy could hardly be considered fat)?
- 🐭 Why do you think Andy accepts being berated by Miranda? Are there jobs and positions out there that require us to get beaten down in order to move up the proverbial ladder?
- What is the price of assimilation?

The Devil Wears Prada (2006), written by Aline Brosh McKenna, directed by David Frankel

Elapsed time: This scene begins at 00:27:45 and ends at 00:36:28 (DVD Scene 11)

Rating: PG-13 for some sensuality

Divine Secrets of the Ya-Ya Sisterhood

Privilege

Teensy, Vivi, Necie, and Caro are four lifelong friends; when they were children they formed the Ya-Ya Sisterhood, a secret society that focused on their "queendom." Vivi's adult daughter, Sidda (Sandra Bullock), is a successful Broadway playwright. During a *Time* magazine interview, Sidda described her childhood as unhappy which embarrassed her mother when she read the article. The Ya-Yas kidnap Sidda and bring her back home to the South to show her the error of her ways.

The Ya-Yas have kept a scrapbook of their adventures since they were children, and Sidda is reading through it while the grande-dames reminisce. During a flashback, the ladies describe the time when three of them went to a rich aunt's home in Atlanta to watch the premiere of *Gone with the Wind*. Necie's maid, Willetta, was asked to accompany the girls on their trip, but she was deemed "an unsuitable chaperone" and was asked to ride "in the colored car." Upon arrival, Aunt Louise suggested that the children immediately go upstairs "and get that Louisiana maid in a uniform right away." Later the girls are exploring their surroundings and are amazed at the accommodations. The three girls are taking a bubble bath together when Willetta (in her French maid's uniform) makes them get out of the bath. Necie asks Willetta, "Isn't this the most magnificent thing that could ever happen?" Willetta responds, "I suppose that's what I'd be thinking if I was you." Later, Necie finds Willetta crying in her bedroom because she misses her family. Necie innocently asks if she missed "Maman Delia" who happens to be Necie's grandmother. Willetta chimes, "Child, your gran ain't my family. I got my own gran. And my own momma and daddy too." Necie figures that hot chocolate will make Willetta feel better, so she asks, "Will you make me some, Willetta?" Willetta refuses. The next day Willetta makes Necie some hot chocolate, but she is scolded by Aunt Louise for entering the dining room without permission. Louise's son, James, calls Willetta a "nigger" and the young Ya-Yas retaliate against him and Aunt Louise. The scene ends as the Ya-Yas run from the room cheering. [OBJ]

- 🐾 Do you think Necie is ignorant when she asks Willetta, "Isn't this the most magnificent thing that could ever happen?"
- 🐾 Why do you think Necie believes Willetta might actually be missing "Maman Delia"?
- 🐾 When the Ya-Yas retaliate against James and Aunt Louise, what

is gained?

- What is the best form of "retaliation" when injustice occurs? What are the differences and similarities between the ways adults and children react to injustice?
- How do class differences in this case drive the perspectives of the characters? How is racism different from classism? Stated differently, is racism simply how classism manifests?

Divine Secrets of the Ya-Ya Sisterhood (All Girl Productions, 2002), written by Callie Khouri and Mark Andrus, directed by Callie Khouri
Elapsed time: This scene begins at 00:23:00 and ends at 00:29:12 (DVD Scene 7)
Rating: PG-13 for mature thematic elements, language, and brief sensuality

Dodgeball: A True Underdog Story

Stereotype

Peter LaFleur (Vince Vaughn) owns and operates Average Joe's Gym, a haven for the underachievers and athletically challenged. His next door neighbor, Whitey Goodman (Ben Stiller), runs the hugely successful Globo Gym where the buff and sexy pump iron. Whitey has purchased a second mortgage on Average Joe's and threatens to raze the gym unless Peter and his compatriots pay him $50,000 in 30 days. The team enters a dodgeball tournament as the last minute underdog team that will ultimately unseat the Globo Gym team.

The Average Joe's team has qualified for the national championship dodgeball tournament in Las Vegas. They begin taking on teams and winning matches. The dress and mannerisms of each team match their names: the Lumberjacks are dressed in flannel shirts and jeans with suspenders, wool hats, and beards; the Kamikaze team (from Japan) members are dressed as sumo wrestlers "in diapers" (the announcer states that the Globo Gym team will "drop an A-bomb here on the Kamikazes"); the Skillz that Killz team are the "inner city champs" and wear urban street wear of gangsta rappers and "bling bling." The scene ends when the announcer talks about the "luck of the Irish" when referring to Average Joe's leader, Patches O'Houlihan. 〔OBJ〕

- Discuss the appropriateness of the common use of stereotypes as sources of humor in mainstream film.
- 👬 In *Psychology of Stereotyping*, David Schneider (2003) argues, "There is no such thing as a right or wrong definition—one that is true or false. Rather, the term 'definition' is more properly qualified by adjectives such as 'useful' or 'not useful,' 'viable' or 'not viable,' 'accepted' or 'not accepted'"(p. 15). How are these stereotypical images useful?
- Name some groups of people and the stereotypes associated with these groups. Where do these assumptions come from? Are they always true?

Dodgeball: A True Underdog Story (20th Century Fox, 2004), written and directed by Rawson Thurber

Elapsed time: This scene begins at 00:53:50 and ends at 00:59:15 (DVD Scene 15)

Rating: PG-13 for rude and sexual humor and language

Do the Right Thing

Invisibility

Racial tensions ignite on the hottest day of the summer in the predominantly Black Bedford-Stuyvesant section of Brooklyn. The story follows Mookie, a pizza delivery man for Sal's Pizzeria, an Italian family-run restaurant, and his varied exploits throughout the day.

Buggin' Out, a neighborhood radical, purchases a slice of pizza and sits down to eat. He glances up at the Sal's "Wall of Fame" where there are pictures of famous American Italians such as Robert De Niro, Al Pacino, and Frank Sinatra. Buggin' Out asks, "Why ain't there no brothers on the wall?" referring to the absence of images of African Americans. Sal replies that in *his* Italian restaurant, he reserves the right to put up whatever images he desires. Buggin' Out suggests that since Sal's only customers are Black, there ought to be pictures of famous Blacks such as Malcolm X, Nelson Mandela, and Michael Jordan. He continues his tirade and Sal evicts Buggin' Out from the restaurant. The clip ends as Buggin' Out calls for a boycott of Sal's Pizzeria. [OBJ]

- 👬 In this clip, Sal balks at Buggin' Out's request to include African American images on the walls of his restaurant citing that the pizzeria

is an Italian American establishment. What responsibility, if any, does Sal have to his Black customers and the location of his restaurant?

- Schools and universities often have racial affinity groups for minority groups (e.g., Black Student Unions, Asian Student Coalitions, etc.). How accepted would a White Student Union be at your school? What would be the value of having such an organization?
- What is the purpose of panethnic nomenclature such as African American or Italian American?

Do the Right Thing (40 Acres and a Mule Filmworks, 1989), written and directed by Spike Lee

Elapsed time: This scene begins at 00:19:23 and ends at 00:21:21 (DVD Scene 3)

Rating: R for language and some scenes of nudity and violence

Down to Earth

Prejudice

Lance Barton (Chris Rock), an aspiring stand-up comedian, is accidentally killed; when he gets to heaven the angels reveal that they made a mistake and promise to give Lance a new body. Although Lance is African American, he is placed in the body of Mr. Charles Wellington, the 15th richest and most disliked man in America, who is middle aged and White. Lance gets to see the world through a whole new set of eyes (literally).

This scene begins at the opening credits as Lance, a young African American bike messenger, approaches a ritzy high-rise hotel where he is met at the door by the doorman, who upon first glance at Lance declares, "Deliveries in the back." Lance asks him why he assumed that he was a delivery guy and not a guest of someone who lives in the building. The doorman feels bad about his assumption and asks him who he wanted to see; Lance announces that he has a delivery for Mr. Wellington. The doorman slams the door.

- You go to the bank and withdraw $1,000 in cash. When leaving, you wait for the elevator down to the parking lot. As the elevator door opens, you see five young Black men who look "street tough" in it. Do

you enter the elevator and ride it down? If it was a group of streetwise White young men, would you enter?

- Author Pearl S. Buck once argued that prejudice against women is much more significant and pervasive than racial prejudice. In what ways is this statement true and/or false?
- In your hometown, are there groups of people whom, when you meet them or see them, you assume must work at certain places or be in your town for a specific purpose?

Down to Earth (3 Art Entertainment, 2001), written by Elaine May and Warren Beatty, directed by Paul and Chris Waits
Elapsed time: This scene begins at 00:00:45 and ends at 00:01:47 (DVD Scene 1)
Rating: PG-13 for language, sexual humor, and some drug references

Dreamgirls

Invisibility

The 1970s hit Broadway musical comes to life on the silver screen as Effie (Jennifer Hudson in her Academy Award–winning role), Deena (Beyonce Knowles), and Lorrell are young starlets with a dream to be the next singing sensations. Their dreams are made real by the shady activities of their manager, Curtis (Jamie Foxx).

Jimmy "Thunder" Early (Eddie Murphy) is an R&B superstar, and Curtis is trying to court him to sing a song with his girls, the Dreamettes. Jimmy's manager, Marty (Danny Glover), is not keen on the idea and tries to get Jimmy to leave the club. CeCe, Curtis's songwriter, begins playing a tune called "Cadillac Car" on the piano, which piques Jimmy's interest. Soon, Jimmy and the Dreamettes are recording the song and it grows increasingly popular on the music charts. As it becomes a major hit, the song is rerecorded by an all-White group with a more mellow "elevator music" sound that is more amenable to White television audiences via *American Bandstand*. CeCe is frustrated by the loss of soul in his music and feels like the "Black sound" has been erased in the attempts to crossover for mass audiences. In his anger, he states, "They act like we don't even exist." He questions Curtis, "Is that how it works, Curtis? The man decides he wants something; he just takes it?" Curtis schools CeCe on the

numerous Black artists who were ignored or had their music stolen by White artists. The scene ends as Curtis pours out a box of keys on the table. [OBJ]

- What are some art forms that are categorized as "Black"? Discuss the negatives and positives of this determination or differentiation?
- 🎭 Artists like Elvis Presley and Jerry Lee Lewis admitted the influence of Black music in their styles. How might their careers have been different had they performed in the style of the White singers in this clip?
- Country music was once considered low-class Black music. How do you account for the cultural shift?
- Discuss the prevalence of advertising and marketing strategies that target specific ethnic or racial groups? What common themes emerge?

Dreamgirls (DreamWorks Pictures, 2006), written for the screen and directed by Bill Condon

Elapsed time: This scene begins at 00:22:32 and ends at 00:27:56 (DVD Scene 4)

Rating: PG-13 for language, some sexuality, and drug content

Ella Enchanted

Oppression/power

Ella of Frell (Anne Hathaway) has been cursed by her fairy godmother, Lucinda, with a spell of obedience; she must obey every command, no matter how wicked. She goes on a quest to find Lucinda and along the way she unearths an evil plot to overthrow Prince Charmont's kingdom.

Ella's evil stepsisters learn of her secret—she must obey everything they say—even freeze in midair. They make her steal items in broad daylight, which gets her arrested. They even convince Ella to sabotage her relationship with her best friend, Arieda, by commanding Ella to state that she "could never be friends with an Ayorthian" (Arieda's ethnic group). The scene ends when Ella closes the door on Arieda (Parminder Nagra; *Bend It Like Beckham*).

- Do you know anyone or any group who often does or says hurtful things because they are forced to do so by "the powers that be"?

- 🎥 What is the symbolic effect of casting an East Indian as the Ayorthian? Would this scene have the same dramatic effect if the actor were White?
- Often people who bully others have themselves been bullied—explain this phenomenon.

Ella Enchanted (Miramax Films, 2004), written by Laurie Craig, Karen Lutz, Kirsten Smith, Jennifer Heath, and Michele Wolff, directed by Tommie O'Haver

Elapsed time: This scene begins at 00:20:03 and ends at 00:24:36 (DVD Scene 7)

Rating: PG for some crude humor and language

The Emperor's Club

Privilege

Tradition, academic excellence, and honor are trademark characteristics of the education provided at St. Benedict's School for Boys where straight-laced Mr. William Hundert (Kevin Kline) is a classics professor. Hundert is respected by his students, until Sedgewick Bell, a young troublemaker, stirs things up with his irreverent antics. The two build a lasting relationship that is forged in the fire.

Sedgewick (Emile Hirsch) has come a long way from his first days at the school; through Mr. Hundert's tutelage, he has begun to turn his behavior and poor academic performance around. The class is preparing for the annual Mr. Julius Caesar competition, a prestigious academic award that Hundert's own father had won in the past. Sedgewick is the last student to finish the essay portion, and it is clear that he has been struggling through the test. Later, Mr. Hundert smiles as he grades the essays and realizes that Sedgewick has the fourth highest grade in the class; he is clearly disappointed though, because only the top three scores qualify for the finals of the competition. Hundert changes Sedgewick's grade so that he can enter the finals. During the final competition, the top three finalists must answer questions posed by Mr. Hundert, who realizes that Sedgewick is cheating. Hundert alerts the headmaster who tells him to ignore the indiscretion; Hundert, however, asks a question that was not on the study materials so he knew Sedgewick would not have the

answer. The scene ends as the new Mr. Julius Caesar is crowned.

- If we are honest, each of us would acknowledge privilege in some area of our lives. Describe a benefit that you have received just by reason of birth.
- 🎥 Why would Mr. Hundert show favoritism toward Sedgewick by giving him the coveted third spot? How would you describe the possible impact upon Hundert, Sedgewick, and the student who was looked over? Additionally, discuss the possible reasons why Hunderdt accused Sedgewick of cheating and ultimately giving him a different question.
- Discuss the correlation between privilege and the American belief in meritocracy.

The Emperor's Club (Universal Pictures, 2002), written by Neil Tolkin, directed by Michael Hoffman

Elapsed time: This scene begins at 00:53:57 and ends at 01:01:43 (DVD Scene 12)

Rating: PG-13 for some sexual content

Erin Brockovich

Dominance

Who says you can't fight City Hall? Erin takes on all comers in the "based on a true story" biopic of underdog versus corporate giant. Desperate for a job to support her children, Erin (Julia Roberts) starts working for Ed Masry (Albert Finney), a local attorney; soon they are embroiled in the legal battle of all battles to fight a major utilities company whose power lines are making children sick.

Erin has just spent the last 18 months conducting background research to support their case against utilities conglomerate PG&E. It is becoming evident to Erin that her work has gone unappreciated; in fact, it appears that the lawyers are making some type of arrangement that will not benefit their clients. When another female attorney asks Erin to leave the room to "fill in some of the holes in her research," Erin proves that she is well qualified to help make decisions in the case, regardless of the fact that she does not have a law degree. The scene ends when Mr. Masry scolds Erin for her inappropriate actions in

the boardroom.

- ☜ Why is Erin asked to leave the room?
- What are the educational, social, and economic benefits of a college education?
- ☜ Why was it appropriate/inappropriate for Mr. Masry to scold Erin for her actions?
- Are there times when experience trumps a college education? Provide some examples.

Erin Brockovich (Universal Pictures, 200), written by Susannah Grant, directed by Steven Soderbergh
Elapsed time: This scene begins at 01:34:24 and ends at 01:38:26 (DVD Scene 34)
Rating: R for language

Facing the Giants

Power/co-optation

Despite a 6-year losing streak, high school football coach Grant Taylor leads his team to victory by instilling a spirit of determination, faith, and teamwork.

Coach Taylor has just learned that he is physically unable to father children, although he and his wife have been trying for more than 4 years. He is despondent and is sitting in his office. Soon after, he stumbles upon a secret meeting of some influential parents, the athletic director, and one of his assistant coaches who are trying to get Grant fired. The parents refer to Coach Taylor as "second best" and "not a good coach," and "not capable of winning."

- ☜ Why do you believe that this meeting was held at night, in secret?
- ☜ Why would the assistant coach be invited to this meeting? What responsibility, if any, did he have to tell Coach Taylor about the conspiracy?
- How would you define acceptance and tolerance? In what ways are these common words of diversity veiled disguises for prejudice and

power?

Facing the Giants (Sherwood Pictures, 2006), written and directed by Alex Kendrick

Elapsed time: This scene begins at 00:27:33 and ends at 00:30:00 (DVD Scene 7)

Rating: PG for some thematic elements

Falling Down

Ethnocentrism

A divorced engineer for the defense industry gets stuck in L.A. traffic and finally snaps. He gets out of his car and begins a walk through central L.A., where he encounters various levels of harassment, which he learns to deal with by acquiring weapons along the way. His actions attract the attention of a retiring cop, and he gets involved with the case, following the engineer's path toward Venice, where his daughter is having a birthday party.

Bill (played by Michael Douglas) is on a pay phone and realizes that he needs additional change. He enters a convenience store that is owned by an Asian storekeeper. When Bill asks for change, the store owner requires a purchase. Bill doesn't like the price he is being charged for a can of soda and begins to go on a tirade—vandalizing the store and physically assaulting the store owner. During the scene, Bill criticizes Mr. Lee's use of the English language ("you come to *my* country, you take *my* money, and you don't even have the grace to learn how to speak my language"). Bill continues to make comments about how "my country" has helped Mr. Lee's country. The scene ends when Bill states "It's been a pleasure frequenting your establishment" and exits the store.

- In what ways can patriotism be oppressive?
- What are your political beliefs and values? Why?
- What issues in your community, nation, or world are you most concerned about?
- What problems arise when immigrants or other minorities retain their cultural traditions, stay connected to their native countries or cultures,

and continue to speak their native languages, rather than becoming integrated into and assimilated by the larger American culture?

Falling Down (Alcor Films, 1993) written by Ebbe Roe Smith, directed by Joel Schumacher

Elapsed time: This scene begins at 00:06:53 and ends at 00:12:53 (DVD Scene 5)

Rating: R for violence and strong language

The Family Stone

Heterosexism/compulsory heterosexuality

The Stone family unites for a common cause when their favorite son brings his uptight girlfriend home for the Christmas holiday, with plans of proposing to her. Overwhelmed by the hostile reception, she begs her sister to join her for emotional support, triggering further complications.

The Stone family, Meredith (Sarah Jessica Parker), and Julie, Meredith's sister, are sitting around the dinner table talking when the topic changes to Thad-Stone (who is gay and deaf) and his partner Patrick who are adopting a son. The Stone family is very supportive of Patrick and Thad's relationship—to the point where Sybil (Diane Keaton) states that she had "hoped" all her sons would be gay so they would never leave her. Meredith, who is the girlfriend of one of Thad's brothers, turns the conversation to the "causes" of homosexuality (genetics, nurturing, environment). The mood, which had been playful, turns more serious when Meredith asks, "You didn't *really* hope for gay children, did you?" In her mind, Meredith was asking innocent questions because she believes that no parent "would hope for a child to be challenged like that." The scene ends when Meredith states, "I just think that any parent would want a normal child." [OBJ]

- 🎥 The Stone family is very supportive of Thad. They make all types of jokes about being gay. Why is it acceptable for them to make these remarks?
- Create a list of what you have heard as the "causes" of homosexuality. Can you create a similar list for heterosexuality?

- 🎭 During this scene, Meredith tries to make a connection between Patrick's challenges of being African American and a child being raised by gay parents. What might the connection be?

The Family Stone (Fox 2000 Pictures, 2005), written and directed by Thomas Bezucha

Elapsed time: This scene begins at 00:42:03 and ends at 00:46:00 (DVD Scene 16)

Rating: PG-13 for some sexual content including dialogue and drug references

Fight Club

Gender

A lonely 30-something young professional seeks an escape from his mundane existence with the help of a devious soap salesman. They find their release from the prison of reality through underground fight clubs, where men can be what the world now denies them. Their boxing matches and harmless pranks soon lead to an out-of-control spiral toward oblivion.

The scene begins with Jack sitting on the toilet; he is holding a magazine and is peering at the centerfold. One could assume that Jack is reading a pornographic magazine, but it is actually a furniture catalog. The narrator is discussing becoming a slave to the "IKEA nesting instinct"; he describes how his furniture defines him. Jack suffers from insomnia, and his doctor encourages him to visit a testicular cancer support group to really understand pain and suffering. He does, and while there he meets and partners with a large man, Bob (played by rocker Meat Loaf), who shares his story of steroid abuse and its negative results on him both emotionally and physically (Bob now has very large breasts, similar to a woman's). Bob encourages Jack to "let go and cry" and pulls Jack into his bosom. Jack begins to weep and at the end of the scene we see him fast asleep in his bed.

- 🎭 How have gender constructions of masculinity possibly added to Jack's dissatisfaction?
- 🎭 Why does the doctor suggest that Jack visit a testicular cancer support group of all places? What message does this send about gender, in

particular, manhood?
- In what ways has the language of resistance and fighting for freedom been contextualized as masculine?

Fight Club (Art Linson Productions, 1999), written by Jim Uhls, directed by David Fincher

Elapsed time: This scene begins at 00:04:46 and ends at 00:09:26 (DVD Scene 4)

Rating: R for disturbing and graphic depiction of violent, antisocial behavior, sexual content, and language

The Final Cut

Power

Imagine having a microchip implanted in your brain before you are born, which will record your entire life (good and bad) so that at the time of your death, a technician can splice your memories into a fitting memorial for your family. Meet Alan Hakman (Robin Williams), the technician (known as a "cutter") who watches videos of people's lives and chooses which "re-memories" are included in the final product. During a routine job, Alan stumbles upon a memory that puts his own life in danger.

Alan is being hounded by an antichip activist named Fletcher (James Caviezel; *The Passion of the Christ*), who wants to obtain the memory video of one of the founders of the Zoe Implant in order to discredit the process of rememorization. Fletcher argues that it is wrong for cutters to rewrite a person's history; he decries the power that Alan has to make someone remember "moments someone like you decides are special." He argues that there is no way to measure the impact of the Zoe Implant on the way that people live their lives. He asks a series of rhetorical questions that the implanted might ask: "Am I being filmed? Should I say this or not? What'll they think in 30 years if I do this or that?" He continues to question: "What about the simple right not to be photographed? The right not to pop up in some guy's re-memory without even knowing you were being filmed?" Fletcher's chief complaint about the implant is the cutter's ability to "take murderers and make them saints." Alan retorts that he did not come up with the technology; his work "fulfills a human need" as he bears the

burden of being a "sin eater," or one who cleanses the soul of the deceased. The scene ends as Alan walks away.

- 🐭 What are the pros and cons of the Zoe Implant? If given the opportunity, how would you respond to an invitation to get an implant? How would your response differ if the implant was required by the government?
- In what ways do history books and other texts act as "sin eaters" of our acts, such as the American slave trade, the Chinese Exclusion Act, and Japanese internment?
- How would you alter your own history if given the opportunity to be a technician?

The Final Cut (Lion's Gate Entertainment, 2004), written and directed by Omar Naim

Elapsed time: This scene begins at 00:46:05 and ends at 00:50:00 (DVD Scene 13)

Rating: PG-13 for mature thematic material, some violence, sexuality, and language

Finding Forrester

Prejudice

Jamal Wallace, an African American teenage male, who lives in the inner city, is offered a basketball scholarship to an elite private prep school. He is not only athletically talented, but he is also a gifted writer. He meets William Forrester, a reclusive author, who befriends him and coaches him to become a better writer.

Jamal's writing teacher, Professor Crawford accuses Jamal of plagiarizing his assignments. Professor Crawford mentions that he has seen an incredible amount of progress in Jamal's writing and states "either you've been blessed with an uncommon gift, which has kicked in . . . or . . . you're getting your inspiration from elsewhere. Given your previous education and your background . . . I'm sure you'll forgive me for coming to my own conclusions."

- 🐭 If you were Jamal, how would you have reacted to Professor Craw-

ford's comments?
- 🐭 What assumptions could Professor Crawford be making about Jamal's "background"?
- Have you ever been falsely accused of something you hadn't done? How did this impact you, and how did you respond? How did it affect your relationship with the person who blamed you?

Finding Forrester (Columbia Pictures, 2000), written by Mike Rich, directed by Gus Van Sant

Elapsed time: This scene begins at 01:29:52 and ends at 01:31:43 (DVD Scene 22)

Rating: PG-13 for brief, strong language and some sexual references

Finding Nemo

Stereotype

This animated tale is the story of the adventures of a father searching for his son who has been caught in a fisherman's net and taken above the surface of the ocean. He faces jellyfish attacks, fends off hungry sharks, and meets all sorts of interesting characters, including the absent-minded Dory, along the way.

Marlin the clownfish is taking his son, Nemo, to the bus stop on the first day of school. Marlin is a widower and single father who is overprotective of his little boy, who was born with a disability. At the bus stop, the other parents ask Marlin to tell a joke—they assume that because he is a clownfish, he must be funny. Marlin tries to tell them that not all clownfish are funny, but he tries unsuccessfully to tell a joke anyway. The scene ends after the young fish are carted off to school and the parents have a brief exchange where one of the fish says of Marlin, "For a clownfish, he really isn't that funny."

- If a group of men are talking, what do you assume they are talking about? Why? If a group of women are talking, what do you assume they are talking about? Why?
- If you were to travel outside of the United States, what do you suppose would be the generalizations made about Americans? How would you feel being the representative of America at this time?

- What assumptions have ever been made about you due to your name, race, religion, and the like?
- What happens when people live up to their stereotypes? What happens when people don't live up to their stereotypes?

Finding Nemo (Disney Pixar, 2003), written by Andrew Stanton, directed by Andrew Stanton and Lee Unkrich

Elapsed time: This scene begins at 00:05:09 and ends at 00:10:56 (DVD Scene 3)

Rating: G for all audiences

The Firm

Invisibility

Mitch McDeere (Tom Cruise), fresh out of law school, joins a prestigious Tennessee-based firm only to learn that the firm is under investigation by the FBI. Mitch is torn between loyalty to the company that afforded him a break from his lower-class past and doing what is right according to the law.

In this scene, which begins with the opening credits, Mitch is being highly sought after graduating as one of the top five students from Harvard Law School. He is interviewing with some of the most prestigious firms across the country. In each of the firms that he meets with, there are no people of color present. During a discussion with one of the wives of the partners of a Memphis law firm, Abbey, Mitch's wife observes that the partners in the firm are "all White, all male, and all married." Toward the end of this clip, one young African American child is entertaining the crowd with his acrobatic gymnastic routine. [OBJ]

- In what ways might feelings of invisibility impact a person's self-esteem and sense of self?
- 🎥 What might be the meaning of the young Black male's appearance in this clip? What are the ways in which minority groups must "perform" for majorities?
- 🎥 In what ways does the African American child's presence cause any reaction in you? What are the parallels of the significance of this

child's presence as an entertainer for a White crowd and the historic portrayals of Blacks in film?

- Besides racial minorities, what other groups in our society are made invisible by virtue of social class, gender, sexual orientation, or religion?

- 🐭 What is the significance of Abbey's observation that all the partners were married, White males?

The Firm (Paramount Pictures, 1993), screenplay written by David Rabe, directed by Sydney Pollack

Elapsed time: This scene begins at 00:00:22 and ends at 00:09:38 (DVD Scene 1)

Rating: R for language and some violence

Flubber

Social justice

Robin Williams stars as Professor Phillip Brainard, an inventor who has developed a mysterious goo called Flubber, which when applied to anything enables it to bounce superhigh. Everyone wants to get their hands on Flubber, an amorphous ooze with a mind of its own.

Professor Brainard is on the faculty of Medfield College, an institution on the brink of financial ruin. Medfield's basketball team, comprised of skillless geeks, is an embarrassment to the school. On this day, the team is facing the Rutland Rangers, a championship level team of superstar athletes. The Medfield Squirrels team are naturally "getting their nuts buried" by Rutland. Brainard has added "Flubberized" tacks to the bottoms of the Medfield team's shoes and has put some Flubber on their hands as well—giving them high-flying skills. Medfield ultimately wins the game.

- 🐭 What are the purposes of affirmative action programs? In what ways was Brainard helping Medfield's team like affirmative action? In what ways was it not?

- When colleges and universities, and even the U. S. government, give assistance to those who would never be given a chance to excel in life, does it always have positive outcomes? Support your answer with ex-

amples.

- Affirmative action programs provide access for the underrepresented, but access alone is not enough. What other mechanisms would you suggest to overcome the legacy of mistreatment of minority groups?

Flubber (Walt Disney Pictures, 1997), written by John Hughes, directed by Les Mayfield

Elapsed time: This scene begins at 00:53:44 and ends at 00:59:07 (DVD Scene 12)

Rating: PG for slapstick action and mild language

Flushed Away

Ethnocentrism

Young Roddy the Rat, a civilized rodent, must go down into the sewers to save his fellow rats from certain doom. The Great Toad has plans to flood the sewer system with human waste to destroy all the rodents; he wants to preserve the sewer system as a habitat for amphibians only. Roddy must save the day and get the girl!

Roddy and Rita are being chased down the sewer by Whitey and his crony, both of whom are henchmen for the Great Toad. Roddy and Rita escape, and the scene flashes to the Toad's lair where the henchmen are being scolded by the Toad. He speaks very condescendingly to the rats; in fact, he regrets sending "rodents to do an amphibian's job." While talking to Le Frog, a hired assassin, the Toad reveals that once Roddy is captured, he will be able to complete his master plan—"To wash away, once and for all, the curse, the scourge of rats." He continues by explaining his disdain for rodents; the Great Toad was once the favorite pet of Prince Charles, until the day he was flushed down the toilet when Prince Charles received a pet rat as a gift.

- Explore the causes of real-life examples of ethnic cleansing. What do you think drove the people in power to want to eradicate an entire group of people?
- What meaning can you make from the title of Walter Rodney's book *How Europe Underdeveloped Africa* (1973)?
- How often does being hurt by one person of a particular ethnic group

change our attitude about the entire group?

Flushed Away (DreamWorks Animations, 2006), written by Dick Clement, Ian La Frenais, Chris Lloyd, Joe Keenan, and William Davies; directed by David Bowers and Sam Fell

Elapsed time: This scene begins at 00:46:00 and ends at 00:49:49 (DVD Scene 9)

Rating: G for all audiences

Freedom Writers

Anti-Semitism/ethnocentrism/privilege

Ms. Erin Gruwell (Hilary Swank) takes her first job as a teacher in a predominantly Black and Latino school that is impoverished. The students wage daily wars just to survive against drive-by shootings and gang warfare. She teaches the students to channel their anger, fears, and frustration through writing to give them a "voice of their own." Based upon the acclaimed bestseller, *The Freedom Writers Diary*.

On this particular day, as Ms. Gruwell is teaching a grammar lesson, a Latino student named Tito passes a racist caricature of a Black student named Jamal. When Ms. Gruwell intercepts the handwritten drawing, she becomes incensed and explains how drawings like these led to the Jewish Holocaust. Many of the students in her class are members of gangs or territorial sects; Ms. Gruwell belittles their rival groups implying that the Nazis were "the most famous gang of all." She explains the Nazi regime's rise to power through violence and propaganda such as the drawing—"They just wiped out everybody else." She continues to describe how the caricatures of Blacks and Jews were used to justify violence against these groups; how scientific evidence was used to prove "Jews and Blacks were the lowest form of human species. Jews and Blacks were just like animals; and because they were animals, it didn't really matter if they lived or died." Soon, several of the students balk, suggesting that she does not understand their experience and the hard choices they make on a daily basis. One student describes his life as a war; they have few aspirations other than remaining alive, or at least, dying "like a warrior" with respect. A female student, Eva, emotionally chimes in how she hates White people because they are "always wanting their respect like they deserve it for free." Ms. Gruwell retorts, "I'm a

teacher. It doesn't matter what color I am." Eva claims that "it's all about color. It's about people deciding what you deserve, about people wanting what they don't deserve, about Whites thinking they run this world no matter what." She continues by describing her suffering at the hands of Whites—a friend shot, her father arrested—"because they feel like it. Because they can. And they can, because they're White."

- In what ways does race matter?
- 🎞 Why does Eva think White people are the source of her suffering?
- Charles Cooley's looking glass theory refers to the interactive process by which individuals develop a sense of self. It posits that individuals develop a self-image through imagining how others perceive them, the others, in effect, acting as a mirror for them. How does this theory coincide with your own sense of identity?

Freedom Writers (Paramount Pictures, 2007), written and directed by Richard Lagravenese

Elapsed time: This scene begins at 00:27:22 and ends at 00:37:15 (DVD Scene 5)

Rating: PG-13 for violent content, some thematic material, and language

Girlfight

Gender

Diana Guzman is a fighter—she fights for survival on the mean streets of the Bronx, at her home with an abusive father, and for respect in her high school. She must learn to channel that aggression and therefore turns to her brother's boxing coach for help and training.

Diana goes to visit Hector, a boxing coach, to ask him to become her trainer. Hector is none too excited about the thought of training a girl. He says, "You can train, but you can't fight." He continues, "Girls don't have the same power as boys." Hector's friend encourages her to do aerobics instead. Finally Hector concedes, but Diana will have to pay $10 per session; Diana asks her father for the money to train, since he already pays for her brother's boxing lessons. Her father balks at the suggestion, insisting that Tiny's lessons are to "prepare him for the world out there." He sees it as insurance; besides, "He ain't over there at

the A&S Plaza buying lipstick or whatever you girls do there." Diana retorts, "Please. Don't front like I'm some girly-girl when you know I'm not." To that he asks, "Would it kill you to wear a skirt once in a while?" He tells her to get a job to earn the extra money. The scene ends when Diana walks away from the table.

- What are some of the social norms that perpetuate the differences between boys and girls and eventually men and women?
- 🎬 Why is Hector resistant to training a girl? What is your response to Hector's friend suggesting that Diana take aerobics?
- What is the difference between the portrayals of "girly-girls" and "tomboys"? Is there a difference in the way they are viewed, particularly by men? In the end, is there a certain type of girl who has more power than another?
- Evaluate this statement: Women of color are more apt to be tomboys.

Girlfight (Screen Gems, 2000), written and directed by Karyn Kusama
Elapsed time: This scene begins at 00:13:00 and ends at 00:16:30 (DVD Scene 5)
Rating: R for language

Gladiator

Sexism/dominance/oppression

Maximus (Russell Crowe) is a heralded general in the Roman military who faithfully served the emperor until his death (at the hands of his own son). The new emperor had Maximus's family executed and Maximus sold into slavery. He is sold to a trader who supplies fighters for the gladiator games at the Colosseum. Maximus becomes a crowd favorite by winning gauntlet after gauntlet, but Maximus never forgets his vow of revenge against Emperor Commodus.

Emperor Commodus (Joaquin Phoenix) has learned that his sister-wife, Lucilla (Connie Nielsen) has betrayed him; she is in love with the his mortal enemy, Maximus. The scene opens with Commodus referring to himself as "Commodus the Merciful." In his speech to one of his generals, Commodus states that Lucilla's son will be held captive in the emperor's company. He

warns that if Lucilla commits suicide, refuses his sexual advances, or, "if his mother so much as looks at me in a manner that displeases me, he will die." To her he says, "you will love me as I loved you. You will provide me with an heir, so that Commodus and his progeny will rule for a thousand years." He ends his speech with forcefully asking her the question, "Am I not merciful?"

- Those who often assert power and dominance over others do so because of personal inadequacy. Discuss real-life examples where you presume this happens.
- How would America be different if it were a dictatorship or under the rule of an emperor?
- In what ways do men and women use sex as a weapon of control and power?
- 🎞 How does Commodus consider himself "merciful"?

Gladiator (DreamWorks Pictures, 2000), written by David Franzoni, John Logan, and William Nicholson, directed by Ridley Scott

Elapsed time: This scene begins at 02:13:25 and ends at 02:15:44 (DVD Scene 25)

Rating: R for intense, graphic combat

Glory

Social justice

Robert Gould Shaw (played by Matthew Broderick) leads the U.S. Civil War's first all-Black volunteer company, fighting prejudices of both his own Union army and the Confederates. The story is drafted from a collection of the actual letters written by Captain Shaw.

The opening sequence of the movie shows scores of White soldiers in encampments preparing for an upcoming battle. Soon, the soldiers begin marching past a line of Black men going in the opposite direction. We hear the words of Captain Shaw as he is writing a letter to his mother about his appointment as a leader of a regiment of soldiers in the Civil War. He tells her not to worry about him and explains his reason for fighting—"We are fighting for men and women whose poetry has not yet been written." He continues by stating that the purpose of the war is to "make it a whole country . . . for all who live here so

that all can speak." The scene ends as the battle at Antietam Creek begins.

- 🎭 Reflect on the words of Ralph Waldo Emerson as quoted by Captain Shaw in this scene: "A deep man believes that the evil eye can wither, that the heart's blessing can heal, and that love can overcome all odds."
- Devise a list of principles or characteristics that would make a person an advocate for social justice.
- If the manufacturer of one of your favorite products practiced racial discrimination, what would you do?
- What should be done about "reparations" to descendants of slaves in America? How should it be implemented? What is the impact on race relations in the United States if reparations are or are not awarded?

Glory (Tristar Pictures, 1989), screenplay written by Kevin Jarre, directed by Edward Zwick

Elapsed time: This scene begins at 00:01:00 and ends at 00:03:56 (DVD Scene 1)

Rating: R for language and war-related action

Goodfellas

Power/oppression

The lowly, blue-collar side of New York's Italian Mafia is explored in this crime biopic of wise guy Henry Hill who makes his way from petty criminal to drug dealer to crime boss. Watch the rise and fall of Hill and his two counterparts, the slick jack-of-all-trades criminal Jimmy Conway and the brutish, intimidating Tommy DeVito as they crush the competition in the seedy underworld of organized crime.

Henry is a teenager and is getting involved in "the business." Paul Cicero leads meetings in a local restaurant as Henry narrates. Henry tells the story of how as a Mafioso, Paul provides protective services "for people who can't go to the cops." Paulie provides these services for those who pay tribute to him like they used to in the "old country." The scene cuts to Henry smashing car windows in the middle of the night. Henry states that his association with Paulie afforded him certain rights and privileges—never having to wait in line at the bakery,

nobody parking in his mother's driveway (even though they don't own a car), and having more money than he can spend. Henry continues to vandalize the neighborhood. The scene concludes as Henry explains, "One day . . . one day, some of the neighborhood kids carried my mother's groceries all the way home. It was out of respect."

- How do groups or individuals gain power over others? What are the mechanisms?
- In what ways does "absolute power corrupt absolutely"?
- How might a minority group overcome oppression?

Goodfellas (Warner Bros., 1990), written by Nicholas Pileggi, directed by Martin Scorsese

Elapsed time: This scene begins at 00:08:06 and ends at 00:10:03 (DVD Scene 4)

Rating: R for strong language and violence

Guess Who

Prejudice

Theresa is home for her parents' 25th wedding anniversary, but she has big news of her own. She has invited her boyfriend (to whom she is secretly engaged) to meet her parents for the first time. Theresa, who is African American, has not told her parents that her boyfriend, Simon, is White. *Guess Who* is a fresh remake of the classic *Guess Who's Coming to Dinner.*

The Jones family and Simon are at the table having dinner. They are joined by Theresa's grandfather, who is none too pleased that Theresa is in an interracial relationship. Simon (Ashton Kutcher) ignores Theresa's advice and attempts to impress the Jones men by telling "Black jokes." Simon begins by telling the story of how he corrected his own grandmother for referring to Theresa in a racially derogatory manner. Percy (Bernie Mac) pressures Simon to keep telling these "harmless" jokes—until one joke goes horribly awry.

- Evaluate this statement regarding ethnic humor—"you are what you laugh at."

- How often are racial and ethnic jokes told in your circle of friends?
- Why does it seem all right for members of a particular ethnic group to tell ethnic jokes about their own kind, but not for outsiders?
- White comedians are often chastised for telling jokes about Blacks, but many people argue that Black comedians are not chided for telling "White jokes." What are your thoughts about this?

Guess Who (Columbia Pictures, 2005), screenplay written by David Ronn, directed by Kevin Rodney Sullivan

Elapsed time: This scene begins at 00:47:08 and ends at 00:53:43 (DVD Scene 13)

Rating: PG-13 for sex-related humor

Hairspray

Stereotype/discrimination/prejudice

Tracy Turnblad has a big personality and bigger hair to match! Her life's ambition is to be a dancer on the televised *Corny Collins Show*, which is against her reclusive mother's (played by John Travolta) wishes and those of the show's producer, who also happens to be the mother of her biggest rival. Tracy auditions and becomes an overnight sensation and uses her celebrity status to fight for racial integration on the primetime show.

Tracy has cut school to audition to be a dancer on the *Corny Collins Show*, an *American Bandstand*-style television show. As a fuller-figured girl, Tracy is set apart from most of the girls who are competing for the one available spot. Velma Von Tussle (Michelle Pfeiffer), the show's stage manager and former beauty queen (and mother of the show's female lead dancer), has plans to eliminate the competition for her daughter. Velma and her daughter, Amber, frequently make derogatory comments about Tracy's weight and the features of other girls. When questioning the girls' values, Velma asks, "Would you swim in an integrated pool?" Tracy affirms that she is "all for integration." Velma states, "And may I be frank? First impressions can be tough, and when I saw you, I knew it. If your size weren't enough, your last answer just blew it. And so, my dear, so short and stout; you'll never be in, so we're kicking you out." Later, Tracy tries to sneak back into her class unnoticed but is caught and sent

to detention. To her surprise and delight, the detention room is full of Black students who are doing all of the latest dance crazes. Seaweed, one of the Black students, states, "The man can dine me on a diet of detention, so long as he don't starve me of my tunes, baby!" An avid dancer, Tracy asks the students to teach her some moves. Although they doubt her ability to catch on, they soon recognize that she is "not bad for a White chick." Tracy recognizes Seaweed from his stints on the "Negro Day" specials of the *Corny Collins Show*. Tracy proudly exclaims, "Negro Day is the best. I wish every day could be Negro Day!" The scene ends as Link Larkin (Zac Efron) invites Tracy to the dance hosted by Corny Collins.

- 🎬 What is the significance of the detention hall being populated only by Black students?
- How do you account for the proliferation of males who are playing female characters such as John Travolta as Edna Turnblad in *Hairspray*, Tyler Perry as Madea Simmons, Martin Lawrence in *Big Momma's House,* and Eddie Murphy in films like *Norbit* and *The Nutty Professor* series?
- 🎬 How do you respond to the comment that Tracy's dancing is "not bad for a White chick"?
- Evaluate why weight seems to be an indicator of worth in society?

Hairspray (New Line Cinema, 2007), written by Leslie Dixon, directed by Adam Shankman

Elapsed time: This scene begins at 00:16:28 and ends at 00:24:01 (DVD Scene 4)

Rating: PG for language, some suggestive content, and momentary teen smoking

Happy Feet

Oppression

Mumble, the young penguin, faces the ire of his entire village of emperor penguins. All of the other penguins love to sing, but not Mumble, he is a dancer. When he is kicked out of Emperor Land, Mumble sets out on a journey to prove the importance of being true to yourself.

It is mating season in Emperor Land and several male penguins are vying for

the attention of Gloria, a young female with a beautiful singing voice. The males sing their "heart songs," and the one with the complementary song to Gloria's will win her affection. Mumble returns with his new friends, The Amigos, and tries to dance his way into Gloria's heart. It appears to be working and the other young penguins begin to dance with Mumble. The elder patriarchs of Emperor Land catch on and attempt to put a stop to the fracas. The leader, Noah, blames the shortage of fish on a "foreign" element (Mumble and his friends), and he calls for their expulsion—he calls them a "disorder," and an "aberration," referring to their dancing as a "kind of backsliding" and a "pagan display."

- 🐧 What keywords used in this scene are indicative of how agent groups use propaganda to vilify target groups? How might the comments made by the elder penguins be an indictment of religious dogmatism?
- 🐧 Mumble is singled out because of his inability to sing and the fact that his dancing ability is a birth defect. In what ways does his expulsion from Emperor Land correlate to the way mentally or physically disabled people are treated in our society?
- 🐧 The elder penguins believe that getting rid of Mumble is necessary for the safety of the colony. How is this decision justified or unjustified?
- How do your grandparents and older family members view people your age?

Happy Feet (Kingdom Feature Productions, 2006), written by John Colle and Warren Coleman, directed by George Miller and Warren Coleman
Elapsed time: This scene begins at 00:52:00 and ends at 01:00:45 (DVD Scene 15)
Rating: G for all audiences

Harold and Kumar Go to White Castle (2004)

Power/stereotype

After a night of smoking pot, Harold (John Cho) and Kumar (Kal Penn) get a major case of the munchies that only White Castle burgers will fill; unfortunately, the closest one is in the next state. Their quest

becomes a mythic adventure of sex, debauchery, and mayhem.

This scene begins at the opening credits. Two executives are chatting about their plans to meet some women for sex that night. One of the men states that he has too much work to do for a meeting the next day, but his buddy suggests making another person do his work for him. The supervisor brings his stack of work to Harold, an Asian member of the team. Under a veiled threat of downsizing, Harold is required to do his boss's work. As the two White executives leave the building, they discuss how "easy" it was to pass off their work to a subordinate. One even states that Harold will be excited to complete this project because "those Asian guys just love crunching numbers." 〔OBJ〕

- Jokes about certain ethnic groups are unacceptable, although at one time they were not considered offensive at all. Are there any groups today that it seems perfectly normal to make fun of? Why?
- Audiences seem to enjoy watching comedians who insult other audience members. What does that say about American culture? Why does it appear funny to put others down?
- Asians are often termed the "model minority." What does this term mean? How might this term be considered offensive to both Asians and other minority groups?
- David Hume, Scottish philosopher, once said, "Character is the result of a system of stereotyped principles." What does Hume mean by this statement?

Harold and Kumar Go to White Castle (Endgame Entertainment, 2004), written by Jon Hurwitz and Hayden Schlossberg, directed by Danny Leiner
Elapsed time: This scene begins at 00:00:25 and ends at 00:02:17 (DVD Scene 1)
Rating: R for strong language, sexual content, drug use, and some crude humor

Harry Potter and the Chamber of Secrets

Ethnocentrism/classism/prejudice

It is the second year at Hogwarts, and Harry Potter, Ron, and Hermione are back. Members of the school turn up petrified as they watch bloody writing appearing on the walls, revealing to everyone that some-

one has opened the chamber of secrets. The attacks continue, forcing the possibility of the closure of Hogwarts. Harry and his friends must secretly uncover the truth about the chamber before the school closes or lives are taken.

The scene opens with the students at Hogwarts arguing over the usage of the Quidditch (a fictional game played at Hogwarts) field. Draco Malfoy is bragging about the new broomsticks that his team has—courtesy of Malfoy's father. Young Draco shows off his new broomsticks, and Ron, a friend of Harry's, remarks in astonishment, "Those are Nimbus Two Thousand and Ones!" Malfoy sarcastically replies, "That's right, Weasley. You see, unlike some, my father can afford to buy the best." Ron's friend, Hermione, jumps to his defense stating that it was talent, not money that makes up the rival team. Draco retorts, "No one asked your opinion, you filthy little mudblood." Ron attempts to put a spell on Draco that backfires. The scene ends when Harry and Hermione carry Ron away.

- 🎬 Look at the term "mudblood." What was Draco implying by using this word?
- In what ways do we refer to the poor in our nation as "inferior"?
- 🎬 Hermione makes the argument that Malfoy received special treatment because of his higher economic status. In what ways do the rich receive special treatment in our society? How necessary are affirmative action programs in the twenty-first century?
- 🎬 Comment on the cultural symbolism of Ron's attempt to cast a spell on Draco and its consequent results.

Harry Potter and the Chamber of Secrets (1492 Pictures, 2002), screenplay written by Steve Kloves, directed by Chris Columbus
Elapsed time: This scene begins at 00:38:00 and ends at 00:39:53 (DVD Scene 12)
Rating: PG for scary moments, some creature violence, and mild language

Hercules

Power

Greek mythology comes to life with Disney magic! Hercules is the

son of the top dog on Mount Olympus, Zeus; too bad he doesn't know it. Adopted by humans when he was just a baby, Hercules has all the power of the gods with all of the fallibility of humans. His quest is to move from "zero to hero" and he must win the heart of Meg and defeat his father's arch-nemesis, a hothead named Hades.

Hercules has been gifted with super strength, but his one weakness is his love for Meg. He is unaware that Meg is under the control of Hades (he tells her, "I own you"), who has plans to overthrow Zeus and the other gods on Mount Olympus, if he can manage to defeat Hercules. If she refuses to help Hades, Meg will see her "freedom fluttering out the window forever." To free Meg from Hades' clutches, Hercules agrees to give up his own powers for 24 hrs. The scene ends as Hades rides off into the night in his winged chariot.

- 🎬 Put yourself in Hercules' shoes. How would you respond to Hades?
- Why can't people who are being controlled by someone or something break these bonds themselves?
- Are we free to make our own choices in life, or are our decisions always limited by the rules of society?
- Why does one person's weakness translate into another person's power? Does this dichotomy work at all levels (school, work, home, etc.)?

Hercules (Walt Disney Pictures, 1997), written by John Musker, Ron Clements, Bob Shaw, Donald McEnery, and Irene Mecchi, directed by John Musker and Ron Clements
Elapsed time: This scene begins at 01:03:26 ends at 01:10:10 (DVD Scene 23)
Rating: G for all audiences

Higher Learning

Privilege/prejudice

Malik (Omar Epps) is a new student at Columbus and he is quickly overwhelmed by the collegiate life. He and his roommate are not getting along, Professor Phipps (Laurence Fishburne) is constantly berating him, and campus race relations are at an all-time low. Director John Singleton weaves an interlocking tale of the struggles of fresh-

man year at fictional Columbus University—dealing with diversity, identity, and belonging.

The scene begins as drunken college guys flip over a car and a wild party commences in the background. Three White female friends are walking down the sidewalk discussing their desires to move off campus instead of living in the dormitories. One woman mentions that her parents cannot afford to pay for her to move off campus because of a layoff; her friend mentions that "My roommate's a Mexican, so I bet she got a scholarship."

- If you received a fully paid scholarship to attend a top-rated, prestigious, predominantly White university or to attend one of the renowned and famed Black colleges, which would you choose?
- In what ways can privilege be equated to hidden arrogance?
- Shirley Chisholm, the first African American Congresswoman and presidential candidate, once stated that "All Americans are the prisoners of racial prejudice." What might she have meant by this comment? If this is true, how might we become freed from racial prejudice?
- 🎥 Why is there an automatic assumption about the Mexican roommate's scholarship? In what ways are race and socioeconomic status connected?

Higher Learning (Columbia Pictures, 1994), written and directed by John Singleton

Elapsed time: This scene begins at 00:08:49 and ends at 00:09:51 (DVD Scene 3)

Rating: R for sexual violence and strong language

Hitch

Power/out-group

Alex Hitchens (Will Smith) is a dating consultant who helps men overcome their own misgivings about love, their own shyness, to find the women of their dreams. He is up for the challenge of his career when he meets Albert Brennaman (Kevin James), a bumbling accountant, who is in love with a supermodel.

Hitch prefers to keep his services anonymous; he gains new clients by referral only. He has been hired by Vance Munson (Jeffrey Donovan) and is meeting him for the first time at a fancy restaurant. Vance appears to be completely smitten with a woman—he describes how food has lost its taste and how he cannot see going on with his life. Hitch looks pleased with what he is saying, until Vance admits that his life will never be the same until he has sex with the woman. Vance says, "I think things aren't going to snap back unless I bang her . . . you know, bang her. Clear my head. Get in, get off, get out." Hitch believes Vance does not understand his line of work; he argues, "My clients actually like women. 'Hit it and quit it is not my thing.'" Hitch refuses to work with him— this is not why he provides this service. Vance does not like rejection and when Hitch stands up to leave, Vance grabs his arms and explains, "You see what I'm doing? This is what I'm about—power suit, power tie, power steering. People can wince, cry, beg, but eventually they do what I want." Hitch responds by reversing the arm grab and plants the man's face onto the table and threatens bodily harm if he ever touched him again. [OBJ]

- 🎥 What does the grabbing of Hitch's arms reveal about Vance? What are some types of body language that reveal a person's controlling nature? Was Hitch justified in his physical response?
- You have probably heard the phrase, "absolute power corrupts absolutely." In what ways is powerlessness corruptive as well? Provide examples.
- What are the differences between leadership and power?

Hitch (Columbia Pictures, 2005), written by Kevin Bisch, directed by Andy Tennant

Elapsed time: This scene begins at 00:30:10 and ends at 00:32:57 (DVD Scene 8)

Rating: PG-13 for language and some strong sexual references

Holes

Racism/sexism

Living out a family curse and wrongfully convicted and sentenced to hard labor at Camp Green Lake, a juvenile detention center in the

middle of the desert, Stanley Yelnats (Shia LaBeouf) and his fellow juvies are forced to dig holes in the sand each day, supposedly for "character development." What they don't know is that the warden is searching for something, and she is using them for her purposes. But what is she looking for?

Over 100 years ago, Stanley's family was cursed by a village gypsy. At various times throughout the film, flashbacks tell the ancient story of Stanley's forebears who once lived on the land that is Camp Green Lake. In one such flashback, the local school marm, Miss Kathryn Barlow (Patricia Arquette) is falling in love with the neighborhood onion picker and merchant, Sam (Dule Hill), who does various odd jobs at the school. She is also fending off the advances of Trout Walker, the son of one of the richest men in the town. One late evening, Trout sees Sam and Kathryn kissing, which is against the law because Sam is Black and Kathryn is White. The sheriff and other townspeople plan to hang Sam, but one of them shoots Sam while he tries to escape in his boat. The scene ends as Miss Kathryn rides out of town after she murders the sheriff.

- Kissing between two people of opposite races was once illegal. What is your gut reaction when you see two people in an interracial relationship today?
- Why was it once illegal for a Black man to kiss a White woman, but it was not illegal for a White man to kiss a Black woman?
- Interracial dating and marriages were against the law until the mid-1970s. What other laws regarding race, gender, or sexual orientation have been made that had direct impact upon individual decisions?

Holes (MGM, 2003), written by Louis Sachar, directed by Andrew Davis
Elapsed time: This scene begins at 00:44:35 and ends at 00:53:50 (DVD Scene 12)
Rating: PG for violence, mild language, and some thematic elements

Holiday Heart

Invisibility/compulsory heterosexuality

Choirmaster by day and female impersonator by night, Holiday is a lonely gay man with a broken heart. He comes to the aid of a drug-

addicted woman and her daughter Nikki. Holiday becomes a surrogate parent to young Nikki and battles to save the family that he has created when Nikki's mother starts using drugs again.

Holiday (Ving Rhames) drives to the front of his house and begins to daydream about his former partner, Fisher, a police officer who was killed in the line of duty. At Fisher's funeral, Holiday is dressed in drag and the congregation reacts negatively to the presence of a gay male in women's clothing. In his comments to the crowd at the funeral, Holiday speaks to Fisher's corpse and states, "Judging from the temperature drop at my entrance, baby, you did right by keeping me in the corner crack of your closet." Holiday continues to have a flashback to the time when Fisher bought the home for himself and Holiday. It is a duplex and Fisher states, "we can tell people that you live on one side and I live on the other." Fisher continues, "We can play the game." [OBJ]

- In *Harry Potter and the Order of the Phoenix*, author J. K. Rowling wrote: "Indifference and neglect often do much more damage than outright dislike." How is this true of the pressure to hide a facet of your identity?
- Upon accepting an award for her writing, poet Audre Lorde once remarked, "I don't want to be recognized for being a Black poet who happens to be gay; but I do want to be recognized for being a Black poet who happens to be gay." What was she trying to say in this seemingly contradictory statement?
- In what ways is sexual orientation as much a social construction as race and gender? In what ways is sexual orientation lived as a systemic institution?

Holiday Heart (MGM, 2000), written by Cheryl West, directed by Robert Townsend

Elapsed time: This scene begins at 00:04:35 and ends at 00:06:48 (DVD Scene 1)

Rating: R for language and drug content

The House of Sand and Fog

Sexism

Based upon the critically acclaimed novel by Andre Dubus, *The House*

of Sand and Fog is a dramatic tale about the collision of cultures. Kathy (Jennifer Connolly) is a recovering addict who has lost everything, including the house she is living in. Massoud Behrani has bought Kathy's house at an auction with plans to resell it. Their lives intersect as they each stake ownership claims on the house; the rightful owner is named, but only after tragic consequences.

Colonel Massoud Behrani (Ben Kingsley) has purchased a home at an auction, but the previous owner, Kathy Nicolo (who was evicted for nonpayment of taxes) has hired a county attorney to get her house back. The county sends Mr. Behrani a letter informing him that he must vacate the premises immediately. When he goes to the county office, he asks to speak to the supervising lawyer, Mr. Walsh. He is surprised to learn that the person he is seeking is actually a woman. The scene ends when Colonel Behrani leaves Mrs. Walsh's office. 🔅

- 🎬 Evaluate the meaning of the poster in Mrs. Walsh's office which reads, "Your oppression is our revolution."
- What types of services would you feel more comfortable having a gender-specific provider? Why?
- Define the following terms: misogyny, misandry, and chauvinism.
- In what ways was the sexual revolution a boon for feminism and in what ways did it enhance sexist practices toward women?

The House of Sand and Fog (DreamWorks Pictures, 2003), written by Vadim Perelman and Shawn Otto, directed by Vadim Perelman

Elapsed time: This scene begins at 00:35:29 and ends at 00:41:14 (DVD Scene 9)

Rating: R for some violence, disturbing images, language, and a scene of sensuality

Howard Stern's Private Parts

Discrimination/power

Howard Stern narrates his own biopic as he explains his humble beginnings as a nerdy nobody to becoming the self-proclaimed "King of All Media." With his wife Allison by his side, Howard takes on all comers on his way to the top.

Howard has been working for some time as an on-air announcer for radio station WRNW 107. His voice is a bit weak, and according to his boss, Moti, is not made for radio. In fact, Moti states simply that "Howard, you stink. I don't mince words. You will never be a great disc jockey. You have lousy voice, lousy personality, and this will not change." Howard is described as a hard worker and is actually promoted to program manager and is given a significant raise. He and Allison get married, and Howard is enjoying his success until Moti asks him to fire the radio announcer, Dickie Davis. Howard objects, citing the fact that Dickie has three kids and doesn't know what the deejay has done wrong. Moti states that it is "none of your business" why he is being fired, and as a manager, he must fire him. Moti argues, "It's good to fire someone. It gives a good message to the others. Just fire him." Howard continues to object, and Moti snaps back, "Howard, disc jockeys are dogs. Your job is to make them fetch. Now if you truly want to be management, you be a man and fire him. Do it. Be a man." Later, Howard asks his wife if she would be mad at him if he stopped working as a manager. Allison tells him to "Do what you need to do."

- President Roosevelt is known for the statement "Speak softly and carry a big stick." What does this statement mean? Is this a good policy for a nation to follow? What about for an individual?
- 🐾 Explain Moti's use of insults as a means of control over both Howard and Dickie. Why doesn't Moti fire Dickie himself?
- In what ways can a person use personal and positional power for the betterment of others? What is the responsibility of agent groups to work for justice for target groups?

Howard Stern Private Parts (Paramount Pictures and Ryshet Entertainment, 1997), screenplay written by Len Blum and Michael Kalesniko, directed by Betty Thomas

Elapsed time: This scene begins at 00:18:38 and ends at 00:22:09 (DVD Scene 6)

Rating: R for strong language, nudity, and crude sexual humor

The Hunchback of Notre Dame

In-group/out-group

The Victor Hugo classic is remade a la Disney style animation with

sweeping musical and dance numbers. A deformed bell ringer, Quasimodo, dreams of living outside of his belfry. On one fated day, he comes to the rescue of a beautiful gypsy named Esmeralda who is being persecuted during the town festival. Quasimodo falls in love with her and pledges to hide her in his sanctuary.

Quasimodo's master, Frollo, stops by the bell tower and finds Quasimodo talking with his stone gargoyle "friends." Frollo begins giving Quasimodo his alphabet lesson where he mentions a letter and Quasimodo says a word that begins with that letter ("A = abomination, B =blasphemy, C = contrition, D = damnation, E = eternal damnation"). When Quasimodo mentions his desire to attend the outdoor festival, Frollo scolds him and explains to him that his job is to protect Quasimodo from the scorn of the crowds; he tells Quasimodo that he is his only friend. Frollo sings, "Always remember what I taught you Quasimodo; you are deformed. You are ugly." Quasimodo repeats these lines and more, as Frollo states that Quasimodo is a monster and is reviled. Frollo gives him instructions to "Stay in here. Be faithful to me. Grateful to me. Do as I say—obey." Quasimodo resigns by saying, "You are good to me, master." The scene ends when Quasimodo finishes singing the song "Out There."

- 🐭 Do you feel that Frollo truly believes he is protecting Quasimodo? If you were born with a deformity, would you prefer to be hidden away from the world or would you want to experience all that life has to offer, including the inevitable—people staring at you and making fun of you?
- Well known for being a former slave and abolitionist, Frederick Douglass argued that he was only a slave as long as he wanted to be. Discuss how compliance and interdependence are mechanisms of power relationships.
- What are the processes by which a person can move from target to agent group? Are the processes similar for agent to target? In what ways is the ability to move between groups an individual rather than group process?

The Hunchback of Notre Dame (Walt Disney Pictures, 1996), written by Irene Mecchi, Tab Murphy, Jonathan Roberts, Bob Tzudiker, and Noni White, directed by Kirk Wise and Gary Trousdale
Elapsed time: This scene begins at 00:10:31 and ends at 00:16:26 (DVD Scene 3)
Rating: G for all audiences

I Now Pronounce You Chuck and Larry

Gender/stereotype

In a scam to gain pension benefits for his children, a heterosexual fire-fighter named Larry (Kevin James) asks his longtime buddy, Chuck (Adam Sandler) to pose as his domestic partner. The two get married as a way of fooling a city investigator who is trying to prove that the "couple" is actually straight. Things get really complicated when Chuck falls for his female lawyer who is fighting for their rights as a gay couple.

Larry exits his house to find the city investigator, Clinton Fitzer (played by Steve Buscemi), snooping through Larry and Chuck's garbage, which Clinton declares "not homosexual garbage." Larry panics, and he and Chuck begin to search for "gay stuff" to throw away. Larry' son, Eric (who is very effeminate and whose sexuality is questioned by Larry throughout the film) comes out of his room practicing a song for an upcoming school musical; Chuck wonders whether they should throw Eric away. Chuck and Larry then go to the grocery store to purchase more gay artifacts—items like a copy of *Brokeback Mountain*, compact discs by Barry Manilow, Liza Minnelli, and "the mothership [of gay]," a picture of the 1980s boy band, Wham! ⟨OBJ⟩

- In American popular opinion, in what ways do gender and sexual orientation intersect?
- ⚑ In this particular clip, the characters are shopping for "gay stuff." If you had to shop for "heterosexual stuff," what would you be looking for? What might these items say about what it means to be heterosexual?
- How should a person or a group of people that feels offended by a stereotype respond?

I Now Pronounce You Chuck and Larry (Universal Pictures, 2007), written by Barry Fanaro and Alexander Payne, directed by Dennis Dugan

Elapsed time: This scene begins at 00:43:54 and ends at 00:48:13 (DVD Scene 8)

Rating: PG-13 for crude sexual content throughout, nudity, language, and drug references

In the Mix

Power/discrimination

A young DJ named Darrell (pop superstar Usher) is hired to be the driver and bodyguard of the daughter of an organized crime syndicate. Darrell joins "the family" at the wrong time, though, because he has arrived in the middle of a hostile takeover and has fallen in love with Dolly, the boss's daughter—a double no-no.

After they spend the night together, Darrell wants to tell Dolly's father about their blossoming relationship—out of respect. Dolly wants to speak to her father first, but business precludes her. Dolly and Darrell decide to relax at the day spa. In the meantime, Jackie, one of Mr. Pacelli's henchmen, informs him of the tryst between Darrell and Dolly. Back at the spa, Dolly is in the shower while Darrell relaxes, but soon Mr. P. (Chazz Palminteri) and his boys barge in and try to drown Darrell. Mr. P. speaks of honor and betrayal and gets incensed at Darrell's comments of his love for Dolly and commands his flunkies to get rid of Darrell. Dolly returns from the shower to find her father sitting there looking at her with contempt. Mr. P. says, "This is not what I wanted for you." He mentions that she has "embarrassed" him and the family by hooking up with Darrell. She questions whether Darrell's skin color had anything to do with this conflict—"What did you want, a White guy?" Her father protests the insinuation. Knowing her father's penchant for violence, she begs for Darrell's safety, promising that she will do *anything* to save his life. Frank tells her to "end it now," meaning her relationship with Darrell. Darrell is spared; later, at his apartment, Dolly informs him that she has decided to marry Chad, a suitor approved by her father. The scene ends after Dolly slaps Jackie for making a racial slur about Darrell.

- In a land based upon ideals of individual freedom, are we free to make our own choices in life, or are our decisions always limited by the rules of society?
- Have you or any of your friends ever been in relationships to which your parents objected? What were the consequences?
- What advice would you give a person who was interested in pursuing an intercultural relationship (clashes of religion, race, or class)?

In the Mix (Lionsgate Films and 20th Century Fox, 2005), written by Jacqueline
Zambrano, directed by Ron Underwood
Elapsed time: This scene begins at 01:13:00 and ends at 01:20:50 (DVD Scene
10)
Rating: PG-13 for sexual content, violence, and language

The Incredibles

Oppression/invisibility

> A family of undercover superheroes, while trying to live the quiet sub-
> urban life, is forced into action to save the world from the evil machi-
> nations of a nerdy sidekick gone bad.

Following his wedding to Elastigirl, Mr. Incredible, a superhero, is sued by a
citizen he saved from committing suicide. Soon after, lawsuits abound against
superheroes. The government "quietly initiated" the Superhero Relocation Pro-
gram which grants amnesty in exchange for never resuming hero work. At a
press conference, a woman (legislator or judge) states, "It's time for their secret
identity to become their only identity. It's time for them to join us or go away."
A newspaper headline asks, in reference to the disappearance of the superhe-
roes, "Where are they now?" The narrator replies, "They are living among us—
average citizens, average heroes, quietly and anonymously continuing to make
the world a better place."

- 🎥 What unequal power relations are portrayed in this scene?
- 🎥 How does eliminating the visible presence of superheroes main-
 tain/destroy societal order?
- Imagine what it would be like to have super powers. What would your
 powers be? What would your super hero name be? Now, imagine that
 there was a law requiring you to never use your powers. How would
 you feel? What would you do?
- 🎥 What do the secret powers of this family suggest to you about
 gender: Mr. Incredible (strength), Elastigirl (rubber skin), Dash (super
 speed), and Violet (invisibility).

The Incredibles (Walt Disney Pictures, 2004), written and directed by Brad Bird
Elapsed time: This scene begins at 00:09:18 and ends at 00:11:34 (DVD Scene 2)
Rating: G for all audiences

John Q

Dominance/classism

John Quincy Archibald (Denzel Washington) is a man pushed to the edge—imagine your young son is playing baseball and as he is running the bases he has a massive coronary; imagine finding out that your insurance company will not pay for the operation and your son is going to die. What would you do? John decides to hold the hospital administration and patients hostage until they agree to perform the surgery.

John's only son is in the hospital fighting for his life; without a heart transplant he will die. The costs of his care are skyrocketing, and John is meeting with the human resources and insurance manager at his workplace. John has learned that because of a change in his insurance policy (which was unknown to him), he does not have the appropriate coverage for his son's operation. John believes that he is a full-time employee, but his new contract indicates that he has part-time status and therefore is only eligible for "second-tier" coverage of $20,000. John explains to the administrator that he has an in-hand policy that should be enforceable, especially since the premiums for the first-tier coverage had continued to be deducted from his paycheck. The administrator agreed "which is why we will cover you for the full twenty." John argues that since the company changed his status and changed his insurance policy, they should be responsible. The administrator states, "That doesn't seem right, does it?" He informs John that he has the right to appeal the decision. John seeks additional coverage, but because he already has medical coverage, he is ineligible for supplemental insurance; he is also ineligible for public assistance because he and his wife both have jobs. He continues to get the runaround from a variety of sources. One insurer apologizes to John for denying his application, but John responds, "I don't need you to be sorry. I need you to help me!" The scene ends after the hospital administrator (Anne Heche) informs John that their generosity has ended and John walks out of her office.

- In what ways are public assistance and welfare stigmatized in American society?
- Discuss your reactions to the following questions about career choice and interest: What major/career is prestigious? What major/career is frivolous? What major/career is difficult? What major/career is easy?
- Discuss the ways in which discrimination is manifested in the medical industry along the lines of race, gender, class, and sexual orientation.

John Q (New Line Cinemas, 2002) written by James Kearns, directed by Nick Cassavetes

Elapsed time: This scene begins at 00:24:05 and ends at 00:28:19 (DVD Scene 6)

Rating: PG-13 for violence, language, and intense thematic elements

Jungle Fever

Racism/prejudice

Flipper Purify (Wesley Snipes), an up-and-coming Black architect at a prestigious firm, has an affair with an Italian-American secretary at his office. Both Angela (Annabella Sciorra) and Flipper must face the ire of their friends and family. Can their new love stand the test?

Flipper and Angela are discussing their possible future together when Angie brings up the subject of children. Flipper indicates that he is not interested in having children with Angie—referring to biracial children as "mixed nuts." Angie mentions that both Flipper's wife and daughter have White ancestry, but Flipper states that in his eyes, they "look Black, act Black, so they are Black." [OBJ]

- Evaluate this statement: Racial minorities cannot be racist.
- 🎥 Flipper uses the terms octoroon, quadroon, and mulatto. What do these terms mean in an American historical context?
- In the year 2050, do you think there will be more or fewer interracial couples and marriages?
- What are the challenges faced by interracial or intercultural couples?

Jungle Fever (40 Acres and a Mule Filmworks, 1991) written and directed by
 Spike Lee
Elapsed time: This scene begins at 01:48:16 and ends at 01:50:03 (DVD Scene
 17)
Rating: R for drug use, language, and violence

Kicking and Screaming

Difference/heterosexism

Tired of being in his famous father's shadow, shy suburbanite Phil
Weston becomes the coach of his son's soccer team—the trouble is,
Phil has never played the game nor does he have any athletic prow-
ess. His team of underdogs manages to make it to the championship
where Phil must face his own father's team.

This scene begins as Phil is introduced to the parents of one of his players. Phil
is sort of stunned when he realizes that the child has two moms (lesbians). In
his attempts to be gracious, Phil looks around and whispers that he under-
stands that they "are not like the other parents at all." He mentions that they
are "better" because they are different, which angers one of the other children's
parents.

- 🎞 What did you notice about Phil's reaction to his realization of the
 sexuality of the two women?
- What are the best mechanisms for recognizing similarities and differ-
 ences between groups? How do we create coalitions across difference?
- How would you answer this question: Who are the students who feel
 most culturally safe in our campus community? Who are the students
 who feel most unsafe?

Kicking and Screaming (Universal Pictures, 2005), written by Leo Benvenuti and
 Steve Rudnick, directed by Jesse Dylan
Elapsed time: This scene begins at 00:17:39 and ends at 00:19:00 (DVD Scene
 5)
Rating: PG for thematic elements, language, and some crude humor

Kill Bill (vol. 1)

Ethnocentrism/power

The Bride (Uma Thurman) has emerged from a coma after being shot at her wedding more than 4 years ago, and she is hell-bent on hunting down the man who tried to kill her. One by one she kills off every single member of his squad of international assassins.

The Bride narrates how O-Ren Iishi (Lucy Liu) and her band of killers, The Crazy 88, took control of the crime syndicate in Tokyo. She introduces several players around the conference table, beginning with her lawyer, "the half-French, half-Japanese Sofie Fatale." The next one to be introduced is Gogo, O-Ren's bodyguard, whose "madness" makes up for her youth; Gogo refers to Ferraris as "Italian trash." The Bride questions how "a half-breed, Japanese-Chinese American became the boss of all bosses in Tokyo." She responds by intimating that "the subject of O-Ren's blood and nationality" only came up once in their meetings. On the night of her appointment to the head of the crime council, one of the council members, Boss Tanaka, protests what he calls "the perversion of our illustrious council." He describes the council as something he loves "more than my own children." The perversion to the council, as Tanaka, sees it is "making a Chinese-Jap American half breed bitch its leader!" O-Ren immediately dispatches Boss Tanaka and decapitates him with her sword. She addresses the remaining bosses, "So that you understand how serious I am, I am going to say this in English. As your leader, I encourage you, from time to time, and always in a respectful manner, to question my logic But allow me to convince you; and I promise you here and now, no subject will ever be taboo—except, of course, the subject that was just under discussion. The price you pay for bringing up either my Chinese or American heritage as a negative" is certain death (as she holds up Boss Tanaka's head). The scene ends when O-Ren adjourns the meeting. [OBJ]

- 🎞 What is the significance of O-Ren's speaking in English as a symbol of her austerity?
- What is the difference between patriotism and ethnocentrism?
- Historically, how would you describe the experiences of mixed-race people? How would you describe their social experiences?

Kill Bill, vol. 1 (Miramax Films, 2003), written and directed by Quentin Tarantino

Elapsed time: This scene begins at 00:59:00 and ends at 01:04:29 (DVD Scene 12)

Rating: R for strong, bloody violence, language, and some sexual content

Kingdom of Heaven

Social justice

Traveling into Jerusalem during the time of the Crusades in the Middle Ages, a young knight, Balian of Ibelin (Orlando Bloom) finds himself leading a battle to save the Holy Land from its enemies.

The walls of Jerusalem are facing imminent attack from Muslim opposition; theirs is a battle for rightful ownership of the land within the city walls. The men of the city have gathered to hear Balian's words of encouragement. Balian says, "It has fallen to us to defend Jerusalem, and we have made our preparations as well as they can be made. None of us took this city from the Muslims. No Muslim, of the great army now coming against us was born when this city was lost." He explains how the Muslim temples were built on Jewish holy lands that were laid waste by the Romans. He asks, "Which is more holy—the wall, the mosque, the sepulcher?" His answer, "No one has claim. All have claim! We defend this city, not to protect these stones, but the people living between these walls." A concerned cleric asks how they will defend their borders without knights. Balian commands any man who is able to carry a weapon to kneel, and there he commissions them to "rise as knights." He gives them instruction to "be without fear in the face of your enemies. Be brave and upright that God may love thee. Speak the truth even if it leads to your death. Safeguard the helpless. That is your oath." The cleric questions Balian's authority to "alter the world." He asks, "Does making a man a knight make him a better fighter" to which Balian turns and says, "Yes" and walks away.

- What is our responsibility to encourage and empower the oppressed?
- What are ways in which we can engage to help those who are discriminated against?
- 🎞 What is achieved when Balian "knights" the citizens of Jerusalem?

Kingdom of Heaven (20th Century Fox, 2005), written by William Monahan, directed by Ridley Scott
Elapsed time: This scene begins at 01:41:00 and ends at 01:44:54 (DVD Scene 35)
Rating: R for strong violence and epic warfare

A Knight's Tale

Classism

> Inspired by *The Canterbury Tales*, this is the story of William Thatcher (Heath Ledger), a young squire with a gift for jousting. After his master dies suddenly, the squire hits the road with his cohorts Roland and Wat. Along the journey, they stumble across an unknown writer, Geoffrey Chaucer. William, lacking a proper pedigree, convinces Chaucer to forge genealogy documents that will pass him off as a knight. With his newly minted history in hand, the young man sets out to prove himself a worthy knight at the country's jousting competition and finds romance along the way.

William, Roland (Mark Addy), and Wat (Alan Tudyk) have just discovered that the nobleman they have been working for has died in a jousting competition. The group is faced with deciding how they will continue to earn money. William decides that he will ride in the place of his deceased master, but Roland reminds him of his station—"What's your name, William? I'm asking you, William Thatcher, to answer me your name. It's not Sir William. It's not Count or Duke or Earl William. It's certainly not King William. . . . You have to be of noble birth to compete." The scene ends when William states, "Then pray that they don't [find out his true identity]."

- In what ways are people today being excluded because of their socioeconomic class?
- How does a person achieve the "American Dream"? What, then, is the "American Nightmare"?
- What price do people pay for trying to rise above their current social positions? How is "hard work" not enough?
- What impact can being a member of a certain social class have on a person's self-concept?

A Knight's Tale (Black and Blu Entertainment, 2001), written and directed by
Brian Helgeland
Elapsed time: This scene begins at 00:00:25 and ends at 00:03:10 (DVD Scene
1)
Rating: PG-13 for action, violence, and some brief sex-related dialogue

Knocked Up (2007)

Dominance/power/prejudice/oppression

> After a night of drunken passion, Alison and Ben find out that they
> are expecting a baby. The next 9 months are a roller coaster for Ben,
> who has spent his entire adulthood drinking and getting high, and
> Alison, an up-and-coming star on E! Entertainment Network. Can
> they work through their differences to make a life for themselves and
> their baby?

Alison (played by Katherine Heigl), who works on the set of E! News, finds
out that she is being promoted to an in-front-of-the-camera position where
she will be interviewing celebrities. While making the announcement, her su-
periors suggest that Allison needs to lose weight. Her female superior also
makes sarcastic remarks that suggest that it is incredible that Alison got the
promotion in the first place.

- During a physical exam, your doctor (of the opposite sex) starts mak-
 ing sexual advances toward you. What would you do? How would you
 react if the doctor were of the same sex?
- Discuss this quote by philosopher Friedrich Nietzsche: "People who
 feel insecure in social situations never miss a chance to exhibit their
 dominance over close, submissive friends, whom they put down pub-
 licly, in front of everyone—by teasing, for example."
- How are unmarried pregnant women treated in our society? How do
 you know this?

Knocked Up (Universal Pictures, 2007), written and directed by Judd Apatow
Elapsed time: This scene begins at 00:07:00 and ends at 00:08:47 (DVD Scene
5)
Rating: R for sexual content, drug use, and language

The Last King of Scotland

Gender/power

> Forest Whitaker (in his Oscar-winning role) plays Ugandan president and dictator, General Idi Amin. The story describes how Amin befriends a Scottish doctor named Nicholas Garrigan, and the two lead a life of excess until Amin's ruthless behavior becomes more than the doctor can stand. Based upon the novel of the same title by Giles Foden.

Dr. Nicholas Garrigan (James McAvoy) has become the friend and physician of Idi Amin, president of the African nation of Uganda. President Amin has invited Nicholas to a party, and when he arrives, Nicholas is introduced to Amin's three wives (each described by the number of children borne to the couple). Amin calls everyone to attention and begins to lecture the guests about Africa being the cradle of civilization and how its historical significance and contributions had been stolen by other cultures and nations. He urges his fellow Ugandans to appreciate their rich heritage. Later, the president calls Nicholas to his bedside; Amin is in great pain and assumes that someone has tried to poison him. After a brief examination, Dr. Garrigan ascertains that the president is flatulent and needs relief. President Amin apologizes for allowing him to be seen in such a vulnerable position; he says, "I am ashamed that you saw me like that. I was frightened." Garrigan responds that he will keep their meeting confidential, to which Amin states, "But a man who shows fear, he is weak and he is a slave." President Amin shares his rise to power from poverty, being abandoned by his father, and being abused by the British army who took him in as a servant. Amin says, "And now, here I am, the president of Uganda. And who put me here? It was the British." The scene ends when the men say goodnight to each other.

- • ❧ Evaluate the meaning of Amin's introductions of his wives. Compare and contrast the value of women in American and Ugandan societies.
- • ❧ How did Amin's negative circumstances influences his rise to power? What lessons might we learn from this story?
- • Discuss the role of fear in the quest for societal dominance.

The Last King of Scotland (Fox Searchlight Pictures, DNA Films, and Filmfour, 2007), written by Peter Morgan and Jeremy Brock, directed by Kevin McDonald

Elapsed time: This scene begins at 00:29:42 and ends at 00:37:16 (DVD Scene 8)

Rating: R for some strong violence and gruesome images, sexual content, and language

Lean on Me

Power

Academy Award–winning actor, Morgan Freeman, stars in this biopic of Mr. Joe Clark, a tough-as-nails school principal called in to lead East Side High School in Paterson, New Jersey, a school failing in every way: drugs, violence, and kids who cannot pass a basic skills test. To show the miscreants that he means business, Mr. Clark speaks loudly (with a bullhorn) and carries a BIG stick (a Louisville Slugger). His exploits are controversial but very successful.

Mr. Clark has made several enemies because of his blatant disregard for district policies, especially when he required school doors to be locked with chains because the school could not afford security doors. His biggest enemy, Mrs. Barrett, has requested a meeting with the mayor, the fire chief, the school's superintendent, and several other community members. Mrs. Barrett wants Mr. Clark fired at any cost, and she wants the mayor to appoint her to the school board so that she can lead the charge. Barrett warns the mayor that she has the political clout to bar his reelection if she does not get her way. The mayor concedes, and he and the fire chief devise a plan to catch Mr. Clark with the chains on the locked doors (a fire code violation).

- It has been said that "the ends justify the means." What are your feelings about using torture as interrogation as a national security strategy?
- Evaluate this quote by civil rights leader, Malcolm X: "The day that the Black man takes an uncompromising step and realizes that he is within his rights, when his own freedom is being jeopardized, to use any means necessary to bring about his freedom or put a halt to that injustice, I don't think he'll be by himself."

- In what ways are political elections in America unfair? How do race, class, gender, and sexual orientation affect a person's candidacy and electability?

Lean on Me (Warner Bros., 1989) written by Michael Schiffer, directed by John Avildsen

Elapsed time: This scene begins at 01:11:10 and ends at 01:14:15 (DVD Scene 21)

Rating: PG-13 for language and some conversation about teen pregnancy

Legally Blonde

Stereotype

Elle Woods (played by Reese Witherspoon) has little on her mind besides her sorority sisters, popularity, and marrying well. When her beau, Warner, is accepted to Harvard Law School, he breaks up with Elle because he feels that Elle's "type" would be a liability to his future plans. Elle enrolls in Harvard Law with the hope of gaining Warner's affection but ends up finding herself—and, winning a high-profile murder case.

Elle is on the telephone with her girlfriend as she is waiting in line for the water fountain outside the courtroom. Enrique, a witness in the case that Elle and her team are trying, skips in front of her in line; Elle taps her foot in defiance. Enrique turns and chides Elle for stomping her "last season Prada shoes" at him; Elle insists to her team that Enrique is gay (although he has testified that he is the lover of the female defendant) because "gay men know designers." The scene ends as the judge is silencing the courtroom after Enrique's lie is exposed. [OBJ]

- Discuss the meanings behind these words often used to describe gay men: metrosexual, flamer, queen, queer.
- Evaluate this comment: The face of gay America is White.
- Gay men in mainstream American films are often portrayed as affluent or wealthy. Discuss the intersections between sexual orientation and class.

Legally Blonde (Metro Goldwyn Mayer Pictures, 2001), written by Karen Lutz and Kirsten Smith, directed by Robert Luketic
Elapsed time: This scene begins at 01:10:23 and ends at 01:13:05 (DVD Scene 25)
Rating: PG-13 for language and sexual references

License to Wed

Power

Sadie Jones is engaged and wants to get married in her home church, by her favorite minister, Father Frank. The minister's methods of premarital counseling are a bit unorthodox, but he assures they are 100% effective. Can Sadie's fiancé, Ben, survive the tests?

Sadie Jones (Mandy Moore) is planning to get married; she and her fiancé, Ben (John Krasinski) are going to visit Father Frank (Robin Williams) to set a date for the wedding. A cancellation will allow them to wed in 3 weeks. Father Frank and his protégé, Choir Boy, explain that the former has instituted a new marriage preparation course for all couples who will be married at the church. He explains that should a couple not satisfactorily complete the preparation course, then Father Frank has "the right to call off the wedding." Even though Ben questions and objects to the course, Choir Boy indicates they "have no choice." Father Frank explains the rules of the course, which include the couple to write down their own wedding vows to be read at the ceremony and to refrain from having sex until the honeymoon. Ben clearly is uncomfortable with this second rule. The scene ends as Sadie and Ben leave the church.

- Have you ever been required to follow a set of strict rules in preparation for something? How did that feel? Were you successful?
- What power do these leaders have over their congregations? How might the power of religious leaders be exercised and/or misused?
- How is submission viewed in American culture? How does submissiveness fit within the values of our society?
- In what ways do power dynamics play out in families and marriages?

License to Wed (Warner Bros., 2007), written by Kim Barker, Tim Rasmussen, and
Vince DiMeglio, directed by Ken Kwapis
Elapsed time: This scene begins at 00:11:26 and ends at 00:15:48 (DVD Scene
4)
Rating: PG-13 for sexual humor and language

The Lion King

Social justice

> When a young lion prince named Simba is born in Africa, his uncle
> Scar is forced to become the second in line to the throne. Scar plots
> with the hyenas to kill King Mufasa and Prince Simba, in order to
> become the king himself. King Mufasa is killed and Simba is led to
> believe by Scar that it was his fault, and so flees the kingdom in shame.
> After years of exile he is persuaded to return home to overthrow the
> usurper and claim the kingdom as his own.

Young Simba is being taught about the "Circle of Life" by his father Mufasa,
who explains the delicate balance of power when coexisting with other crea-
tures. When Mufasa mentions respecting all creatures, "from the crawling ant
to the leaping antelopes," Simba asks, "But, Dad, don't we eat the antelopes?"
Mufasa gives this explanation: "When we die, our bodies become the grass,
and the antelope eat the grass; and so, we are all connected in the great Circle
of Life."

- 🎥 How would you describe the "Circle of Life" in America? In what
 ways does/doesn't our country's president understand the balance?
- It could be said that equality is not possible in America—how might
 someone come to this decision? If you disagree with the statement,
 describe how you come to this decision?
- What are the best ways to break down barriers between groups in or-
 der to achieve a proper balance?

The Lion King (Walt Disney Pictures, 1994), written by Irene Necchi and Jona-
than Roberts, directed by Roger Allers and Rob Minkoff
Elapsed time: This scene begins at 00:08:01 and ends at 00:10:02 (DVD Scene
3)
Rating: G for all audiences

The Little Mermaid

Prejudice

Ariel is one of the mermaid daughters of Triton, the king of the sea. She has everything that a mer-princess could ever want, but she longs for life above the sea and on land. She falls in love with a human named Eric, whom she saves when his ship sinks in the sea. Ursula, the sea witch, grants Ariel's wish to be human, and the spell will only remain permanent if Eric falls in love with a voiceless Ariel. Love triumphs!

King Triton has learned that Ariel has fallen in love; he believes the lucky suitor is a merman, but Sebastian, the king's assistant, informs the king that Ariel is really in love with a human. The king finds Ariel in her favorite hideaway where she has a collection of artifacts from land, including a statue of Prince Eric—to which she is proclaiming her undying affection. Triton begins destroying the collection despite Ariel's pleas. She mentions that her father is being unreasonable because he does not know Eric. Triton responds, "I don't have to know him. They're all the same—spineless, savage, harpooning fish-eaters, incapable of any feeling."

- Has there ever been a person in your life whom your parents or friends "warned" you about, when they didn't know them?
- Why might it be important to highlight both similarities and differences as a means of overcoming prejudice?
- How do your perceptions about how others see you or "your kind" impact your attempts to build relationships with others?

The Little Mermaid (Walt Disney Pictures, 1989) written and directed by John Musker and Ron Clements

Elapsed time: This scene begins at 00:32:39 and ends at 00:36:28 (DVD Scene 12)

Rating: G for all audiences

Love Don't Cost a Thing

Ethnocentrism/homophobia

Take 1980s hit movie *Can't Buy Me Love* and add a racially diverse

cast and a hip-hop soundtrack, and you've got *Love Don't Cost a Thing.* Nerdy Alvin Johnson, a social outcast, would love to be popular. He sacrifices his college scholarship, a prestigious prize from General Motors, even his longtime friends for an opportunity to pretend to date the hottest girl in school because he believes that she is the ticket to high school superstardom.

Alvin (Nick Cannon) and his friends desire to be cool enough to be able to walk down the popular kids' hallway. They realize that they do not have the social capital to do so because they are "invisible" to the popular crowd. Al's friend, Kenneth (Kal Penn) states that "in that community, we're immigrants without green cards." Fed up with being a social misfit, Walter (Kenan Thompson) decides to walk down the hallway; he is immediately rebuffed. Walter tries to prove his coolness by showing some of the male jocks that he is wearing brand-name jeans, and when he turns around to show them the label on his jeans, Ted (Al Thompson) pushes him against a locker and asks him, "Is that the gay surrender? You a homo thug?" He threatens Walter with physical violence. The scene ends as Al and his friends carry Walter away. OBJ

- Who determines who or what is cool in high school or other institutions?
- Why would Walter point to his brand-name jeans to prove he is cool?
- Why does Ted resort to using homophobic slander against Walter?
- In what ways do we see bias related to a person's *perceived* sexual orientation?

Love Don't Cost a Thing (Alcon Entertainment, 2003), written by Troy Beyer and Michael Swerdick, directed by Troy Beyer

Elapsed time: This scene begins at 00:08:21 and ends at 00:11:35 (DVD Scene 4)

Rating: PG-13 for sexual content and humor

Madea's Family Reunion

Out-group

The Simmons family has been brought together for a family reunion

and a wedding all in the same weekend. Madea (Tyler Perry), the cranky matriarch, tries to hold them together with a strong hand. She gives advice, doles out discipline, and teaches the young women how to be strong, even in the face of trying circumstances.

Aunt Ruby, the family's oldest living relative, gathers the entire family together at the site of the plantation where their progenitor lived as a slave. Aunt Myrtle (played by Cicely Tyson) lectures the younger members of the family on the importance of reclaiming their heritage as proud Black people who see themselves as more than drug dealers, gangbangers, and sexualized beings. The scene ends when the elder mothers say "God bless you."

- If you could save the life of a member of the Aryan nation, the skinheads, the Ku Klux Klan, would you do so? Why or why not?
- How might minority children learn more from a good teacher of the same race than from a good White teacher?
- Elders, such as grandparents, often are sources of "pearls of wisdom." What is the best piece of advice you've received from an elder?
- If Rev. Dr. Martin Luther King, Jr. were alive today, what issues would he be tackling? What is the status of his "dream" today?

Madea's Family Reunion (Lion's Gate Films, 2006), written and directed by Tyler Perry

Elapsed time: This scene begins at 01:21:13 and ends at 01:26:10 (DVD Scene 17)

Rating: PG-13 for mature thematic material, domestic violence, sex, and drug references

Maid in Manhattan

Invisibility/out-group

Marisa Ventura (Jennifer Lopez) is a single mother born and bred in the boroughs of New York City; she works as a maid in a first-class Manhattan hotel. Through a twist of fate and mistaken identity, Marisa meets Christopher Marshall (Ralph Fiennes), a handsome heir to a political dynasty, who believes that she is a guest at the hotel. Fate steps in and throws the unlikely pair together for one night. When

Marisa's true identity is revealed, the two find that they are worlds apart, but the power of love prevails.

Marisa has lost her job and after several hours returns home where her mother and son are waiting. Marisa's mother chides her for losing her job and for trying to date outside her class and station. She asks, "Where's your pride?" Marisa forcefully responds, "People like you make people like him some kind of God—why—because he's rich, he's White, he has things we don't have, that we don't even want to dream about? It must really burn you that I think I have the right to go out with him." Mom responds matter-of-factly, "You don't." The scene ends when Marisa closes the bathroom door.

- 🎬 It appears that Marisa's mother is not supportive of her dreams. What do you feel about her advice to start working with another maid service?
- This film features story lines about interracial dating and crossing socioeconomic class boundaries. What are the dating rules in your family?
- 🎬 If you were in Marisa's shoes, how would you have handled the situation?

Maid in Manhattan (Revolution Studios, 2002), written by John Hughes, directed by Wayne Wang

Elapsed time: This scene begins at 01:27:58 and ends at 01:30:47 (DVD Scene 25)

Rating: PG-13 for some language/sexual references

Malibu's Most Wanted

Co-optation/privilege

A senator arranges for his son, a rich White kid who fancies himself Black, to be kidnapped by a couple of Black actors pretending to be gangsters to try and shock him out of his plans to become a rapper.

As the film opens, we are introduced to Bradley Gluckman (a.k.a. B-Rad G), the son of a gubernatorial candidate in California. B-Rad is White but has appropriated a pseudo-Black hip-hop culture and sees a future for himself as

a gangsta rapper. The scene opens with images of inner city life (guns, drugs, drive-by shootings) as the narrator (B-Rad) discusses the perils of life in the ghetto. B-Rad (played by Jamie Kennedy) mentions that there are no streets tougher than the ones he lives on . . . in Malibu, California, with its "bag ladies" (shopping in expensive stores), "ballers" (Little League baseball teams), how "everybody's strapped with a nine" (golf clubs). He refers to "my ghetto—the mall," which is divided into "crews and sets" (terms for street gangs) like "the Beach Boys and the ACC (Abused Children of Celebrities)." His home is a mansion overlooking the beach; Brad states that "it ain't much, but it's all I got."

- How do you identify racially? What factors make up your racial identity?
- What are the consequences (individual, social, societal) of living a "raced" life?
- If given the option to live for a period of time in a different racial group, what race would you choose and why? What would you expect to learn?
- In what ways do race and socioeconomic class interface in this culture?
- Evaluate this statement: "Every American, merely by virtue of landing on these shores, becomes culturally part Yankee, part American Indian, and part Black, with a little pinch of ethnic salt."

Malibu's Most Wanted (Warner Bros., 2003), written by Fax Bahr and Adam Small, directed by John Whitesell
Elapsed time: This scene begins at 00:00:05 and ends at 00:02:40 (DVD Scene 1)
Rating: PG-13 for sexual humor, language, and violence

Man of the Year

Power

In a world where most people get their news from comedians with a journalistic flair, what would life be like if John Stewart, Steven Colbert, or Jay Leno ran for president of the United States? Well, Tom Dobbs (Robin Williams) is a popular stand-up comic with a news

program who decides to campaign for the nation's highest office—and wins. Isn't life funny?

It is Election Day and Tom Dobbs is outpacing the presidential incumbent in virtually every state in the union. Eleanor Greene, a software designer for Delacroy, had learned that there was a computer glitch in the electronic voting system she developed. She alerted the president of the company, who told her that the error was simply a problem with her own computer. As she watches the election returns, she realizes that the system has malfunctioned and the wrong man (Dobbs) has won the presidential election. She confronts the president of the company who questions if she is calling him a liar when he said the problem was fixed. Delacroy's chief counsel, Stewart (Jeff Goldblum), asks why she was testing the system anyway. He asks, "Look into your soul and ask yourself this question. Why would you test the computer at such limits with so few days left to fix a problem if you found one?" (Delacroy stands to lose billions of dollars should an error be found as they have the sole contract with the federal government for the electronic voting system.) Stewart asks, "Do you want to destroy this company? Because that's what you may do. Do you want to put over 1,000 employees out of work?" Eleanor argues back that the election will be fraudulent, to which he responds, "Here it is: the people are voting; there is an election; the democratic process is working. The only sour note? They won't end up with the person they voted for to be the president." When Eleanor continues to question the legality and propriety, he responds, "Perception of legitimacy is more important than legitimacy itself. That's the greater truth." He encourages her to fix the problem for future elections but warns her to forget about what she has learned about the current election. The president and Stewart continue to talk after Eleanor leaves. Goldblum says, "I don't know if she's enrolled in the program . . . I'm gonna make a phone call." Later, when Eleanor is alone in her apartment, she is attacked and drugged. The scene ends after Dobbs is declared the president of the United States.

- 🐾 What would you do if you were the software analyst and you found this problem?
- 🐾 Examine the statement, "Perception of legitimacy is more important than legitimacy itself." What does this mean? Do you agree or disagree?
- What would be the national and global implications of a celebrity comedian/journalist winning the presidency of the United States?

Man of the Year (Morgan Creek, 2006), written and directed by Barry Levinson
Elapsed time: This scene begins at 00:33:45 and ends at 00:46:15 (DVD Scene 6)
Rating: PG-13 for language including some crude sexual references, drug-related material, and brief violence

The Matrix Revolutions

Out-group/social justice

The conclusion of the sci-fi trilogy brings "The Chosen One," Neo, (Keanu Reeves) into the heart of Machine City to wage war against the Machines who are hell-bent on total human domination and destruction.

Archenemies Neo and Agent Smith (Hugo Weaving), a powerful renegade warrior, have been waging the battle of all battles; Neo has been taking a beating. As the scene opens, Neo is barely conscious and lying in a puddle of water. As he stirs, Agent Smith asks Neo, "Why? Why? Why? Why do you do it? Why do you get up? Why keep fighting? Do you believe you're fighting for something?" Smith continues to question human values of freedom, peace, and love, citing the inevitability of human destruction. When Smith asks him one more time, "Why do you keep fighting?" Neo responds, "Because I choose to." Their epic battle ends when Neo destroys Agent Smith.

* What are the benefits and personal risks of being a social justice advocate?
* What are the attributes of a good ally?
* 🐾 Explain the significance of Neo becoming a clone of Agent Smith before Neo was able to defeat his enemy?

The Matrix Revolutions (Warner Bros., 2003), written and directed by Andy and Larry Wachowski
Elapsed time: This scene begins at 01:48:00 and ends at 01:54:35 (DVD Scene 29)
Rating: R for sci-fi violence and some sexuality

Mean Girls

Discrimination/dominance/stereotype

Cady (Lindsay Lohan) is a new student at a Michigan high school; she and her family have lived most of her life in Africa. She struggles to make friends and learn the rules and roles of life in suburban America.

Cady is being toured around the cafeteria by her friends Damien and Janis. They draw a map of the lunchroom for Cady; the map shows where each specific social group sits—"the preps, JV jocks, Asian nerds, cool Asians, varsity jocks, unfriendly Black hotties, girls who eat their feelings, girls who don't eat anything, desperate wannabes, sexually active band geeks, and the dominant group, the plastics." Later, Cady is asked to sit down with the plastics, one of whom questions, "If you're from Africa, why are you White?" The scene ends with Cady being taught the rules that the plastics are bound to uphold.

- 🐭 How is the situation in this scene realistic or unrealistic based on your own high school experience?
- 🐭 For what reasons would the plastics, who are supposedly evil, go out of their way to invite Cady to eat with them? What is significant about their list of rules?
- 🐭 If you were to create a ranked order list of the groups listed by Janis (from least to greatest in terms of social standing), what would that list look like? What does this say about power and social status in your community?
- How does one group gain social dominance over other groups?

Mean Girls (Paramount Pictures, 2004), written by Tina Fey, directed by Mark Waters

Elapsed time: This scene begins at 00:08:40 and ends at 00:11:52 (DVD Scene 2)

Rating: PG-13 for sexual content, language, and some teen partying

The Mighty Ducks

Ethnocentrism/out-group

What do you get when you cross a successful trial lawyer and a ragtag bunch of pee wee hockey players? A recipe for family entertainment. Emilio Estevez plays Gordon Bombay who becomes coach for the skill-lacking District 5 team, The Ducks, who move from underdog status to challenge the top team in the league.

Coach Bombay has recently learned that the district boundaries have changed and one of the best players on the Hawks (the champions) squad now lives in Ducks' territory. League rules require that Adam Banks, the star player, must transfer to the proper district or the Hawks will forfeit the season. Adam's father vehemently states that his son "would rather not play than play" for the Ducks. Coach Reilly, the Hawks' coach (and Coach Bombay's former mentor), argues with Coach Bombay about the situation. Coach Bombay suggests that the Hawks "got a whole team of Banks. One kid isn't going to make a difference." Coach Reilly retorts, "Even with Banks, what do you think you're gonna prove, you and that bunch of losers?" Coach Bombay answers back, "That's right coach, they are losers. We hate losers. They don't even deserve to live." Coach Bombay was being sarcastic, but he was not aware that two of his players were eavesdropping nearby. The scene ends after several Ducks' team members walk out of the locker room after the comments that the coach had made.

- Discuss competition as an important value in American culture.
- How different does a person or group of persons have to be before they will be considered as "other"? How important is the degree of similarity or difference when determining group identity?
- What would happen if all the people in the world were the same? What kinds of traditions would exist? What holidays would we celebrate? Which holidays would no longer be celebrated? How difficult would it be to decide on those important things? What would we gain and what would we lose?

The Mighty Ducks (Walt Disney Pictures, 1992), written by Steven Brill, directed by Stephen Herek

Elapsed time: This scene begins at 00:55:05 and ends at 00:59:22 (DVD Scene 14)

Rating: PG for mild language

Miss Congeniality

Sexism/invisibility

> Learning about a plot to explode a bomb at the Miss United States beauty pageant, the FBI sends one of its own agents undercover as a contestant. There's only one problem: Gracie (played by Sandra Bullock) is no beauty queen—she fights, pigs out, and has few social graces. How will she fit into the world of poise and manners?

Gracie is trying to get her colleagues to hear her ideas about how and where the suspect will attack; the men are virtually ignoring her. In the briefing room, all of the male agents are seated around a table and are clueless about how to move forward. Gracie, the only female who speaks (the other female agent is completely silent and in the background), offers a variety of ideas, and the lead agent takes credit for all of her suggestions. While trying to decide which female agent will take on the undercover assignment, the male agents use a children's software program to dress and undress the female agents. Soon the room is full of male agents ogling the more svelte and attractive females and wincing at the images of the less attractive agents. The scene ends as the agents bring up Gracie's picture and declare her "not bad."

- Research has shown that teachers often pay more attention to or value the opinions of boys more than girls. How is this true in your school?
- In her argument about the significance of male-over-female domination, feminist Andrea Dworkin stated that "Sexism is the foundation on which all tyranny is built." How might she have come to this position?
- How has feminism been vilified? How might terms like Femi-Nazi be used against women's rights?
- How does beauty relate to power, job opportunities, and career advancement?

Miss Congeniality (Castle Rock Entertainment, 2000), written by Marc Lawrence and Katie Ford, directed by Donald Petrie
Elapsed time: This scene begins at 00:15:20 and ends at 00:20:02 (DVD Scene 5)
Rating: PG-13 for sexual references and a scene of violence

Mona Lisa Smile

Compulsory heterosexuality/gender

Miss Katherine Watson (Julia Roberts) is a new member of the art history faculty at the esteemed Wellesley College for women. Set in the 1950s, the Wellesley women were the smartest in the country and were getting the best education but were expected to fulfill only the life roles of wife and mother. Miss Watson wanted to challenge all that!

Miss Watson's students invite her to join their secret society called "Adam's Rib," where they play a game of truth and consequences. The young ladies question Miss Watson's decision not to be married. Soon after, one of her students, Betty (Kirsten Dunst), writes a scathing rebuke of Miss Watson's subversive and political teaching methods that encourage the women to be free thinkers and to not be limited by traditional thoughts of women as wives and mothers only. During a classroom lecture on contemporary art, Miss Watson shows magazine advertisements with women as housewives and juxtaposes that with their prestigious Wellesley training.

- 🐭 Miss Watson asks the students how they wish to be remembered 50 years in the future. How would you want to be remembered?
- 🐭 The "Adam's Rib" society refers to a biblical reference where Eve was created from a bone taken from Adam's body. What does your faith tradition teach about the role of women?
- In what ways do gender constructions impact a man's decision to report acts of violence, assault, or rape against himself?

Mona Lisa Smile (Columbia Pictures, 2003), written by Lawrence Konner and Mark Rosenthal, directed by Mike Newell

Elapsed time: This scene begins at 01:02:48 and ends at 01:11:50 (DVD Scene 18)

Rating: PG-13 for sexual content and thematic issues

Monster's Ball

Racism

Talk about star-crossed lovers! Hank (Billy Bob Thornton), an angry,

miserable prison guard who works on Death Row falls in love with Leticia (Halle Berry in her Academy Award–winning role), the wife of the man whom he will be responsible for leading to the electric chair.

Hank has arrived home to greet his ailing father who is adding news articles to a scrapbook that he keeps on the trial and expected execution of the man who killed his wife. While they are eating breakfast, Buck (Peter Boyle) notices two Black children in his yard. He asks Hank, "What the hell are those niggers doing out there? Damn porch monkeys. Be moving in here soon, sitting next to me, watching my TV. There was a time when they knew their place. Wasn't none of this mixing going on." He continues, "Your mother, she hated them niggers too." Moments later, Hank is storming off his porch with a rifle and threatens the young boys, who have come to visit Sonny, Hank's son, who has just arrived. He demands that they get off his property and shoots the gun into the air to scare the boys. Buck watches out the window with an approving smile on his face. The scene ends as Hank walks back into the house. [OBJ]

- Discuss the prevalence and manifestations of racism in today's society.
- What does it mean when someone is supposed to "know their place"? Name some groups to whom this terminology is often affixed.
- In what ways can racism be likened to a communicable disease, a religion, and an inheritance?
- 🎬 The children in this scene pose little threat to Hank and Buck. Why does he threaten them with a rifle, then?

Monster's Ball (Lionsgate Films, 2001), written by Milo Addica and Will Rokos, directed by Marc Forster

Elapsed time: This scene begins at 00:07:18 and ends at 00:09:55 (DVD Scene 2)

Rating: R for strong sexual content, language and violence

Mulan

Sexism/gender

Mulan, an animated tale set in ancient China just after the completion of the Great Wall, is the story of a young female who desires to take

the place of her ailing father who is unable to fight in the battle against the Huns. Mulan steals her father's armor and sword, cuts her hair, and joins the army in his stead in the guise of a boy.

Mulan is wounded after defeating the entire Hun army single-handedly. A doctor treats her wounds and while doing so, reveals her secret. "I knew there was something wrong with you," Chin Fu, the emperor's adviser declares triumphantly. He pulls Mulan from the tent and rips off her hair tie—"a woman," he says. By law, Mulan is to be executed for doing what she did, despite the fact that she saved an entire army from destruction. Shang, the army's leader whom Mulan had saved, had difficulty deciding whether to execute her or not. He raises his sword, seemingly to cut off her head, but instead throws it at her feet and pulls the army out, leaving Mulan to fend for herself in the harsh conditions of the snowy mountains.

- How do you feel about women serving on the frontlines of battle in the military?
- In what ways does male superiority apear in our society today?
- In what ways are men discriminated against in our society? What restrictions are placed on men because of their gender?
- Discuss the roles of women in most animated films by Disney. What messages are children (boys and girls) receiving about gender roles and expectations?

Mulan (Walt Disney Pictures, 2000), written by Robert San Souci, directed by Tony Bancroft and Barr Cook

Elapsed time: This scene begins at 00:59:49 and ends at 01:01:45 (DVD Scene 24)

Rating: G for all audiences

My Big Fat Greek Wedding

Ethnocentrism/compulsory heterosexuality

Thirty years old and "still" unmarried, Toula (Nia Vardalos) is a modern-day Cinderella (with an ethnic flavor); she dreams of being rescued by a fairy tale prince (or at least that's her parents' dream). Her parents have only one rule; Toula must marry someone with a Greek

heritage. As fate would have it, Toula falls in love with a non-Greek. Can true love conquer ethnic tradition?

Toula is narrating her ethnic upbringing by her proud Greek parents. She describes how being Greek had set her apart from other kids in the neighborhood; while they ate "Wonder bread sandwiches" for lunch at school, she had traditional foods like moussaka, which a peer referred to as "moose ka ka." Their home was patterned after the Parthenon, replete with statues of the Greek gods—"just in case the neighbors had any doubt about our heritage." Toula's father believes that Greek society is the cradle of ancient civilization; his kids are sent to a Greek school; he feels it a mission in life to educate non-Greeks about the significant contribution of Greeks to science and the arts. Toula admits that her Greek training taught her three basic principles about her role as a Greek woman: "marry Greek boys, make Greek babies, and feed everyone until the day we die." The scene ends as Toula and her father open their family's restaurant, the Dancing Zorbas, and Toula states, "So here I am, day after day, year after year. Thirty and way past my expiration date."

- How does your family (parents and other relatives) pass down ethnic traditions and customs? How do you feel about learning your family's heritage and history?
- Does your family have any traditions that are out of the norm from your neighbors or classmates? How did this set you apart?
- In America, how old is too old to be living with your parents?

My Big Fat Greek Wedding (Gold Circle Films, 2002), written by Nia Vardalos, directed by Joel Zwick
Elapsed time: This scene begins at 00:01:00 and ends at 00:07:34 (DVD Scene 1)
Rating: PG for sensuality and language

The Notebook

Classism

A modern classic love story that follows Noah Calhoun (a poor, country boy) and Allie Hamilton (a rich girl from the city) from courtship as teenagers through their married lives and into the senior days in a

nursing home, where Allie suffers from Alzheimer's. In an effort to keep her memory fresh, Noah repeatedly reminds Allie of stories of their love by reading from a notebook filled with exciting stories of their lives together.

This scene opens as Allie (Rachel McAdams) and Noah (Ryan Gosling) are rushing home well past Allie's curfew, only to find police cars surrounding Allie's parents' house. Allie's parents do not approve of her dating Ryan because he is from a lower class. In this scene, Allie has a heart-to-heart talk with her parents about her love for Noah. They indicate that "he is not suitable," and refer to Noah as "trash." This entire conversation is within earshot of Noah, who is sitting in another very lavish room in the Hamilton house. When Allie emerges from the room after her private talk with her parents, she finds that Noah has left the house. She rushes after him, but he too reminds her about their differences. Noah says, "I'm not going to have nice things, fancy things. It's never going to happen for me; it's not in the cards for me." The scene ends when Noah heads toward his car.

- Evaluate this statement by Mark Twain: "If you pick up a starving dog and make him prosperous, he will not bite you. This is the principal difference between a dog and a man."
- On a busy street you are approached apologetically by a well-dressed stranger who asks for a dollar to catch a bus and make a phone call. He says he has lost his wallet. What would you do? If approached in the same way by a haggard-looking stranger claiming to be hungry and unable to find a job, what would you do?
- 🎬 Why do you think Noah believes that he's "not going to have nice things, fancy things"? How does this sentiment hold true for most born into a lower class in life?
- How has your family's socioeconomic class status impacted your upbringing and worldview? Discuss the following questions: When you were growing up, what was your family's source(s) of income? Describe your home(s) and neighborhood(s) growing up. How does the education you are getting now compare with the education of others in your family in this generation, and in the previous two generations? How was your and your family's leisure or nonwork time spent when you were growing up? What impact does your class background have on your current attitudes, behaviors, and feelings?

The Notebook (New Line Cinema, 2004), written by Jeremy Leven, directed by
Nick Cassavetes
Elapsed time: This scene begins at 00:36:49 and ends at 00:42:00 (DVD Scene
7)
Rating: PG-13 for some sexuality

Notes on a Scandal

Power

Novice art teacher, Sheba Hart (Cate Blanchett) begins a secret love
affair with her 15-year-old student. Her mentor teacher, Barbara Cov-
ett (masterfully played by Dame Judith Dench), knows about the af-
fair and uses emotional blackmail to keep Sheba under her control.
Barbara's plans are working out well until Sheba tries to take control
of her life.

Sheba is talking with Barbara at a local pub, and she is explaining the details of
her affair. Naturally, Sheba is concerned that the school and her husband will
find out about her indiscretions, and she hopes that Barbara will not expose
her secret until after the end of the school year and the holidays. In a narration,
Barbara realizes that she has the ability to manipulate Sheba into doing what-
ever she wants. While promising not to tell the school administration, Barbara
secretly declares, "I could gain everything by doing nothing." The scene ends
as Sheba enters her home and Barbara states "Sheba and I share a deep under-
standing now."

- 🐾 What does Barbara mean when she says, "I could gain everything
 by doing nothing"? What is their "deep understanding"?
- In the last few years, the national media has reported several cases of
 female teachers having affairs with male students. How have gender
 constructions played out in both the reporting of these stories and in
 the consequences delivered to the teachers. How would you describe
 the public sentiment in cases such as these? How are male teacher/
 female student trysts treated differently or similarly?
- How do culture, class, race, and gender affect the school experiences
 of students?

Notes on a Scandal (2006), written by Patrick Marber, directed by Richard Eyre
Elapsed time: This scene begins at 00:32:29 and ends at 00:36:19 (DVD Scene 8)
Rating: R for language and some aberrant sexual content

Now and Then

Gender

A wonderful coming-of-age film about four friends—their tests and trials of hitting puberty and their pact to always be there for each other. Roberta, Teeny, Samantha, and Chrissy are remembering the mythic "summer of 1970."

The young ladies have spent much of the summer trying to spiritually connect with the ghost of "Dear Johnny," a teenaged boy who had been murdered in their town. They decide that they must talk to a person who was alive when Johnny was killed; they plan to meet Samantha's grandmother who is playing poker. Chrissy is surprised by this notion. Their plans are interrupted when a young boy tells them about a softball game that is being played. Three of the ladies want to go, but Chrissy argues, "It will be all boys," which gives Teeny an added impetus. She says, "So, what are we waiting for?" At the game, Roberta's is up at bat and the pitcher is one of the Wormer brothers, the girls' sworn enemies. The pitcher taunts Roberta by telling the other boys to move in from the outfield. Another boy, sitting on the fence behind Roberta, shouts "Who are you kidding? Girls can't play softball." Angered, Roberta approaches the boy and while she is heading toward him, Chrissy remarks, "Remember, Roberta, you're a lady." The boy continues his assault, "Why don't you go home and play with your dolls?" Chrissy remarks, "The only doll Roberta's got is a G.I. Joe." Roberta and the boy get into a fistfight—Roberta definitely bests him. One of the Wormers calls the boy a wimp and Samantha chimes in about how embarrassed he must be for getting beaten up by a girl. Meanwhile, Chrissy is more concerned with fixing Roberta's mussed hair. In anger, the boy lashes out at Roberta and says, "Too bad your mother's dead. Somebody should teach you to act like a girl." The scene ends after Samantha jumps the boy and begins to beat him up.

- 🐾 Roberta is told to remember she's "a lady" and "somebody should teach [her] to act like a girl." Why is this an expectation? How do

you think Roberta feels in trying to live up to these demands on her behavior?

- Why is it so bad for a boy to get beaten up by a girl? Will this ever change?
- How has the meaning of "act like a girl" or "act like a lady" changed over the past 50 years? 10 years? What does it mean to "act like a boy" or "act like a man"?

Now and Then (New Line Cinema, 1995), written by I. Marlene King, directed by Lesli Linka Glatter

Elapsed time: This scene begins at 00:52:41 and ends at 00:55:33 (DVD Scene 8)

Rating: PG-13 for adolescent sex discussions

"O"

Co-optation

William Shakespeare's classic tale, *Othello*, gets a twentieth-century update with a hip-hop twist. Odin (Mekhi Phifer) is a star basketball player with a criminal past who has been recruited to play for an exclusive prep school. He is the only Black player on the team; all is going well until his girlfriend, Desi (Julia Stiles) is suspected of cheating on him.

Odin is the star of the basketball team, but lately his personal life has been out of control and it is wreaking havoc on his game. During practice, Duke, the coach, is riding Odin for his lackluster performance; he is ultimately told to sits the bench. Odin attacks his replacement (who he believes is having an affair with Desi) and angrily leaves the court. Later, Hugo Goulding (Josh Harnett), the coach's son, is in his dad's office. Duke is not a very attentive father and rarely interacts with Hugo, except on the basketball court. Hugo tries to tell his dad about his grades and other issues, but Duke is more concerned about his star player, Odin. He tells Hugo, "You know I don't ever have to worry about you, thank God. You've always done well and you always will, but Odin's different. He's all alone here. There's not even another Black student in this whole damn place. We're his family." He tells Hugo to keep an eye on Odin, "cause if he's got a problem, we've got a problem." Duke exits the room and leaves Hugo to finish his dinner by himself.

- ☻ Duke suggests that Odin's acceptance and success are a matter of concern for him and Hugo. Discuss the multiple reasons for Duke's concern?
- What are the expectations of a person or peoples who are the only representative(s) of a minority group among a differing predominant group?
- In what ways have Americans co-opted and/or misappropriated the cultural elements of other countries or religions without attending to the cultural significance? Where do these elements play out most in popular culture?

"O" (Lionsgate Entertainment, 2001), written by Brad Kaaya, directed by Tim Blake Nelson

Elapsed time: This scene begins at 00:51:02 and ends at 00:54:50 (DVD Scene 14)

Rating: R for violence, a scene of strong sexuality, language, and drug use

Old School

Oppression

Desiring to return to the carefree days of college life, three 30-something men, Frank (Will Ferrell), Mitch (Luke Wilson), and Beanie (Vince Vaughn) move into an off-campus house near a local university and start a fraternity for the school's rejects.

The fraternity leaders learn that they are being required by Dean Pritchard (Jeremy Piven) to submit to a charter review process that includes tests in academics, athletics, school spirit, debate, and community service. The dean admits to a board member that he "got creative with some of their tests," meaning that he tried to fix the outcome to punish the fraternity. Later, he admits to having promised a student government leader a guaranteed admission to Columbia University, if she agreed to revoke the fraternity's charter. The team ends up passing the required tests, that is, until the dean refuses to remove the name of a fraternity member who had died and was unable to compete in the challenges. ⌖

- Discuss the prevalence of movies where students must prove their

worth through some type of academic exercise.

- King Solomon, once described as the wisest of all kings, once said, "If you see oppression of the poor, and justice and righteousness trampled in a country, do not be astounded." What does his message suggest about human nature?

- Fraternities and sororities are designed to be selective groups. What methods have been used to "weed out" those deemed unworthy of selection?

Old School (DreamWorks Pictures, 2003), written by Todd Phillips and Scot Armstrong, directed by Todd Phillips

Elapsed time: This scene begins at 01:11:41 and ends at 01:22:06 (DVD Scene 9)

Rating: R for language and mature subject matter and sexuality

One Night with the King

Sexism

At the time when the Hebrews are under Babylonian exile, the Persian king is searching for a new love and queen. She must be able to pass numerous tests and must be willing to sacrifice all for her king. A young Hebrew girl named Hadassah has been chosen to compete for the king's hand, but must hide her identity to protect her Israelite kinsmen. Can love survive politics and religious nationalism?

King Xerxes is sitting at a banquet with many of his royal advisers and subjects. Prince Adamanth (who is plotting against him) has asked the king to summon Queen Vashti to a command performance at the banquet—knowing full well that the queen was having a banquet of her own and would not attend the king's banquet. Queen Vashti responds, "I'm queen, not a pawn, and I will not lower my dignity or shame my reign by wearing the royal crown before your drunk and thinly veiled war council." None too pleased, Xerxes responds, "Am I to be a mockery before my subjects?" Prince Adamanth adds, "Might this deed of refusal travel abroad to all women, making their husbands contemptible in their eyes? Will it not be said by all, 'Xerxes commanded his wife to come before him, but she came not?' Vashti's guilty not only of disobedience to

the crown but against the protocol of our fathers." Xerxes questions what the proper response is for her insolence and is told that "Vashti should come no more before the king; she is to be dethroned and a new 'more worthy" queen chosen." Xerxes stands and pronounces, "The land has no more queen." The scene ends as the palace guards surround Queen Vashti and the narrator describes how a new queen should quickly be chosen as a "unifier" before the king departs for war: "Every maiden was to be considered; the choicest of whom to be brought from across the empire and into the palace."

- 🐭 Reverse the roles. Had King Xerxes told Queen Vashti that he refused to attend *her* banquet, would this have been acceptable? Why is this so?
- 🐭 Explain what "more worthy" means in this clip.
- Noted journalist and social critic, H. L. Mencken argued that "The worst government is often the most moral. One composed of cynics is often very tolerant and humane. But when fanatics are on top there is no limit to oppression." What did he mean by this statement?

One Night with the King (Gener8Xion Entertainment, 2006), written by Stephan Blinn, directed by Michael Sajbel
Elapsed time: This scene begins at 00:17:11 and ends at 00:22:12 (DVD Scene 5)
Rating: PG for violence, some sensuality, and thematic elements

The Patriot

Social justice

Benjamin Martin (Mel Gibson) is a retired soldier who is committed to raising his seven children on his farm in South Carolina. His eldest son, Gabriel (Heath Ledger), is equally committed to joining the resistance against the British forces, against the wishes of his father who has seen his fair share of combat. Gabriel is captured, and Benjamin joins the battle to rescue his boy and push the British off American soil.

Benjamin has gathered a militia who are planning a coup against General Cornwallis. In an earlier raid, they had found Cornwallis's journal of his war

plans. Later that evening, while discussing their plans to allow Blacks to join their regiment, Dan Scott (Donal Logue) states, "I don't know about you, but I don't like the idea giving muskets to slaves." Jean Villenueve (Tchéky Karyo), a French soldier, responds to Scott's comment by saying, "Your sense of freedom is as pale as your skin." Gabriel encourages Occam the slave (Jay Arlen Jones) to ignore the earlier comment. He admits that "They call this the New World. It's not. It's the same as the old." He explains that once the British are defeated, there will be equality—"A world where all men are created equal under God." Benjamin interrupts the discussion by acknowledging the military genius of Cornwallis, but argues that Cornwallis's pride may be his downfall. The scene ends as Benjamin mentions how he sees pride as a weakness.

- What are the persistent barriers to becoming "A world where all men are created equal under God"?
- 🎥 What does Villenueve mean by "Your sense of freedom is as pale as your skin"?
- Discuss the paradoxical concept that war is used to create peace.

The Patriot (Columbia Pictures, 2000), written by Robert Rodat, directed by Roland Emmerich

Elapsed time: This scene begins at 01:07:28 and ends at 01:11:40 (DVD Scene 14)

Rating: R for strong war violence

Pay It Forward

In-group/out-group/sexism/power

Taking his teacher's advice to create a social studies project that will "change the world," young Trevor (Haley Joel Osment) develops a plan to pay good deeds "forward" instead of to the person who does the good deed. Trevor turns the plan on his own recovering alcoholic mother and his social studies teacher by trying to fix them up with each other. Worlds collide in interesting ways in this feel-good story about making a difference.

Eugene (Kevin Spacey) and Arlene (Helen Hunt) are having a heated conversation outside a hotel. They had been attempting to spark a love connection,

but Arlene has decided to give her ex-husband another opportunity, now that he is sober. She states, "I feel like I've got to give him a chance . . . to change. He promised to try." Eugene reminds Arlene about the ways Ricky abused her, but Arlene keeps making excuses for his behavior. Eugene retorts, "What is it with women like you? Is that something you really tell yourself? 'It's okay he beat me.'" He informs her about the horrible abuse that he himself had experienced at the hands of his own father. "My father got down on his knees and begged my mother; and my mother, she always took him back. She'd cover the bruises and the cuts and she'd take him back because he begged and he cried." He explains how his father poured gasoline on him and lit his own son on fire (which has permanently scarred and disfigured his appearance.) He remarks that the last thing he remembers from his ordeal is the look of "immense satisfaction" on his father's face. The scene ends as Eugene walks up the stairs to his hotel room.

- 🎬 What does Eugene mean when he says "women like you"? What does this statement reflect?
- Evaluate this comment made by Ingrid Newkirk, president and co-founder of the People for the Ethical Treatment of Animals (PETA) organization. Newkirk stated, "It is only human supremacy, which is as unacceptable as racism and sexism, that makes us afraid of being more inclusive."
- Men are socialized to be "helpless" when it comes to household duties. In what ways does the privilege of helplessness keep men in power?

Pay It Forward (Warner Bros., 2000), written by Leslie Dixon, directed by Mimi Leder

Elapsed time: This scene begins at 01:29:14 and ends at 01:34:33 (DVD Scene 27)

Rating: PG-13 for mature thematic elements including substance abuse/recovery, some sexual situations, language, and brief violence

Pleasantville

Oppression

A brother and sister from the 1990s are sucked into their television set and suddenly find themselves trapped in a *Leave It to Beaver* style

1950s television show, complete with loving parents, old-fashioned values, and an overwhelming amount of innocence and naiveté. Not sure how to get home, they integrate themselves into this "backward" society and slowly bring some color to this black and white world. But as innocence fades, the two teens begin to wonder if their 1990s outlook is really to be preferred.

This scene begins as the "White" citizens have created a code of conduct that will prohibit/inhibit citizens from becoming "colored." Big Bob, the mayor (J. T. Walsh), explains the need for a code. "We have to have a 'Code of Conduct' we can all agree to live by . . . If we all agree on these then we can take a vote and I think we'll start to move in the right direction. 'ONE: All public disruption and acts of vandalism are to cease immediately. TWO: All citizens of Pleasantville are to treat one another in a courteous and "pleasant" manner . . . '" The scene shifts to teenagers reading the code while in the soda shop. Bud reads, "THREE: The area commonly known as Lover's Lane as well as the Pleasantville Public Library shall be closed until further notice. FOUR: The only permissible recorded music shall be the following: Pat Boone, Johnny Mathis, Perry Como, Jack Jones, and the marches of John Phillips Souza or the Star Spangled Banner. In no event shall any music be tolerated that is not of a temperate or 'pleasant' nature. FIVE: There shall be no public sale of umbrellas or preparation for inclement weather of any kind. SIX: No bed frame or mattress may be sold measuring more than 38 inches wide. SEVEN: The only permissible paint colors shall be black, white or gray, despite the recent availability of certain alternatives. EIGHT: All elementary and high school curriculums shall teach the 'nonchangist' view of history—emphasizing 'continuity' over 'alteration.'" The scene ends after a teenager is chided for playing an "illegal" song on the jukebox.

- Why do some people view change as threatening?
- 🐾 After viewing this scene, draw contrasts between what it means to be White versus "colored" in this clip. How does this contrast exist today?
- Explain how "whiteness" has impacted the ways in which people of color are viewed in American society.

Pleasantville (New Line Cinemas, 1998), written and directed by Gary Ross
Elapsed time: This scene begins at 01:31:46 and ends at 01:36:04 (DVD Scene 32)
Rating: PG-13 for some thematic elements emphasizing sexuality and for language

Pocahontas

Difference/oppression

Return to the founding of the New World when settlers from England found their way into the Virginia waterways. Here, John Smith and his fellow travelers meet Powhatan and the indigenous people of the land. Conflicts ensue and misunderstandings arise, but amidst all this tension, a new love is born, and it could be the ties that bind these two groups together.

John Smith has been captured by the Indians, and a messenger comes running to the English outpost to inform them that "the savages" got him. Soon Ratcliffe, a dishonest leader of the English who has plans to ravage the land of gold, sees a chance to exploit the situation. He begins saying, "I told you those savages couldn't be trusted. Smith tried to befriend them; look what they've done to him." He tells them of plans to attack the Indians. He begins to sing, "What can you expect from filthy little heathens? Here's what you get when races are diverse. Their skins are hellish red; they're only good when dead. They're vermin, as I said, and worse, they're savages. Barely even human ... They're not like you and me, which means they must be evil." His song continues and he refers to Indians as "dirty shrieking devils" and begins to sound "the drums of war." At the same time, Powhatan leads his tribe with a similar song—he views the English as "paleface demons" who are motivated by greed. He sings, "Beneath that milky hide there's emptiness inside. I wonder if they even bleed. They're savages, barely even human—killers at the core. They're different from us, which means they can't be trusted." The scene ends with a lightning strike.

- Why do anti-Indian prejudice and racism not make the headlines as much as racist acts against Blacks and Latinos? In what ways has Native American history been made invisible in our culture?
- Native Americans appear "less civilized" than their English counterparts (think of clothing, housing, etc.) Explain the irony in the Native Americans' use of the term "savages."
- In his book, *The Color of Water*, African American author James McBride describes feelings of confusion about his mother's teaching— "White folks, she felt, were implicitly evil toward blacks, yet she forced us to go to white schools to get the best education. Blacks could be

trusted more, but anything involving blacks was probably substandard
... .She was against welfare and never applied for it despite our need,
but championed those who availed themselves of it." How do you ex-
plain McBride's mother's contradictions? Does your answer change
when you learn his mother was White?

Pocahontas (Walt Disney Pictures, 1995), written by Carl Binder, directed by Mi-
chael Gabriel and Eric Goldberg
Elapsed time: This scene begins at 01:03:05 and ends at 01:05:25 (DVD Scene
22)
Rating: G for all audiences

Pooh's Heffalump Movie

Prejudice/stereotype

Pooh and his friends, Eeyore, Rabbit, Tigger, Piglet, and Roo, are up to
their old tricks in the One Hundred Acre Wood. This time, everyone
is in an uproar because of the strange sounds echoing through the for-
est. They presume that the sound could only be that of the treacherous
Heffalump. The team sets out on an expedition to find the mysterious
creature, only to learn that there was never anything to fear—the Hef-
falumps are quite friendly and playful.

Earlier that morning, the team had set out on a great expedition following the
footprints of the dreaded Heffalump, with its "fiery eyes and a tail with a spike,
claws on its paws that are sharp as a tack, and wing-a-ma-things coming out
of its back." They are on the lookout for the "dreadfully dreaded, thoroughly
three-headed, horribly hazardous Heffalumps." In this scene, Young Roo actu-
ally found Lumpy, the Heffalump, and captured him "in the name of the One
Hundred Acre Wood." Roo and Lumpy become fast friends, and Roo is taking
Lumpy to meet his friends. They come to the fence that separates Roo's area
from Lumpy's area, and Lump abruptly halts and turns to go home because
he is "not supposed to go in that part of the woods" because "scary things live
there." Roo counters, "That's where I live. There aren't any scary things there."
Lumpy begins to describe Piglet, Tigger, and Rabbit with scary descriptions
(e.g., he calls Piglet a "little pig monster that squeals and shakes all the time").

Roo says that they are all great once you get to know them and questions where he learned all of this bad information. When Lumpy responds, "Everybody knows," Roo remarks "Hmm . . . that's just what Rabbit and Tigger said about Heffalumps." The scene ends after Roo and Lumpy climb through the fence.

- In your local community, are there sections of town where you will not venture because of the people who live there?
- Discuss this comment made by poet, Maya Angelou: "Prejudice is a burden that confuses the past, threatens the future and renders the present inaccessible."
- Why does it seem easier to believe prejudices not founded upon reason than to believe reason itself?

Pooh's Heffalump Movie (DisneyToon Studios, 2005), written by Brian Hohlfield and Evan Spiliotopolos, directed by Frank Nissen
Elapsed time: This scene begins at 00:31:47 and ends at 00:34:13 (DVD Scene 13)
Rating: G for all audiences

Pretty Woman

Classism

Vivian Ward (Julia Roberts), a prostitute "working" on Hollywood & Vine in Beverly Hills, meets wealthy industrialist, Edward Lewis (Richard Gere). Lewis hires Vivian for the evening and ultimately asks her to remain with him for the entire week—to attend various social functions and for romantic interludes. He ends up falling in love with her, and in true Hollywood fashion, the two remain together in the end.

Edward is planning to take Vivian out for a dinner date at an expensive restaurant and asks her to go buy a dress. She is still dressed in her hooker dress when she walks into a very ritzy store in Beverly Hills. Immediately upon entering the store, Vivian receives dirty looks from the other customers and the store clerks. As she browses, the head clerk offers her help, but when Vivian asks the price of the gown, the clerk tells her that it won't fit, and then a second clerk talks about it being too expensive. Ultimately, the clerks refuse her service and

ask her to leave the store. Vivian complies and as she walks down the road, she continues to get stares and dirty looks from people on the street.

- 🎬 Were the clerks justified in refusing service to Vivian?
- Store keepers are often trained to watch certain people when they enter a store. What "types" of people do you think they are told to monitor and why?
- 🎬 Suppose you were a customer in the store at the time of this incident, how would you respond?
- 🎬 How would this scene be different if Vivian were a Black prostitute? How would this scene be different if she were Black (or other racial minority) and not a hooker—would she be denied service?

Pretty Woman (Silver Screen Partners IV, 1990), written by J. F. Lawton, directed by Gerry Marshall

Elapsed time: This scene begins at 00:40:05 and ends at 00:42:10 (DVD Scene 6)

Rating: R for sexuality and some language

Radio

In-group/power

Although he is mentally disabled, James Robert Kennedy has a heart of gold and becomes the mascot (of sorts) to the Anderson, SC, high school football team. Known as "Radio" for his collection of old transistors, James is befriended by the athletic director, and in turn, he and Radio help this old town understand the meaning of community.

Coach Jones (Ed Harris) has gotten Radio (Cuba Gooding, Jr.) a job in the school as the equipment manager. Radio is sorting the basketballs when Adam Clay, one of the popular boys in the high school, tricks Radio into going into the girls' locker room. Adam and his friends laugh as Radio flees from the screams of the girls who are changing in the locker room. For his inappropriate behavior, Coach Jones suspends Adam from an important basketball game.

- How do you react to this thought: In order to gain control, you must lose it.

- Discuss the role of music as an art form that brings people together and tears down barriers of difference. How would you describe music's role in social movements?
- Pearl S. Buck once argued, "Race prejudice is not only a shadow over the colored it is a shadow over all of us, and the shadow is darkest over those who feel it least and allow its evil effects to go on." In what ways can you use the power of agency to reduce prejudice and discrimination in your society?
- How would you describe rules of etiquette when dealing with persons with disabilities?

Radio (Revolution Studies, 2003), written by Mike Rich, directed by Mike Tollin
Elapsed time: This scene begins at 01:10:58 and ends at 01:16:09 (DVD Scene 21)
Rating: PG for mild language and thematic elements

Ratatouille

Out-group

Tired of eating out of the garbage and the unknown scraps on the streets and in alleys, Remy the rat, dreams of living the good life. He has a taste for fine foods and dreams of becoming a celebrated French chef. He partners with a bumbling chef's apprentice named Linguini, and together they make amazing dishes that bring acclaim to their Parisian restaurant.

After a lengthy absence, Remy and his brother, Emile, have a reunion in an alley. Remy has been secretly working in a French restaurant; Emile is eating garbage in the alley outside the restaurant. Remy refuses to allow his brother to eat "rejectamente" and tries to show Emile how to appreciate good food. Meanwhile, inside the restaurant, Master Chef Skinner is interrogating Linguini about his suspicious connection to rats. Linguini questions why his celebrated dish is called "ratatouille" because it sounds like "rat patootie." Outside, Emile wants Remy to come home with him because their dad thinks Remy has died. His father is celebrating Remy's return home (and to his senses). He is excited that Remy will be coming back to work with him as a poison checker. He notices that Remy is a little thin and questions whether Remy's leanness is

"a shortage of food or a surplus of snobbery." Remy tries to explain that he is only home for a visit (Remy says, "A bird's got to leave the nest," to which Remy's dad responds, "We're not birds, we're rats"). Remy claims to be "a different kind of rat," and his dad responds, "Maybe you're not a rat at all." Remy informs his father that he has been in close contact with humans "who are not so bad." To challenge this notion of the humans' *humanity*, Remy's dad takes him to the storefront of an exterminator where there are dead rats hanging by their necks in traps and bottles of rat poison. "Now take a good long look, Remy," his dad says, "this is what happens when a rat gets a little too comfortable around humans." He continues, "The world we live in belongs to the enemy. We must live carefully. We look out for our own kind, Remy. When all is said and done, we're all we've got." Remy challenges the proscripted existence of rats, but his father argues, "This is the way things are. You can't change nature." As Remy starts to walk away, his dad questions where he is going, and Remy responds, "With any luck—forward."

- Are you more likely to meet people of new cultures, or are you more comfortable sticking with your own kind? What is your parents' expectation?
- 🐭 Discuss the significance of Remy's response, "With any luck—forward."
- Why doesn't Remy's dad take a chance and accept that Remy has actually created a bond with the humans? What is at stake for Remy? Remy's dad?
- 🐭 How would Remy's dad evaluate this statement by Martin Luther King? "Discrimination is a hellhound that gnaws at Negroes [rats] in every waking moment of their lives to remind them that the lie of their inferiority is accepted as truth in the society dominating them."

Ratatouille (Walt Disney Pictures, 2007), written and directed by Brad Bird
Elapsed time: This scene begins at 00:52:53 and ends at 01:00:54 (DVD Scene 16)
Rating: G for all audiences

Reign over Me

Oppression

Dr. Allen Johnson (Don Cheadle) is stuck in a rut; he no longer enjoys

his thriving dental practice, and he feels powerless to tell his wife (Jada Pinkett-Smith) that he does not enjoy their mundane existence. That is, until he runs into his old college roommate, Dr. Charlie Fineman (Adam Sandler), who lost his wife and his children (and his grasp on reality) in the September 11 terrorist attacks. The two attempt to save each other from the brink of madness.

Charlie's in-laws are trying to have him committed to a mental institution because he refuses to carry pictures of his deceased family or becomes belligerent and destructive when confronted with the thoughts of his lost loved ones. At the hearing, psychiatrists disagree whether he should be committed or whether he is just severely grief-stricken and "needs to find his own way." Later, Charlie's father-in-law, Mr. Timpleman (Robert Kline), is testifying and the plaintiff's attorney, Mr. Fallon, is asking very pointed questions about his daughter and her children. The plaintiff testifies that Charlie's actions and presumed lack of grief are "destroying my wife a second time." He explains to the court how Charlie broke a special lamp when discussing his family. Charlie is clearly getting agitated and is starting to freak out. The attorney begins to show pictures of Charlie's children and purposely holds them up in front of Charlie to incite his emotional and mental breakdown. Charlie is handed his iPod and he begins to listen to music (a defense mechanism); interestingly enough, the song he is using to drown out his pain is "Reign over Me." The more pictures of his children are shown, the more agitated Charlie becomes. When the lawyer finishes his questions, he lays the pictures on the table right in front of Charlie. Charlie begins to scream uncontrollably until he is ejected from the court; an act that may guarantee committal. In the chambers, the judge (Donald Sutherland) scolds Mr. Fallon for his inappropriate behavior and informs him, "First off, if you ever pull crap like that in my court again, I will have hardened inmates using you as a dress-up doll." He instructs the Timplemans that they will have the final decision as to whether Charlie is to be committed. He asks Mrs. Timpleman, "Do you understand the power I am putting in your hands?" [OBJ]

- In what ways have male patriarchy and masculine gender constructions created methods for internalized oppression among men?
- Discuss the correlations and connections between the systems of capitalism and oppression.
- How do you account for the overrepresentation of racial minorities in the special education system?

Reign over Me (Columbia Pictures, 2007), written and directed by Mark Binder
Elapsed time: This scene begins at 01:42:26 and ends at 01:50:51 (DVD Scene 26)
Rating: R for language and some sexual references

Remember the Titans

Homophobia

This film is based upon the true story of the 1971 integration of T. C. Williams High School in Virginia. Coach Herman Boone, an African American man, has been hired to be the head coach of the newly integrated team; his appointment was in the place of a well-loved, hall-of-fame candidate, Coach Yost, who is White. Throughout the season, Coaches Boone and Yost work to diminish the racial barriers among the team.

During the football preseason, a new White student shows up with his father in a red sports car. This new student, Ronnie Bass, is from California and has long blond hair, a floral shirt, and is very handsome. Right away the team members joke and call him "fruitcake." His team members tease him and give him the moniker "Sunshine" because of his home state and his golden locks. In the locker room, Ronnie kisses Gerry Bertier, his teammate. The kiss, coupled with Ronnie's slightly feminine appearance, causes Ronnie's teammates to question his sexual orientation. In this scene, Petey, who is Ronnie's roommate, states, "Look, man, it don't matter to me, you know, if you know, I just got to know, you know." This scene begins when Petey sits down at the lunch table across from Ronnie and ends when another player mentions that Petey must have stayed in the sun too long.

- 🎬 Petey never uses the words "gay" or "homosexual" during his questioning. Why do you think he avoids using these terms?
- 🎬 What are some reasons Petey needs to "know for sure"?
- 🎬 How would you feel if you were in Petey's shoes? Ronnie's?
- The film *Remember the Titans* centers on the subject of racism. How is racism similar or different than homophobia?

Remember the Titans (Jerry Bruckheimer Films, 2000), written by Gregory How-ard, directed by Boaz Yakin
Elapsed time: This scene begins at 00:40:52 and ends at 00:41:26 (DVD Scene 13)
Rating: PG for thematic elements and some language

The Ringer

Difference/prejudice

Steve Barker is up to his elbows in debt; his uncle Gary is even deeper in debt to some rough-looking gentlemen. Gary comes up with a plan to have Steve pose as mentally challenged to participate in the Special Olympics. Sounds like an easy win, until the other Olympians learn of the plot and decide to teach Steve an important life lesson.

Gary is on the phone with Steve (Johnny Knoxville) when several goons ap-proach him to collect the $40,000 debt that he owes. While they have him pinned against the bar, a news story about a champion Special Olympian comes on the TV. Gary devises a plan to fix the outcome of the Olympics and goes to Steve's house to enlist him in the scheme. Steve recognizes that this is wrong and refuses to honor his uncle's request. Gary prods, suggesting that Steve can easily beat the others because he is a former track star and that all he would have to do is "act like one of them." Steve continues to refuse and Gary states, "Oh, come on. A normal guy against a bunch of feebs. You'll look like Carl freakin' Lewis out there."

- List the pejoratives used to define people with mental or physical dis-abilities. How are these words used?
- What is the difference between being religious and being spiritual?
- Diversity can be defined as the "battle between *us* and *them*." Discuss both the statement and the opportunities created by diverse and mul-ticultural experiences.

The Ringer (Fox Searchlight Pictures, 2005), written by Ricky Blitt, directed by Barry Blaustein
Elapsed time: This scene begins at 00:08:35 and ends at 00:12:13 (DVD Scene 3)
Rating: PG-13 for crude and sexual humor, language, and some drug references

Romy and Michele's High School Reunion

Privilege

Romy and Michele have been through it all including being tortured by the popular crowd when in high school. When they receive word of a 10-year reunion they come to realize their lives aren't as impressive as they'd like them to be. Instead of staying home they go to the reunion with business outfits, cell phones, and one heck of a bogus success story.

Romy and Michele are reminiscing about their days in high school. There is a flashback to the two girls in line at the high school cafeteria. Both girls were relative social outcasts in high school but are unaware of their station in the pecking order. Romy has a crush on the most popular boy in school, who happens to be dating the most popular girl. Christy decides to "have some fun" at Romy's and Michele's expense. While chatting with the girls, Christy underhandedly sticks magnets on Michele's metal back brace. The entire courtyard notices and begins to laugh. [OBJ]

- In film, blonde girls are often typified not only as the most popular, but also as the most devious and mean. Why do you suppose this is and why has this archetype flourished for so long?
- 🐾 For teenage girls who watch this film, what kind of messages might they be receiving about the importance of appearance, body image, and friendship?
- 🐾 What do you think of Michele's disdain and treatment of the young man who pointed out what Christy had done?
- 🐾 One of Christy's friends says that Romy and Michele are "semi-interesting" but under the glare of their peers recants and adds "in a freakazoid way." How does group belonging and involvement impact our daily behavior?

Romy and Michele's High School Reunion (Bungalow 78 Productions, 1997), written by Robin Schiff, directed by David Mirkin

Elapsed time: This scene begins at 00:11:24 and ends at 00:16:11 (DVD Scene 4)

Rating: R for language

Rosewood

Out-group

A New Year has dawned for segregated sleepy-town, Rosewood, Florida, but instead of celebrations and New Year's resolutions, the town is embroiled in an all-out race war. A young White woman has falsely accused a Black man of raping her; the White citizens are taking their ire out on the town's Black community. A White shopkeeper (Jon Voight) and a mysterious stranger (Ving Rhames) join forces to save the women and children who have fled into the swamps.

It is New Year's Eve and the Carrier family has gathered for dinner with Mr. Mann (Rhames) as their special invited guest. Sylvester (Don Cheadle) is explaining how he chastised Mr. Andrews, a White male for making sexually inappropriate comments to his young cousin, Scrappie. Sylvester tells Mr. Andrews, "I don't mess with your peoples, I don' want you messin' with mines." Aunt Sarah (Esther Rolle) cautions him about speaking firmly to White men; she says, "Sylvester, you can't talk to White folks like that, and not expect a rope around your neck." She mentions that a "colored" man was burned for winking at a White woman, and Sylvester challenges the double standard. The scene ends as the family says a prayer and begins eating.

- Is/was there a double standard regarding the way Black men are to regard White women and how White men regard Black women?
- Why can't Sylvester "talk to White folks like that and not expect a rope around [his] neck"? Name some real-life examples that showed the consequences of this type of behavior.
- Historically, the southern United States has been pictured as the cradle of racism; explain how geographic stereotypes minimized the role of the north in maintaining systems of racial oppression.

Rosewood (Warner Bros., 1997), written by Gregory Poirier, directed by John
 Singleton
Elapsed time: This scene begins at 00:15:10 and ends at 00:18:12 (DVD Scene
 4)
Rating: R for violence and some sexuality

The Rundown

Oppression

> A licensed bounty hunter is sent on an assignment to rescue his em-
> ployer's son who is captured in a small village in Brazil. Beck (Dwayne
> "The Rock" Johnson), the bounty hunter, must defeat an oppressive
> dictator who has enslaved most of the village citizens and is using
> them for his own corrupt desires.

This scene is the first meeting between Beck and Hatcher (Christopher Walk-
en) who has control of the village. Beck inquires about Travis (the missing
son) whom Hatcher seems to be using for his own personal agenda. During
their conversation, Hatcher shows Beck a valley filled with dirty, beaten, mal-
nourished people who are chained together digging and searching for buried
treasure. Beck responds, "Looks more like hell." Hatcher responds that he sees
"a spellbinding sense of purpose. I see the value of keeping your eye on the ball.
When a bride slips the ring on her finger, when a business man lays his hands
on a Rolex, when a rapper gets a shiny new tooth; this is the cost, Mr. Beck. My
horror for their beauty, my hell for their little slice of heaven. Somebody's got
to keep his eye on the ball. . . . That's just a simple fact of life, and if you're bold
enough to face that cold, hard fact, you can make a lot of money."

- 🐾 Explain how Hatcher's words about the villagers' labor contradict
 what is actually shown.
- What can everyday citizens do to end oppression and combat social
 injustice around the globe?
- 🐾 If Beck wanted to intervene, what would he need to know about
 the villagers?

The Rundown (Columbia Pictures, 2003), written by R. J. Stewart, directed by Peter Berg

Elapsed time: This scene begins at 00:18:36 and ends at 00:20:02 (DVD Scene 5)

Rating: PG-13 for adventure violence and some crude dialogue

Save the Last Dance

Discrimination

Sara is a White female raised in the Midwest who has dreams of becoming a famous ballet dancer. While Sara auditions for Juilliard, her mother is killed in a car accident. Sara is forced to move into an impoverished section of Chicago with her ne'er-do-well father and begins to attend a predominantly Black high school. She is befriended by Chenille, a popular girl at the school. She finds herself attracted to Chenille's brother, Derek, a good student with a prospective career in medicine. Multiple forces attempt to prohibit Sara and Derek from being together.

Sara (Julia Stiles) and Derek (Sean Patrick Thomas) are at the popular dance club, Steps, which is mostly populated by Black people. Sara and Derek have just finished dancing—they were actually separated by Nikki, Derek's ex-girlfriend, who does not approve of the interracial couple. Derek's friend, Malachi, also disapproves, and he tells Sara, "You'll never look as good as she does with him [Derek]. That's oil; you're milk; ain't any point trying to mix." The clip ends as Derek walks up the steps to meet Sara.

- 🎬 Of all of the analogies he could have used, why do you think Malachi used the terms "oil" and "milk" when referring to Sara and Derek?
- How often do we see Whites discriminated against in film? In real life?
- What are your family's and/or your peers' thoughts about interracial dating?
- 🎬 Sara seems "out of place" at this all-Black club. Describe a time when you were the only member of your racial group in a situation.
- Why is hip-hop so popular among White teenagers?

Save the Last Dance (Cort/Madden Productions, 2001), written by Duane Adler, directed by Thomas Carter
Elapsed time: This scene begins at 01:09:37 and ends at 01:10:25 (DVD Scene 12)
Rating: PG-13 for violence, sexual content, language, and brief drug references

Saved!

Heterosexism

American Eagle High School is the banner school for raising good, wholesome Christian students—the more Christian you are, the more popular. Mary is a good Christian girl with good Christian friends and a good Christian boyfriend. One day, her boyfriend, Dean, informs Mary that he is gay. Crushed, Mary believes that she has been given the task of sacrificing her virginity to save Dean and turn him straight. Once the other students at the school learn of Dean's gayness, Dean is sent to a "de-gayification center" called Mercy House. Mary's got a secret too—she's pregnant—all hell is breaking loose.

Mary goes to Dean's house to take him to school. Dean's parents have sent him to Mercy House after having found gay porn under his mattress. Mary describes Mercy House as a place for alcoholics, unwed mothers, and drug addicts. At school, Mary takes plenty of heat from the other students, especially Hillary Faye, who in disgust says, "We've never had 'a gay' at American Eagle." Her friend, Veronica, continues, "What if you had married him? The gayness would be passed on to your children!"

- If your married, male spiritual leader cheated on his wife with another woman, what would the consequences be in your congregation? How would you feel? What if he had an affair with another man?
- What does your faith tradition teach about homosexuality? How does this teaching coincide with your current belief/value system?
- Some people question why homosexuals "flaunt" their sexuality—in what ways is heterosexuality flaunted?

Saved! (United Artists, 2004), written and directed by Brian Dannelly
Elapsed time: This scene begins at 00:11:28 and ends at 00:13:05 (DVD Scene 4)
Rating: PG-13 for strong thematic issues involving teens—sexual content, pregnancy, smoking, and language

Saw

Power

A graphic tale that pits ordinary citizens against their greatest fears or their most vile habits, *Saw* is the story of the "Jigsaw killer" who engineers sick and twisted traps that victims must free themselves from or die.

Dr. Lawrence Gordon (Cary Elwes) finds himself chained to a wall in an abandoned location. He is joined by another man in a similar predicament. He realizes that he may know the person who has imprisoned them and begins to narrate the story of the Jigsaw killer, who challenges his victims with elaborate and macabre obstacles (often with a time limit that will ensure the person's death if the task is not completed). Jigsaw leaves recorded voice instructions on a cassette player that reveals the reasons why the victim has been chosen, the methods by which he can be freed, and the time restrictions. Most of Jigsaw's victims die while struggling to be freed, but one formidable woman manages to escape. Jigsaw tells her that she will now appreciate her life more because she has been through this ordeal. The scene ends as the Jigsaw doll congratulates Amanda (Shawnee Smith) on her accomplishment. 🎞️

- Discuss the effectiveness of using confrontational or provocative methods in order to draw attention to societal ills. Do we as humans sometimes need to be confronted with our greatest fears or vilest habits in order to become better people?
- 🎬 Why do you think the Jigsaw killer reveals the reasons the victim has been chosen? What are your thoughts about his approach to "social justice"?
- In what ways can gender, class, ethnicity, and other dimensions be integrated into justice strategies?

Saw (Lions Gate, 2004), written by James Wan and Leigh Whannell, directed by
 James Wan
Elapsed time: This scene begins at 00:15:40 and ends at 00:28:43 (DVD Scene
 6)
Rating: R for strong, grisly violence and language

Shawshank Redemption

Social justice

Andy Dufresne (played by Tim Robbins) is sentenced to life in the
Shawshank Prison after being convicted in the deaths of his wife and
her lover. While there, he is befriended by Red (Morgan Freeman)
who guides him in the ways of prison life. His story of freedom behind
bars and his escape from prison are chronicled here.

An elderly prisoner named Brooks (James Whitmore) learns that he is being
paroled after over 50 years behind bars. Brooks is afraid and in this scene we
see life after prison for Brooks—he references how quick the pace is of every-
day life and seeing the proliferation of automobiles on the street. Brooks lives a
solitary life in a halfway house and works at a grocery store bagging groceries.
He commits suicide after carving "Brooks was here" on the wall above his table.
The scene ends after Red states, "He should have died in here."

- What role does the government have in rehabilitating and training
 inmates before release into the community?
- Imagine you were a police officer and were instructed to go out and
 arrest a drug dealer. To what area would you go and why?
- Evaluate this statement: Justice is not colorblind.
- What are your thoughts about marrying someone who is currently in
 or had served time in prison?

Shawshank Redemption (Castle Rock Entertainment, 1994), written by Stephen
 King, directed by Frank Darabont
Elapsed time: This scene begins at 01:00:25 and ends at 01:05:42 (DVD Scene
 17)
Rating: R for language and prison violence

She's the Man

Gender

Viola (Amanda Bynes) is a star soccer player who learns that the girls' soccer team is being eliminated by budget cuts. Unable to join the boys' soccer team as a girl, she decides to pretend to be her twin brother, Sebastian, and earns a spot on the team. Who would have imagined the trouble that she would find herself/himself in as she/he falls in love with her roommate and teammate—he just happens to think that she is a guy.

Viola has been masquerading as her brother, Sebastian, and her worlds will collide at today's Junior League carnival, where her mother, her ex-boyfriend, her brother's ex-girlfriend, and Duke, the boy she has a crush on who is also "Sebastian's" roommate (Duke has a crush on Olivia, Viola's lab partner), will all be in attendance. She undergoes several quick changes from Viola to Sebastian. As Viola, she has the opportunity to kiss Duke while working the kissing booth; Justin, her ex-boyfriend breaks them apart and a fight ensues. Viola's mother breaks up the fight and tells her to act like a lady. Later, dressed as Sebastian, Viola returns to "his" room and finds Duke with a tampon in his nose to stop the bleeding. Viola reacts in a feminine manner to the blood, but when Duke notices, she plays up masculinity and tells him to "Suck it up! Be a man! Rub some dirt in it." As Duke explains his kissing Viola, she finds it difficult to stay in character as Sebastian. She reverts back and forth between masculine and feminine characteristics. Sebastian compares Olivia and Viola, and asks Duke, "What does your heart say?" Duke blusters and Sebastian changes his tune and says, "I mean, which one would you rather see naked?" Duke scolds him, "Why do you always talk about girls in such graphic terms? You really have issues." Viola/Sebastian asks, "You really are a sensitive guy, aren't you?" Duke explains that relationships are more than physicality for him, and he wants to be able to share his innermost thoughts and feelings with his intimate partner. Realizing how open he is being with another "guy," Duke sits up and declares, "If you tell anyone, I'll kick your ass." Viola/Sebastian rolls over and vows to keep his secret.

- How are gender differences in communications intertwined with social power? How do we interpret power relations via nonverbal communication?
- How would you describe how women come to perceive themselves by

reading materials in children's books, comics, popular music, television, and books intended for adult female audiences?

- How have computers and the Internet served to entrench gender roles in some ways and transcend them in others? How have these techno-logical advances also increased and decreased sexist behaviors?

She's the Man (DreamWorks Pictures, 2006), written by Ewan Leslie, Karen Lutz, and Kirsten Smith, directed by Andy Fickman

Elapsed time: This scene begins at 00:44:26 and ends at 00:55:07 (DVD Scene 3)

Rating: PG-13 for some sexual material

Shrek the Third

Out-group

In this third installment, Shrek and Fiona have been appointed to reign over the land of Far, Far Away. Shrek, however, is not interested, and he, Puss-in-Boots, and Donkey go on a quest to find Artie, the next in line for the throne. Fiona and her girls must also defend the castle against the vengeful machinations of the jilted Prince Charming.

Shrek and Princess Fiona have been called upon to represent the King and Queen after the King has taken ill. Donkey and Puss-in-Boots have arrived to inform Shrek of his duties for the day, which include knighting a soldier and christening a ship—both of which end poorly. After an extreme makeover, Shrek and Fiona must appear before the people; again, sparks fly (literally), and after the busted event, Shrek tells Fiona that it is time to return home to the swamp. Shrek says, "Who do you think we're kidding? I am an ogre. I'm not cut out for this, Fiona, and I never will be." Shrek throws the ever-nosey Donkey out of his room, and Puss states, "Some people just don't understand boundaries," just before Shrek ejects him too. Fiona tries to encourage Shrek by reminding him about the impending return to their "vermin filled shack strewn with fungus and filled with the stench of mud and neglect." Shrek smiles and says, "You had me at vermin-filled." After a conversation on the possibilities of having a family of ogres, Shrek and Fiona learn that the King is dying and is planning to name Shrek as his successor. Shrek responds, "Come on, Dad. An ogre as king? I don't think that's such a good idea. There must be somebody

else. Anybody!" The king informs them of an additional heir to the throne, a son named Arthur. The scene ends after the king is laid to rest and the mourners depart.

- Describe a time in your life when something was expected of you that you didn't feel you could live up to?
- 🐭 What was the point of Shrek's and Fiona's "extreme makeover"? What would you say are the consequences?
- 🐭 Why doesn't Shrek want to be king?

Shrek the Third (DreamWorks, 2007), written by Jeffrey Price, Peter S. Seaman, and Jon Zack, directed by Chris Miller and Raman Hui

Elapsed time: This scene begins at 00:03:20 and ends at 00:13:45 (DVD Scene 2)

Rating: PG for some crude humor and suggestive content

The Siege

Oppression

In pre-9/11 New York, tensions run high as the American military has decided to declare martial law and is rounding up all Arab Americans as potential terrorist suspects, including the son of Frank Haddad, a Lebanese American federal agent (played by Tony Shalhoub). FBI agent Hubbard (Denzel Washington) and CIA operative Elise Kraft (Annette Benning) are engaged in an alliance to restore freedom to the wrongfully accused and imprisoned.

Agent Hubbard enters a military compound and finds his partner frantically searching for his son whom he suspects has been detained by the military with hundreds of other Arab Americans. Agent Haddad explains to Hubbard that the military barged into his home and took his son into custody, despite his wife's protests that Haddad worked for the FBI. Haddad continues to explain that he has been an American citizen for 20 years and has served his country for numerous years, only to be treated poorly because of his ethnicity. Haddad rejects Hubbard's offer to help locate his son stating that "this is where I belong" referring to the numerous other people behind the fences. He throws his FBI identification at Hubbard and tells him, "Tell them I'm not their sand nig-

ger anymore." When Hubbard complains about the maltreatment of Haddad's son, one of the soldiers retorts, "Don't get in my face, Hubbard. I just might decide you're an Ethiopian." The scene ends as Haddad is being led away by Major General William Devereaux (Bruce Willis).

- 🐛 Describe the process by which something like this could happen in America. What are your feelings regarding the capture and imprisonment of suspected terrorists via the Patriot Act?
- How would you define these terms: Islamophobia and Islamo-fascism? What are the origins of these words?
- Why are we often afraid to ask people questions about their background and ethnicity?

The Siege (20th Century Fox, 1998), written by Edward Zwick, Menno Meyjes, and Lawrence Wright, directed by Edward Zwick

Elapsed time: This scene begins at 01:21:32 and ends at 01:24:29 (DVD Scene 22)

Rating: R for violence, language, and brief nudity

Snatch

Anti-Semitism

In the world of organized crime, Turkish is no mastermind. In fact, he is chum in shark-infested waters. Turkish is an unlicensed boxing promoter who has gotten into bed with Brick Top, a powerful gangster who wants Turkish to fix the fight. When Turkish learns about a missing 84-carat diamond, he wants a piece of the action but so does every crime boss from the United Kingdom to America.

In London, we are introduced to Doug the Head, a member of an organized crime family. Doug plies his trade in the diamond industry—"if it's stones and it's stolen, he's the man to speak to." Then we learn that Doug "pretends he's Jewish. Wishes he were Jewish. Even tells his family they're Jewish." Doug believes that being Jewish in the diamond business is a benefit; he even states that he will only buy diamonds that are kosher. As he enters his diamond store, several Hasidic boys are hanging out on the stoop, but Doug questions their presence there. [OBJ]

- 🐭 Why does Doug believe that being Jewish in the diamond business is a benefit?
- 🐭 What does Doug's questioning of the Hasidic boys reveal to us?
- Are there any real-life examples of persons who passed themselves off as something, but their own personal ignorance got in their way?
- Compare and contrast the manifestations of anti-Semitism in the United States and in the Middle East.

Snatch (Screen Gems, 2000), written and directed by Guy Ritchie
Elapsed time: This scene begins at 00:13:43 and ends at 00:14:51 (DVD Scene 7)
Rating: R for strong violence, language, some nudity

Something New

Prejudice/discrimination

Kenya McQueen (Sanaa Lathan) is a take-no-prisoners successful career woman, but she has had no time for love. When she hires a landscaper to transform her hideous backyard, she does not anticipate falling in love with him. How will she explain to her friends that she, as a Black woman, is dating a White man in a different economic class?

Interracial dating is new for Kenya, but she and Brian (Simon Baker) have been enjoying their newfound relationship. Kenya questions the oddness that "White people have a special thing for dogs." She mentions how there are "dog hotels, dog shrinks. You know you kiss them in the mouth. You let them sleep with you." Later, the couple is out at a nightclub, and they are joined by Kenya's friends. Sommore, a Black stand-up comic, is doing her act on stage and is discussing her romantic fondness and preference for Black men. She jokes about how Black men are given mixed messages about the roles as fathers, and makes light of the DC sniper and how he was a role model for his son. Sommore brings up the topic of interracial dating and she explains that she has never dated outside her race; she mentions, "But my only problem with the White man is that y'all don't know how to break up with a woman. I watch the Crime Channel. You date them, you come up missing don't you? You'll be chopped up in the freezer, in a sandwich bag with a BBQ sign on your head."

At their table, Kenya and her friends are talking about their new relationships, but you can tell that Kenya is still uncomfortable about her relationship. Sommore joins them at the table and notices Brian and says, "I see y'all brought your nightlight with you" (everyone laughs except Kenya). Turning to Kenya, Sommore jokes, "Girl, either you're getting your swirl on or you got your probation officer with you."

- 🎤 List and discuss the multiple uses for stereotyping in this scene.
- What are your personal feelings about interracial dating/marriage? How did you come to your convictions on this?
- 🎤 Why is Kenya so uneasy about her relationship with Brian, a White man? Are her feelings justified?

Something New (Focus Features, 2006), written by Kriss Turner, directed by Sanaa Hamri

Elapsed time: This scene begins at 00:48:49 and ends at 00:53:37 (DVD Scene 10)

Rating: PG-13 for sexual reference

Spanglish

Power/privilege

FFlor, a recent immigrant from Mexico, becomes the nanny for the Clasky family: Deborah (Téa Leoni), a real estate broker; John (Adam Sandler), a successful chef and restaurateur; Bernice, their wallflower daughter; and Evelyn (Cloris Leachman), Deborah's mother who is a former recording artist. Flor's daughter, Cristina, narrates the story and becomes the favored child of the Clasky family—despite Flor's wishes.

Flor senses that her role as Cristina's mother is being challenged by Mrs. Clasky, who showers Cristina with gifts and attention—and veritably ignores her own daughter. In this scene, Deborah's favoritism has gotten Cristina a $20,000 scholarship to attend an exclusive school with Bernice; Flor is very concerned about her daughter fitting in at the new school (Mr. Clasky shares her concerns about his own daughter). Cristina admits that Flor was "caught in a vise of manipulation," and she ultimately gives in and allows Cristina to

attend the school. On the first day of the new year, Deborah gives Cristina an expensive necklace and claims that it came from her, Bernice, and Flor; Flor admits that the gift was not hers. Deborah seems to place herself in front of Flor on a regular basis, particularly with regard to important decisions about Cristina. After Cristina boards the bus, Flor walks in anger toward the Clasky's home. When Mrs. Clasky begins running after Flor, the nanny begins running as well. Deborah is yelling at anyone in her way, shouting "Left!" as she passes. The contest between the mothers speeds up and Deborah quickly blasts by a panting Flor, and turns to her and says, "I love you for trying," as if to say that Flor will never beat her (in any way). The scene ends as Cristina narrates, "When people exist under one roof, a tiny society forms . . . masters and servants unconsciously dancing in lock step, so that when things go wrong, traumas converge."

- 🐾 "When people exist under one roof, a tiny society forms . . . masters and servants unconsciously dancing in lock step, so that when things go wrong, traumas converge." What do Cristina's final comments mean?
- 🐾 Why might Deborah see herself as a better mother for Cristina? Why does Deborah feel she can "put herself in front of Flor" with regard to Christina's well-being?
- Make sense of these comments made by noted journalist, Carl T. Rowan: "It is often easier to become outraged by injustice half a world away than by oppression and discrimination half a block from home."

Spanglish (Columbia Pictures, 2004), written and directed by James L. Brooks
Elapsed time: This scene begins at 01:15:03 and ends at 01:27:47 (DVD Scene 17)
Rating: PG-13 for some sexual content and brief language

The Stepford Wives

Sexism

Flashback to "happier" times when women served their men, cooked and cleaned for them, and were happiest when they got the newest kitchen appliance. But wait, this isn't 1950s; it's the twenty-first cen-

tury. Joanna Eberhart (Nicole Kidman) is a former TV executive who has lost her job and her family has moved to Stepford, Connecticut. To her surprise and dismay, this little sleepy town is a throwback to a bygone era.

Joanna is introducing the new line-up of reality shows for her network, which prides itself on the empowerment of women. The first show she describes is between "a man, a woman, and a buzzer" and the show is titled "Balance of Power." She shows a trailer clip from the show and the female contestant answers all of the questions correctly, before the male has an opportunity to even buzz in. The next show that Joanna introduces as "this planet's ultimate reality phenomenon" is titled "I Can Do Better" and sets married couples up on dates with other people. After the dates, the couple decides whether they want to stay together or separate. The husband, Hank, tells how much he enjoyed his date, but that his heart belongs to his wife. His wife, however, had multiple trysts and opts to leave her husband. The network affiliates listening to Joanna's presentation cheer the new line-up when Hank, the disgruntled husband, shows up and argues with Joanna. Hank brandishes a gun and says that he is going to kill all the women; he is thwarted by the police. In her office, Joanna learns that prior to coming to the network, Hank had shot his wife and several of her lovers from the television show. Ultimately Joanna is fired from her position at the network.

- 🎬 What is the irony in the show title, "Balance of Power" and what its trailer depicts? How would you characterize Joanna's values by analyzing her choices for the new line-up?
- 🎬 Why was Hank only planning to kill women? Discuss this in light of this quote made by feminist activist Robin Morgan: "Sexism is not the fault of women—kill your fathers, not your mothers."
- Reality television shows often depict women in highly sexualized and demeaning ways. Who do you believe is at fault—the "real" women, the producers, or the audience who craves the material?

The Stepford Wives (Paramount Pictures, 2004), written by Paul Rudnick, directed by Frank Oz

Elapsed time: This scene begins at 00:03:14 and ends at 00:11:21 (DVD Scene 2)

Rating: PG-13 for sexual content, thematic material, and language

Step Up

Co-optation/ethnocentrism

Sentenced to doing 200 hours of community service at the performing arts school he was caught vandalizing, teenage miscreant, Tyler, becomes infatuated with a young co-ed dancer. Tyler (Channing Tatum) is a hip-hop dancer himself and the two agree to perform in the school's senior showcase; their performance is a wonderful blend of classical ballet and hip-hop street moves.

Mac, Tyler's best friend, walks in on Tyler teaching several students some of his moves. Mac (Damaine Radcliffe) feels left out as Tyler missed their appointment to play basketball to continue practicing his dance techniques. Mac chides Tyler for "getting down with his Irish roots" [Tyler is White, but his peer group is all-Black]. Mac appears disappointed in Tyler because his behavior seems to reject the urban culture that they both seem to adhere to. Rather than admit how much he enjoys dancing at the school, Tyler tells Mac that he is only dancing to gain the attention of one of the female dancers. The clip ends when Mac drives away and Tyler walks back into the school.

- List three aspects of your ethnic group that you appreciate most and three aspects that you dislike the most.
- What ethnic, racial, sexual, or religious groups do you feel you understand the best (other than your own group)? Why? How did you get to be so knowledgeable about this group? What group(s) would you like to understand better?
- Suppose your best friend does some act that completely goes against your belief system and that you consider morally reprehensible. How would you respond?

Step Up (Eketahuna LLC, 2006), written by Duane Adler and Melissa Rosenberg, directed by Anne Fletcher

Elapsed time: This scene begins at 01:11:43 and ends at 01:13:18 (DVD Scene 9)

Rating: PG-13 for thematic elements, brief violence, and innuendo

Stitch: The Movie

Difference

Experiment 626, better known as Stitch, a destructive, yet loveable, alien, is back in this sequel to Disney's *Lilo and Stitch*. This time, Lilo and her alien friend have to rescue the other 625 experiments from the evil Captain Gantu.

The island is having a luau and the people have gathered to surf, build sandcastles, and eat plenty of food. Two aliens, Pleakley and Dr. Jumba, have arrived in what they call a "ridiculous Earth vehicle," and Pleakley describes his excitement about his "very first day at an Earth beach." He mentions how he has been studying earthly mingling customs and tries to greet some of the locals who scoff at his greeting. Dr. Jumba questions the appropriateness of their attire, when Nani enters looking for Lilo, who is helping Stitch prepare for the luau. Lilo tells Stitch, "Today you will take your rightful place as part of the Hawaiian community." Stitch appears in what can be called local attire, but Lilo tells him, "You do not need to dress up—just be yourself." Hearing this, Stitch pops out his hidden arms and claws, but Lilo says, "Maybe not that much yourself." She continues her lesson informing him about the custom of calling everyone "cousin" because they all are *ohana* (family). Stitch tries the greeting with a young boy and gives him a hug, but the boy runs away screaming. He tries to play volleyball but bursts the ball with his claws. He offers to cut the pineapple but uses a chainsaw and destroys the feast. A guest at the luau says, "That blue dude," referring to Stitch, "he's like totally freaky." Later, Stitch is very sad and realizes that he has "no cousins" of his own, but Lilo tells him, "You're a part of our ohana now, but getting everyone else to like you is harder." Stitch repeats what he heard earlier, "I'm freaky," but Lilo says, "You're different. You're one of a kind—like Frankenstein." Stitch buries his face in his ice cream bowl to end the scene.

- List people who are "different." What criteria did you use to make your list?
- 🐭 What is the irony in Lilo telling Stitch, "Today you will take your rightful place as part of the Hawaiian community," and ultimately how Stitch is treated in this community? Are our communities much the

same? Are we often cautioned to not reveal "that much" of ourselves?
* Because Stitch's differences are so pronounced, it is hard for him to fit in. What types of differences are easy to see in our society? What areas of diversity are invisible?

Stitch: The Movie (Walt Disney Pictures, 2003), written by Roberts Gannaway and Jess Winfield, directed by Roberts Gannaway and Tony Craig
Elapsed time: This scene begins at 00:02:18 and ends at 00:06:28 (DVD Scene 1)
Rating: G for all audiences

Superbad

Gender

Super geeks Seth, Evan, and Fogell are on a quest for popularity and sexual conquest—each pledging to land their dream girls before they leave for college. To impress their prospective dates, they agree to get fake IDs and bring a buffet of liquor to a party. Can they reverse a lifetime of loser status in just one night?

After the party of a lifetime where Seth (Jonah Hill) saved Evan (Michael Cera) from being beaten up and arrested, the two retire to Evan's house. Seth and Evan have been lifelong friends, but they are struggling with the prospect of going to separate colleges next year. In their drunken stupor, both Seth and Evan pledge their love for one another; they question why they have been unable to show affection to each other. 🚸

* Why is it rare to see open, physical affection between two men in our society? When is physical touch between men "acceptable"?
* American "party culture" appears to have high preference for female-to-female sexual behavior (as evidenced by the popularity of reality TV shows and the *Girls Gone Wild* series). Why do you suppose this is? What themes are revealed in these types of programs?
* Evaluate this statement: Men and women cannot be "just friends."

Superbad (Columbia Pictures, 2007), written by Seth Rogen and Evan Goldberg, directed by Greg Mottolla
Elapsed time: This scene begins at 01:45:50 and ends at 01:47:13 (DVD Scene 27)
Rating: R for pervasive crude and sexual content, strong language, drinking, and some drug use

S.W.A.T.

Sexism

Two hard-nosed, temperamental police officers in the elite S.W.A.T. team are transporting an international drug kingpin into federal custody; the only problem is that the drug dealer has offered a $100 million reward for anyone who frees him from police custody.

Hondo (Samuel L. Jackson) is recruiting members for his special forces team; he and Officer Street (Colin Ferrell) are searching for an Officer Chris Sanchez in a hospital emergency room. Officer Sanchez has just been involved in a scuffle with a prisoner; Sanchez won. Hondo and Street are reading Sanchez's file and are pleased with what they see. They want Sanchez on their team; imagine their surprise when they swing open the hospital curtain and learn that Chris Sanchez is a woman. Sanchez vents that she is tired of being scolded by her superiors every time "some *vato* doesn't like getting thrown to the pavement by a woman."

- Why are Hondo and Street surprised to find that Sanchez is a woman? Discuss their surprise at the damage she inflicted on the assailant.
- Author Mary Wollstonecraft Shelley once wrote, "I do not wish women to have power over men; but over themselves." What do you think she meant by this statement?
- How might you explain the prevalence of sexism and homophobia in the police force and in the military?

S.W.A.T. (Columbia Pictures, 2003), written by David Ayer and David McKenna, directed by Clark Johnson

Elapsed time: This scene begins at 00:30:16 and ends at 00:31:46 (DVD Scene 10)

Rating: PG-13 for violence, language, and sexual references

Swing Kids

Dominance/ethnocentrism/anti-Semitism/social justice

In Nazi Germany, conformity is the rule and the youth, above all, are expected to follow the rules. But a group of youth calling themselves the Swing Kids are rebelling through the influence of swing music from America. Two friends must choose between personal beliefs and friendships and expected loyalty to the Third Reich—they must find the courage to fight for freedom.

Peter (Robert Sean Leonard) and his friend Thomas (Christian Bale) have joined the Hitler-Jugend, Hitler's Nazi "boy scout" camp (Peter against his will). They are in a restaurant listening to their friend Arvid playing swing music with his band. Two Third Reich soldiers make a special request that the band play "one good German song," which infuriates Arvid because he contends, "There are no more German songs, only Nazi songs." He shouts to the crowd, "What's the matter with all of you? Can't you see what's happening? Are you afraid to look? We are murdering Austrians. Next it will be the Czechs and then the Poles, not to mention the Gypsies and the Jews. It's unmentionable. You think that just because you're not doing it yourself that you're not a part of it? Well, I'm sick and tired of doing my part!" He storms from the restaurant and as he is limping away (Arvid has a physical disability), Peter catches up to him to calm him down, but Arvid will not be consoled. He states, "Anytime you go along with them, anytime you try to help them, it just makes it easier." Thomas, who is a proud member of the Nazi regime, questions Arvid's behavior, particularly Arvid's mention of the Gypsies and the Jews. Thomas questions, "What about the cripples and the retards. You know that's who you belong with. . . . Nazis go anywhere they want. Do anything

they please. Everybody gets out of our way." He warns Arvid to watch out because "we're coming after you next." When Peter argues with Thomas about his beliefs, Thomas fires back, "Oh, I am sorry I forgot. Your father was a Jew lover, too, wasn't he?" Later, Arvid commits suicide, and the scene ends after his funeral service at the cemetery.

- Why is it easier to belong to a group in power? Describe a time when you went along with a group decision that you did not personally agree with.
- What is the value of defining individuals or groups by categories? Why do certain groups prefer to self-segregate?
- Define *propaganda*. Discuss the historical and contemporary methods of using propaganda to support oppressive practices and in dismantling them.

Swing Kids (Hollywood Pictures, 1993), written by Jonathan Marc Feldman, directed by Thomas Carter

Elapsed time: This scene begins at 01:10:12 and ends at 01:19:25 (DVD Scene 7)

Rating: PG-13 for language and mature thematic elements

The Talented Mr. Ripley

Heterosexism/compulsory heterosexuality

Matt Damon (of *Good Will Hunting*) plays Tom Ripley, a young man skilled in forgery and impersonation, who has been hired to find the wayward son of a wealthy industrialist who is traipsing through Europe. Ripley believes that "it's better to be a fake somebody than a real nobody" and he uses his "talents" to worm his way into a better life of the rich and famous.

Tom is in Italy and is being questioned by the police in the mysterious death of Dickie Greenleaf, the man whom Tom has been impersonating. During the interrogation, the police detective asks Tom whether he is a homosexual; Tom's translator tells him, "By the way, um, officially there are no Italian homosexuals." Tom states that he is not a homosexual and qualifies this by saying that he has a fiancée.

- If you identify as heterosexual, how would your parents react if you told them that you were gay?
- 🎞 Why does the translator say, "By the way, um, officially there are no Italian homosexuals"?
- 🎞 Why does Tom feel he must qualify his statement that he is "not a homosexual" by saying he has a fiancée? In what other ways do people try to "prove" their heterosexuality?

The Talented Mr. Ripley (Paramount, 1999), written and directed by Anthony Minghella

Elapsed time: This scene begins at 01:41:20 and ends at 01:44:47 (DVD Scene 20)

Rating: R for violence, language, and brief nudity

Talladega Nights: The Legend of Ricky Bobby

Homophobia

Ricky Bobby (Will Ferrell) is God's gift to NASCAR, or at least that is what he thinks. He is a record-setting, championship winning driver, but all of that is about to change when a new driver is hired to be his teammate. Joining the team is a Formula-1 winner from France, Jean Girard (Sacha Baron Cohen), who breaks Ricky's confidence by breaking all of his records.

Ricky Bobby and his best friend and teammate, Cal, have been giving Jean a hard time while playing billiards. Ricky threatens Jean who ends up breaking Ricky's arm. Mr. Dennit, the owner of the racing team, breaks up the fight and formally introduces Jean to the team. When Jean introduces his husband, Ricky reacts by stating that he is going to faint "because of the gayness." The next day at the race track, the announcers and commentators are introducing Jean to the fans and they flash scenes of Jean and his husband at home with their "gay" horses and German shepherds. The scene ends as Ricky and his wife and Cal walk off the track. 🔳

- Why does Ricky Bobby say he is going to faint "because of the gayness"?
- Research scientists have suggested that more than 500 different ani-

mal species engage in homosexual activities and relationships. How does this affect your thoughts on the possibility of sexuality as predetermined?

- Discuss both the levels of acceptance and invisibility of homosexuals in men's and women's sports. To what do you attribute the visibility (or lack of) within certain sports and not others?

Talladega Nights: The Legend of Ricky Bobby (Columbia Pictures, 2006), written by Will Ferrell and Adam McKay, directed by Adam McKay

Elapsed time: This scene begins at 00:26:09 and ends at 00:34:25 (DVD Scene 6)

Rating: PG-13 for crude sexual humor and language

Three to Tango

Homophobia

In order to win an architectural contract, Oscar (Matthew Perry) must pretend to be gay to spy on his prospective boss's girlfriend (Neve Campbell). Oscar ends up falling in love with his "assignment" but must contain his feelings in order to win the lucrative prize.

Oscar's best friends have just learned that Oscar is gay and they are quite nervous. Even though they have been friends for years, the friends are clearly uncomfortable with their old chum. They reference Oscar's cooking and home décor as proof of his gayness. Even Oscar's parents are having a hard time accepting the news.

- Heterosexual men seem to have significant difficulty and fear when confronted by perceived male homosexuality. Why do you suppose that is?
- Male athletic culture suggests that it is all right for men to pat each other's rear ends as a sign of praise. What is the meaning behind this practice? Why is it unacceptable in ordinary life and why does the rule seem to change off the field or court?
- Coretta Scott King, the widow of Martin Luther King, Jr., likened homophobia to racism, sexism, and anti-Semitism in that it "seeks to dehumanize a large group of people, to deny their humanity, their dig-

nity and personhood." If alive today, do you imagine that Dr. King would be involved in the gay rights movement? Defend your position by appealing to Kingian philosophies, writings, and speeches.

Three to Tango (Warner Bros., 1999), written by Rodney Vaccaro, directed by Damon Santostefano

Elapsed time: This scene begins at 01:02:21 and ends at 01:05:04 (DVD Scene 20)

Rating: PG-13 for sex-related situations and language

Titanic

Classism

A pair of star-crossed lovers meets on the ill-fated *Titanic*, the unsinkable ship. They have little in common—Jack (Leonardo DiCaprio) is a poor street kid, while his would-be-love, Rose (Kate Winslet) is a high society debutante who is promised to marry another man. The film gives new meaning to "till death do us part."

The ship's crew is beginning to evacuate the ship after it has hit an iceberg. There are clearly not enough lifeboats for the passengers and the crew. The ship's captain calls for the evacuation of women and children first. Those persons being put on the lifeboat first are dressed quite handsomely and are considered "first class." On a lower level of the ship (locked behind a closed gate) are lower-class passengers begging to be let out; a mother is speaking to her children who are wondering when they will be saved. The mother responds, "after the first class passengers." Above, Rose is trying to get her mother to understand the gravity of the situation by telling her that because of the shortage of lifeboats, half of the passengers will die, to which Rose's intended states, "not the better half." [OBJ]

- What will it take to achieve social and economic equality for all in America?
- Evaluate this statement: Because of its principles of capitalism and democracy, equality is impossible in America.
- Without asking questions, describe the ethnicity, race, sexual identity, socioeconomic class, and religion of the person on your left.

Titanic (20th Century Fox, 1997), written and directed by James Cameron
Elapsed time: This scene begins at 01:53:00 and ends at 01:57:03 (DVD Scene 19)
Rating: PG-13 for disaster-related peril and violence, nudity, sensuality, and brief language

TMNT (Teenage Mutant Ninja Turtles)

Dominance

Those famous mutant crime fighters Donatello, Raphael, Michelangelo, and Leonardo, the Teenage Mutant Ninja Turtles, are back. The foursome have grown apart after Leonardo was sent on a training expedition to South America. This time, they not only face minions of dark warlord enemies, but their biggest battle is becoming a team themselves.

Leonardo learns that during his absence, Raphael has been secretly moonlighting as The Nightwatcher, a metal-masked crime fighter. Raphael resents Leo's absence and the two begin fighting. During their fight, Raphael argues that Leo has a superiority complex in his position as "leader" of the turtles. Leo views Raphael as hot-tempered and in need of his leadership. (The scene ends as Raphael runs away.)

- With what strategies does American society maintain its status as one of the world's superpowers?
- What do you think about current U. S. foreign policy and how do you think America can rebuild relationships with past allies that this policy has alienated?
- In what ways can sibling rivalry be seen as a struggle for dominance? Discuss the benefits and disadvantages of this rivalry.

TMNT (Imagi Animation Studios, 2007), written and directed by Kevin Munrow
Elapsed time: This scene begins at 00:51:44 and ends at 00:57:15 (DVD Scene 13)
Rating: PG for animated action violence, some scary cartoon images, and mild language

To Wong Foo, Thanks for Everything, Julie Newmar

Gender

Vida La Boheme (Patrick Swayze), Noxeema Jackson (Wesley Snipes), and Chi Chi Rodriguez (John Leguizamo) are traveling from New York to California to participate in a drag queen competition. When a police officer with wandering hands finds out Vida's "little secret," the "ladies" are forced to flee. Their travels land them in a small town where they must win over the town's provincial beliefs, fend off attacks, and save the people from their mundane lives.

The trio is driving through Pennsylvania and decides to stop in Bala Cynwyd, Vida's suburban hometown. Noxie and Chi Chi remark that Vida apparently comes from an upper-class background, and they question why she chose to leave. Vida responds that she left "so that Vida could be Vida." Upon seeing the disgust in his mother's eyes, Vida quickly retreats. Back on the road, Vida and Noxie suggest that Chi Chi has much to learn before she becomes a "full-fledged drag queen." Chi Chi takes this as a sign of disrespect and jumps out of the car. Noxie explains the differences between a transvestite ("when a straight man puts on a dress and gets his sexual kicks"), a transsexual ("when a man is trapped in a woman's body and has the little operation"), a drag queen ("when a gay man has way too much fashion sense for one gender" and refers to Chi Chi as "a tired little Latin boy in a dress."

- How might you feel if your own mother did not accept who you were or the choices you make/made?
- Why do subcultures exist and how do they operate? Why does discrimination happen between subgroups of a larger group? Think of one group of people and define some of the subgroups of that major group. How are each of the subgroups different and what might determine these differences?
- What impact, do you imagine, did playing these roles have on Swayze, Leguizamo, and Snipes? Imagine that you were an aspiring actor and were invited to star in a revival of these roles. Would you accept the role? If you had the option of naming your character, what name would you choose?

To Wong Foo, Thanks for Everything, Julie Newmar (Universal Pictures, 1995), written by Douglas Beane, directed by Beeban Kidron

Elapsed time: This scene begins at 00:18:48 and ends at 00:24:25 (DVD Scene 5)

Rating: PG-13 for subject matter involving men living in drag, a brief scene of spousal abuse, and some language

Transformers

Difference

> The 1980s cartoon characters come to life as the Autobots and Decepticons, two warring factions of robots that can change shape into automobiles and flying machines, are fighting their ancient war here on earth. Each is hoping to obtain a powerful ancient relic that will give the user the power to take over the world. Human beings become the collateral agents of the action as the Decepticons are hell-bent on human annihilation.

Sam (Shia LaBoeuf) and his friend, Miles, are driving to a party at the lake. When they arrive, all of the popular students are hanging out swimming and playing sports. A leader of the cool kids questions why Sam and Miles are there, suggesting that Sam is unwelcome. Both Sam and the jock trade sarcastic comments—Sam equates jocks with brain damage. The scene ends as Mikaela, a beautiful girl who is at the gathering, walks away.

- Why is it so important to "fit in"? Have you ever seen people completely change the way they look in order to be part of the crowd? What happened?
- How are you being raised differently from the way your parents were raised? How will you raise your own children differently?
- Have you ever had to explain a friendship to someone? Have you ever had someone say, "I can't believe you're friends with him/her"? How does that feel?
- In the film, *The Transformers*, the Decepticons (the villains) are represented by state government vehicles. What might the filmmakers be saying?

Transformers (DreamWorks, 2007), written by Robert Orci and Alex Kurtzman, directed by Michael Bay

Elapsed time: This scene begins at 00:20:20 and ends at 00:22:20 (DVD Scene 4)

Rating: PG-13 for intense sequences of sci-fi action violence, brief sexual humor, and language

A Troll in Central Park

Oppression/power

A fun-loving troll, living in a land ruled by an evil tyrant, grows flowers secretly in his house. He has a magical green thumb that lets him grow flowers at will. One day he decides that he wants a rose in the middle of his garden, but when it starts growing, it doesn't stop. He is banished by Queen Gnorga to New York City, "where nothing ever grows." Stanley befriends two young children, Gus and Rosie, and is enjoying his exile in Central Park—that is, until Queen Gnorga shows up.

Stanley has been caught growing flowers (which is against the law) when Stanley's rose breaks through a window and several angry guards come to find out what's going on. The guard tells Stanley that he will be taken to Queen Gnorga who is the "number one flower hater in all the land." When we meet Queen Gnorga, she refers to herself as the "Queen of Mean" who has plans to rid the world of anything and anybody who is "nice." She wants to turn Stanley into stone, but her henchman convinces her that sending Stanley to a place where no flower will grow is a better punishment—banishing him to a "land of rock and steel where nothing grows." The scene ends as Stanley looks up into the sky and notices the NYC skyline.

- Who gets ostracized in your school (no names please)? Why does this happen? Has it ever happened to you? What did it feel like?
- There's a cliché that goes "Don't hate me because I'm beautiful." Is there any truth in this? Do people get hated because they're good looking?
- In American immigration law, minor offenses that are considered misdemeanors for citizens are cause for deportation for aliens. What are your thoughts on this policy?

A Troll in Central Park (A. Film, 1994), written by Stu Krieger, directed by Don
Bluth and Gary Goldman
Elapsed time: This scene begins at 00:05:37 and ends at 00:11:05 (DVD Scene
4)
Rating: G for all audiences

Tyler Perry's Daddy's Little Girls

Classism/discrimination

Monty James (Idris Alba) is a single father just trying to take care of
his three daughters, despite a criminal background that haunts him,
the call of the streets, the dangerous neighborhood he lives in, and the
children's awful mother, who has plans to make the girls work for her
drug-dealing boyfriend. Monty is a hard-working auto mechanic and
chauffeur, and he meets and falls in love with an Ivy-league corporate
attorney named Julia (Gabrielle Union) who takes on his case.

Against her friends' advice, Julia has been romantically involved with Monty
and has been getting to know his daughters. The "family" is out visiting an
aquarium when they run into Brenda (Terrie J. Vaughan), one of Julia's close
friends. Julia distances herself from an embrace with Monty when confronted
by her friend. Brenda asks Julia why she is there "with this man." Monty tries
to introduce himself and holds out his hand for Brenda to shake, but she dis-
misses him with a simple "I remember you." (Monty had driven Brenda and
Julia to several destinations in his job as a driver.) Rather than admit her fond-
ness for Monty, Julia tells Brenda, "We're just hanging out." Brenda states, "Are
you serious? You like him? Snap out of it Julia! You are a partner at your firm,
the only black woman at that level. What do you think your partners would
think if they knew you were sleeping around with the help? Are you trying to
ruin your life?" Monty asks Julia if she is embarrassed by his social status, and
Julia states that she is not trying to change him. She does admit, however, "I
can't sit here and lie to you and say that I don't think about who you are and
what you have. I do. This is new for me, Monty, and it's different, and I'm
trying. I am trying and you gotta give me credit for that." The scene ends as
Monty and his girls are staring into the aquarium.

- 🐾 Why does Julia expect to be given "credit" for seeing Monty? Does

she deserve it? Justify your answer.

- 🎥 How does gender play out in this situation? If the roles were reversed and Monty was the one with money, what would his best friend say about the relationship?
- How commonplace is discrimination based on class at your school? Cite examples.

Tyler Perry's Daddy's Little Girls (Lionsgate and Tyler Perry Studios, 2007), written and directed by Tyler Perry

Elapsed time: This scene begins at 01:13:31 and ends at 01:16:40 (DVD Scene 16)

Rating: PG-13 for thematic material, drug and sexual content, some violence and language

Undercover Brother

Ethnocentrism/stereotype/co-optation

Move over James Bond . . . move over Austin Powers . . . there's a new international man of mystery in town, and his name is Undercover Brother (Eddie Griffin). He's a funky throwback to the solid-gold 70s, with an attitude to match. General Warren Boutwell (Billy Dee Williams), a decorated Black soldier and possible presidential candidate, has been brainwashed into opening a fried chicken franchise, and Undercover Brother has been hired to infiltrate and take down "The Man" and save the Black nation from utter embarrassment and total White supremacy.

The Chief (Chi McBride) of The Brotherhood, an underground spy organization for the betterment of Black people, is planning a sting operation to infiltrate the Multinational, Inc. headquarters of "The Man." Undercover Brother must undergo a battery of trainings to help prepare him for his secret mission—he must become immersed in White culture. The "token White guy" at the Brotherhood (played by Neil Patrick Harris) gives Undercover Brother a quiz on White culture. The final question refers to a trivia question from the successful television show *Friends*. The clip ends after Undercover Brother passes his test.

- Culture is defined as a people or group's collective values, beliefs, and norms. How would you define White culture?
- Define the following terms: sellout, race traitor, and intraracial diversity.
- Is there a point where we should just say, "It's a joke. Don't take it so seriously"? Is an insulting comment all right if we say, "Hey, I was only joking"?

Undercover Brother (Universal Pictures, 2002), written by John Ridley, directed by Malcolm Lee

Elapsed time: This scene begins at 00:29:49 and ends at 00:33:31 (DVD Scene 8)

Rating: PG-13 for language, sexual humor, drug content, and campy violence

V for Vendetta

Oppression/heterosexism

A young woman named Evey is rescued from a life-and-death situation by a masked vigilante known only as "V" who ignites a revolution when he detonates two London landmarks and takes over the government-controlled airwaves, urging his fellow citizens to rise up against tyranny and oppression. As Evey uncovers the truth about V's mysterious background, she also discovers the truth about herself—and emerges as his unlikely ally in the culmination of his plot to bring freedom and justice back to a society fraught with cruelty and corruption.

Evey (Natalie Portman) is imprisoned and is being tortured as a prisoner of war. During this scene, Evey finds a note in a hole in the wall from a fellow/former prisoner named Valerie who is drafting her autobiography on toilet paper. Valerie begins her story of how she, as a lesbian, had been mistreated by her family and forced to leave her home. She later falls in love with a woman named Ruth. She and Ruth enjoyed their life together until the war began and civil liberties were being stripped away. Valerie explains, "I remember how 'different' became dangerous." A military group bursts into their home and arrests Ruth and soon after comes back for Valerie. She states, "I still don't understand it, why they hate us so much." [OBJ]

- 🐾 Valerie states that being "different" is a crime. How might that be true in our society?
- Explain your feelings about the role of government in regulating marriage?
- 🐾 This scene suggests that in the future (2015), rights for gay persons will be even fewer than they are today. Why do you suppose that is?
- Why do nations go to war? If there were a global war that came down to two individuals, do you think they would keep fighting?

V for Vendetta (Silver Pictures, 2005), written by Andy and Larry Wachowski, directed by James McTeigue

Elapsed time: This scene begins at 01:12:04 and ends at 01:18:43 (DVD Scene 19)

Rating: R for strong violence and some language

Varsity Blues

Oppression/power

In a small town in Texas, there is one phenomenon that binds the entire town together—high school football. The only route to success is on the gridiron, and fate brings popularity for one second string quarterback, Jonathan "Mox" Moxon (James Van Der Beek), when the star quarterback is injured. Add a psycho-serious coach with a win-at-all-costs philosophy, and the stage is set for a mutiny on the football field.

Billy Bob is a gentle giant; he has a larger than life personality and physical frame to match. He drinks maple syrup by the bottle and eats peanut butter by the jar; he even has a pet pig. He is the main defensive lineman for the football team, and he has taken his fair share of hits on the field—a recent one has him a bit out of sorts. While in class, Billy Bob faints and is taken to the school nurse. Coach Kilmer (Jon Voigt) tells him to ignore the nurse's advice to skip the next game because "she doesn't have no division title to win." In fact, the coach tells him that he will "play every minute of that game." Later that night, Billy Bob is wearing an oxygen mask as he sits on the side of the field. The team needs a big play to win the game and the coach sends Billy Bob into the fray; Billy Bob faints on the field and Lance, the star quarterback, is critically

injured. The scene ends as Lance is being carted off the field on a stretcher. [OBJ]

- 🎬 Why would Coach Kilmer tell Billy Bob to ignore the nurse's advice to skip the next game?
- Why is athletic victory deemed more important than a person's health and safety in American culture? How might this be related to gender constructions?
- American culture is severely weight conscious. Explore the types of oppression that exist for those who are not wafer-thin.

Varsity Blues (Paramount Pictures, 1999), written by W. Peter Iliff, directed by Brian Robbins

Elapsed time: This scene begins at 00:27:00 and ends at 00:31:00 (DVD Scene 7)

Rating: R for strong language throughout, sexuality and nudity, and some substance abuse

A Walk to Remember

Difference/out-group

Jamie Sullivan (Mandy Moore) has learned that she has terminal cancer and makes a list of things she wishes to do before she dies. She is a devout Christian who values helping others less fortunate. Landon Carter (Shane West), a popular boy in her high school, regularly makes fun of her—until he needs her help. The two fall in love, are married, and pledge a love that will last a lifetime.

Jamie and Landon are on a school bus returning from volunteering at a neighborhood tutoring center. Landon has had a particularly difficult time with one of his students. Jamie, who is often characterized as a goody-two shoes, offers some advice on how to be more helpful at the center. Landon makes fun of Jamie—especially for carrying a Bible with her wherever she goes. Jamie goes on the defensive and states, "Please don't pretend you know me, OK?" Landon responds with a litany of Jamie's activities; he is trying to insult her again, but she is not swayed by his comments. The scene ends when Jamie moves back to her seat.

- In your school, who are the "normal" kids? How do you know this?
- In what ways are "religious" people discriminated against?
- Why is it hard to see things from someone else's point of view? What does it take to really understand another person's perspective?

A Walk to Remember (DiNovi Pictures, 2002), written by Karen Janszen, directed by Adam Shankman
Elapsed time: This scene begins at 00:16:03 and ends at 00:18:13 (DVD Scene 5)
Rating: PG for thematic elements, language, and some sensual material

Wedding Crashers

Heterosexism

John Beckwith (Owen Wilson) and his best friend, Jeremy Grey (Vince Vaughn), have made a career of crashing weddings and charming the bridesmaids. John, however, breaks his own rules and falls for the daughter of a high-ranking politician. He and Jeremy spend a wild, and confusing, weekend with the family.

William Cleary (Christopher Walken) is the U.S. secretary of the Treasury and John and Jeremy have scammed their way into a family dinner, when the grandmother, Mary (Ellen Albertini Dow) praises her son's efforts in Washington, DC. She mentions how her late husband once worked for President Franklin Roosevelt, but she regards Eleanor Roosevelt as a "big dyke" who "looked like a big lesbian mule." She is chastised by her granddaughter, Claire, who suggests, "Grandma, you can't talk like that. It's not right." Jeremy makes note that Todd, the Clearys' son, has not been eating his dinner. Todd mentions that he does not eat meat or fish, to which the grandmother adds, "He's a homo." Claire says that Todd is "an amazing painter" and that he is a student at the Rhode Island School of Design. Todd tells how his father "used to think I'd be a political liability, you know, in case he ever ran for president." William chimes in, "Now, Todd! Actually, truth be told, polling shows a majority of the American people would ultimately empathize with our situation." Todd angrily interrupts, "What is our situation, Dad?" and Grandma says, "You're a homo." Todd storms away from the table and says that he is going to his room to paint "homo things." [OBJ]

- How open is your family when it comes to talking about difference?
- Do you have a parent, grandparent, or other family member who does not like something about who you are? How do you handle this person?
- In what ways do we tolerate senior citizens who hold bigoted values? How should we respond?

Wedding Crashers (New Line Cinemas, 2005), written by Steve Faber and Bob Fisher, directed by David Dobkin
Elapsed time: This scene begins at 00:51:32 and ends at 00:53:52 (DVD Scene)
Rating: R for sexual content, nudity, and language

Welcome to the Dollhouse

Oppression/invisibility

A tragic tale of 11-year-old Dawn Weiner and her experiences as an unpopular preteen in junior high school. Dawn is teased by her classmates, faces the daily threat by the school bully, and has a secret crush on her older brother's friend.

Dawn (Heather Matarazzo) is in front of the class reading an essay that she was required to write on the subject of dignity after she was chastised for "grade grubbing." The scene breaks to an all-school assembly where a teenage female is describing her experiences as the victim of kidnapping. While the student is speaking, Dawn is being pelted by spitballs and facing the ire of her fellow students—right under the noses of two teachers. No one seems to see what is happening to Dawn, but the moment that Dawn fires back, she gets into trouble. While in the principal's office, Dawn's mother asks her, "Whoever told you to fight back?"

- What do you think is the most difficult aspect of being a racial, ethnic, or religious minority member? What is the most difficult aspect of being a majority group member?
- When is it a good idea to defy authority?
- 🎥 The teachers around Dawn seem oblivious to her peers' taunts and insults but immediately respond when Dawn fights back. What does this reveal about the plight of oppressed groups?

Welcome to the Dollhouse (Suburban Pictures, 1995), written and directed by Todd Solondz
Elapsed time: This scene begins at 00:17:36 and ends at 00:20:59 (DVD Scene 7)
Rating: R for language

What Women Want

Gender

Swinging ladies' man and confirmed bachelor, Nick Marshall (Mel Gibson), wakes up one day with the power to hear women's intimate thoughts. He uses this new ability to one-up his new boss, an up-and-coming executive named Darcy McGuire (Helen Hunt), whom he views as a threat to his masculinity and professional aspirations.

Nick has climbed the corporate ladder at the Sloane-Curtis advertising agency and is expecting to be named the new creative director. As the scene opens, Nick is waiting in the office of his boss (Alan Alda) to receive the promotion. Nick learns that the board of the agency wants to hire a woman to be the creative director and win new accounts targeting women. Darcy, the new hire, calls for a meeting and gives her creative team a kit of products that are seeking new advertising direction. The box includes a pantyhose, bath beads, pore strips, and body wax. Each person must come up with promotional ideas for products that women use. ⌐OBJ¬

- 🎥 What does Darcy's kit say about "what women want"? Why do you suppose these products are featured? What would a kit for men's products include? What if the agency had been hired to design advertisements for a transgender population—what products should be included?
- In an imaginary sequel to this film, *What Men Want*, a woman has the ability to read men's minds. What do you anticipate she would learn with her new powers?
- If you could ask a member of the opposite sex one question to unlock the mysteries of their minds, what would you ask and why?

What Women Want (Paramount, 2000), written by Josh Goldsmith and Cathy Yuspa, directed by Nancy Meyers
Elapsed time: This scene begins at 00:10:10 and ends at 00:19:52 (DVD Scene 3)
Rating: PG-13 for sexual content and language

White Man's Burden

Prejudice/racism

What would happen in America if Black people were in the majority and Whites were in the minority? This film turns race relations on its ear as we are transported to a time where color roles are reversed and racial politics are brand new. The story line follows Louis Pinnock (John Travolta), a member of the White minority who is trying to save his family from life in the ghetto. He loses his job, his family, his home, and he decides to fight back—the only way he knows how.

A well-to-do Black family and their friends are gathered around the dinner table and are discussing the "problem" with White people. Thad (Harry Belafonte), the host of the evening, is talking about how he lost money in a business venture where the building was burned down by White persons. Thad believes "there is something inherently wrong with those people." He says they are "genetically inferior, or they're culturally crippled, or they're socially deprived," and finally stops to ask "Are these a people who are beyond being helped?"

- W. E. B. Du Bois once said that the "problem of the 20th century is the color line." How true is this statement in the twenty-first century?
- In American society we have tried to "transcend" the subject of race; discuss how race is an integral part of American history and culture.
- Evaluate this statement by Benjamin Disraeli: "The difference of race is one of the reasons why I fear war may always exist; because race implies difference, difference implies superiority, and superiority leads to predominance."
- We hear of Black-on-Black crimes regularly on the news. Why don't we hear of White-on-White crimes (or of other racial groups)?

White Man's Burden (A Band Apart, 1995), written and directed by Desmond
Nakano
Elapsed time: This scene begins at 00:00:35 and ends at 00:02:26 (DVD Scene
1)
Rating: R for strong language and some violence

Why Did I Get Married?

Discrimination/prejudice

Writer/director Tyler Perry brings another romantic story: eight mar-
ried college friends gather together for their annual winter getaway.
Each couple has skeletons in their closets, and each friend is deter-
mined to meddle and help heal what hurts. Adultery, secrets, lies, and
temptations abound. Featuring an all-star cast including singers Janet
Jackson and Jill Scott.

Friends since college, Diane (Sharon Leal), Sheila (Jill Scott), Angela (Tasha
Smith), and Patricia (Janet Jackson) are doing some shopping at the resort
where they are having their reunion. They are joined by Sheila's friend, Trina,
who was brought on the trip by Sheila's husband (Sheila is not aware that her
husband is having an affair). Trina is trying to convince Sheila to buy some new
lingerie; Sheila is trying to put the spark back in to her relationship. She admits
that she believes Mike is "disgusted" by her plus-sized body. In the middle of
their conversation, a store clerk walks up to the five Black women and states
that they do not keep cash in the store and quickly walks away. Later that night,
Sheila and Mike (Richard T. Jones) are preparing for bed; when Sheila enters
the room wearing the new negligee that Trina recommended, Mike laughs and
begins to repeatedly insult her—he says that she looks like she is wearing a tent
and that she "looks like the cow that jumped over the moon." He tells Sheila
that he "might" be interested in her if she would lose 50 pounds. The scene ends
as Sheila cries herself to sleep.

- What would you do if a store clerk walked up to you and said some-
 thing to infer that you were planning to steal or rob from the store?
- How does gender relate to body size expectations? When a guy says he
 likes a girl with some meat or curves, what size is he referring to?
- In what ways does physical attractiveness advantage some over others?

How does this affect cultural trends?

Why Did I Get Married? (Lionsgate, 2007), written and directed by Tyler Perry
Elapsed time: This scene begins at 00:47:15 and ends at 00:52:32 (DVD Scene 12)
Rating: PG-13 for mature thematic material, sexual references, and language

Wild Hogs

Gender/dominance

Four middle-aged men attempt to regain pieces of their youth by donning black leather jackets and pants and going on a cross-country motorcycle ride. They fancy themselves tough bikers and name their "gang" the Wild Hogs. They have mishap after mishap and have an ill-fated run-in with a tough biker gang called the Del Fuegos. In the end, they find both their sense of adventure and their own self-respect.

In this scene we meet Bobby (played by Martin Lawrence), an aspiring writer, who has taken a year off from work to write a do-it-yourself book, but it's the last day of that year and his wife has come to let him know that he needs to go back to work. Karen, Bobby's wife, appears to be the boss of the home—everyone listens to her, while Bobby seems to get little respect. His mother-in-law contends that he is not deserving of respect because he does not provide for his family. This clip ends as Bobby goes back to work.

- Do you think men work better with other men than with women? Would you rather have a man or woman as your boss?
- How do men tend to work out their differences differently from women?
- U.S. journalist Stephanie Coontz once stated, "A two-parent family based on love and commitment can be a wonderful thing, but historically speaking the 'two-parent paradigm' has left an extraordinary amount of room for economic inequality, violence, and male dominance." Discuss.

Wild Hogs (Touchstone Pictures, 2007), written by Brad Copeland, directed by Walt Becker
Elapsed time: This scene begins at 00:03:00 and ends at 00:04:59 (DVD Scene 1)
Rating: PG-13 for crude and sexual content, and some violence

X-Men

Difference

Born into a world filled with prejudice are children who possess extraordinary and dangerous powers such as manipulating the weather and shooting laser beams from their eyes—the result of unique genetic mutations. Under the tutelage of Professor Xavier (Patrick Stewart), these outcasts learn to harness their powers for the good of mankind. Now they must put their powers to use against the sinister Magneto (Sir Ian McKellan), a mutant who believes that humans and mutants can never co-exist, who has developed a machine that will "mutanize" all human beings.

Magneto describes his philosophy to Rogue, a mutant who has the ability to take on the powers of other mutants simply by touching them. In order to complete his evil plan, Magneto plans to use Rogue's power by sacrificing her life in his doomsday machine. He explains how, when he arrived from the concentration camps in Poland in 1949, he believed the American promises of tolerance and peace. Rogue asks why he plans to kill her; Magneto replies, "Because there's no land of tolerance. There is no peace. . . . Women and children, whole families, destroyed simply because they were born different from those in power. But after tonight, the world's powerful will be just like us. They will return home as brothers—as mutants. Our cause will be theirs. Your sacrifice will mean our survival. I'll understand if that comes as little consolation." (The scene ends with the image of the Statue of Liberty.)

- Do you believe that we could achieve peace if the differences between groups of people were eliminated?
- Describe a real-world example of requirements to conform one group to another.

- 🐾 Magneto goes to extremes to eliminate discrimination; can you describe ways to reduce discrimination in our society?

X-Men (Bad Hat Harry Productions, 2000), written by Tom DeSanto and Bryan Singer, directed by Bryan Singer
Elapsed time: This scene begins at 01:06:53 and ends at 01:08:34 (DVD Scene 18)
Rating: PG-13 for sci-fi action violence

X-Men III: The Last Stand

Difference/racism

The X-men trilogy is based in a world where members of the human race become mutants with extraordinary powers. The "normal" humans are threatened by the mutants and develop laws that penalize mutants for using their powers. In this last part of the trilogy, scientists have created a "cure" for mutants; mutants can now choose to retain their abilities or give them up and become "normal."

Hank McCoy (Kelsey Grammer) meets with teachers at the mutant school where he first tells them of the "cure" that will "suppress the mutant X gene ... permanently." Storm (Halle Berry), a mutant with the power to control the weather, reacts defensively to the thought of being "cured." She asks, "Since when did we become a disease?"

- 🐾 Why do the humans feel the need to find a cure for the mutant gene?
- Suppose one day you receive a phone call from a representative of the government advising you that a terrible mistake had been made: You were supposed to have been born a different race (e.g., if you are White, then Black or other racial minority; if you are a racial minority, then White). It will now be necessary to rectify that mistake—a painless operation will be performed at no expense to you—that will transform you into the "proper" race. The government is prepared to compensate you for its mistake. How much would you want?
- How might we end racism in our society? Do we need to get rid of "race" in order to do it?

- If you suddenly developed an allergy to some substance found only in the United States, and you had to emigrate to another country, which one would you choose? How would you expect to be treated? Suppose you were frowned at for identifying with your American-ness?

X-Men III: The Last Stand (20th Century Fox, 2006), written by Simon Kinberg and Zak Penn, directed by Brett Ratner

Elapsed time: This scene begins at 00:15:07 and ends at 00:17:50 (DVD Scene 4)

Rating: PG-13 for intense sequences of action violence, some sexual content, and language

Conclusion:
The Prevailing
(Hidden) Discourses

How power, oppression, prejudice, dominance, and ethnocentrism survive

If you look at the feature films listed in the contents of this book, you will find films from different types of genres and themes, of all types of subject matter. Adventure, action, drama, comedies galore, and animated movies for children's audiences—something for all. The sheer size of this text suggests that the cinematic experience is a fixture of American entertainment. It could be argued that movies are a purely American phenomenon, in the same way that the Grecian schools gave us philosophy and European culture dominates dramatic theater and literature. What is also glaringly apparent, if you have examined the clips, is that movies are so much more than entertainment; they are propaganda machines.

Any media historian will tell you of how the movie-going experience has changed the ways in which the family got its news and information. Many students today are unaware of the newsreels that used to play before the beginning of movies in the theater and drive-in. Families were not treated to the "coming

attractions" that appear today but were provided with the latest national news (most often with some additional movie-style hype added). The audiences were inundated with sensationalized headlines that were wrapped with journalistic truths, and then the movie would start. These stories gave the subsequent film a level of crediblity that raised the film to a more factual, informative level. We must not forget the messages hidden within the films themselves. As an example, let's take a look at the heyday of horror films and their subtle messaging.

The earliest horror films were chockfull of hidden and overt messages. Jeff Martin, who teaches a course on the history of horror films, noted that in the years following World War II, "horror films often included political messages—creatures like 'The Blob' reflected our fears about atomic bombs and nuclear radiation; our concerns about the evils of communism were seen in early zombie movies" (Laepple, 2007). The early animated shorts (cartoons) did the same thing. Bugs Bunny cartoons were bastions for anti-Hitler propaganda as well as anti-Japan messaging—titles such as "Bugs Bunny Nips the Nips" and "Tokio Jokio" surfaced during the war. The family hour at the movies or in front of the television was replete with cultural information that was, in some ways, legitimized by the newsreels shown before the movies began.

The newsreel at the beginning of the film featured scrolling headlines (see examples below) of information and sound bytes from presidents and other leaders. What made this messaging real was the accompanying fear. As science and technology were making advances, the average citizen did not know what to expect and constantly was made aware of the threat of possible foreign or alien (from outer space) invasion. Imagine how public opinion was significantly influenced by these messages before and during the movie.

Entertainment Magazine Online (www.emol.org)

By increasing the threat and fear, the newsreels reinforced the public's dependence on governmental agencies and supported the national agenda related to foreign policy and American superiority worldwide.

What is very clear in this text is the prevalence of clips that exemplify power, oppression, prejudice, dominance, and ethnocentrism in American cin-

ema. One could argue that these terms are at the heart of American history and culture. If we take an honest look at our historical record, we would have to acknowledge that this country was formed and built by/upon the dark side of difference.

In diversity-intensive teaching environments, majority students often decry the constant focus on race and difference; they question why we cannot "transcend" these topics. What they are really asking is "why do we have to talk about this stuff—it's uncomfortable and *those* minorities should just get with the [White] program."Transcending race is an impossibility in American culture, because the United States is too young (400 years old in 2007), and in part, because from its inception there has been a race- and color-based system of commerce, politics, and education (some would add religion).The American marketplace has always centered on White dominance; therefore, whiteness becomes the benchmark by which all racial groups are measured (the same is true for gender [men], sexual orientation [heterosexuals], nationality [American], and religion [Christianity]).

One must question how America became the world's leading superpower (having multiple levels of influence around the globe) in such a relatively short period of time. Answering this question requires admitting the power of political dominance that is gained by violence (or the threat of), economic clout, and the ability to project oneself as a superior world leader. America's cultural influence is tangible around the world in entertainment, education, fashion, business, and politics. Certainly, the global "war on terror" and our decision to take democracy and freedom into the uttermost parts of the earth (ethnocentrism at its best) are revelatory about our predisposition to dominance.

This book reveals the pervasive nature of power, oppression, prejudice, dominance, and ethnocentrism as foundational truths in American culture. We must understand how hand-in-glove the issues are—agent groups have the systemic power to dictate how target groups are seen or unseen, heard or unheard, revered or reviled. In most cases, those minorities deemed acceptable are the ones who strongly identify with the dominant society, accept negative stereotypes about themselves and their group, and those who know very little and are not interested in learning about their own ethnic heritage or history. In some respects, they become complicit then in their own oppression. Those who do not pay obeisance to the predominant group then are prejudicially demonized and subject to expulsion. They become invisible and useless. The vantage point of the majority group then becomes the authoritative context by which we come to understand sociocultural issues.

Case in point: We celebrate the discovery of the New World; we continue to honor Christopher Columbus with a federal holiday (although he never

really made it to these shores, and the land he "discovered" was already occupied). A couple of centuries later, the Mayflower story of pilgrims meeting the indigenous people is gleefully told as a nice, neat children's story. What happened to indigenous societies is nothing short of obliteration from historical and contemporary thought. The constant whitewashing of the institutions of slavery, legal segregation, and imperialism allows for a sort of psychocultural absolution. History becomes easily packaged and palatable (for profit) tourist attractions; sites like Colonial Williamsburg, the Jamestown Colony, and the Yorktown Settlement claim to "tell the truth" about our history, but none of the dramatic reenactments or museum exhibits show slaves in the stocks, families ripped apart at auctions, the brutal massacres in action, the blood and rapine. The textbooks show pictures of notable *former* slaves or prisoners but only in dressed-up portraits. What emerges, then, is historicized entertainment wrapped in an educational trench coat, for the average student, a sense that "things really weren't that bad."

All the while those who fought for revolution and freedom were vilified and treated as outsiders, meddlers, and interlopers. Our textbooks rarely mention the significance of slave revolts that happened on almost a daily basis; the dominant discourse would have us believe that slaves and prisoners were satisfied with their places as subhuman noncitizens. Those in power were providing a public service—in some cases, doing the will of God—by enslaving and interring the stupid "savages." This thought process helped to justify systemic policies of enslavement by the white population:

> The logic of symbolic-material connection was relatively straightforward: If they are savage, they need to be eliminated. If they are stupid, they are only good for slavery. If they are docile, they must be whipped into action. If they are nomadic, they have no land rights and their land can be taken. If they are inferior, they cannot be allowed to marry whites and dilute the gene pool or become citizens and weaken the body politic. (Shah, 2003, p. 4)

In the same manner, because of the desire to minimize the significance of media misrepresentations in film, ordinary moviegoers miss the intentionality of a dominance discourse. As a concluding example, let's return to the earlier discussion of the racist ideology present in the film *Dangerous Minds*. On the discussion board of the Internet Movie Database (www.imdb.com), community members discussed the entertainment value of the film and assert their frustrations with the numerous claims of racist intent. Users' comments such as "Give it a rest, please" are coupled with arguments that the film is not about race at all, and that Black people should stop being so *overly sensitive*.

Without a critical eye, most see a liberal, well-intentioned White teacher

who just wants to spread some hope to the poor and downtrodden minorities—what President McKinley in 1898 called "benevolent assimilation." A critical examination of the film reveals her tactics—she threw candy at them like trained seals while teaching them to conjugate verbs about death. She lectured them that they had the power of "choice" to change their situations (denying the impact of systemic oppression), and she held out hope that they could learn poetry—to get them there—songs about drug dealers sung by Bob Dylan. The soundtrack to the film is a critically acclaimed hip-hop explosion, but the Hollywood version of Louann Johnson ignores the poetry of the students' experience to give deference to a White artist and style (although the text of *My Posse Don't Do Homework* indicates that the author-teacher did use rap lyrics to teach poetry). When her savior complex wasn't enough, when she couldn't *fix* their circumstances, she quit—until the students restored her to savior status as they "raged against the dying of The Light." *That's Entertainment?!?!?!?!?!?!?*

One thing that is right about this particular film is the significance of the role of the teacher. A classroom leader who is committed to educating students about the multiple systems of oppression that exist in our society is crucial to producing global citizens who are prepared to engage our diverse and interconnected world. Teachers can help create students who share a commitment to fairness and social justice.

Admittedly, teaching diversity is occasionally difficult, frequently challenging, and provocative. It can leave you a little unsettled, but it yields the ability to hear things and see things differently. It's not a simple process, and, you must realize, diversity is not about us coming together in a circle to sing "Kumbaya." Diversity, in and of itself, is divisive; students must also be invited to share the ways in which they are similar—how their cultural values and beliefs merge with one another despite differences in background. They need educational leaders who will help them to find their commonalities and to place value on their tapestries of difference.

If education is about the search for knowledge and truth, then as educators, we must assist students in the recognition that "truth is relative" based upon living experiences. If this diversity and inclusion "thing" is to work, we need to find some perspective, that is, we must have the ability to see the world from someone else's perspective. A Native American tradition of sitting in a circle to have discussions underscores the importance of having different perspectives about a central figure. You see, finding truth is about seeing the center from all sides. We must share social interactions to have the ability to share perspectives, to discuss, and to respectfully disagree and/or change viewpoints. This resource manual has been developed to assist teachers to take their students on

the quest for truths. In his 1963 book *The Fire Next Time*, James Baldwin gave us the rationale for teachers leading this endeavor:

> Everything now, we must assume, is in our hands; we have no right to assume otherwise. If we do not falter in our duty now, we may be able, handful that we are, to end the racial [sexist, heterosexist, antireligious] nightmare, and achieve our country, and change the history of the world (New York: Modern Library, 1995, p. 104).

Reference

Laepple, W. (2007, October 31). Tales from the script: Gory replaces story as filmmakers try to scare up new ideas. *The Daily Item*. Last accessed July 24, 2008 from http://www.dailyitem. com/archivesearch/local_story_304003125.html.

Shah, H. (2003). "Asian culture" and Asian American identities in the television and film industries of the United States. *SIMILE: Studies in Media & Information Literacy Education, 3*(3), 1–10.

Appendix

Film Clips by Topic

Anti-Semitism

Borat
The Chosen
Freedom Writers
Snatch
Swing Kids

Classism

Harry Potter and the Chamber of Secrets
John Q
A Knight's Tale
The Notebook
Pretty Woman
Titanic
Tyler Perry's Daddy's Little Girls

Compulsory Heterosexuality

Becoming Jane
The Birdcage
Brokeback Mountain
The Family Stone
Holiday Heart
Mona Lisa Smile
My Big Fat Greek Wedding
The Talented Mr. Ripley

Co-Optation

Ace Ventura: When Nature Calls
Can't Hardly Wait
The Chronicles of Narnia: The Lion, the Witch, and the Wardrobe

The Devil Wears Prada
Facing the Giants
Malibu's Most Wanted
"O"
Step Up
Undercover Brother

Difference

Antz
Cursed
Kicking and Screaming
Pocahontas
The Ringer
Stitch: The Movie
Transformers
A Walk to Remember
X-Men
X-Men III: The Last Stand

Discrimination

Addams' Family Values
Annapolis
Babe: Pig in the City
Crash
Hairspray
Howard Stern Private Parts
In the Mix
Mean Girls
Save the Last Dance
Something New
Tyler Perry's Daddy's Little Girls
Why Did I Get Married?

Dominance

Addams' Family Values
Akeelah and the Bee
Antwone Fisher
Bridge to Terabithia
Chicken Run

Clueless
Dangerous Minds
Erin Brockovich
Gladiator
John Q
Knocked Up
Mean Girls
Swing Kids
TMNT
Wild Hogs

Ethnocentrism

Barbershop
Black Hawk Down
A Bronx Tale
Falling Down
Flushed Away
Freedom Writers
Harry Potter and the Chamber of Secrets
Kill Bill (vol. 1)
Love Don't Cost a Thing
D3: The Mighty Ducks
My Big Fat Greek Wedding
Step Up
Swing Kids
Undercover Brother

Gender

Beauty and the Beast
Becoming Jane
Catwoman
Fight Club
Girlfight
I Now Pronounce You Chuck and Larry
The Last King of Scotland
Mona Lisa Smile
Mulan
Now and Then
She's the Man
Superbad

To Wong Foo, Thanks for Everything, Julie
 Newmar
What Women Want
Wild Hogs

Heterosexism

The Birdcage
Boat Trip
The Family Stone
Kicking and Screaming
Saved!
The Talented Mr. Ripley
V for Vendetta
Wedding Crashers

Homophobia

Bedazzled
Cursed
Love Don't Cost a Thing
Remember the Titans
Talladega Nights: The Legend of Ricky Bobby
Three to Tango

In-Group

Clueless
The Hunchback of Notre Dame
Pay It Forward
Radio

Invisibility

Any Given Sunday
Do the Right Thing
Dreamgirls
The Firm
Holiday Heart
The Incredibles
Maid in Manhattan

Miss Congeniality
Welcome to the Dollhouse

Oppression

American Gangster
Black Hawk Down
Charlie and the Chocolate Factory
D3: The Mighty Ducks
Ella Enchanted
Gladiator
Goodfellas
Happy Feet
The Incredibles
Knocked Up
Old School
Pleasantville
Pocahontas
Reign over Me
The Rundown
The Siege
A Troll in Central Park
V for Vendetta
Varsity Blues
Welcome to the Dollhouse

Out-Group

Antz
Barbershop
The Birdcage
Bridge to Terabithia
Hitch
The Hunchback of Notre Dame
Madea's Family Reunion
Maid in Manhattan
The Matrix Revolutions
D3: The Mighty Ducks
Pay It Forward
Ratatouille
Rosewood
Shrek the Third
A Walk to Remember

Power

American Gangster
Annapolis
Bridge to Terabithia
Ella Enchanted
Facing the Giants
The Final Cut
Goodfellas
Harold and Kumar Go to White Castle
Hercules
Hitch
Howard Stern Private Parts
In the Mix
Knocked Up
The Last King of Scotland
Lean on Me
License to Wed
Man of the Year
Notes on a Scandal
Pay It Forward
Radio
Saw
Spanglish
A Troll in Central Park
Varsity Blues

Prejudice

Ace Ventura: When Nature Calls
Akeelah and the Bee
Bend It Like Beckham
Down to Earth
Finding Forrester
Guess Who
Hairspray
Harry Potter and the Chamber of Secrets
Higher Learning
Jungle Fever
Knocked Up
The Little Mermaid
Pooh's Heffalump Movie
The Ringer
Something New

White Man's Burden
Why Did I Get Married?

Privilege

D3: The Mighty Ducks
Dangerous Minds
Divine Secrets of the Ya-Ya Sisterhood
The Emperor's Club
Freedom Writers
Higher Learning
Malibu's Most Wanted
Romy and Michelle's High School Reunion
Spanglish

Racism

A Bronx Tale
Holes
Jungle Fever
Monster's Ball
White Man's Burden
X-Men III: The Last Stand

Sexism

Anchorman: The Legend of Ron Burgundy
Coyote Ugly
Gladiator
Holes
House of Sand and Fog
Miss Congeniality
Mulan
One Night with the King
Pay It Forward
The Stepford Wives
S.W.A.T.

Social Justice

Amazing Grace
Brother Bear

Flubber
Glory
Kingdom of Heaven
The Lion King
The Matrix Revolutions
The Patriot
Shawshank Redemption
Swing Kids

Stereotype

Bedazzled
Boat Trip
Can't Hardly Wait
Crash
Dodgeball: A True Underdog Story
Finding Nemo
Hairspray
Harold and Kumar Go to White Castle
I Now Pronounce You Chuck and Larry
Legally Blonde
Mean Girls
Pooh's Heffalump Movie
Undercover Brother

Studies in the Postmodern Theory of Education

General Editors
Joe L. Kincheloe & Shirley R. Steinberg

Counterpoints publishes the most compelling and imaginative books being written in education today. Grounded on the theoretical advances in criticalism, feminism, and postmodernism in the last two decades of the twentieth century, Counterpoints engages the meaning of these innovations in various forms of educational expression. Committed to the proposition that theoretical literature should be accessible to a variety of audiences, the series insists that its authors avoid esoteric and jargonistic languages that transform educational scholarship into an elite discourse for the initiated. Scholarly work matters only to the degree it affects consciousness and practice at multiple sites. Counterpoints' editorial policy is based on these principles and the ability of scholars to break new ground, to open new conversations, to go where educators have never gone before.

For additional information about this series or for the submission of manuscripts, please contact:

> Joe L. Kincheloe & Shirley R. Steinberg
> c/o Peter Lang Publishing, Inc.
> 29 Broadway, 18th floor
> New York, New York 10006

To order other books in this series, please contact our Customer Service Department:
> (800) 770-LANG (within the U.S.)
> (212) 647-7706 (outside the U.S.)
> (212) 647-7707 FAX

Or browse online by series:
> www.peterlang.com